U0123566

美好生活·花园时光

扫码看全书视频

全能
花艺技法
与设计百科

格研文化 编

中国林业出版社
China Forestry Publishing House

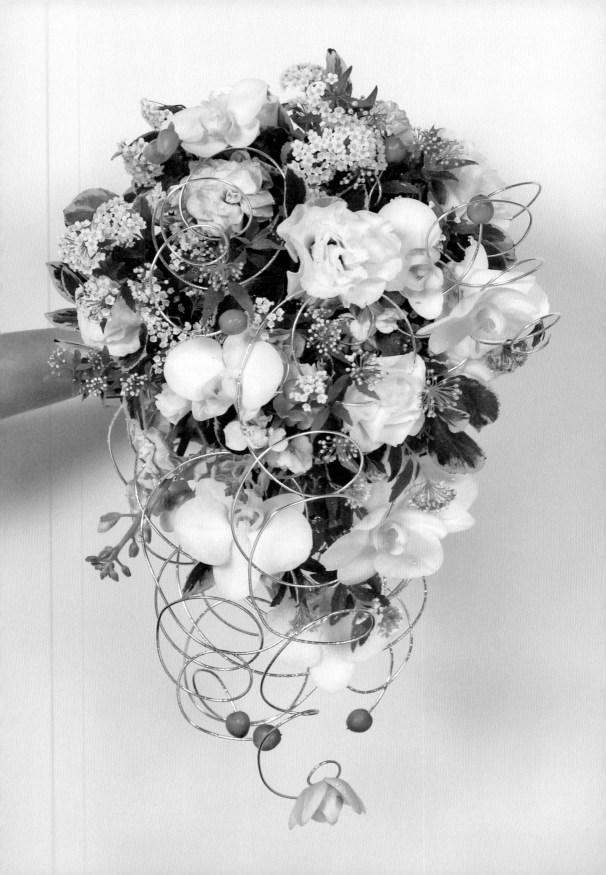

叁

材料的固定

材料的使用技巧

花艺技法

陆

花艺设计风格

柒
花艺设计原理

捌

架构经典设计技巧

玖

花束制作

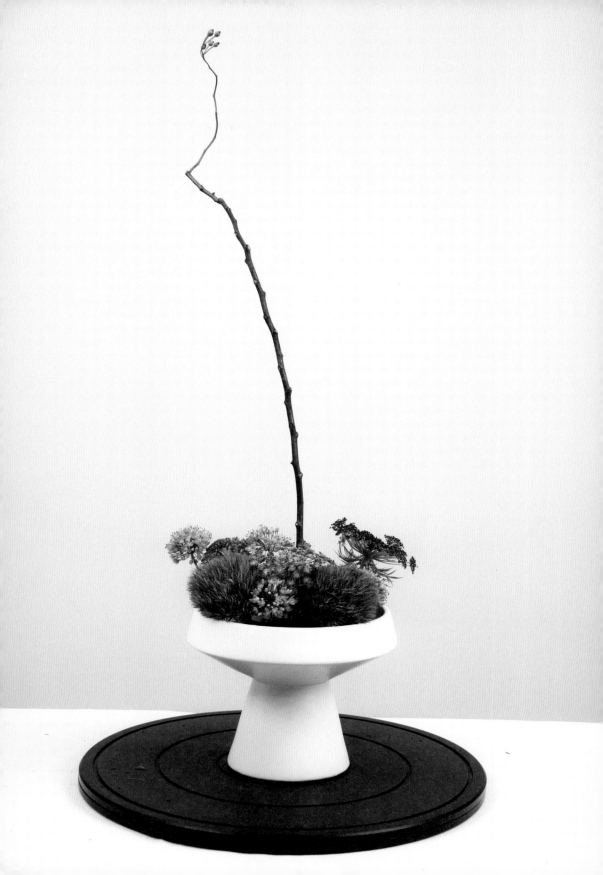

工 具 与 花 材 保 鲜

001 万用剪的选择和使用

　　万用剪可以帮助花艺师处理绝大部分的花材，使用频率非常高。但铁丝、胶带以及一些比较坚硬的木本、藤本的枝材不能用万用剪。

　　万用剪尽量选择深色，因为浅色虽然好看，但是时间长了，剪刀口的保护涂层都会有一定的污损；而且浅色的手柄受汗渍污染后特别明显。

　　剪刀尽量选择适合自己手型的型号，一般专业剪刀都有尺寸标号，比如160、170，号越小，剪刀相对来说也就越小；现在有些品牌推出了左手剪，可供左手习惯的客户选择。

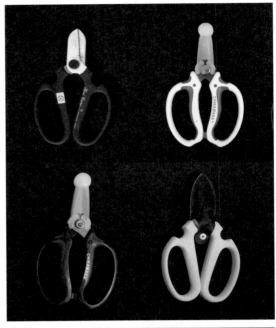

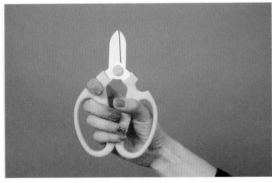

◆食指置于凹槽处，下面握柄圈内余出2个手指的宽度，就比较合适。

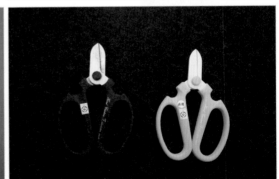

◆随时注意保持万用剪的清洁，尤其是胶状物。

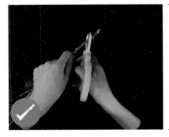

正确方法：剪刀头朝向外侧，与剪取的部分方向一致。

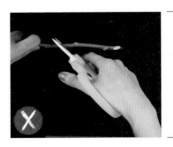

错误方法：万用剪剪刀头冲着握持花杆的手，容易造成划伤。

缎带剪的选择
和使用

花艺设计用到的材料除了植物性材料，也有非植物性材料，比如缎带、包装纸类等，如果用万用剪去剪，可能没有那么锋利。这时，就需要用到缎带剪。剪刀有两片刃，刃之间的缝隙越小，螺丝拧得越紧，越适合去剪薄的东西。缎带剪的刃夹得越紧越锋利，剪口纹理会越平滑。

◆尽量挑刀刃长一些的缎带剪，这样即使宽的缎带也可以一次剪断，并且剪口平滑。有的缎带剪（图右）也带有处理铁丝的功能，可以结合自己的需要选择。

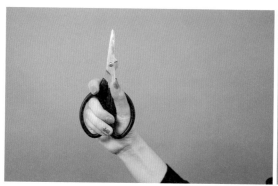

◆握的时候食指放置于剪刀外部。

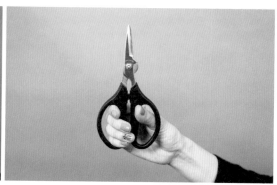

◆也可以全部手指内部持握。

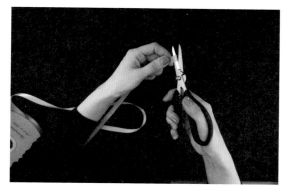

◆缎带剪法：把缎带左右对折，距离底部1/4或1/3位置剪断。

Tips

选择适用于缎带宽度的缎带剪，以免出现宽度不符、多次剪断、形成锯齿等情况。

铁丝剪的选择和使用

在花艺设计中，经常会用到各种型号的铁丝，因此需要各种不同类型的铁丝剪。

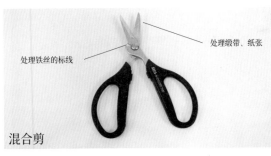

处理铁丝的标线

处理缎带、纸张

混合剪

◆花艺设计中常用到的是26号至16号的花艺铁丝，一般可以选择混合剪来处理。混合剪有两个部分，上半部分用来处理缎带、纸张、叶片之类的轻薄材料；肩部有一个小的缺口，它可以剪花艺铁丝。

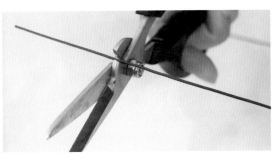

◆混合剪处理铁丝时，缺口向上。

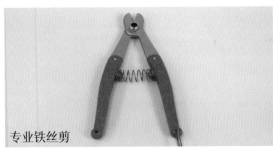

专业铁丝剪

◆如果处理花艺铁丝频率比较高，建议选择专业的铁丝剪，它只有一个作用就是剪铁丝。怎么样去鉴定我可以剪多少号的铁丝呢？把剪刀口张到最大，如果这根铁丝直径为张开角度的1/3~1/4，是可以剪断的。

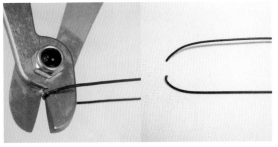

◆错误使用方法：铁丝不可弯折剪断，以免截断口出现弯折。这个弯折非常不好恢复，应该尽量直着剪断。

标准钳

◆钢质的比较脆的一些钢丝，或者悬挂类的钢丝绳，用普通铁丝剪非常容易绷断，这时需要标准钳。注意，有时候力量不够大，夹住之后去晃这根铁丝，如果铁丝硬度不够的情况下，末端就会弯曲。

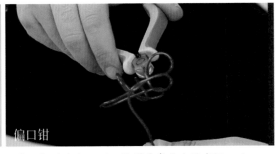

偏口钳

◆偏口钳的头小，可以进到非常狭小的空间，比如架构缝隙等。

枝剪的选择和使用

比较粗壮的枝条，万用剪处理很困难，需要用到专业的枝剪。绝大部分枝剪上面都带着弹簧，有助力的作用。

枝剪作为主要的花艺工具之一，通常用于修剪较为粗壮木本及藤本类材料。

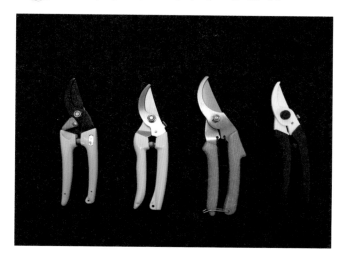

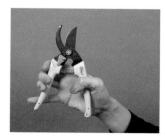

枝剪的手持方法：
刀刃在上，虎口手握刀刃方向的手柄；砧板在下，其余四个手指握住砧板方向的手柄。

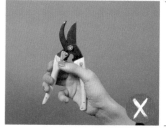

错误**使用方法**：小拇指脱离手柄。

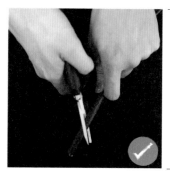

正确使用方法：在使用枝剪时，远离握住枝材的手，枝剪的刀刃方向朝外。省力剪断粗枝的技巧：我们可以拿剪刀去夹住花杆，握紧之后固定住反复旋转，可以直接剪断。

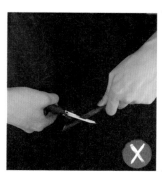

错误**使用方法**：枝剪的刀刃方向朝内。

1.枝剪一直处于刀刃张开的状态，刀刃又比较锋利，使用风险较高，绝大部分的枝剪都有一个"保险"功能，在非使用状态保证刀刃闭合。但不同类型的枝剪"保险"的位置有所不同，有的闭合装置在上面，有的在下面。不推荐大家买"下保险"的枝剪，因为在频繁操作过程中，它一旦松动，可能会打到小手指。"上保险"的可以单手操作。

2.尽量选择和自己手型比较吻合的型号。

_{Lesson 005} 花刀的选择和使用

　　无论剪刀有多么锋利，剪的过程对花茎来说是一个双面挤压的过程，影响花材水分吸收。而花刀对花材损伤小，而且因为比较小，收纳更方便，使用更快捷。

　　花刀的刃有直刃和弯刃，根据习惯选择，没有好坏之分。

◆不同刀锋对比。使用时，一般用刀刃的中下段，而不会用刀尖。

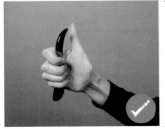

正确使用方法：拇指与刀背形成15°～30°的位移角度，而且永远保持"赞"的姿势。

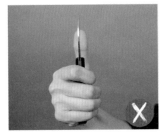

错误**使用方法**：拇指完全与刀背重合。

去枝操作动作展示。

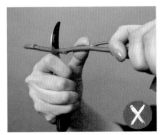

错误**使用方法**：刀锋与拇指相对，有一定切割角度，拇指下压发力。

电钻的选择和使用

LESSON 006

在花艺设计中，尤其是架构的制作，我们经常会用到电钻等木工类的电动工具，可以根据需要进行选择。

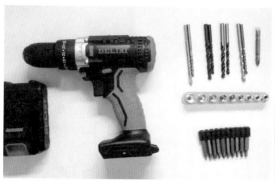

◆全套电钻工具，配有各种不同类型的钻头。

◆电池安装后。

◆档位，数字越大，代表转速、力量越大。

◆夜视辅助灯。

1.在操作电钻时，长发的女生一定要把头发盘起来，否则不慎绞到上面去，会非常危险。

2.电钻选择：

①选择带充电电池的。施工制作中如果电源线不够，或者没有电源，充电式的电钻就很方便。而且建议大家买双电池的，即使连续工作也保证不会断电。电池的功率建议选择16伏以上的，这样电钻的力量比较大，可保证很多大型的结构操作有足够的力量。

②选择带冲击功能的。冲击功能的力量相对来说比较大，可以穿透硬性的结构，比如轻钢龙骨、石膏板结构，或者一些砖体墙。

钳子、手锯的选择和使用

钳子和手锯也是花艺设计中经常用到的工具，很多花艺材料用剪刀和钳子是没法处理的，比如竹子，用剪刀就会劈掉，最好使用手锯处理。

◆可以备一套粗、细都有的手锯。

◆操作时，手锯锯片垂直木板。

尖嘴钳

◆尖嘴钳是花艺师应用得最多的钳子，用于一些精细的操作，比如想用金属丝做一个像蚊香一样的造型，拿手是弯折不动的，尖嘴钳就是最好的选择。尖嘴钳可以探到作品的内部，在局促的空间操作。

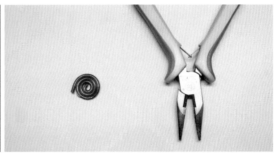

◆尖嘴钳弯曲铁丝效果。

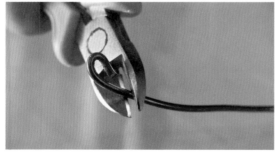

◆偏口钳用于铁丝切口。

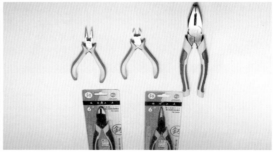

◆花艺常用花艺钳子类型。常用到的花艺钳有标准钳、尖嘴钳、偏口钳。标准钳也俗称老虎钳。

Tips

　　钳头分成三部分，前面细齿部分用于固定，夹紧处理材料；中段的部分用于圆柱体的紧固，比如夹铁棍、竹竿等；最后的部分是用于夹断。因为具有非常好的平整度和重量，有的时候也会把它当做锤子来使用。偏口钳可以非常精准地夹断铁丝。

测量工具

花艺设计中，经常会遇到要量尺寸的情况，常用的测量工具有测光笔、测距仪、盒尺、皮尺等。

◆激光笔常用于户外项目指示作用。

◆一般5m以内的幅度，常用盒尺。

◆1m小型盒尺，一般可用于测量花艺作品尺寸。

◆测距仪，建议使用可充电的，比较方便。

手动码钉枪的使用

码钉枪是花艺设计中经常用到的固定工具，使用范围比较广。

认识码钉枪

手动码钉枪

◆最好选择可以调节打入钉子力度的码钉枪，通过拧螺丝，越往下拧，打入的深度也就越深。

装钉操作指示

◆码钉枪的底部或侧边会有一串数字，代表可以用的不同规格型号的针。并不是所有的码钉枪都可以兼容三种钉子，尽量选择多功能的。

码钉枪的应用场景

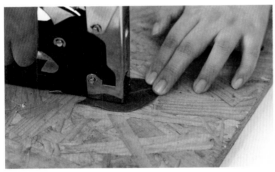

◆固定片状材料应用。

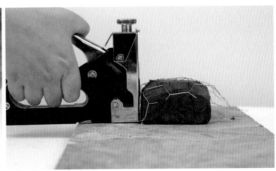

◆在鸡笼网固定花泥中的应用。

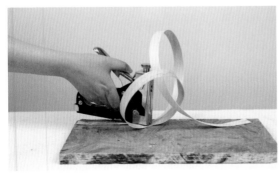

◆固定各种花艺造型，如木片等。

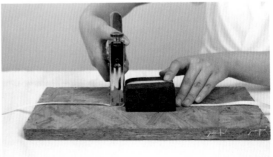

◆丝带固定花泥应用。这种方式可以用于需要花泥的植物墙的制作。

花艺胶带的种类

　　胶带是花艺师不可缺少的工具之一，主要起到连接固定的作用。胶带的类型很多，各有不同的特点，可以根据工作需要，选择合适的胶带。

透明胶带

◆ 常用于普通粘贴固定，可以搭配胶带车用。

防水胶带

◆ 用于花器、花泥固定，接触水仍可保持黏性。也可以作为定位点的标记。

美纹纸胶带

◆ 用于"打底"，可无痕揭掉，对表面损伤很小。

花艺胶带

◆ 用于花茎、叶片固定，有多种颜色与植物颜色相对应，起到视觉隐藏作用。

泡沫双面胶

◆ 强黏性，多用于造型固定，但难清理，轻易不要用。要用的话，也尽量用便宜的剪刀。

3M 胶

◆ 黏性牢固稳定，几乎可无痕揭掉，而且轻薄。

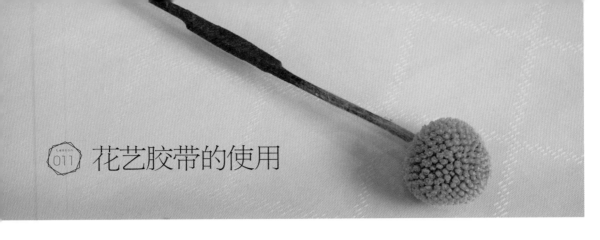

_{Lesson 011} 花艺胶带的使用

　　常用的花艺胶带，以绿色、棕色居多，，可以用于花枝的拼接、遮盖、隐藏接头，铁丝装饰等。绿色、棕色居多。花艺胶带看上去没有黏性，操作时手温加热就会产生黏性。缠绕时需要一边旋转一边拉紧。即使断掉也没有关系，几乎看不到任何拼接痕迹 。

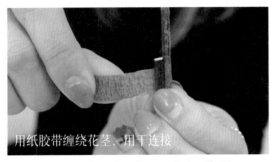

用纸胶带缠绕花茎，用于连接

◆将花茎和加长杆拼在一起，用花艺胶带缠绕。

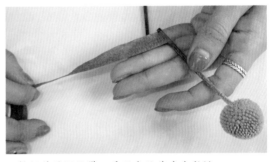

◆抻拉花艺纸胶带，手温会让其产生黏性。

美纹纸的特点和用法

　　美纹纸是很好的打底胶带。其他如泡沫双面胶等，如果直接粘在花器表面，撕下来会留下痕迹，伤害花器。可以用美纹纸打底，然后在美纹纸上粘贴各种胶带，从而保护花器。

◆将美纹纸贴在花器上。

◆在美纹纸上附着双面胶，再粘叶子。

◆美纹纸去除后无粘贴痕迹。

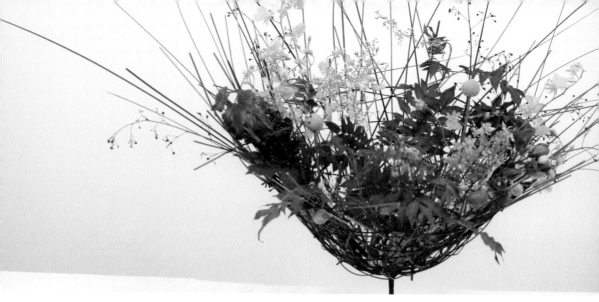

012 鸡笼网、塑料平网的选用

花艺常用工具当中我们常需要用到各种"网"，这些网都叫什么？有什么作用？怎么选择呢？

塑料平网

塑料平网和鸡笼网相比而言，不太会扎手，而且形状固定，适合需要精准定位的花艺作品应用。塑料平网是一体成型的，它不像鸡笼网有很强的拉伸功能，一拉形状就变。比如想去做一些悬挂试管、花材的作品，距离需要精准定位，塑料平网就是一个非常好的选择。它的孔径位置都非常准，每一格的距离都能算得出来。再比如要做一个花墙，拿塑料平网直接把花泥板勒住，两侧用扎带或绑线固定。

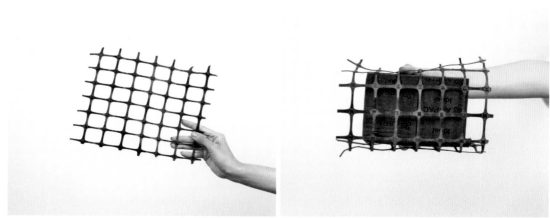

◆ 市场上常见的塑料平网。　　　　　◆ 塑料平网花泥固定，适用于花墙。

鸡笼网

鸡笼网是一种金属质地的编织网，网孔的大小、钢丝的粗细和硬度都有不同的规格。孔的大小可以通过拉伸改变。

◆鸡笼网在建材市场上很容易购买到。

◆可利用鸡笼网进行塑型，多用于架构、造景使用。

◆利用鸡笼网进行花材固定。

◆利用鸡笼网包裹花泥，用于悬挂。

Tips

鸡笼网的用途

1.塑形。比如想做一个山的造型，可以拿鸡笼网直接来弯折。

2.固定。可以直接把它弯折成一个球状放到花器内部，用于支撑固定花枝，自然风格的花艺作品经常用到这种固定方式。一是取材方便，不需要特别笨重的花泥；二是花材一直处于水养状态，可保持较长的瓶插期。要注意的是对于孔径的选择，过密过小的孔径有可能花材插不进去，过大花材有可能固定不住。常用的网孔尺寸2～3cm。

3.包裹。可以包裹花泥。比如悬挂类的作品，虽然悬挂类可以选择自身带有包裹的"香肠"花泥，但是大小往往不符合我们的要求，而切一段合适的花泥块，通过鸡笼网包裹，最后用扎带做一个小的连接固定，就可以把一整块或者一长条的花泥整个给悬挂起来。

花艺铁丝的种类和使用

013

花艺铁丝其实就是各种金属丝，很多材质不一定是铁的。花艺铁丝在设计中应用非常普遍。

不同型号的花艺铁丝

◆铁丝直径多用数字来表示，数字越大越细，多用于交叉点捆绑固定；数字越小越粗，作为作品的骨架，起支撑作用。

不同工艺的花艺铁丝

◆铁丝表面工艺不同，有涂层铁丝、绿色棕色纸胶带包裹铁丝、冷锻铁丝等。

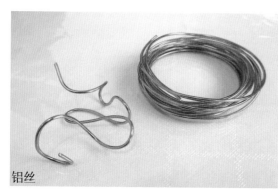

铝丝

◆多用于曲线造型、起到装饰性作用，质量轻、易剪断。

装饰性铁丝

◆有不同颜色，直径细，装饰性大于功能性。

纸皮铁丝

◆使用率极高，可用于绑点固定；多色选择，可与作品或材料颜色统一，起隐蔽作用。

◆花艺铁丝用于架构作品造型。

花泥的种类

　　花泥的主要成分是酚醛树脂，是一种化学材料，它有非常强的吸水力，一块花泥吸上水之后，98%的重量都是水。所以做一些大型作品时，一定要考虑到它的重量。普通花泥在自然界中很难被降解，市场上现在也有相对环保的花泥，在自然界中可以被降解一部分。

常规砖形花泥

◆ 用的场合非常多。

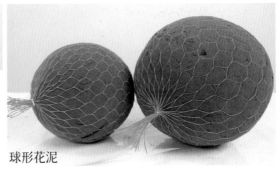

球形花泥

◆ 用于球形花艺作品插制。

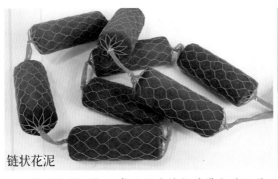

链状花泥

◆ 又称"火腿肠"，常用于悬挂长花带或花链作品，或用于拱门等插制。

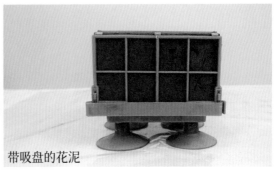

带吸盘的花泥

◆ 底部附有吸盘，常用于车花。

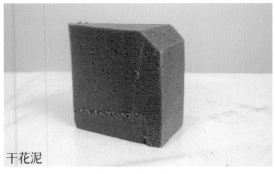

干花泥

◆ 多用于生花、仿真花插制等，多为灰色等，不吸水。

环保花泥

◆ 部分可降解的环保花泥。

花艺辅助工具

（喷壶、注水瓶、花桶的选择和使用）

花材保水需要用到各种各样的储水容器，下面是比较常见的一些。

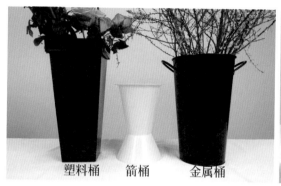

塑料桶　箭桶　金属桶

◆花桶：用于花店、花艺工作室日常贮存以及展示花材叶材等。

玻璃容器

◆透明的玻璃容器可以很方便检查水的新鲜度。非常容易让水混浊的花材，可以选用不透明的容器。

注水壶

◆用于向花器加水。

喷壶

◆用于花材表面喷水。

注水器

◆常用于试管注水。

Tips

花桶

1.上大下小的花桶，在花桶密集堆放的时候，它所占用的空间相对来说会比较小；

2.上小下大的花桶，底座稳固性会比较高，适合放些高大的或者密集型的花材，可以把容易交错的花枝在物理上进行隔绝。

　　金属花桶不太推荐大家使用，它看上去非常文艺，但金属容易与鲜花保鲜剂、杀菌剂发生化学反应，不利于植物保鲜。

3.正确持花器，务必一手扶持花器侧部，一手托底，避免注水后过沉掉落或者是因脆弱炸裂等。

Lesson 016 花艺冷胶和热熔胶枪的特点及使用

花艺热熔胶和冷胶是粘贴花材的常用材料。下面介绍使用技巧。

两种型号的热熔胶枪与胶棒

一般热胶用于粘贴干燥花、仿真花、永生花等，不能用于鲜切花或者是鲜切叶的粘贴，容易把花材烫伤。打上胶的材料可以稍微等一会儿再粘，黏性更强。热熔胶需要加热源，需要用到加热枪，俗称热熔胶枪。根据作品体量的大小和出胶量的多少，有不同的型号。所配套的胶棒也是分粗细的，购买时要注意。已经预热好了的胶枪，会有一部分的胶流出来。建议胶枪加热过程中置于纸张或者纸板上，以免熔化的胶体滴落，污损桌面。

花艺冷胶

冷胶主要用于粘贴娇嫩、新鲜的花材。冷胶的最大好处是对花材几乎没有什么影响，而且可以锁住花材的一部分水分，冷胶有封切口的作用。

其他花艺辅助工具

花艺辅助工具非常多，这里只给大家举一些例子。例如转盘，在插制四面观作品的时候，是一个非常好的辅助工具。再例如，到户外的一些比较恶劣的施工场所，我们需要护目镜、口罩等。太多的辅助工具大家可以在实际的工作当中从其他的行业借鉴。

手捧花架

◆多用于夹持试管、手捧花。

手套

◆多用于花材处理以及花艺设计等操作过程中，起到一定保护作用。

鱼线

◆多用于固定、悬挂等用途。

珠针

◆多用于固定花材、叶材等。

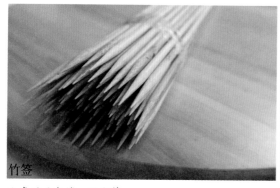

竹签

◆多用于支撑、固定等。

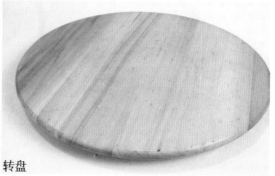

转盘

◆多用于花艺作品演示，如视频直播演示，制作四面观的花艺作品等。

花材预处理 1

^{Lesson}
018

　　花艺市场购买鲜切花之后，需要进行基础处理。第一件事就是先把外包装去掉，让花材透气，要不然容易滋生病菌，然后进一步处理。

① 打玫瑰花刺的时候，一般是斜向下方，不要横着打，否则刺会打到别人身上，还有可能把花枝打断了。玫瑰打刺处理，注意不宜夹得过紧，以免破坏花茎表皮。

② 康乃馨茎秆非常脆，不能用打刺器，最好用手进行去叶处理。

③ 绣球等单支花材，下面会有一个小的保水管，建议直接把管去掉，然后重新斜剪根。

花材预处理 2

花材按照标准处理完之后，需要放到花器内。比如玫瑰、康乃馨是头部对齐，因为它的标准度非常高。花枝尽量平行放，不要交错，否则会占更多空间，而且花枝互相交错，取放花材时花头容易断。

1 绣球首先去除叶片，然后剪根。绣球的茎里有一种像海绵的髓，我们可以拿花刀或者竹签剔除，处理成空心的状态，再把它放到深水里。

2 洋桔梗处理。利用叶片包裹花茎去除茎秆上的叶片。

3 针对标准花材，成组花材花头对齐，进行成捆处理后放入花桶。玫瑰外面的保护瓣建议大家保留，对内部的花瓣有保护作用。除非它是锈迹斑斑的。

4 量比较大的情况下，剪平口比较方便，大概剪掉2~3cm，立刻放到花桶里。利用皮筋进行成束处理。

Tips

花材处理非常重要的一环就是去除茎秆上的叶片，只留上部几片叶即可。否则叶片长时间浸入水中容易腐烂滋生细菌；并且叶片留得太多，也容易消耗花材养分。

空切、空折、水切技法

处理鲜切花时，一个非常重要的工作就是将茎的基部剪去一部分。这样可以把坏死的、受污染的部分剪掉，让花材重新吸水。剪的过程中，要尽量避免空气进入堵塞输导组织，影响吸水，其方式有下面几种。

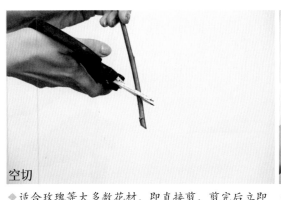

空切

◆适合玫瑰等大多数花材，即直接剪，剪完后立即插入水中。

空折（1）

◆适合康乃馨、满天星等石竹类带节的花材。

空折（2）

◆利用花秆"节"的结构，直接折断后插入水中。

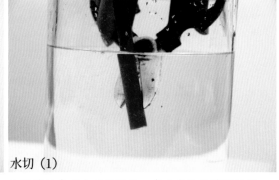

水切（1）

◆将花材在水中充分浸泡，在水中进行剪根处理。适合睡莲、鸢尾等肉质茎及水生的茎秆中空的花材。

水切（2）

◆水切后浸泡一会儿再插入作品，可形成水封效果，利于保鲜。

水切（3）

◆空心秆花材，例如小丽花、非洲菊，最好在水中进行二次剪根。

分、裂、剥、削、锤根技法

花材的类型非常多，茎秆质地不同，相应的处理方法也不一样，目的只有一个，就是保证花材吸水通畅，延长瓶插期。

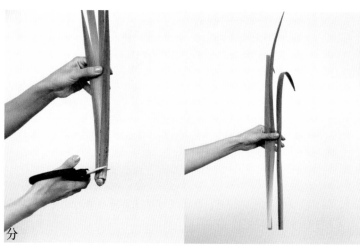

分

◆如菖蒲是一簇一簇生长的，最好不要整簇放在水里，而应该剪成单枝，吸水效果会更好。

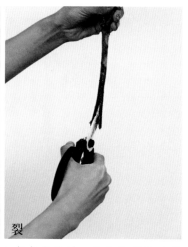

裂

◆木本类枝材，比如杜鹃枝比较脆，枝条比较粗，可以将茎秆基部呈"十"字剪开，如果枝条比较细，可以呈"一"字剪。

V 型切口

◆表皮容易裂开的花材，可以把表皮去除，为了加大吸水的能力，切口可以剪成"V"字形，加大吸水面积。

锤根

◆锤根法。有一些花材表皮非常硬，或茎秆比较细，再怎么剪，切口也很小，我们可以用剪子把末端稍微砸一砸，让它裂开，再重新剪茎放到水里面去，砸开的部分可增大吸水面积。

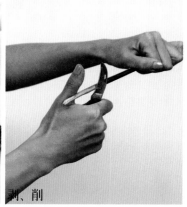

剥、削

深水浸泡、茎秆注水、叶面喷水保鲜法

除了处理茎秆保鲜，这里还给大家介绍以下几种方法。

1. 注水法

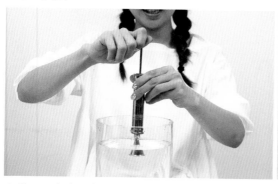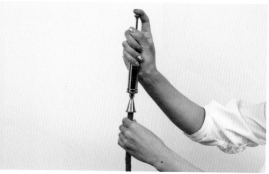

◆夏天，荷花、莲蓬、荷叶等水生花材，经常会出现脱水的情况，这时就可以使用注水法。采用类似注射器的工具，口径的大小是可以调节的，往茎秆内注水。

2. 喷水保湿法

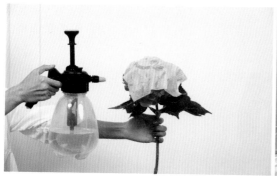

◆像绣球这类表面积很大，容易失水的花材，可以使用喷壶直接喷水，将表面喷湿，为了防止蒸腾作用，可以使用厨房用纸，打湿后覆盖在上面，再盖上保鲜膜或塑料袋，保鲜膜上最好扎一些透气孔。

3. 深水浸泡法

◆用来抢救失水过度的花材。比如玫瑰，如果失水过多，先对花材进行冲洗，剪根，叶子先不要去除，然后把它立在水里，水的位置不要没过花头，差不多在1~2个小时之内，叶片和根部同时吸水，复水性会比较好。

脱水的叶材类可以把其直接浸泡在水里3~4小时，这样通过叶材背面的气孔来吸水，复水性非常好。

煮根、烧根、蜡封保鲜法

这部分介绍花材保鲜技法当中的一些特殊方法，比如烧根、煮根、蜡封法等。

1. 煮根法

煮根法也叫烫根法，如果量比较大，可以用锅来处理，量少可以用容器接一些开水来处理。像一些绣球类比较容易脱水的花材，到店之后已经脱水了，就可以使用煮根法来进行处理。可以直接先剪根，剪完根之后把花材放到开水里面。量比较大的情况下，包括在煮根的情况下，建议大家用报纸把花材整个覆盖住，防止热气把花烫伤，量比较小直接倾斜就可以了。大概烫30秒到1分钟左右，可以看到根部有很多细小的气泡逸出。再快速地浸入到冷水当中，可以延长花材寿命。

◆准备热水。

◆将花材放入热水中，进行浸泡。

2. 烧根法

一些比较粗壮的草本、木本类的花材，可以通过烧根的方法延长保鲜。一是起到消毒的作用，二是起到碳化的作用。烧完根之后再拿剪刀剪掉，插入水里，里面会有很多的气泡排出。可以用打火机烧，也可以用酒精炉等。

◆烧根，利用火对花材根部进行烧根处理，进行碳化。

◆烧根后，进行剪根处理。

◆封蜡法效果展示。

3. 封蜡法

蜡封的主要目的是为了锁水。像睡莲、莲蓬、荷花、荷叶这一类花材，可以通过注水器提前注水后，快速蜡封，把水分封到里面。蜡的温度一定不要过高，融开了快速凝固的时候，快速蘸一下即可。蜡封法可以采用工业蜡，因为熔点相对来说比较低。

鲜花保鲜剂的种类和使用

花材保鲜大致分两类：物理保鲜和化学保鲜。这两种方法结合起来可起到更好效果。

化学保鲜剂分成吸附类和喷剂。

1. 吸附类。剪完根需要把花尽快放到保鲜剂溶液里面，鲜花保鲜剂会有一些型号上的区别，主要区别在于里面糖分的多少，糖分是一种营养成分，对于植物有更好的催熟作用，一些特殊的花材像百合类、芍药类，需要用专门的百合类保鲜剂，它的糖分含量会更高一些，花开更艳。另外，保鲜剂中会含有一部分导管疏通的成分，以及少量杀菌剂等。

2. 喷剂。喷剂的主要作用是防止植物脱水。例如手捧花、手腕花、襟花会一直处在脱水的状态；还有绣球也容易脱水。在其表面喷涂保鲜剂，相当于在表面形成一层锁水的膜，可减少蒸腾作用。

1. 保鲜剂

主要成分有糖、杀菌剂、锁水成分等。

◆可利鲜喷剂。

◆鲜花锁水剂。

◆鲜花营养剂。

◆大盒装鲜花营养剂。

◆桶装鲜花保鲜伴侣剂。

◆小袋装鲜花营养剂。

2. 乙烯抑制剂

在常规花店，或者是大规模的商业项目中，除了花材保鲜剂之外，还要注意空气流通，远离乙烯。我们的食物中，尤其是成熟的水果，如香蕉，乙烯挥发量特别高，花材最好远离。

店内垃圾桶尽量套袋有盖，每天都需要清理。有一些花材对乙烯非常敏感，如飞燕草、康乃馨等，乙烯含量过高容易出现掉瓣、卷边、早熟等。也可以使用一些化学药剂来处理，比如说市面上的1-mcp、高锰酸钾等。

◆1-mcp，气体保鲜剂，可以控制空气中乙烯浓度。

◆高锰酸钾溶液，主要用于器材消毒，并可用于中和乙烯。

_{Lesson}
025 **花材养护换水技巧**

　　花店或者是花艺工作室经常会遇到大批花材到货，我们需要做一些最基础的吸水处理。在吸水处理之前，需要用杀菌剂如84消毒液清洁花器，其次最好用净化水养护。

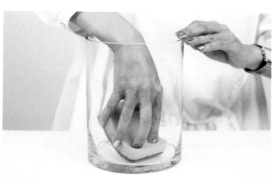

◆花器需要充分清洁，确保水质干净。

◆可用84消毒液等清洁花器。

◆花器横向平躺，然后放置花材，这样可以更加充分利用花器空间。

◆利用注水壶注水，保证水质清洁。

◆草本类花材养水10cm左右。

◆木本类花材养水20～30cm。

花 材 的 分 类

花材的分类

Lesson 026

如何来对花材进行分类？根据不同的角度，我们常见的花材分类方式有色彩分类、形态分类、地域和植物学分类，以及按季节、质感分类等。

1. 按颜色分类

颜色是花材重要的分类方法之一，花材颜色是花艺设计过程中必须考虑的因素。但不是所有的颜色都有对应的花材，比如黑色、灰色系花材就比较少。

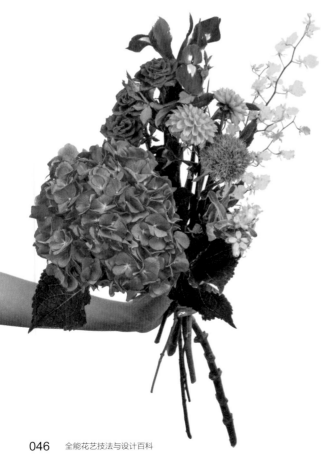

2. 按形态分类

国际上应用比较广泛的四型分类，即块状花材、散状花材、线状花材、特异型花材。当然也有一些更细小的形态上的分类，例如片状花材、果实型花材。

不同的形状给人的感受不太一样。比如块状花材，体量相对来说比较大。以普通玫瑰花的大小为参考标准，大于或约等于玫瑰的花材，一般统称为块状花材；比它小很多的，比如情人草，细细碎碎的，这一类的统称为散状花材；线状花材，顾名思义比较纤细的，有曲线的，也有可能是直线的；特异型花材相对来说也非常好理解，这些花材形状造型非常特殊，价格也稍贵。

3. 植物学分类

植物学分类是比较科学、严谨的分类。常见有国际植物命名法规(International Code of Botanical Nomenclature，ICBN)和被子植物系统发育研究组(Angiosperm Phylogeny Group，APG)以分支分类学和分子系统学为研究方法提出的被子植物分类系统。

4. 按季节分类

荷花、莲蓬属于典型的夏季花材。

5. 按含水量分

按照材料是否含水等状态分为干燥花、鲜切花、永生花等。

散状花材

相对普通玫瑰来说更小的花材，我们都可以称之为散状花材，像小菊，更加细碎的情人草等。其实花材的类型也是相对的，同样大小的花材，比如黄金球，在一个很小体量的花艺作品当中，我们可能就会把它当做块状花材，而在大型作品中，我们把它当做散状花材来进行处理。

散状花材的特征

第一，细碎、多分叉。比如一枝多头的花材，相对比较分散。但也不是绝对的，洋桔梗有比较大的分叉，符合这个条件，但是它的大小和玫瑰几乎接近，实际上我们一般把它当做块状花材。六出花，花朵相对大，但是根据作品的大小，我们也把它作为散状花材。

第二，填充，也就是块状花之间的衔接。绝大部分的花材都是接近圆形的，圆形和圆形进行拼接时会有缝隙，需要一些细碎的小的花材来衔接和过渡。

散状花材的存在，让整个作品变得更加细腻，层次更加丰富。花材虽然小，但是它具备的颜色是非常多样的，用它可以创造更多的层次和色彩感。另外，因为它的加入让整个作品变得更加灵动。

◆小菊

◆六出花，又名水仙百合

◆ 澳洲蜡梅，又称蜡花、淘金彩梅、凤蜡花等

◆ 加拿大一枝黄花，又名黄莺、麒麟草

选择散状花材的原则

首先要考虑到整个作品的形态是怎样的？重点突出什么？散状花材在此刻的作用是填充，还是衔接，还是过渡，还是要丰富层次？根据这些来决定花材种类。

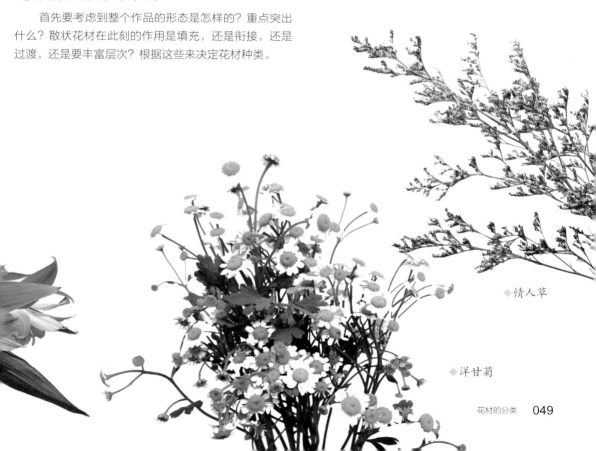

◆ 情人草

◆ 洋甘菊

◆火焰兰
（雄黄兰）

◆长尾婆婆纳

 线状花材

LESSON
028

线其实是对一些花材抽象、概括性的描述。线条分为直线、折线和曲线，但大自然中、植物中其实前两者是非常罕见的，大多都是曲线和弧线的结合。

线可以形成非常好的轮廓感。这牵涉到另外一个概念——负空间。花材作为实体，它所占的实体空间非常小，但在花艺作品当中，用它形成交错空间，感官上你会觉得这个作品的体量是这么大，这就是负空间在起作用。近几年在花艺设计当中会大量使用到线状花材，去关注到负空间的营造。有一个很实际的原因，就是客户都希望花最少的费用，获得看上去更大的作品。线条营造出的空间感，恰恰可以满足这种设计需求。同等价格的花材，线条型的花材会让作品变得更大，创造更多的负空间。

东方设计和西方设计相比，西方更注重于实空间或者是正空间的塑造，而东方，包括中国传统插花、日本花道，除了正空间，更重视负空间的营造。国画中留白的部分，就是负空间，可以给观看者更多的想象空间，创造出更多的艺术的可能性。

◆金槌花
（黄金球）

◆伯利恒之星
（天鹅绒）

◆小苍兰

◆紫罗兰

◆康乃馨

◆须苞石竹

块状花材

　　块状花材是以玫瑰作为参照物，相对来说体量比较大，比如马蹄莲、洋桔梗、康乃馨等。因为体量比较大，占有一定的正空间，所以，绝大部分块状花材用于填充。我们可以试想一下，要插制一面花墙，如果用比较细小的比如风蜡花来插，工作量会有多大，花材会耗费多少。但是如果用比较大朵的玫瑰来插，所使用花材的数量将大大减少，工作量和成本都会降低很多。所以块状花材最大的作用在于可以作为主轮廓。

◆银莲花

　　块状花材的概念也不是一成不变的，需要看它实际被应用的场景。一些小体量的花材，在较小的花艺作品的设计当中可以把它视同为块状花材，在大型作品中，可能就属于散状花材了。

◆玫瑰

　　所以不用过度去纠结于它到底属于散状花材，还是属于块状花材，因为这取决于作品的大小、如何使用，以及它在作品当中的位置，甚至在于作品的组合形式。有些密集型的花材，当重新组合之后可以生成新的花材。比如细碎的花材以组群的形式就会形成一个新的形态，看不到原来的单体的特征。比如须苞石竹，把它插制成一个平面，它在一个大的作品当中，依然可以称之为块状花材。

　　还有，我们需要考虑花的开放状态。比如没有开放的郁金香，是一个很小的花苞，可能属于散状花材，随着它的开放程度变大，它就变成块状花材了，甚至也可以是线状花材。所以花材的形态分类都是相对的。

◆洋桔梗

◆郁金香

◆鹤望兰，又称天堂鸟

◆观赏凤梨

异型花材

　　异形花材是相较于之前的三种分类而言的，其形态不是很规矩的花材。一些花艺教育体系当中没有异形花材这一分类，但在中国花艺圈会默认它的存在，很多的花艺教学体系也支持这种分类。

　　因为造型特殊，所以异形花材非常适合用于创造视觉焦点。比如天堂鸟，颜色明艳，形态像一只鸟，很独特，质感像塑料一样，它几乎具备了所有吸引视线的功能。

◆小苍兰

◆海芋

◆百合

◆鸢尾

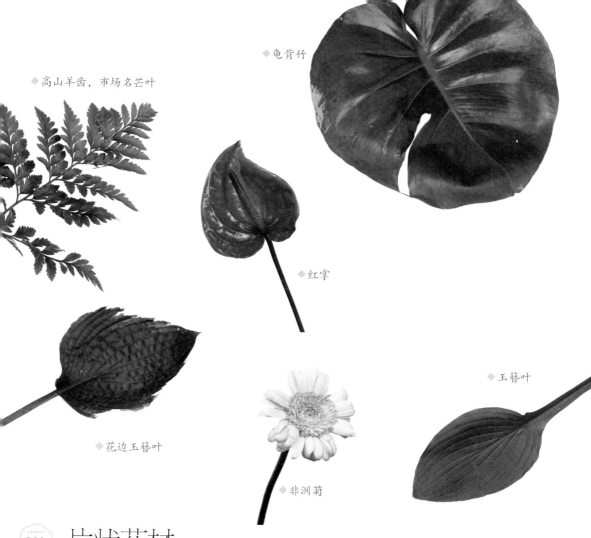

◆高山羊齿，市场名芒叶

◆龟背竹

◆红掌

◆花边玉簪叶

◆非洲菊

◆玉簪叶

片状花材

　　花材分类当中"隐藏"的分类形式——片状花材。有一些花材比较薄，比如绝大部分的叶材，从侧面看几乎是一条线，正过来是一个面，把它卷曲可能会形成一个块，将这一类花材单独分类为片状花材。片状花材以叶材居多，但是也有花材，比如红掌。

　　在做设计时，需要考虑要用到它的侧视图线条，还是正视图的面，还需要考虑到它是否有弯折性。片，并不一定是纯平面，有可能是曲面，也可能是一个直线的折面。

　　片状花材立起来，可以把它当做线状花材来使用，比如一些东方式的设计中，经常会使用到片状花材侧视图的形态，特别是一些可以扭转的花材，扭转的时候就像在中国国画白描当中一些衣纹的处理。

　　把它当做线条的时候，需要考虑它是否容易定型，硬度够不够，如果硬度不够是否有其他技术手段处理（有些叶片坚挺程度不够，可以在背面加上一些铁丝）。很多片状花材，会用到层叠的技法。比如对很多叶材进行叠放，或者是把它作为拼贴一片一片贴上去，拼成像鱼鳞状的纹理，非常有特色。

　　片状花材把它作为正视图取它的面时，就会产生正空间，所以也就限制了这个花艺作品的观看角度。很多插花作品中使用大量的线条，我们只有在一个正视图的角度上去看才是最好的观看角度，很难兼顾到所有的面都是完全一样的。

◆ 假叶树

◆ 高山羊齿（芒叶）

◆ 鸟巢蕨

◆ 肾蕨
（排草）

叶材类

植物都需要叶子来进行光合作用。并不是所有的叶材都会呈现绿色，还有棕色、灰绿色、红色等。鲜花需要有绿叶衬托，叶材大部分时间是一个从属的角色。花艺作品当中只有鲜花，可能会非常饱满，但是适当的加入一些叶材，就会比较细腻。

当然，叶材除了衬托的作用，也可以作为独立的设计存在。它是花材非常重要的一部分，绿色的花艺设计，给人自然的感受。所以对于叶材，我们是取它的色，还是它的形，还是取它的质感，还是取它的瓶插期，需要考虑清楚。

大多数叶材在养护的过程当中，几乎不需要添加保鲜剂，但是要防止蒸腾过快失水。

◆ 龟背竹

◆ 熊猫竹

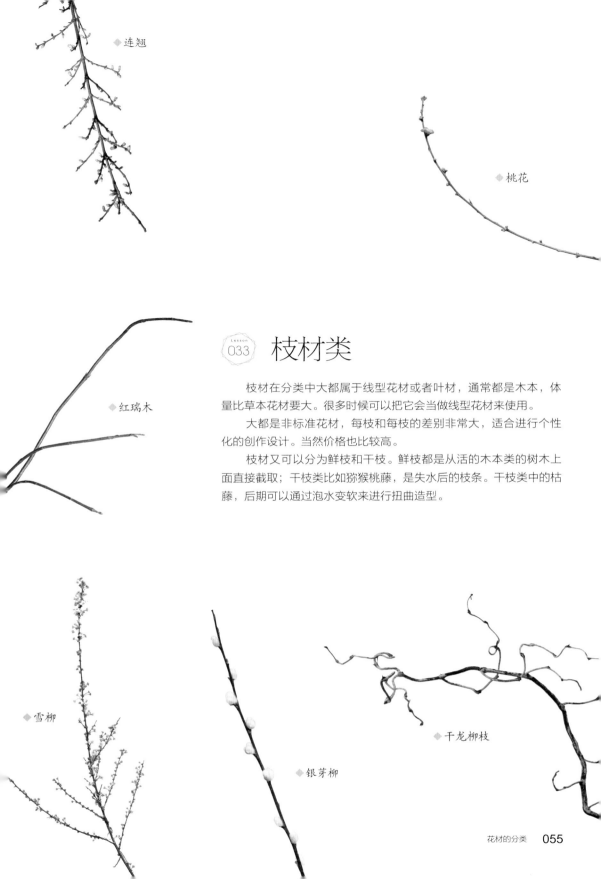

◆连翘

◆桃花

◆红瑞木

Lesson 033 枝材类

 枝材在分类中大都属于线型花材或者叶材，通常都是木本，体量比草本花材要大。很多时候可以把它会当做线型花材来使用。

 大都是非标准花材，每枝和每枝的差别非常大，适合进行个性化的创作设计。当然价格也比较高。

 枝材又可以分为鲜枝和干枝。鲜枝都是从活的木本类的树木上面直接截取；干枝类比如猕猴桃藤，是失水后的枝条。干枝类中的枯藤，后期可以通过泡水变软来进行扭曲造型。

◆雪柳

◆银芽柳

◆干龙柳枝

◆翠扇，又名荞荬

◆珊瑚果

034 # 果实类

　　果实类的花材是指植物果实的部分。苹果、梨等常见的果实在花艺作品当中也有用，但是在花艺设计当中常用的是金丝桃，有红色、白色、粉色等。还有凤梨、珊瑚果、翠扇等。

　　一般果实类的花材瓶插期相对比较长，比较耐存放。

　　如果从形态上来区分，金丝桃果属于散状的花材，翠扇属于非常典型的线状花材，一个主枝上面会有很多的分叉，错落生长。

　　果实类的花材大都显得比较可爱，可以增加作品的趣味性。比如同样是散状花材，满天星和金丝桃果之间，要使作品更加可爱一些，优先选择金丝桃果。

◆无花果（桑科榕属植物），又称阿驲、阿驿、映日果、优昙钵、蜜果、文仙果、奶浆果、品仙果、红心果

◆观赏凤梨为凤梨科多年生草本植物，原产于中、南美洲的热带、亚热带地区。

◆碧根果

◆金丝桃，又名火龙珠（桃金娘科）

红色系花材

　　红色系花材是花材颜色中占比较大的一类花，几乎涵盖了花材的四大形态。块状的玫瑰、散状的火龙珠、线状的木百合和红瑞木、异形的鸡冠花等，还包括一部分红色的叶材。

　　玫瑰的颜色非常多，从浅红、粉红到暗红，几乎涵盖了所有的色系。国产玫瑰的种类有四五十种，进口玫瑰大概也有四五十种，对于初学者来说，记住它们的名字是一个非常大的挑战。玫瑰在使用过程中，我们可能会根据花头大小、杆的长度以及病虫害把它分成A、 B、 C、D这些等级。市面见到的比较多的是B级。

　　康乃馨也是用量很大的切花。它的红色也有很多种，正红色的康乃馨经常会在一些婚礼的场合当中见到。

　　散状花材金丝桃的果实，红色也很正。红色系散状花材有六出百合，深红色、紫红色都有，还有翠菊等。

　　红色的叶子一般在秋天相对比较多，其他季节当然也有，比如红叶石楠、红花檵木等。

◆散状花材——火龙珠

◆块状花材——玫瑰

◆块状花材——康乃馨

◆异形花材——鸡冠花

◆线状花材——木百合、
红瑞木比较常见

◆散装花材——六出百合，
花期长，常用于花束

黄、橙色系花材

黄橙色系的花在自然界中也比较多，市场也有大量类别。在花艺设计中，黄橙色系是非常重要的亮色和对比色的选择。

从最具代表性的玫瑰开始，玫瑰的黄橙色系很多，特别是近些年培育出来的，非常正的橙色系的玫瑰有英国'朱丽叶'；黄橙色的草花也非常多，如金槌花；康乃馨也有很正的黄橙色品种。黄橙色系团块状的花是非常多的，但线状花材相对来说不是特别多，一些枝条类的也很难找到橙色系的。但是像异型花材天堂鸟，里面的花瓣，呈现非常标准的橙色和蓝色互补色。

所以在做黄橙色系作品的时候，不用担心花材的选择。

还有一种稍微特殊一点的花材，商品名叫猫眼，把它也归到橙色里面。可能有的人会说，它是棕色的，棕色的原因是因为它花头内部的结构是黑色的，叠加表面的橙色之后，感觉像是棕色。实际上它花头上的小毛刺的部分还是橙色的。

◆金槌花（黄金球）

◆黄色独本菊

◆六出百合

◆火炬花

◆松果菊（猫眼）

◆橙黄色系玫瑰

◆叶材代表——旱伞草，也叫伞草、风车草

◆绿绣球，实际观赏的是绣球的萼片，花是中间的白点

◆须苞石竹

◆散状花材——喷泉草、柳枝稷

◆块状花材——康乃馨

绿色系花材

◆叶材代表——高山积雪

绿色是自然界的自然色，存量非常大，绝大部分的叶子，在萌芽期都是绿色的。

从花材的形态上来说，绿色花材也包含块状、散状等，有很多选择。比如绿色的康乃馨、须苞石竹、洋桔梗都是非常典型的块状花材；线状花材比如松针、马蔺草，还有竹子也可作为线状的材料，蒲棒叶、旱伞草也是线状的。绣球也有绿色的，但我们看到的呈现绿色的部分，实际上不是它的花，而是萼片。叶材几乎涵盖了所有绿色的可能性，从嫩绿色到非常深的绿色。

在花艺设计当中，绿色的使用频率是非常高的。而且在一个纯商业型的作品当中，多叶材相对来说价格会比较便宜一些。

近些年来，绿色的叶材设计也是一个流行趋势，我们经常会看到一整面的绿墙。婚礼上也有用热带植物去做纯绿色系的设计。设计风格当中有一种叫做绿化式的风格，会去更多地选择叶材做不同的设计。

◆ 紫色系洋桔梗

LESSON 038

蓝紫色系花材

蓝紫色系作为花艺设计当中一个非常重要的色系，选择的范围紫色系相对来说多一些。因为紫色系从红色渐变过来，块状、线状、散状都有，比如玫瑰、康乃馨，洋桔梗，很多菊科的植物，比如像独本菊，有非常漂亮的高级的紫色、深紫色。

在自然界中呈现蓝色的花不多，在做设计时，我们经常用染色的方式去弥补。蓝色系常见的花材有飞燕草、蓝星花。市面上的玫瑰'蓝色妖姬'，还有蓝色的满天星等，都是染的蓝色，不是自然色。

◆ 紫色系康乃馨

◆ 紫色系翠菊

◆ 紫色系风铃草

◆ 蓝色系飞燕草，蓝色花材自然界相对较少，多为人工染色

◆ 蓝紫色系绣球

◆ 灰色系的银叶菊

◆ 白色系珍珠梅

◆ 附有白边的粉色绣球

◆ 尤加利叶

◆ 偏棕色卡布奇诺康乃馨

粉色系以及其他色系花材

Lesson 039

粉色系在自然界非常多。块状的玫瑰、康乃馨，用这两种可以很轻松地搭配出色板一样的粉色系作品。散状花材金丝桃果、落新妇、绣球，异状花材红掌、百合等，都有粉色。

我们把白色、黑色、灰色称为无彩色。

白色的花材占比也非常大，白色的玫瑰、洋桔梗、康乃馨都是非常常见的块状花材，散状花材像满天星、各种白色的小菊、蔷薇等。白色线条状的也有很多，如雪柳等。很多干燥的叶材在做漂白处理后也会呈现白色。

灰色和黑色比较少。标准灰色比如银叶菊、地肤、珊瑚果，还有一些空气凤梨、尤加利叶会呈现灰绿色。

黑色的花通常来说在自然界当中是不存在的，它在光合作用下会被灼伤。我们看到的其实是深紫色、深红色偏多。果实类的比如英蒾、彩椒等。

还有一些棕色系的材料，比如树皮、风车果，其他树枝树干等，在红和黄的基础之上，加一些灰的成分，在色轮当中也不是那么明显。

◆ 带有混色的粉色玫瑰

◆龙胆科 洋桔梗属

植物学分类

　　植物学分类是科学界公认的非常科学、严谨的一种分类。目前花艺圈常用的分类系统有两种，一种是ICBN的分类系统，一种是APG的分类系统。植物学分类系统中的植物名称，是植物的标准学名，也就是类似我们身份证上的名字，而我们常说的比如天鹅绒、猫眼，是市场商品名，相当于昵称、笔名等等。

　　了解花材的学名对于花艺师还是很重要的。植物学名绝大部分在国际上通用是以拉丁文作为标准，当然也有相对应的中文名。大家在去搜一些花材的时候，存在这样的困惑，比如说搜"天鹅绒"，出来的是一种布料，而实际那个花材真正的名字叫做白花虎眼万年青，搜学名可以精准地搜到这种植物。

　　还有比如市场上叫菊的花材，其实相差非常

◆绣球科 绣球属

◆虎耳草科 虎耳草属
绣球亚属

◆石竹科石竹属

远。菊科是一个非常大的科。我们经常用到的独本菊，是非常典型的菊科菊属的植物；但翠菊，就属于菊科翠菊属的；还有非洲菊是属于菊科大丁草属的植物。

相反，有些形态差异大的花材，却是实实在在的"亲属"，比如康乃馨，属于石竹科石竹属，跟它形态相差很大的须苞石竹、满天星，与它科属却是一样的。

另外，一样的名字，可能植物学分类上却完全不同，同样是绣球，圆锥状绣球属于绣球科绣球属的植物，而有些绣球则属于虎耳草科的植物。

我们在养护中，可以把一些相同科属的植物放在一起，因为习性相当。做花艺设计的时候，我们把相同科属的植物放在一起，会有天然的亲和度，是一个非常好的调和手段。

◆菊科植物：向日葵属、菊属、翠菊属

◆蔷薇科蔷薇属

材　料　的　固　定

浸泡花泥

花泥商品有正面和背面之别，一般有字或有眼的为正面，另外一面为背面。正面和背面会有什么区别呢？浸泡时应该注意什么呢？

一般的花泥浸泡时间为60～90秒，最重要的影响因素是水的温度。水温越高，浸泡速度越快。

浸泡花泥用干净的自来水就可以了，有的花泥里含有保鲜剂成分，所以没有必要在水里添加保鲜剂。浸泡时，通常把正面向下，平放到水面，让它自然吸水下沉，直到背面和水面平齐，就表示花泥完全泡好了。

浸泡时要尽量避免用手去按压，否则会导致花泥的表面浸湿了，内部依然是干的。

浸泡花泥方法

①水桶注入足够多的水——水线高于花泥高度。

②将带字的一面朝下。

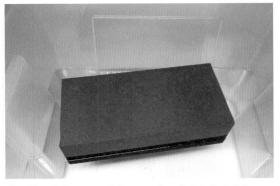

③让花泥自然下沉，浸泡60～90秒，表面与水平齐即可。

Tips

过期的花泥鉴别方法：从底部开始慢慢发黄，这是因为在生产过程中一些酸性物质残留跟空气氧化产生的。

错误做法：物理性强制按压，或者直接表面喷水

◆按压非充分浸泡效果与自然下沉充分浸泡切面对比。

切割花泥、异形花泥的制作

042

花泥大都是砖形的，但是花器是各种各样的，要把花泥放进容器里，一般都需要切割。这部分内容演示如何切出球形花泥。

① 运用花泥刀，切割已经浸泡过的花泥，切成一个立方体。

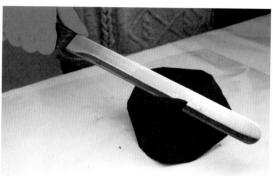

② 切除方形顶端八个角，切出基础造型。

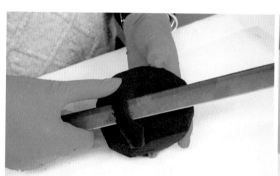

③ 拟合削苹果模式，切出大致造型。

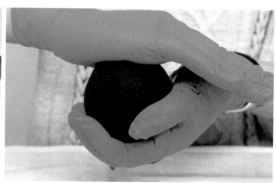

④ 不断揉搓，打磨出圆润的球体。

⑤ 避免手指挤压，或者是无接触滚动。

⑥ 球型花泥制作完成。

花泥的拼接和固定

花器的尺寸和实际的花泥尺寸往往不一致，就需要对花泥进行切割或拼接。

装花泥有一个非常重要的原则——取整不取零。理论上来说，碎花泥也可以用于拼接，但太碎的花泥起不到固定作用，而且如果花插到两块花泥的缝隙中间，花就吸不到水。

花泥的拼接

◆根据花器的高度，将完成浸泡的花泥置于底部，确保花泥高度。对比花器口，根据器口大小切割花泥。

层叠花泥的固定

①

两块花泥之间怎么来固定呢？通常使用交错穿刺的方法。可以从一块花泥的一个角，穿向下方花泥的一个角。杆可以选择竹签，要尽量细，尽量少占用后期作品的中心点位置。在交叉固定时，两根竹签不要在一个平面上，要在一个立体的空间。

Tips

花器如果是高筒状的，需要在花器口固定花泥的话，花泥要切成下小上大的形状。否则花泥会往下掉。

花器口"十"字固定花泥

② 用枝剪剪断固定竹签多余部分。

③ 两块花泥拼合完成。

◆遇到需要将花泥固定在花器的情况，可利用防水胶带，"十"字固定花泥。

花泥悬挂技巧 1

在一些空间的布置中，经常需要做悬挂类的花艺作品，近年的一些花展上这种设计也非常流行。市面上有现成的悬挂类花泥这种售卖，比如我们前面说到的「香肠」花泥，但是它们的形状和尺寸都是固定好的，实际应用中有很大的限制。所以，要学会悬挂花泥的技巧。这里介绍的是用鸡笼网做固定的悬挂技巧。

① 提前制作好花泥球，比对尺寸，剪取鸡笼网。利用鸡笼网充分包裹花泥。

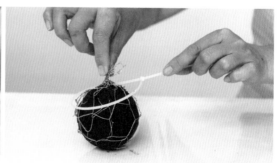

② 运用扎带进行收口打结。多穿几根扎带便于承重。穿的时候尽量多经过一些鸡笼网孔，有利于承重。

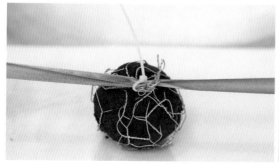

③ 在不锁死扎带的前提下，穿过缎带，然后进行扎带收口。

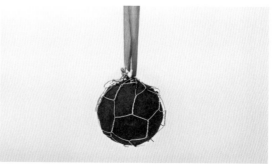

④ 剪除扎带多余部分，悬挂结构完成。

材料的固定

花泥悬挂技巧 2

一种方法。

来，这时花泥如何进行固定呢？这里给大家介绍

做悬挂型花艺作品时，需要把花泥悬挂起

材料

花泥；两根木本枝材（鲜活的，有一定强度和弹性，粗细合适）；细铁丝（主要用于缠绕固定）；粗铁丝（长度取对折之后大于要对穿花泥的直径）；细缎带；粗缎带。

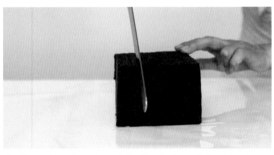

① 将花泥提前浸泡，进行花泥切割。将大块花泥切割为正方体。

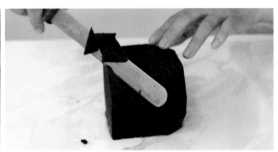

② 将正方体的棱角切除，切割出多面体。

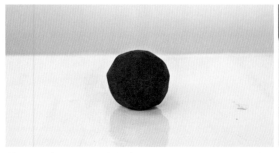

③ 利用花泥刀削制成类球状。不断切割揉搓，形成花泥球。

④ 利用枝剪，剪取硬质木棍。

⑤ 选取适当硬度铁丝，弯折为"U"形。头部穿插丝带，旋拧形成针状结构。

⑥ 将针状结构，垂直插入花球中心线。朝外拉丝带，把丝带穿过花泥球，将铁丝取下。

⑦ 朝外拉丝带，把丝带穿过花泥球，将铁丝取下。

⑧ 将小木棍居中串入丝带，拉回丝带，按压木棍进行固定。另一端同样进行木棍固定，两端的木棍形成空间交叉，将丝带进行系扣。

⑨ 另一端同样进行木棍固定，两端的木棍形成空间交叉，将丝带进行系扣。

⑩ 选取宽缎带，进行对折。将双层缎带折叠为M型。

⑪利用窄丝带进行宽缎带的固定。利用纸皮铁丝进行缠绕捆绑加固。

⑫利用悬挂花泥，进行花材插制。

悬空花泥的支撑固定

当需要在花器的上方悬空插花，我们需要用到花泥的支撑固定。

🌿 **材料**

花泥、树枝、竹签等支撑杆（需要有一定的韧性，最好带分叉）

①剪取当长度的竹棍，并将剪取部分中间剪成一定豁口。

②将带豁口的短竹棍与竹签（或长树枝）进行十字交叉，借用豁口进行固定。

③利用同色系纸皮铁丝进行缠绕旋拧加固。

④运用以上步骤完成2个固定结构。

桦树皮遮蔽花泥技巧

在设计中，我们经常会遇到不方便使用花器的情况，需要对花泥进行装饰、遮蔽，这部分介绍使用桦树皮来遮盖装饰花泥的技巧。

材料

花泥、玻璃纸、美纹纸、桦树皮

① 切割花泥，比对花泥轮廓，用玻璃纸包裹，去除多余边缘。玻璃纸外部贴合美纹纸。

② 比对花泥尺寸，以及桦树皮尺寸，精准确认所需截取的尺寸。

③ 根据比对尺寸进行剪裁。

④ 在桦树皮内部以及边缘，涂抹热熔胶。将桦树皮比对花泥外部，完整贴合，衔接处封闭处理。

木片遮蔽试管技巧

在很多设计中都会用到试管。一般情况下，试管是允许外露的，但有时候为了视觉的统一性，需要对试管遮蔽。木片是一种非常好的柔性材料，可以选择作为遮蔽试管的材料。

①利用美纹纸包裹试管外壁。

②美纹纸包裹效果展示。

③剪取等长木片若干，长度大于试管。将木片用水浸泡，擦干。

④木片内面全部附着贴合双面胶。按一定纹理贴合木片，完成遮蔽。

Tips

1.直接将木片粘在试管上。建议用双面胶，如果用热熔胶，一些质量不好的试管存在炸裂的风险。最好的方法是在试管外先粘美纹纸，木片粘在美纹纸上，保护试管，以回收利用。

2.试管分为两种，一种是圆底的试管，一种是平底的试管。圆底比较好刷洗，但是圆底部分不太好遮蔽，平底的方便遮蔽。

3.木片在拼贴之前，最好先把木片浸水，韧性会更好一些。浸泡完后稍微晾一会，不然胶粘不牢。

包装纸遮蔽花泥技巧

这节介绍如何用包装纸来遮蔽花泥。在人数众多的花艺沙龙活动中；或者追求特殊肌理效果时，可以选择用包装纸遮盖花泥。而且相比别的方式，包装纸成本更低。

① 浸泡花泥,切割花泥，比对花泥轮廓裁剪玻璃纸。玻璃纸充分包裹花泥，做好防水预处理。

② 利用胶带进行边缘固定。

③ 玻璃纸外面，运用包装纸进行包裹。

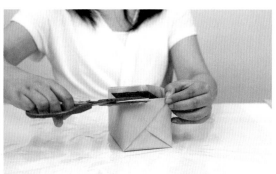

④ 用剪刀去除边缘，与玻璃纸取齐。利用包装纸进行花泥遮蔽效果。

金属丝、拉菲草、花艺胶带、麻绳、缎带遮蔽试管技巧

这一节继续介绍试管的各类遮蔽技巧，毛线、金属丝、胶带等。玻璃试管管壁非常光滑，直接粘材料不太容易附着，可以先用花艺胶带缠绕，再附着其他材料。

花艺胶带遮蔽

◆从试管瓶口开始，逐步利用花艺胶带缠绕试管瓶身，确保无缝隙。

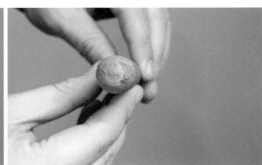

◆运用花艺胶带完整封闭试管底部。

麻绳遮蔽

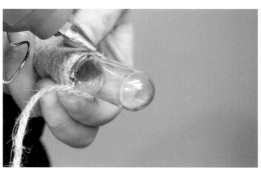

◆一边捆绕，一边利用胶枪进行麻绳固定。

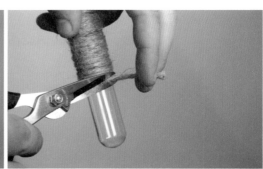

◆剪裁多余部分。

其他方式

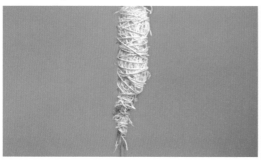

◆利用木屑丝、拉菲草与纸皮铁丝结合进行试管遮蔽，可增加纹理感。

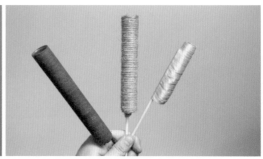

◆花艺胶带、麻绳、缎带遮蔽效果展示。

叶材遮蔽试管技巧

叶材也是遮蔽花器的好材料，而且持久性很好，经常喷水就可以叶材让保持鲜活状态。叶材种类非常多，很容易找到跟作品整体风格、肌理相一致的材料。这节使用的是鸟巢蕨。

材料

试管、美纹纸、鸟巢蕨

①美纹纸基底保护：剪取可完整包裹试管长度的美纹纸，将试管置于美纹纸中间，美纹纸边缘与试管口对齐。

②完整包裹瓶身，最后进行底部包裹收尾。

③用双面胶全面附着试管瓶身。

④将叶材旋转贴合瓶身。

⑤叶材遮蔽效果对比。

⑥内部多个试管并排粘连，最后用叶材完整包裹。

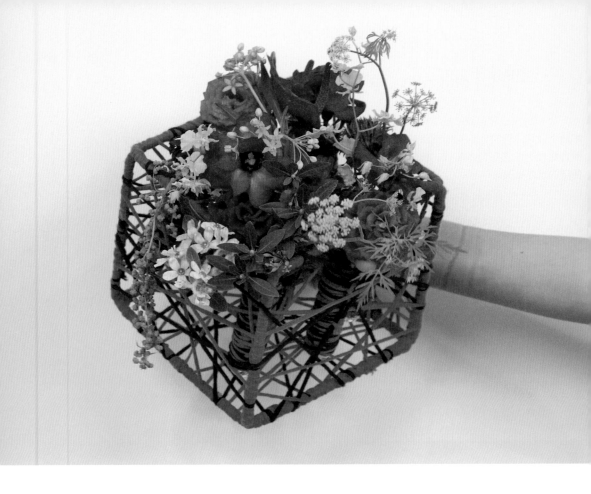

Lesson 056 毛线遮蔽立体框架及试管技巧

　　这节介绍利用毛线遮蔽试管的方法。首先可以做一个立体框架结构，然后用毛线缠绕、编织，最终达到遮蔽的效果。

材料
粗铁丝、试管、花艺胶带、毛线、热熔胶枪等。

框架制作

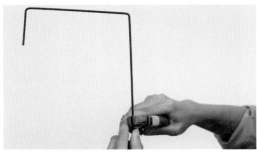

①利用钳子将铁丝弯折，制作标准正方形结构若干，构建正方体。

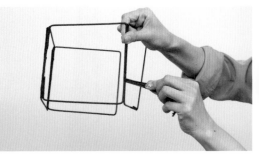

②利用同色系花艺胶带进行框架连接粘合。

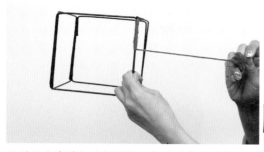 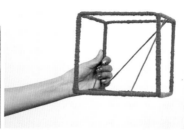

③利用毛线进行边框缠绕，起到遮蔽、固定、装饰作用。

④框架包裹效果展示，同时从内部起手进行缠绕。

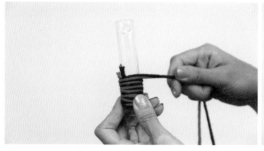 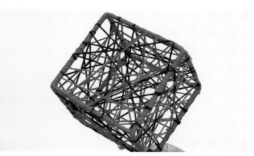

⑤利用双股毛线进行试管缠绕。

⑥框架结构内部进行同色毛线缠绕，加入第二种色彩，进行内部缠绕，同时填充空间，完成框架结构。

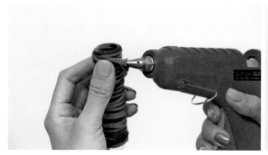

⑦利用热熔胶进行毛线收口操作。

⑧毛线缠绕后的试管，完成若干。

 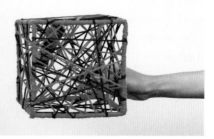

⑨运用同色系毛线进行双捆绑点预留。利用捆绑预留进行试管与框架打结固定。

⑩将缠绕毛线的试管各个角度充分填充于框架内部，形成固定效果，向试管里充分注水。在试管内加入花材，完成整体作品设计。

叶材遮蔽花泥技巧

（057）

花泥也可以用叶材来遮蔽。叶材种类多，不同的叶材，可以得到变化万千的肌理效果。叶材要选择耐脱水的，一般蜡质表面的叶片都比较合适。这里介绍的是山茶叶。

粘贴鲜活的植物性材料，热熔胶会烫伤叶片，不推荐使用。植物性喷胶适合大面积的粘贴。这个案例用的是双面胶，适合小面积粘贴，无需干燥凝固的时间。但叶面可能不平整，需要用冷胶进一步处理。

 材料
花泥、玻璃纸、美纹纸、双面胶、冷胶、山茶叶

 Tips
每种叶材都有自己的特点。山茶叶需要提前对叶柄进行修剪，可以多片叶子同时一起剪掉。

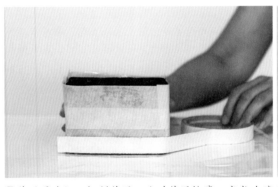

①花泥浸泡好，切割花泥，比对花泥轮廓，完成玻璃纸包裹，去除多余边缘，做好防水操作。玻璃纸外部贴合美纹纸。美纹纸外部贴合双面胶。

②将山茶叶横向从花泥底部向上逐层粘贴。

③叶面收口处利用冷胶进行固定。

④叶材遮蔽效果展示，注意贴合过程中，叶材如果超出花泥上表面，可根据实际情况剪除多余部分。

苔藓遮蔽花泥技巧 1

这节介绍苔藓遮蔽花泥的技巧，当花泥高于花器时，需要对花泥遮蔽，可以使用片状苔藓。

材料

针盘盒、铁丝、花泥、苔藓

①将浸泡好的花泥放入针盘盒，将花泥削成圆弧状。

②用剪刀将苔藓背面进行打薄处理，并且进行清理。

③铁丝弯折成"U"形针。制作多个"U"形针备用。

④利用"U"形针将多块苔藓固定。苔藓完整固定于花泥上，边缘包裹，并且对边缘收口处理。

苔藓遮蔽花泥技巧 2

这节介绍花泥球如何用苔藓进行遮盖。苔藓遮盖后的花泥球，简单装饰一些花材就很漂亮。

材料

铁丝、花泥、鱼线、苔藓

① 将花泥充分浸泡，预处理为花泥球。

② 利用钳子弯折铁丝，形成"U"形针，利用鱼线打结固定。

③ 预处理苔藓，将苔藓包裹于花泥球表面。利用带有鱼线的"U"形针进行苔藓固定。

④ 利用"U"形针的鱼线，缠绕苔藓球表面，进行整体缠绕固定。

苔藓遮蔽试管技巧 1

材料

试管、美纹纸、植物喷胶；苔藓

大部分架构类花艺作品试管是允许外露的，但是在一些自然风格的设计作品中，外露的试管有些突兀，用苔藓遮盖会显得非常自然。

①试管外部粘合美纹纸。

②完整美纹纸包裹效果展示。

③将苔藓胶喷于试管表面。

④将苔藓铺于试管表面。

材料

试管、鱼线、苔藓

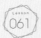

苔藓遮蔽试管技巧 2

这节介绍如何用鱼线固定苔藓来遮盖试管。

①利用透明胶将鱼线固定于试管中部。胶带呈"T"型进行粘贴。

②利用鱼线进行苔藓缠绕固定。

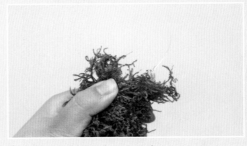

③将收尾鱼线预留出一定长度。

④利用透明胶带将鱼线粘合至试管内壁，进行收尾处理。

蜡烛遮蔽试管技巧

蜡烛遮蔽试管所用到的蜡是工业蜡，其熔点比较低，相对安全。

材料

试管、熔蜡锅、工业蜡

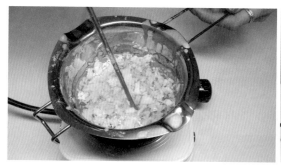

①将大豆蜡放入熔蜡锅。利用隔热搅拌棒充分搅拌为液体状。

②测温达到50℃。

③利用隔热勺，将燃烧蜡充分浇淋在试管瓶身，注意避免手直接接触试管。

④准备冷水，将试管入水冷却。

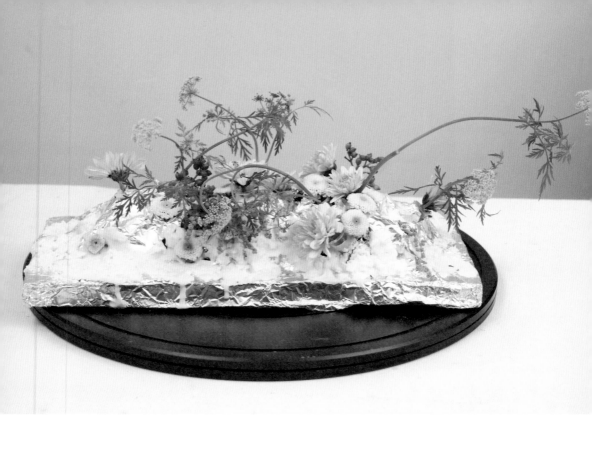

热熔蜡遮蔽试管技巧作品案例

热熔蜡非常适合冬季主题设计的应用，其色彩、质感都特别像冰雪。这部分演示一个类似的作品。

材料
木板、鸡笼网、豆蜡、锡箔纸；花材

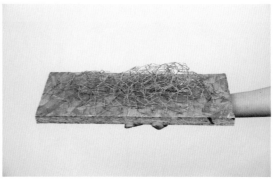

① 剪取适当面积鸡笼网，进行弯折，形成山形。利用手动码钉枪，将鸡笼网固定在木板上。

② 鸡笼网固定好的效果。

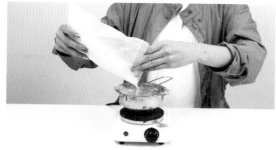

③ 提前进行加热融蜡操作。

④ 利用滴蜡对试管进行包裹遮蔽预处理，同时淋蜡固定于鸡笼网表面。

⑤ 利用锡箔纸，进行鸡笼网表面包裹，形成山脉的附着表面，同时起到遮蔽鸡笼网作用。

⑥ 依循预埋试管口径，在铝箔纸表面进行打孔。

⑦ 在锡箔纸表面进一步淋蜡处理。表面可以撒一些碎蜡进行装饰。

⑧ 试管内注水。

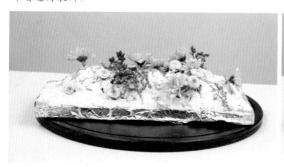

⑨ 利用试管以及空隙进行花材固定。

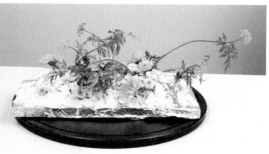

⑩ 加入适当的花材，作品完成效果展示。

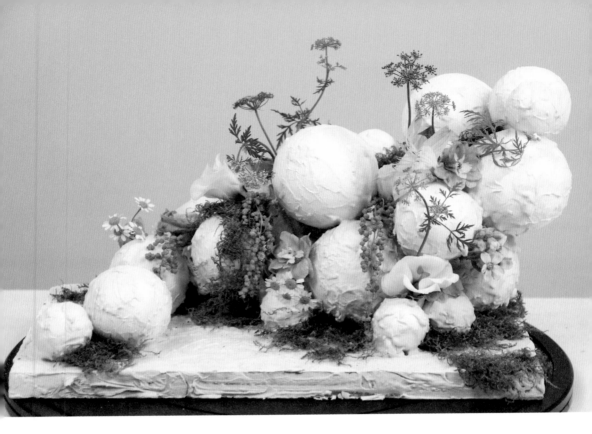

快粘粉遮蔽试管案例

在花艺设计中，经常会用到其他行业的材料，建筑材料尤其多。今天介绍的是快粘粉的应用。快粘粉遇水之后可以快速凝固、定型，形成独特的效果。如果想追求类似于粗糙石膏界面效果的时候，可以使用快粘粉。

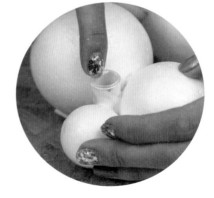

材料

快粘粉、泡沫球、试管、木板、苔藓、蓝星花、大阿米芹、百合

◆快粘粉（快粘粉用于快速粘贴以及定型作用，有一定模仿石膏质地的效果）、便宜的塑料桶、手套、口罩（有比较呛的石灰味道）、底座、泡沫球、小试管

Tips

快粘粉干燥的时间是10~15分钟，所以不要一次大量配置；快粘粉与水的比例一般为：1:0.5，和到粘稠状即可。处理试管时可以用保鲜膜或其他东西把口堵上，避免流进去。在操作时建议准备一盆干净的水，万一蹭上之后可以快速清洗。

①选择不同体量泡沫球。

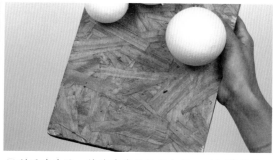

②利用泡沫胶，将泡沫球粘贴于木板。以组群形式，将大小不一的泡沫球进行组合粘贴，形成一定造型。

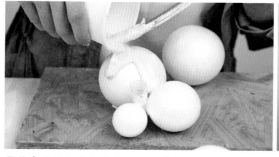

③将表面均匀涂抹快粘粉的试管，置于泡沫球空隙中。在试管以及泡沫球表面充分淋浇调好的快粘粉，用于试管遮蔽以及固定。

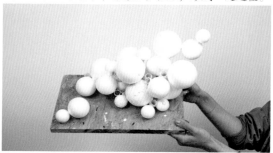

④用泡沫胶将泡沫球进行粘贴与固定，形成作品设计基础造型。泡沫球缝隙预理粘有快粘粉的试管。

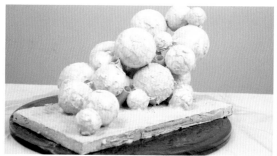

⑤在已做好的造型整体表面充分涂抹快干粉，静置，形成固定效果。表面形成天然石膏肌理。

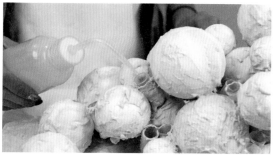

⑥试管内注水。

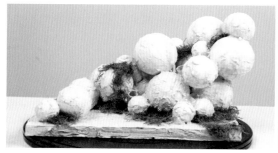

⑦利用苔藓胶将苔藓固定在表面，增加整体造型质感以及色彩。

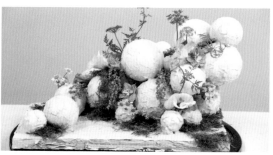

⑧在试管内插入蓝星花等花材，营造清凉氛围以及流淌的感觉。

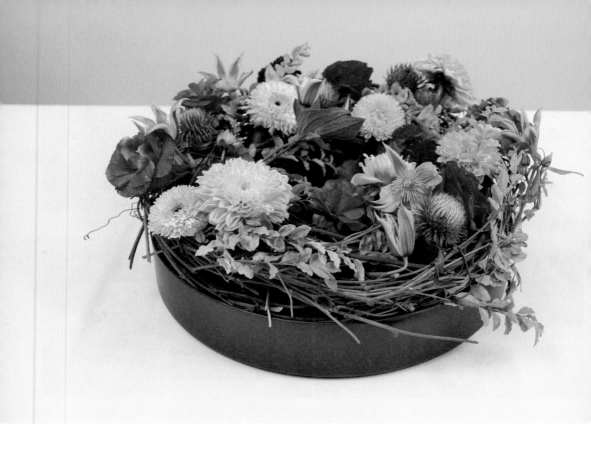

藤条遮蔽技巧以及作品演示

065

这节介绍用藤条遮蔽试管的技巧。用到的材料是土伏藤，土伏藤经常会在花环当中用到，也是遮蔽的好材料。

①利用棕色系花艺纸胶带对试管外部包裹，进行遮蔽。

②利用同色系花艺纸皮铁丝对试管口预处理，并进行双侧旋拧。铁丝试管口固定效果展示。

③将藤条缠绕为圆环状。

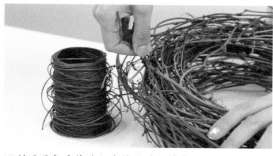

④利用同色系花艺纸皮铁丝进行藤条圆环收口固定以及边缘处理。

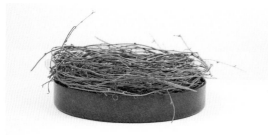

⑤将藤条环形结构卡于花器内。

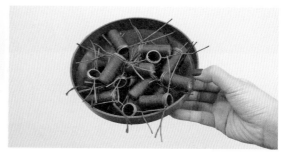

⑥制作多个处理好的试管。

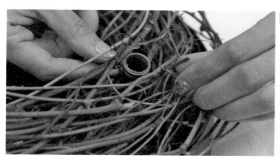

⑦利用小试管两端的纸皮铁丝，将试管预埋固定于藤条圆环空隙处。

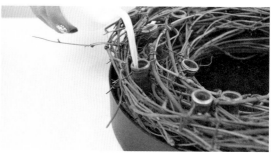

⑧在试管内注水，同步花器内注水。

⑨藤条上附着叶材。

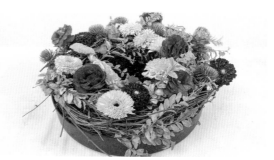

⑩加入小丽花、非洲菊、洋桔梗、白头翁以及铁线莲填充造型。

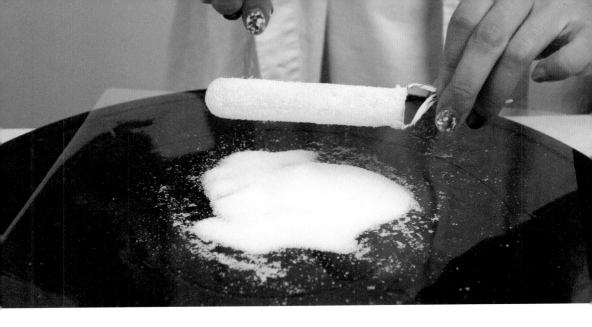

细砂遮蔽试管技巧

试管的遮蔽，对于花艺师来说是一个非常大的挑战，虽然方法很多，但还是需要不断创新，以找到与作品风格想匹配的方法。这节介绍喷砂或撒砂来遮盖试管的技巧。我们采用的材料是石英砂，有点像白糖的质感。非常适合圣诞主题以及冰雪风格的作品中应用。当然除了石英砂，其他像金砂、混合黑砂都可以，可根据实际需要选择。

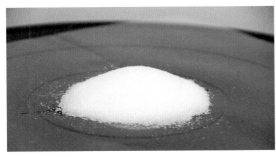

①准备石英砂。

②利用花艺纸皮铁丝做试管固定预处理。

③将花艺专用喷胶均匀喷于试管表面。

④将石英砂在试管表面充分覆盖。

喷漆遮蔽试管技巧

将试管变个颜色，让它成为一种装饰或是与作品融为一体，喷漆是非常简单的方式。

喷的过程中一定要注意，因为喷漆越接近于喷口的位置越不稳定，所以尽量远距离喷，太近漆会流淌，影响效果。

除了整喷、满喷的效果，还有很多种玩法。比如可以赋予它一定的材质效果，在已经粘附的材料上面喷漆；或者做渐变的颜色，还可以喷出自然流淌的有点像水墨画的感觉。另外，还可以先在试管上贴上一些纹理，比如过年的喜字、窗花、青花瓷纹理等等，然后喷涂，这样试管上面就会带有纹样。

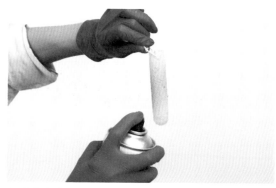

◆喷漆方法。

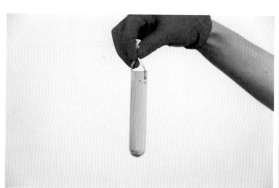

◆满喷遮蔽效果展示。

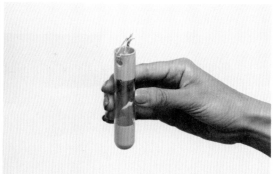

◆利用美纹纸，形成具有纹样的喷涂遮蔽效果。

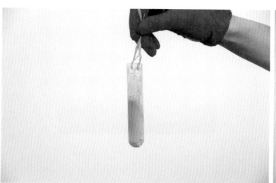

◆双色喷涂遮蔽效果。

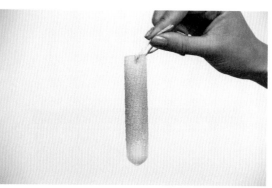

◆在覆盖石英砂的表面喷漆，形成富有质感的喷漆效果。

竹丝遮蔽试管技巧

竹丝作为一种非常好的架构类花艺材料，有很多的型号、尺寸，购买时要注意几个问题：一是整体长度；二是厚度，竹丝竹片越厚，它的强度就越大；三是宽度。竹丝有很多种颜色，这里用到的是扁平的绿色的竹丝。下面介绍利用竹丝对试管的遮蔽的技巧。

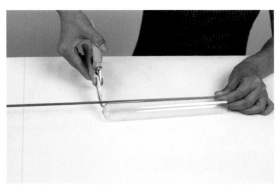

①比对试管长度，剪取等长竹丝。

②剪取若干竹丝，尽可能取齐。

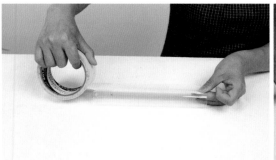

③利用美纹纸包裹试管外壁。

④将双面胶粘合于美纹纸上，布满试管。

⑤将竹丝逐一整齐排列粘合在试管外壁。

⑥剪除多余边缘，完成试管遮蔽。

热熔胶固定试管技巧

做一些架构类作品时，在片状材料上或者平行材料上固定试管，纸皮铁丝的技法就不合适，这种情况下可以考虑使用热熔胶粘贴。

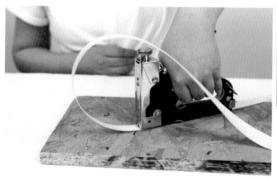

◆利用码钉枪，固定竹片结构。

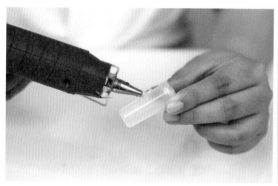

◆将热熔胶涂于试管表面。

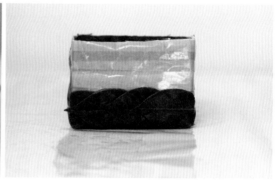

◆增加木片数量，形成一定造型基座结构。

◆将涂了胶的试管粘贴于木片表面。

◆将花材、叶材置于试管中。

◆用注水壶向试管内注水。

花艺铁丝、纸皮铁丝固定试管技巧 1

在架构类花艺作品中，会大量地用到试管。试管如何固定在结构上呢？最常用纸皮铁丝和花艺铁丝。但这两种铁丝的适用范围和特点是有区别的。

纸皮铁丝固定技巧

◆试管固定在竹签上：将试管与竹签利用纸皮铁丝旋转拧紧固定。

◆剪断多余铁丝，收口。

Tips

纸皮铁丝适用范围是框架型或支撑比较密集的结构，方便找到悬挂点或者是捆绑点。捆绑点不要在侧壁上，也不要在两者交界的位置上，比较适合在结构性作品背面的位置上，这样绑点比较隐蔽，稳固性也好。一个绑点稳定性不够，所以每一只试管最好有两个以上的捆绑点。拧紧剪掉多余的铁丝时，接头保留长一点，否则有可能松开脱扣。

单面挂耳固定技巧

◆大型的试管在做悬挂时，需要承受非常大的力，所以有的上面带有孔柄，可以用花艺铁丝穿过这个孔柄悬挂，做单个铁丝耳朵固定。

◆单面挂耳试管效果展示以及注水操作。

『猴子挂』固定技巧

◆针对管口有沿的试管，可以在管口用纸皮铁丝做两个"耳朵"，像猴子的两只胳膊一样，可以挂在不同的空间，称为"猴子挂"。但不适合大试管。

◆试管固定3种方操作效果展示。

071 花艺铁丝、纸皮铁丝固定试管技巧 2

花艺架构中小的试管可以用纸皮铁丝固定，大试管需要用强度更大的花艺铁丝。这节介绍如何将试管固定到已经做好的架构上。

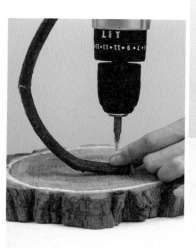

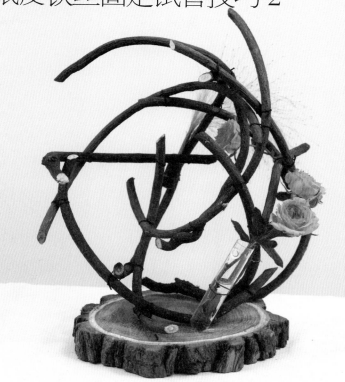

◆准备好基座木板，利用电钻进行葡萄藤固定。

◆固定后，形成基础的基座结构。增加更多枯藤线条，利用花艺纸皮铁丝进行结构固定。

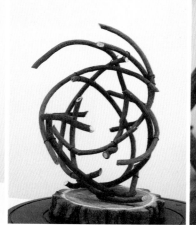

◆主结构完成，形成整体结构。

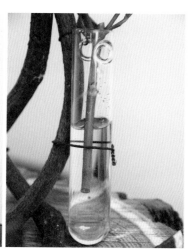

◆利用纸皮铁丝多绑点进行固定。

剑山的清洁养护

　　剑山在使用过程中，经常会出现针变形，花材茎秆残渣腐烂堵塞的情况，需要对其进行养护和清理。针变形可以用剑山矫正器来恢复，清理残渣可用专业的刷子。

　　另外，为了收纳方便，经常会有两块剑山叠置的情况，为了避免针尖直接扎到另一块剑山的底部，导致针尖发钝，一定要用橡胶套保护。

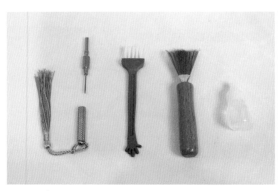

◆剑山清洁工具。

◆垂直将弯曲的刺插入矫正器，顺势掰正。

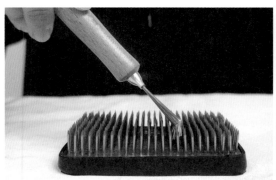

◆清理木本植物残渣使用硬质钢丝刷。

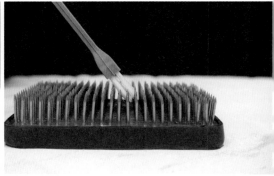

◆普通清洁刷，配合剑山清洁剂使用。

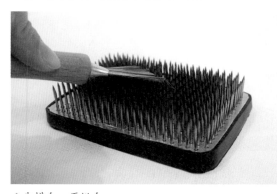

◆先横向，再纵向。

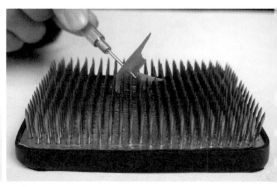

◆清理剑山杂物。

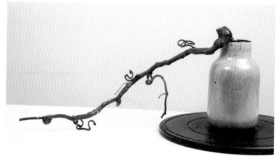

③撒固定好的效果。

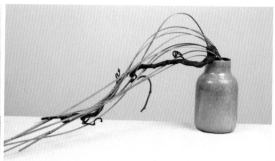

④利用纸皮铁丝将竹片与枯枝固定，做出流线型结构。

⑤逐步增加竹条，并对末端进行修剪。

⑥将果实适当进行修剪。利用热熔胶枪，从瓶口外沿开始，将果实粘贴至竹条上进行装饰。

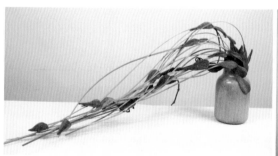

⑦装饰果实时，适当为其余花材预留出空间。

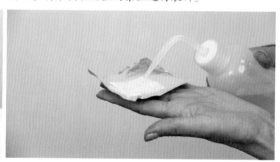

⑧准备好保水棉以及铝箔纸，充分注水预处理。

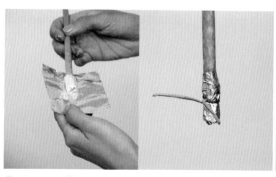

⑨利用保水棉以及铝箔纸，进行海芋茎部保水处理。末端利用纸皮铁丝将马蹄莲与竹片固定。

⑩利用纸皮铁丝，多绑点固定马蹄莲。

撒的运用作品 2

撒作为中国传统插花中一个非常巧妙的技法，可以非常好地和西方的架构融合在一起。常见的撒中，有一种叫做应力撒，就是利用一些活的木本类枝材的弹性在花器内做固定，然后以此为支撑来插花。这个作品中我们用到的就是应力撒。

做撒

①截取蔷薇枝，弯折为"U"形。

②利用"U"形弧度以及花器边框进行一侧固定。调整弧度，卡死。运用同样的操作方式，弯折另一根蔷薇枝，形成"十"字固定。

③选取一段枝杈剪取"Y"字结构。将"Y"形结构固定在十字"U"形结构上。

④选取蔷薇枝，截取要插入花器内的分枝。

⑤利用纸皮铁丝将蔷薇枝固定在撒上，一枝比较繁茂，一枝比较枯寂，形成对比。

⑥在原有结构基础上，利用纸皮铁丝进行莲蓬的固定，打破花器对作品的视觉束缚。

⑦加入更多的莲蓬，形成正向倒向结构。不断地增加"线"，形成空间的衔接以及分割。完成空间结构设计。

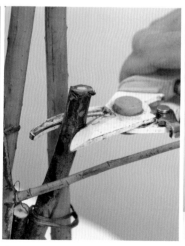

⑧主体结构完成后，修剪多余的撒的结构部分，保证空间画面整洁。

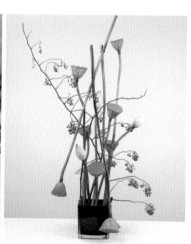

⑨从不同角度加入荷花，丰富作品造型。

撒的运用作品 3

这节介绍一个非常简单快捷的用藤本枝做撒的技巧。花器是浅盆，一般做水景插花选浅盆较多。

①将枯藤清洗干净，利用纸皮铁丝对枯藤进行外部固定。固定好后置于花器中，形成天然撒的基础结构。

②对睡莲茎穿入铁丝处理，便于后期塑形。

③将睡莲叶片穿插于枯藤中，注意叶柄要浸于水中，再加入睡莲花，利用纸皮铁丝进行固定。

④将睡莲以组群形式加入作品中，丰富整体层次，利用纸皮铁丝固定。

⑤适当在水面中加入睡莲，形成动态设计。

枝材的固定技巧 1

这一节讲解枝材的固定技巧。我们用具观赏性的枝条在整个花器内进行支撑搭建，然后形成新的结构。这些枝条要有多个分叉，而且能比较长时间地浸没在水中。因为枝条本身具有观赏性，所以非常适合在透明的花器中应用。

材料

玻璃容器、连翘花枝、郁金香、黄莺、雪柳、玫瑰等

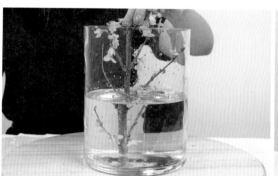

①筛选枝杈结构丰富的连翘花枝作为主结构。

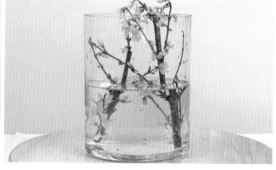

②主枝结构通过一定角度，形成多个固定点。

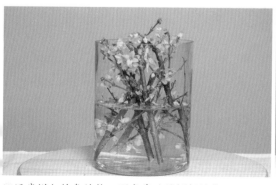

③逐步增加枝条结构，形成基础的框架结构。

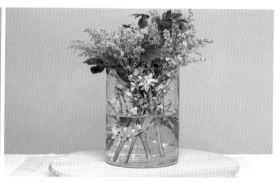

④增加花材与叶材，填充结构。

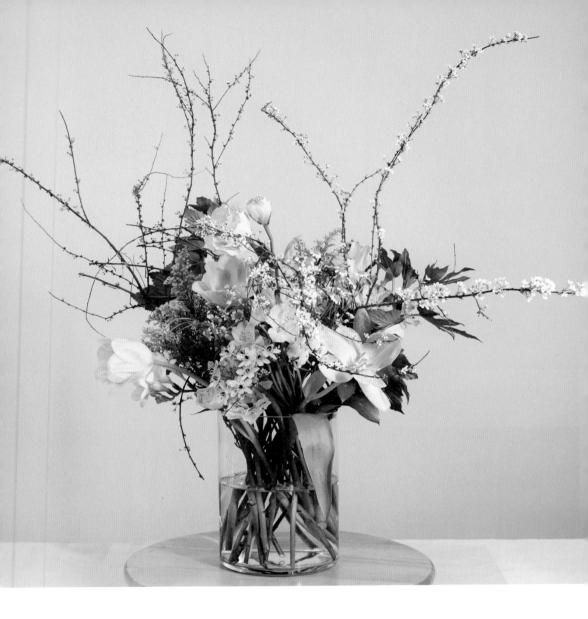

枝材的固定技巧 2

这一节继续介绍一种枝材的固定技巧，以方便
居家插花。就是在插花时通过调整枝材相互之间角
度、位置，来相互支撑进行固定。

材料

郁金香、洋甘菊、伯利恒之星、小苍兰、
黄莺、雪柳、六出花、木草莓叶、洋桔梗

① 花材斜切，插入水中形成固定根基的框架。

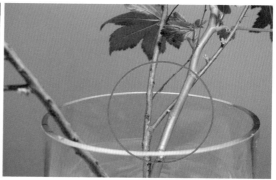

② 充分利用枝条的分叉结构，作为固定点。

③ 枝与枝之间建议120°夹角。

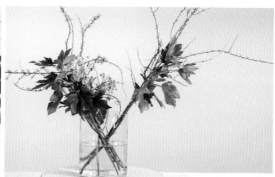

④ 不断增加枝条、线性结构，进行固定打底。

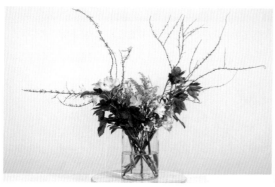

⑤ 填充花材以及枝材轮廓，逐步进行中心点插制。

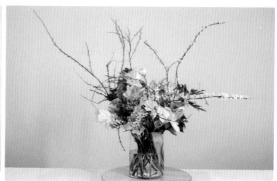

⑥ 作品完成。

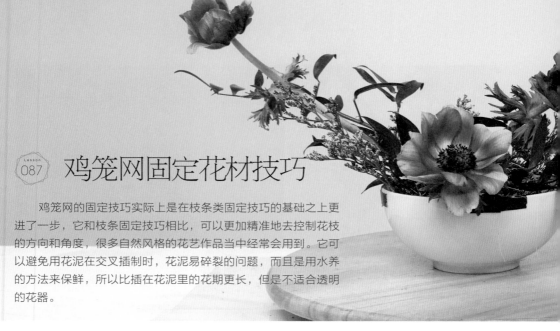

087 鸡笼网固定花材技巧

鸡笼网的固定技巧实际上是在枝条类固定技巧的基础之上更进了一步，它和枝条固定技巧相比，可以更加精准地去控制花枝的方向和角度，很多自然风格的花艺作品当中经常会用到。它可以避免用花泥在交叉插制时，花泥易碎裂的问题，而且是用水养的方法来保鲜，所以比插在花泥里的花期更长，但是不适合透明的花器。

材料

银莲、熊猫竹、情人草

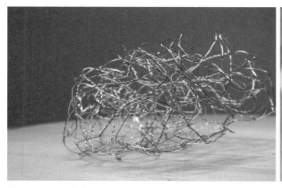

①用铁丝钳剪出适当面积的鸡笼网，向内弯曲，并不断挤压，形成团状。直至大小与花器基本一致。

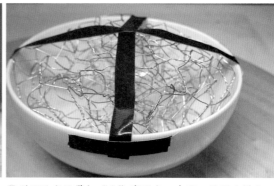

②利用防水胶带打"十"字固定，在瓶口处再次横向固定。

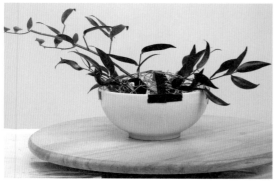

③枝材、叶材打底，保证花材充分吸水。

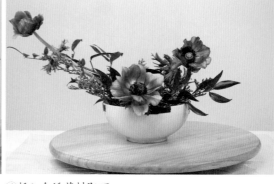

④插入合适花材即可。

Lesson 088 玻璃纸固定花材技巧

玻璃纸具有非常高的通透性，是花艺师最常接触到的一类隔离和保水材料。其实它也可以作为花枝的支撑工具，并起到出其不意的效果。

直接固定

玻璃纸是透明的，质感很特别。在透明的花器中，将玻璃纸揉捏后置入其中，再加上水，远看就是像是冰块一样，尤其是在宴会等场合中，通过各种灯光效果，设计感非常惊艳。

另外，将它放入瓶器内作为支撑，可以起到很好的垫高作用，一些断头花，非常适合这种固定方式。

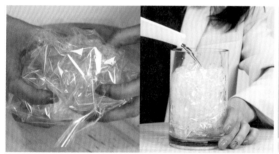

1 将玻璃纸揉捏成球，置入花器后注水。

2 利用玻璃纸空隙进行花材固定。

3 将更小的花器置入大花器中。将玻璃纸揉捏后塞入小花器之外大花器之内。花可以插入小容器中。

作为填充

在大玻璃花器中套一个小的玻璃花器，然后把玻璃纸塞在两个容器中间，这样花材就可以插在小容器里，达到同样的效果。这种方法更适合花材量比较大的时候应用。

在注水时，两个容器中可以加两种不同颜色的水，获得独特的效果。而且玻璃纸本身有很多色彩，容易获得不同的效果。

锡箔纸固定花材技巧

锡箔纸除了用于烧烤之外，在花艺上也可以用它实现各种奇思妙想，比如做固定。锡箔纸一旦有皱褶是不可逆的，揉捏会形成非常随机的现代的质感，并且锡箔纸在塑形之后仍然具有一定的强度。

塑形

①将铝箔纸揉成一定的形状，之后在底部再加一张进行叠合，无缝衔接，可用于假山造型的设计。

包裹花泥装饰

②利用锡纸包裹充分浸泡的花泥。

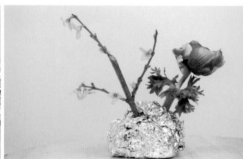

③插入花材。

容器插花固定支撑

④将锡箔纸揉成球，球体直径与花器直径保持一致。

⑤利用空隙进行花材固定。

122　全能花艺技法与设计百科

石子固定花材技巧

LESSON 090

这一节介绍一个比较有趣的适合快速居家插花的固定技巧，即石子的固定技巧。石子固定通常适合草花类，而且花头不能过重，因为石子的固定力量相对较小。

① 选用常见的陶粒，进行充分清洗。

② 干燥与湿润后对比。

③ 将陶粒置于花器内，充分注水，陶粒在水中呈漂浮状态。

④ 根部可充分吸水。

⑤ 插入喜欢的花材即可。

叶片固定花材技巧

这一节介绍用叶片层叠的手法，对花材进行固定。叶材层叠可以形成特殊的纹理，不同的叶材可以做出各种不同的效果。鸟巢蕨叶子带有弧形的波浪纹，像起伏的波浪一样的，非常有特色。

材料

鸟巢蕨、海芋、黄金球（金槌花）

①利用花剪、花刀，剔除鸟巢蕨主叶脉。将叶材的两端，用剪刀修成圆弧形状。

②按照花器轮廓逐层卷叠填充叶材。

③最后成卷进行缝隙填充，使其呈旋涡状。

④花材不是特别服帖的情况下可以使用珠针固定。为了隐藏珠针白色的点，可以拿丙烯颜料给它刷一下。

保水凝胶固定花材技巧

保水凝胶是近几年常用的一种保水材料，它遇水变黏稠，但又不会呈固体的状态，是一种非常好的家居插花的固定材料。

Tips

1 添加凝胶时，不要添加过多，否则花材没有办法吸水。

2 凝胶容易吸潮，一旦打开，一定及时密封。

3 多余的保水凝胶千万不要大量倒入下水道里，会堵塞管道。

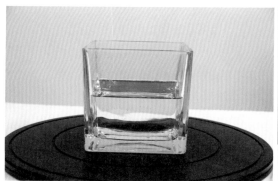

①准备花器，充分注水。

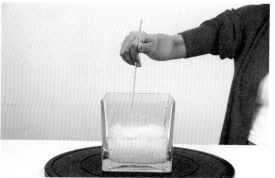

②按照说明书比例，倒入保水凝胶粉状物，并进行充分搅拌。

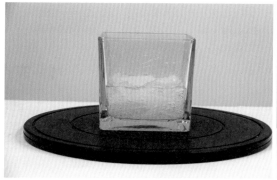

③静置片刻，呈现凝固状态。

④利用保水凝胶进行花材固定，适用于轻质或者小体量花材。

豆子固定花材技巧

Lesson 093

　　应用透明花器，很大的困惑是花泥的隐藏。其实我们可以开阔思路，运用身边常见的像豆子等做介质，起到装饰和固定作用。豆类不太适合比较浅的花器，因为固定力量不够。

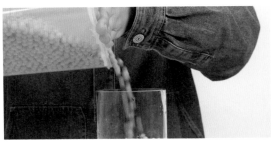

① 容器中倒入豆子，注意封闭出口，以免喷溅

② 充分利用豆类空隙插入花材。

③ 花材插至容器底部，确保植物根部可以充分吸水。

④ 完成效果。

正确做法：倒入一定黄豆后，注入一定水量（与黄豆高度持平），水线以上再次注入一定量的黄豆。

错误做法：水注入过多，豆类漂浮。

094 热熔胶固定花材技巧

这一节给大家介绍的是使用热熔胶材料去做固定框架，或者头饰类、手腕类的花饰的固定。

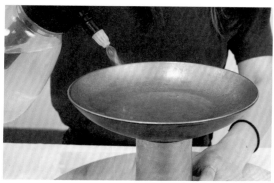

① 用喷壶向平整的金属表面（利于散热）洒水，充分湿润。

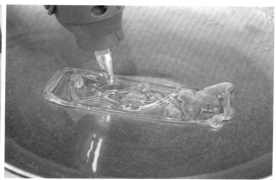

② 涂抹热熔胶，先外围框架，然后填充，内部充分连接，不要产生断连。

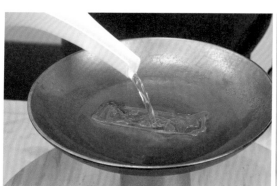

③ 造型完成后，注水，进行充分冷却，等待成型。

④ 取出成型的热熔胶。

⑤ 小面积成品可以形成手腕花基底。

⑥ 也可做大面积成品进行花器内部固定填充。

LESSON 095 透明胶条固定花材技巧

　　这一节介绍如何用胶条固定花器口。花器口比较大，需要分割花器口时，胶条的固定方法非常合适，而且更换花材很方便。另外，在花店的日常经营中，经常会产生一些断头花材舍不得扔掉，可以选择比较广口的低矮玻璃容器，上面用胶条分割，将断头花插在上面，达到短枝花材临时性仓储的目的。

材料

须苞石竹、康乃馨、六出花、熊猫竹

①根据花材的空间布局，利用胶条进行花器分割，形成较多不规则空隙。

②利用胶带进行瓶身装饰。

③贴成"井"字格。

④利用胶带进行花器分割，花器中最后记得注水。

纸板固定花材技巧

我们身边有很多物品，都可以用于花艺设计中，往往可以取得别出心裁的效果，比如这一节要介绍的纸板。

拼插

◆将纸板剪出插槽，进行组合拼插，然后可以粘贴试管等进行插花。

材料
小菊、康乃馨

组合成立体个性结构插花

◆可以用纸板剪出多种形状，然后用泡沫胶粘贴，中间要留有一定的空隙。

◆立体结构图侧面，形成一定厚度。

◆立体结构组群结构侧面图，形成层次。

◆立体结构正面观。用这种方法固定的作品，最好只做一面观赏。

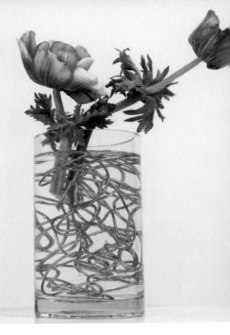

097 铝丝固定花材技巧

铝的材质比较软，容易造型；颜色也非常多，也比较稳定，具有非常好的装饰性。这节介绍如何使用铝丝对花器来进行固定。

材料
银莲花

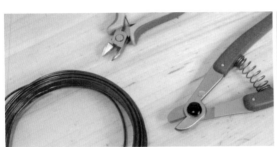

①铝丝以及钳子工具。

②不断地重复弯曲，形成类似毛线团的完整结构。

③不断比对成型结构，与花器体量相匹配。

④利用铝丝结构空隙进行花材固定。

正确方法：
用铝丝随意弯折各种立体造型。

错误方法：
弯成一个平面。

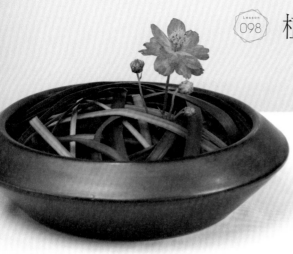

植物编织固定花材技巧

通过对植物编织形成结构也可以固定花材。在使用这个技巧时，要注意材料的选择。要选择具有一定长度、韧性、强度的材料，一些枝材、草本、叶材做编织都比较合适，比如散尾葵、红瑞木、长叶春兰等。这节介绍的是用长叶春兰编织固定的技巧。

 材料

春兰叶、硫华菊（黄秋英）

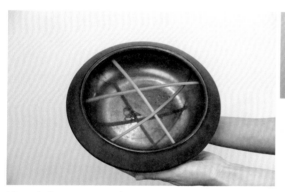

① 比对花器口径，让春兰叶长度长于口径，进行剪裁，区分根部以及尖部。利用春兰叶大段较硬的根部起手，形成交叉状，起到一定支撑性。

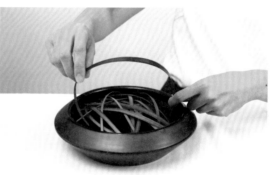

② 继续上面的方法编织，形成基础支撑结构。加入叶片上端较软的部分，利用其柔韧性形成曲度固定。

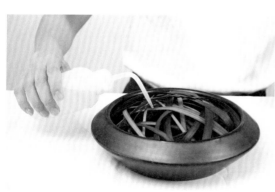

③ 花器内注水。

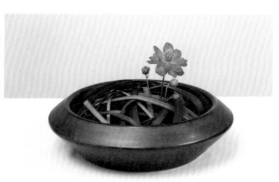

④ 插入喜欢的花材即可。

Lesson 099　竹片固定花材技巧

像之前介绍的几种方式一样，竹片固定也适合透明花器。

玻璃容器的竹片固定应用

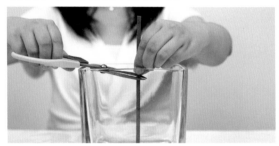

①比对花器高度，进行竹片剪取。

②剪取大量竹片素材，可以长短不一，形成高低错落的效果。

试管的竹片固定应用

③有序地将竹片左右垂直方向填充花器，利用竹片空隙插花。

④试管内也可以用竹片或竹签填充的方式来固定花材。

Lesson 100

木片固定花材技巧

木片的纹理非常特别，也可以用于透明花器。

① 剪取木片若干，成段。将木片浸泡打湿，擦干利用纸皮铁丝连接。

② 做几个木片卷曲的结构，利用订书机固定。

③ 将木片结构层层叠叠搭置于花器内，注意要横向放置，形成网状。

④ 增加层次，形成稳定结构，充分注水。

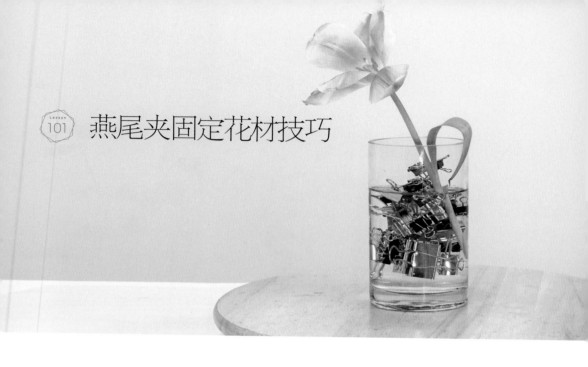

燕尾夹固定花材技巧

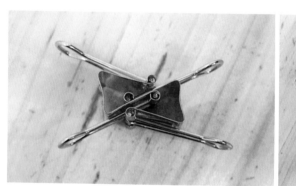

① 两个凤尾夹末端相夹，形成基础结构。

② 其余凤尾夹逐一夹持头部，形成串联状。

③ 链状结构逐一拼合成团状，形成基础结构放入水中。

④ 质感非常现代风的设计。

扎带的固定技巧

生活中固定花材的素材随处可得，关键是有一双善于发现的眼睛。这一节介绍如何用扎带来固定花材。

① 将扎带首尾相连，形成三角形。

② 再扎一个形成四边形。

③ 将前面制作的单一结构逐层首尾相连，形成立体结构逐步增加层次。

④ 完整结构展示。

材　料　的　使　用　技　巧

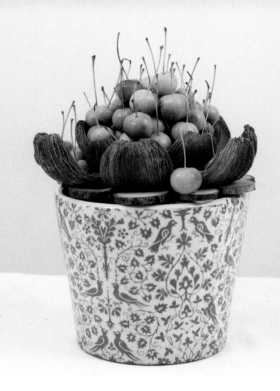

拼合技巧

　　拼合和重组不一样。重组是相同材料拆分之后形成新的形态，比如铁炮百合拆开后，拼一朵大的百合，或拿多支单朵玫瑰拼一个更大的玫瑰。拼合是不同材料之间组合，创造一个全新的形象，比如木百合，它中间原本没有东西，但可以通过粘贴给它增加一个小的花蕊，创造出全新的花卉形象。做设计时，我们需要凭空想象，"无中生有"。

材料
花器、纸板、鸡笼网、木片、
胶枪、冷胶、翅果、海棠果

基础结构拼合

①比对花器口径，在纸板上画出相同大小的轮廓后进行剪裁，尺寸略小于轮廓，保证圆片可以卡在花器内部。

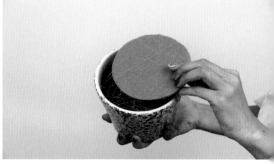

②花器内部置入鸡笼网，起到支撑作用，将圆片置于花器内卡死。

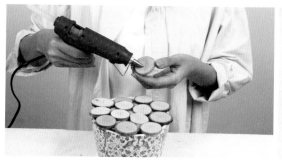

③利用胶枪将木片有序排列，粘贴于纸片表面，拼合为基座图形。

④形成一定厚度，并且木片结构的边缘大于花器边缘。

花材拼合

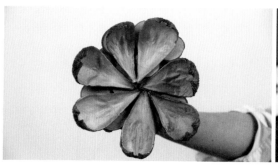
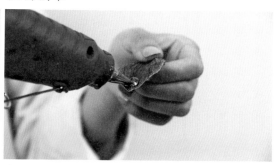

⑤木片形成层叠效果，边缘有效地搭叠在花器边缘。

⑥利用热熔胶枪，将翅果逐一固定。

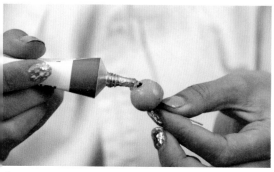
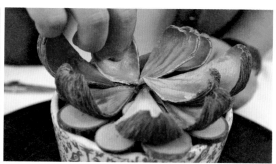

⑦拼合为花瓣图形。

⑧逐步增加内部层次，形成莲花造型。

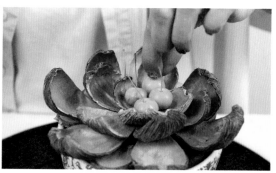

⑨提前预处理海棠果，利用鲜花冷胶进行粘贴。

⑩将海棠果填充至造型内部。

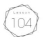

弯曲技巧 1

Lesson 104

很多我们购买的花材，虽然有非常优美的线条，但是往往不太符合设计要求，这时我们就需要来对它进行一些弯曲加工的处理。

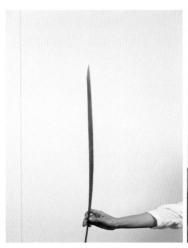

◆ 未弯曲状态。

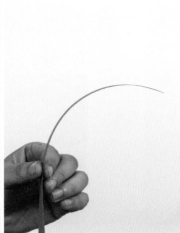

◆ 鸢尾叶自然弯曲下垂状态。

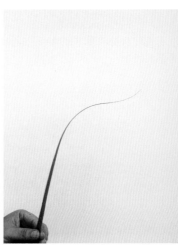

◆ 通过按摩方式进行二次弯曲效果。

◆ 立体弯曲效果。

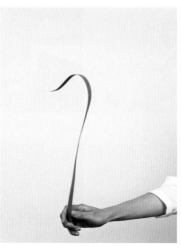

◆ 不同角度立体弯曲效果。

◆ 组合效果，多用于东方风格。

弯曲技巧 2

（105）

鲜切花材中，有很多肉质中空茎秆，比如马蹄莲、荷花等，我们可以通过用手捋和加铁丝来达到弯曲和取直的效果。用手捋可能会损害茎秆鲜活性；加铁丝注意一定要顺着茎秆中间，一旦偏折，就会把茎秆刺烂，如果一根的强度不够，可以加两根。弯曲时要注意弧度自然。

用手捋

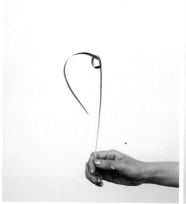

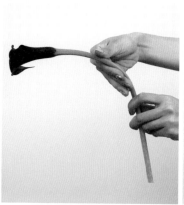

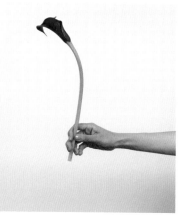

◆春兰叶打结效果。

◆利用手的温度，对花材花秆进行弯曲。

◆弯曲效果。

茎秆内插铁丝造型

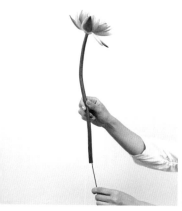

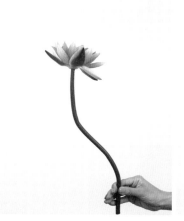

◆利用花艺铁丝对空心类花材进行弯折处理。

◆花材弯曲效果。

◆取直处理效果。

Tips

莺尾叶在偏东方风格的花艺作品中，经常会对它做一些弯曲。弯曲的时候，第一要区分它的朝向，因为朝向可能会决定植物整个的状态。先拿手摸一下，一般来说，莺尾叶一个面是平的，一个面是凸起的，那凸起的面是正面，背面的纹理相对来说比较粗，气孔比较多。

粘贴技巧 1

粘贴是花艺上经常会用到的技巧，在需要拼接时，无论植物性还是非植物性材料，都可以用到该技巧。

材料

鸟巢蕨、红叶石楠、蓝星花

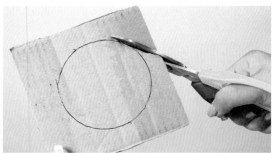

①利用箱板纸画圆，剪取圆形，作为整体结构基底。

②选取落水纸，手工撕扯为不规则纸片若干，边缘产生一些不规则毛边，起到一定装饰性作用。利用胶枪将不规则纸片粘贴于圆形纸片表面，遮蔽纸板，并且每隔几层粘贴一层纸板，层层叠加，形成一定厚度。

③穿插冷胶粘贴叶片，形成一定空间厚度，进行夹层搭配设计。

④顶部用落水纸剪取完整圆形，利用鲜花冷胶粘贴，用于覆盖，遮蔽不规则结构。在落水纸与叶片夹层中，粘贴花材，填充空隙，装饰整体作品。

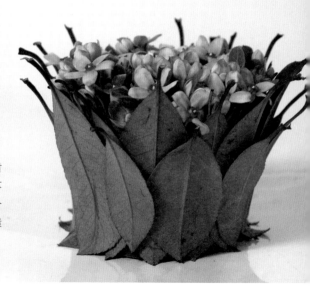

₁₀₇ 粘贴技巧 2

粘贴是经常会用到一种纹理类的花艺技巧，粘贴材料植物性和非植物性都有，载体也是多种多样，比如不锈钢、亚克力、玻璃、纸板等，粘贴不同的材料用的介页也不同。植物性材料主要用花艺冷胶，对花材不会造成损伤。

①切割花泥，充分浸泡，用保鲜膜包裹表面，然后用美纹纸包裹保鲜膜外层。

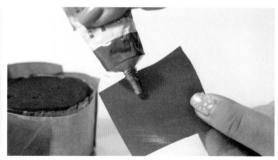

②花刀处理鸟巢蕨，取出叶脉，将叶质部分剪成适合面积方形。用花艺冷胶将剪成方形的鸟巢蕨叶粘贴在美纹纸表面，充分包裹。

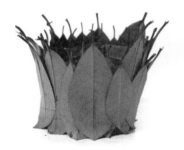

③在方形叶片外部粘贴红叶石楠，逐层叠搭，保证叶柄方向一致。重复粘贴，增加一定体量感。

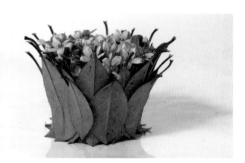

④在花泥中部插制花材丰富作品。

吹、剥技巧

买到的花材，有的比较生，如果想让它快速开放，这时我们会去用到"吹"的技巧。

有时候为了特殊的效果，特别是一些偏自然的风格，我们希望花朵出现更好的层次，更大的展示面积，可能会用到"剥"的技巧。康乃馨比较生时，可以捻搓花萼，再轻轻拨一拨花瓣，开放度就会变大。玫瑰可以通过翻边的技巧，让它一层一层打开，会有更好的展示面积。

吹的技巧

◆利用吹的方式，玫瑰花头处理前后对比。

玫瑰剥的技巧

◆手工将玫瑰花瓣展开。

◆玫瑰剥后充分开放效果。

康乃馨剥的技巧

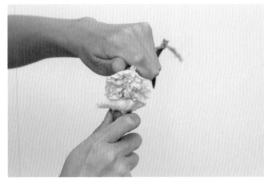

◆利用两枝康乃馨，用手按住花萼部分，花头对花头揉搓。

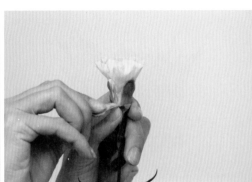

◆剥除康乃馨底部花萼，进行预处理，形成松散形态，增加开放度。

夹的技巧

夹其实是为了固定。采用夹的技巧时，材料必须要有一定的韧性，不能太脆，否则会变形，也不能过软，否则起不到固定作用。这个案例作品中，我们选择了竹片，有非常好的弹性。

①选取竹片，利用胶枪固定线头，或者直接利用双面胶粘合竹片，用毛线进行缠绕，遮蔽竹片。

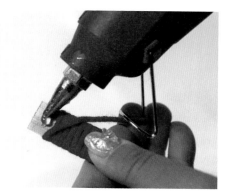

②利用胶枪粘合尾部，剪除多余线头。

③利用绿铁丝进行夹板固定。

④在夹板缝隙处均匀夹制麦草，形成夹合结构。

⑤增加试管串联结构，用于花材固定进行装饰。

⑥垛满麦草后，将完整夹板至于花器上形成夹技巧。

折的技巧 1

一般木本类的枝材用折的技巧比较多。"折枝"可以根据设计要求让枝材形成更加优美的线条。

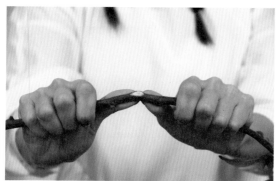

◆利用枝条结的结构进行弯折。

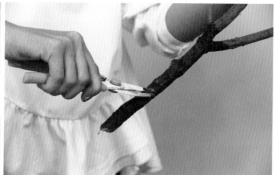

◆观察枝条走向，规避剪切点，确认弯折位置，枝剪开口。

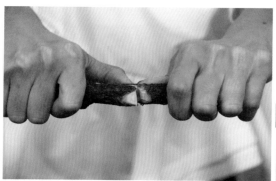

◆用双手弯折，形成曲线，不宜用力过猛，要达到折而不断。

◆如果希望多次弯折，需要在枝条不同角度进行折枝处理，形成曲线弯折。

◆没有进行折弯和弯折效果对比，前者线条直线化，后者形成一定曲度，线条柔和。

折的技巧 2

折的技巧是为了获得花材更加理想的线条感。枝条的质感有的脆，有的弹性非常强，需要多加练习，才能掌握好折的力度。

用楔子防止枝材折后回弹

①枝条较粗且弹性较大时，弯折后可能会恢复原状，可制作三角形楔子进行加固。

②首先利用枝条结构，根据折口大小，剪取楔子。

③将楔子从外侧插入到枝条中。

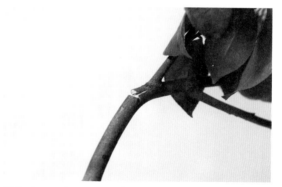

④楔子可以有效防止枝条弹回，加固造型。

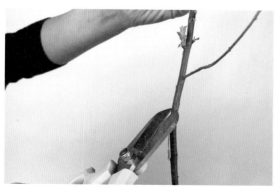

◆雪柳因为质地比较脆，难于弯折，需要用花艺剪刀开小口。

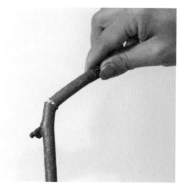

◆玉兰枝折枝，由于质地较脆易断，折时要特别注意。

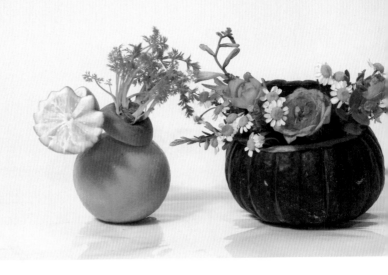

雕刻技巧

材料
玫瑰、洋甘菊、雄黄兰

　　花艺设计中很多场合都需要用到雕刻技术，比如小熊等卡通造型的花艺作品，需要雕刻花泥；还有果蔬雕刻，比如万圣节的南瓜容器等。最常见的雕刻方式有切割类和浮雕类等。通过切割，获得所需要的形状，浮雕则可以获得需要的纹样。

　　叶材也可以进行雕刻，把叶脉统一镂空，获得一定的纹样。雕刻一般用刀，但是也可能用到其他工具，比如可以用打孔器在叶子表面去打一些点，形成波尔卡点等特定的纹样。

花泥雕刻

①利用花泥刀进行花泥雕刻造型。

③将南瓜内部处理干净，放置浸泡切割后的花泥。

果蔬雕刻

②南瓜容器雕刻：将南瓜顶部切除，南瓜盖保留。

④水果雕刻案例：利用刀具将柠檬进行雕刻形成装饰。

着色－吸色技巧

材料
满天星、郁金香、康乃馨、花毛茛

　　吸染是最近几年经常会用到的一种染色方法，是快捷获得想要色彩的方式。吸染对材料有一定伤害，比如婚礼、宴会等商业场合，只需要短暂的视觉效果，这种方式就比较合适。吸染要求花材吸水力比较强、速度比较快、需水量相对较大；其次是花材最好是浅色的，容易着色。在吸染之前可以把花材脱水处理，在脱水环境下放两三个小时，吸染的效果比较好。吸染之后，为了把颜色稳定住，还需要把它静置到清水里再吸水。

　　吸染的染色剂种类非常多，市场上都有售卖。同一种花材可以分阶段吸几种不同的颜色，比如第一阶段吸的是蓝色，然后开始吸紫色，就会出现蓝紫混合的效果；或者把两种颜色进行不同比例的调配和混合再吸，会得到更多的颜色。

①提前准备好试管以及试管架，用于贮存染色剂。

②根据染色需求，向试管中注入染色剂。

③向试管中放置需要染色的花材。注意花材的根部充分深入试管中，确保充分吸入染料。

④花材充分吸入染料后的效果，纹理色彩感较强。

着色－涂色技巧

涂染就是用颜料对植物性材料或者是非植物
性材料进行染色的工艺。一些比较娇嫩的花材不
是特别合适，相对比较硬质的花材适合涂染。比
如天堂鸟叶、龟背竹叶等。

 材料

丙烯颜料、涂色画笔，其中笔刷尽
可能保持一致，确保笔触规律

◆利用丙烯、笔刷等颜料工具进行涂色处理。

◆单层半涂效果，可以基本遮盖本色，部分区域
会有透色现象。多次厚涂后静置，可完全遮盖植物
原本色彩，注意可能会产生裂纹，要及时补救。

◆需要涂多种颜色操作时，可利用美纹纸进行分割。

◆多色涂色效果，可以反复叠加，多色多区域操作。

115 着色 – 喷染技巧

　　喷色可以非常快捷地获得想要的色彩。它和吸染最大的区别是，吸染会呈现一丝一丝的纹理感，因为它是通过输导组织将颜色吸上来的，花材本身的纹理感会显现出来；而喷色不会体现纹理。喷染的时候要注意戴上口罩。

材料
植物喷色剂

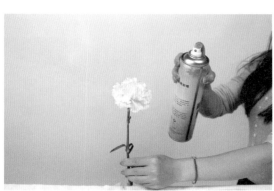

◆喷头对准花材连续喷涂。

◆喷染（轻喷）效果，不易均匀受色。

◆叠加喷涂，可产生晕染效果。

◆多次喷染后效果对比。

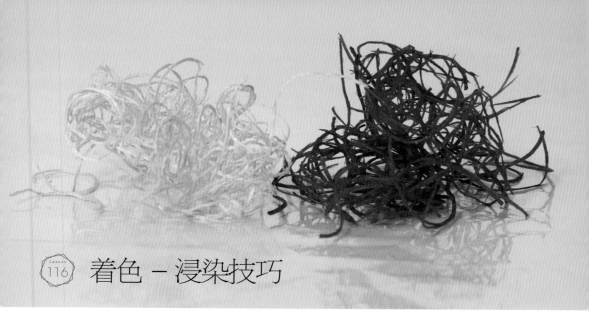

着色 - 浸染技巧

浸染是染色技法中历史比较久的一种方法，可追溯到远古时代。浸染即直接把材料放在染色剂里，浸染后需要晾晒很长时间。现在浸染对植物性材料用得比较少，非植物性材料用得比较多。

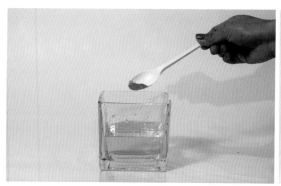

①根据染色深浅、容器体积，倒入适量比例的粉状颜料。

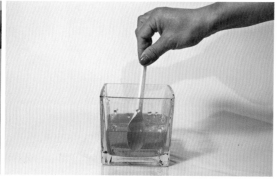

②用工具进行充分搅拌，加快粉粒溶解速度。

③静置，染色剂制作完成。

④将材料置于染色剂中，充分且均匀浸泡。

着色 – 胶染技巧

胶染也是常见的染色工艺，它和正常的喷雾类的染色区别在于附着，喷色只是在材料表面喷涂一层漆，胶染一般是附着一些颗粒状、有质感的物质。不是所有材质的表面都适合去喷，因为对植物性材料有伤害，一般适合非植物性材料。

材料

粉状胶染剂、花艺喷胶、防护膜以及手套

①将喷胶对准花材，控制在一定距离范围内均匀喷胶于花材表面。

②蘸取部分粉末状染剂，均匀浇洒于花材表面。

③非植物材料——火山石胶染效果，增加装饰性。

④多层花植材料胶染效果。

着色材料的运用 1

这部分我们将之前处理的着色材料制作一个作品，可以看到其设计应用效果。

🌿 **材料**
郁金香、康乃馨、花毛茛、鹤望兰
（叶子）、菊花

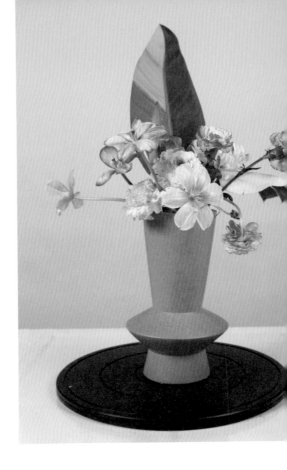

①根据花器以及作品花量大小，剪取鸡笼网，弯折为球形，置入花器中。

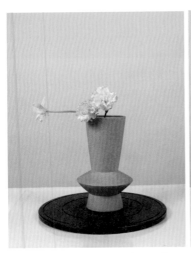

②插制起手花材，确定作品幅宽。

③增加吸染效果花材，丰富作品。

④增加原始花材材质，以及涂色的叶片，完成比较夸张的色彩搭配，对比以及质感加强。

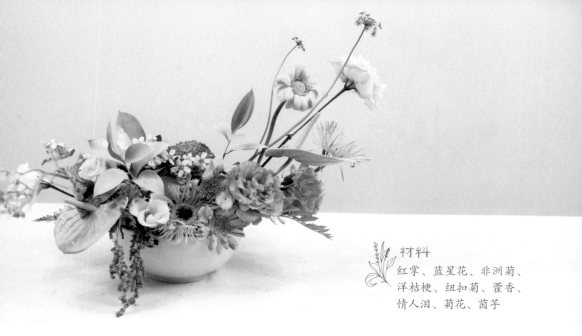

材料

红掌、蓝星花、非洲菊、
洋桔梗、纽扣菊、藿香、
情人泪、菊花、茵芋

119 着色材料的运用 2

这节继续演示是着色材料的运用和呈现。大家对喷染会有一种误解，觉得必须要染色才会显得时尚或新锐。其实任何的着色技术都是为了让作品或材料有更多的可能性。毕竟我们是植物类的设计师，需要有更多的植物表现力，但也要对植物发自内心地爱护。

①花材部分喷染着色效果。

②花材全部喷绕着色效果。

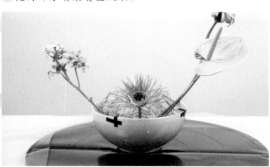

③利用鸡笼网进行花材固定，起手插花材。

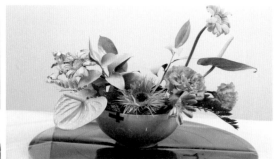

④根据设计，增加天然花材以及染色处理花材，进行空间填充。

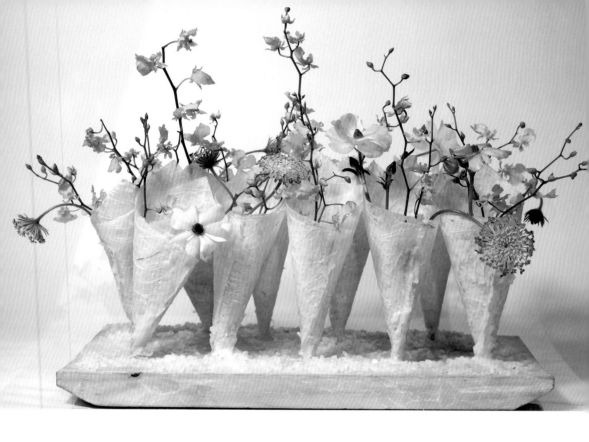

⬡120 涂蜡技巧

　　蜡作为一种密封性的材料，在远古时代就有。它可以和水形成非常好的隔绝关系。除了隔离之外，花艺上通过涂蜡的技巧，可以营造特别的质感。

材料
跳舞兰、松虫草、蝴蝶洋牡丹

①准备适量的固体石蜡。

②将石蜡倒入熔蜡锅加热溶解。

③将叶材在蜡液里充分浸泡。

④文竹涂蜡效果。

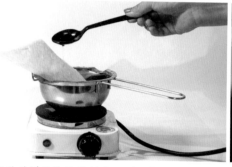

⑤将融化后的蜡液涂抹于纸卷，用于表面形成涂层以及封闭纸卷。

⑥利用竹签，穿插纸卷，固定于木板上。

⑦对所有纸卷底部浇蜡，底部固定并且封口。

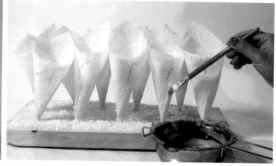

⑧用笔刷刷取蜡液进行纸卷缝隙涂抹用于封口，加固固定。要确保封口后再注水。

⑨木板表面平铺蜡粒，进行遮蔽以及木板装饰。

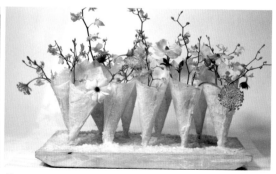

⑩插制花材，完成涂蜡技巧展示效果。

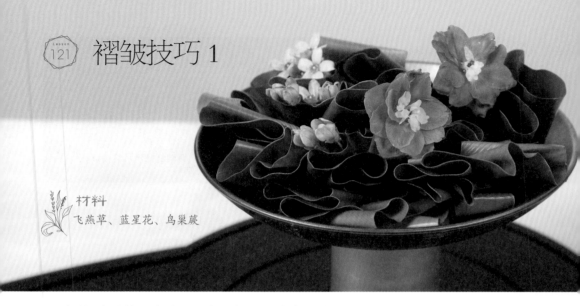

褶皱技巧 1

材料
飞燕草、蓝星花、鸟巢蕨

褶皱和折叠的区别：折叠是在一个平面上连续地重复，褶皱是在一个立体空间上的折叠。褶皱对材料要求：一是长度要足够，二是韧性足够。植物性材料中叶材应用比较多一些，非植物性材料比如纱网、缎带等，应用非常广泛。

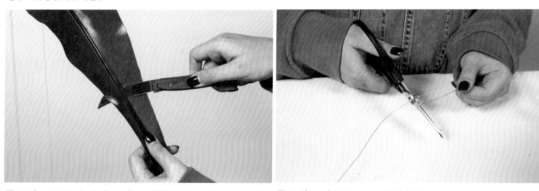

①用花刀剔除主叶脉。对叶材进行褶皱处理，形成立体结构。

②用剪刀截取铁丝，弯折成型。

③用铁丝穿刺褶皱结构，固定，小型褶皱结构可以直接利用订书机固定。

④铁丝固定后完整结构。重复制作多个，要求所有褶皱结构采用相同的规则。

122 褶皱技巧 2

　　褶皱是通过对植物性材料或者是非植物性材料进行折叠或扭曲，在空间中形成一定的结构或纹样的技法。非植物性材料中，锡箔纸、纸张、布料都是非常容易形成褶皱结构的材料。本节作品通过纸张的褶皱，呈现阶梯状纹样的效果。

🌿材料
雪柳、满天星、蝴蝶洋牡丹、小飞燕、丁香

① 选择有一定硬度的卡纸，反复对折，形成风琴形折纸结构。末端订书钉固定，外轮廓剪裁为圆弧状。

② 选择花器，粘贴美纹纸、双面胶，将制作好的褶皱结构粘合。

③ 不断层叠粘贴褶皱结构，包围花器外部，用于遮蔽花器。

④ 插制花材，最后利用剩余褶皱结构进行外部遮蔽以及装饰。

123 打结技巧

　　打结是在日常生活中经常会用到的技巧，应用到花艺的设计中要注意花艺材料要具备一定的长度、比较好的韧性。像红瑞木、结香、春兰叶等，都是很好的适合做打结的材料。

结构制作

①用春兰叶与纸板圆环制作基底。

②用双面胶粘贴纸板圆环表面。

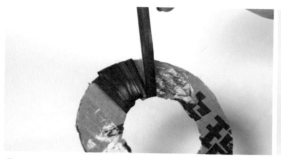

③用春兰叶缠绕纸板，附着表面，遮蔽纸板。　④纸板圆环完整遮蔽后的效果。

花材打结

⑤每根春兰叶单独弯曲处理，打结。　⑥将鲜花冷胶涂于成组叶片上，然后粘在圆环上。

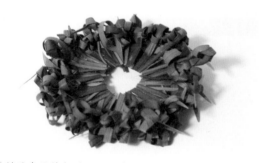

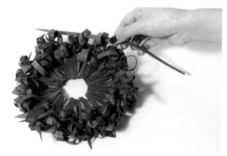

⑦利用冷胶将打结处理后春兰叶沿着圆环外部逐一整　⑧再用单根春兰叶将外部结构进行串联，再次打结，丰
齐粘贴，形成第一圈环领式装饰。　富外围结构。外围串联后效果，利用春兰叶填充外部。

作品设计

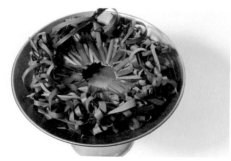

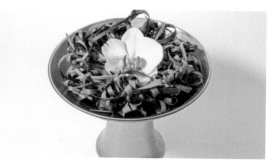

⑨将完整结构置于花器中，花器内注水。　⑩中间部分加入其他装饰性材料或花材，作品完成。

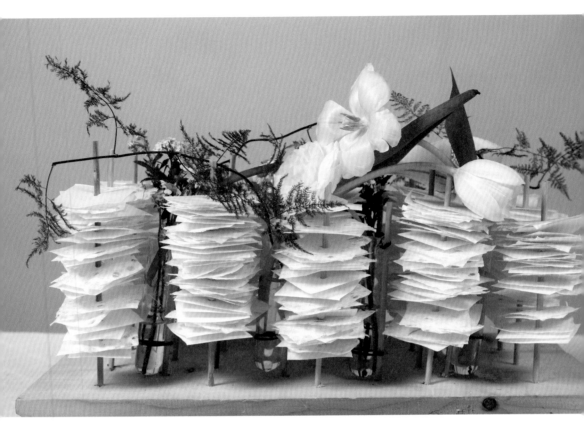

串联技巧

串联需要一个介质，可以是硬质材料，比如竹签，也可以是软性材料，比如鱼线等。在花艺上串联可以带来变化万千的设计效果。

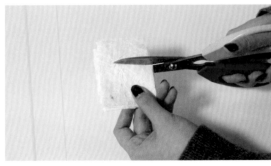

①剪取落水纸、卡纸，形成方形纸片若干。

②复合多张剪好的纸片，用剪刀尖部在中间穿刺，预留出串联位置，形成凹痕，便于后续穿刺。

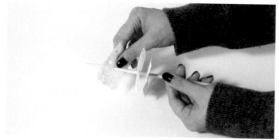
③将落水纸与卡纸纸片穿插，用竹签进行串联。

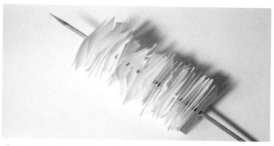
④单串效果，注意纸片间距保持一致，产生一定高度。根据作品需求反复串联多个，并且去除竹签尖端部分。

⑤利用竹签与纸皮铁丝固定试管，保证至少2个绑点，拧紧铁丝。

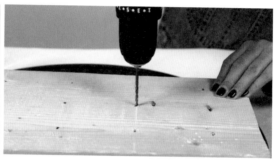
⑥准备基座，利用电钻在基座上钻孔，预留串联固定的位置。

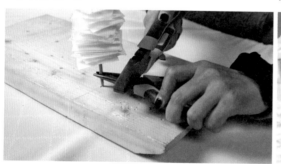
⑦利用尖嘴钳固定串联竹签，用锤击法敲击固定。

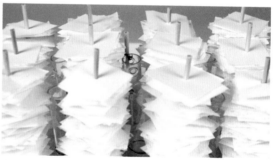
⑧每两个纸串之间预埋试管并固定。

⑨试管内注水。

⑩将花材插制于试管中，利用轻质、曲线花材进行整体装饰。

拆分技巧

　　拆分，通常是指把植物性材料按照植物学分类方式，比如将根、茎、叶、花、果进行拆分，再重新组合。这节用拆分的技巧，做一个小小的装饰型桌花。

①利用纸板，绘制圆形基底。底座剪裁为圆形，不宜过大，以免后期不方便遮蔽，并且用保鲜膜包裹，进行防水处理。

②取少许FIX胶，粘贴FIX胶和花泥钉。将花泥钉粘至纸板中心。

③比对基底大小，削制花泥，进一步按照比例塑性，形成基座。花泥直径比对花泥钉大小，避免尺寸不符，随时调整花泥尺寸。从底部边缘开始插制拆分的橘叶，注意叶片衔接，密度不宜过大。

④从底部到顶部，逐一插制叠加成型，叶片张开角度尽可能保持一致，叶尖部分互相错落开。用冷胶将花瓣粘合至顶部，遮盖花泥。

⑤摘取洋桔梗花瓣，逐一整理、拆分、排列，用于后续操作。

⑥利用冷胶，逐层叠加拆分的花瓣，有效进行根部错落粘贴。

缝纫技巧 1

Lesson 126

缝纫技巧在花艺上应用是前几年在欧洲的花艺圈流行起来的，它的主要目的是材料之间的连接。材料有植物性材料、非植物性材料，选择的余地非常大。植物性材料要考虑到花材的柔韧度，特别娇嫩的花材不适合做缝纫。这节用到的叶材是红叶石楠。缝纫线不能特别硬，鱼线、柔软的金属线都是可以的。除此之外，我们还可以拿柔软的植物性材料作为缝纫线，比如刚草。缝纫时有很多针法的设计，最终都是为了创造特别的纹理。

①挑选红叶石楠叶材，逐一剪取叶片。

②将叶片对折，按照叶片外轮廓进行包裹。用针线将边缘缝合固定包裹叶片。

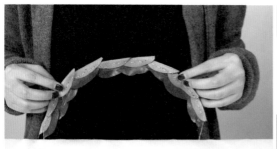

③将多个叶片缝纫串联成条带状，形成一定纹理。

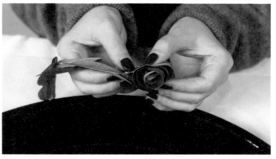

④卷曲条带形成旋涡造型，用于花艺设计作品装饰。

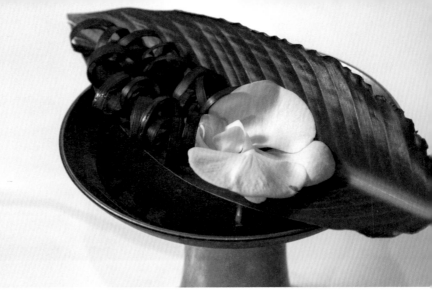

缝纫技巧 2

这节继续介绍缝纫技巧。

①剪取春兰叶，竹签蘸取冷胶。

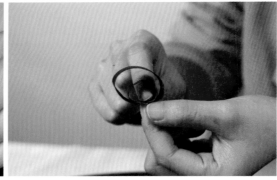

②顺着春兰叶生长方向进行卷曲处理，形成圆环。利用冷胶在末端根部进行粘合，形成闭环。

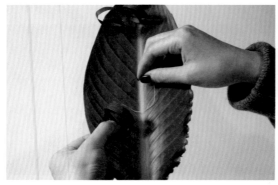

③缝针多组圆环结构至鹤望兰叶上。

④用剪刀在鹤望兰叶上穿孔，用于插制焦点兰花。

漂浮技巧

漂浮是利用液体的浮力，例如水、植物油、矿物油等，去做一些装饰性的设计。

材料
白色千代兰

①利用鱼线以及珠针，从侧面将白色千代兰花朵串起来。

②底部用透明胶带将鹅卵石固定在花串尾部，进行配重处理。

③配重后的花串，注意花头的朝向尽可能相互错落。

④将完整花串垂直放置于花器内，确保漂浮。

花　　　　艺　　　　技　　　　法

Lesson 129 捆绑式技法 1

把植物性材料或者非植物性材料捆扎在一起，形成一定的造型或者结构，花艺上称这样的技法为捆绑法。下面以康乃馨为花材演示这一技法。

①剪取适当长度的铁丝，剪切口形成45°夹角，用于串材料。铁丝可用16号铁丝，为了隐蔽，选用绿色的。将铁丝穿过康乃馨花萼中间位置固定。

②以此串联多支花，形成串联线条，花头尽量平齐。

③弯折铁丝，形成圆环形状。

④整理花秆，形成螺旋绑点捆绑。利用拉菲草制作装饰性材料对外部花秆进行装饰。

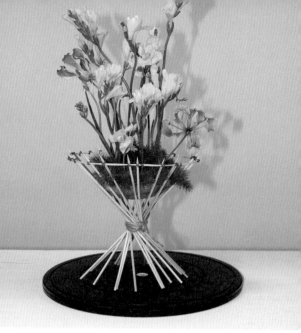

Lesson 130

捆绑式技法 2

捆绑技法除了创造一定的造型之外，还可利用它的一些结构性特征去制作作品。

材料
小苍兰、嘉兰、蓬莱松

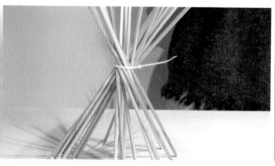

①取若干竹签，取齐，用扎带进行固定捆绑。整理竹签，形成螺旋状。

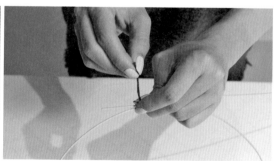

②取一根长竹丝，弯折成环状，利用纸皮铁丝多个绑点固定。

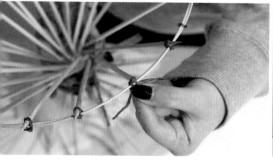

③利用纸皮铁丝，连接螺旋状基底和圆环部分，逐个绑点加固。

④利用尤加利叶拼贴，进行花泥盒遮挡装饰，逐步插入花材，并铺底，完成作品。

131 花瓣式技法 1

花瓣式技法是通过粘贴等技巧，利用片状的材料，形成特定的纹理。下面以花束为例，介绍花瓣式技法。

材料
康乃馨、洋甘菊、洋桔梗、蝴蝶花毛茛

①取3根16号铁丝，利用花艺胶带进行捆绑，形成握柄。

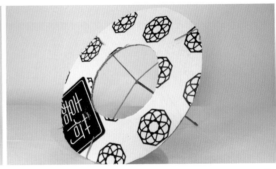

②利用纸箱，根据成品花束的大小剪取圆环形状，与握柄结构比对进行固定安装。

③剪裁彩色卡纸，拼贴覆盖圆环，并将边缘进行遮蔽处理。

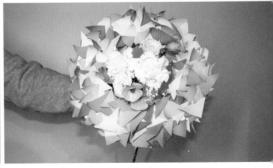

④逐步在圆环中部，围绕握柄进行花材螺旋状填充，注意花材不宜过高。

花瓣式技法 2

（132）

这一节继续演示花瓣式技法，我们手工制作花器时，可通过花瓣式的技法来装饰，效果非常特别。

材料

洋桔梗、洋甘菊、蓬莱松、小苍兰

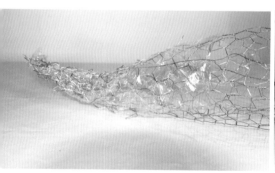

①鸡笼网弯折成牛角形状。用保鲜膜包裹表面成附着面，在外再添加鸡笼网，重复操作，加固结构。

②利用花艺冷胶，在结构表面有序地粘贴尤加利叶，形成纹理，进行遮蔽装饰。

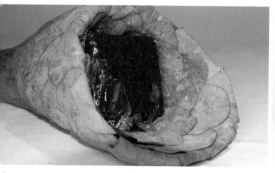

③内部填充玻璃纸以及湿花泥。

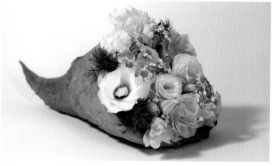

④将花材插入花泥中，逐步完成作品。

编织技法类型

编织技巧日常生活中用到的也比较多，花艺上的主要目的是为了形成特定的肌理纹样、结构，并达到塑型的目的，比如编织成立体花器的结构，起到遮挡花泥的作用等等。

狭长型的材料，如鸢尾叶、春兰叶、马蔺草、钢草、水葱、木贼等都是非常适合编织的材料。除了片状材料，立体材料也完全可以进行编织，比如枝条，鸟巢结构其实是枝条的编织。

编织可以用两种思路：一种是不依托任何外在的结构直接用植物材料来编织，这种质地会比较软；另外一种是加入一些辅助性的材料，像铁丝、鸡笼网等材料来进行编织，其结构会更加多样性，编织也相对简单。

利用新鲜叶材编织

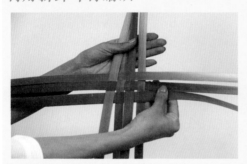

◆利用新鲜叶材进行编织。

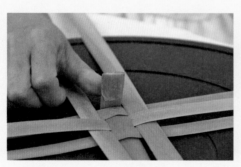

◆用双面胶完成编织收口操作。

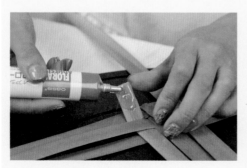

◆用冷胶完成编织收口操作。

利用干燥植物材料编织

◆用扎带对干燥材料进行编织。

◆用订书器完成干燥材料立体结构编织。

非植物材料编织

◆非植物材料：铁丝编织效果。

编辫技法 1

　　编辫是一种塑造纹理和形态的技巧，可以使用植物性的材料，也可以使用非植物性材料。材料不能过短，要有一定的韧性，拉菲草、蒲棒叶等都适合来编辫。编织成什么样的纹理，需要提前设计好。该案例是用花艺纸皮铁丝作为材料。

材料
纸皮铁丝

①弯折成双股开始编辫，反复不规则缠绕与弯折，形成辫形基底结构。

②重复性弯折铁丝成型，不断辅助塑型成条状。

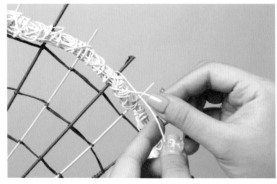

③利用缝隙穿插至扇形结构。在穿插点上进一步利用同色纸皮铁丝进行固定以及以及隐藏。

Lesson
135

编辫技法 2

这节演示如何用编辫技法装饰做一个手捧花。

材料

跳舞兰、雪柳、郁金香、康乃馨

① 选取拉菲草若干，整理为一捆，并打结。从打结处平均分成三股。

② 依次分别叠搭编成辫子。

③ 单根编辫打结收尾。

④ 将辫子结构穿插固定，根据设计需要规则性或者非规则性缠绕，对手捧花束侧面进行装饰。

花艺技法　**177**

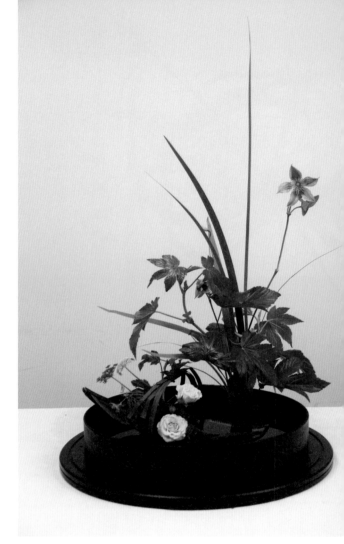

编织式技法

（136）

下面的作品中，拿叶材做了一个像小花篮一样的小作品，非常可爱，它底部是带有弧度的，需要在里面增加结构，而且有一个小的提梁。像这类作品适合在孩子们的花艺沙龙上操作，下面以这个作品作为案例，分享编织是如何来完成的。

材料

木草莓叶、春兰叶、多头蔷薇、铁线莲

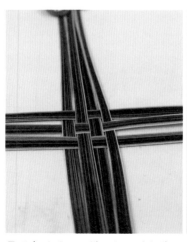

①用春兰叶，三横四纵，进行基础结构编织。

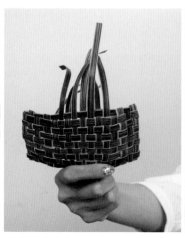

②编织结构完成效果。

③利用透明胶进行末端收口。

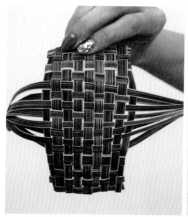

④背部编织效果。

⑤用铁丝进行编织辅助。

⑥利用双面胶、冷胶进行整体造型收口。

⑦一个完整的小船造型呈现。

⑧利用剑山完成水景起手操作。

⑨用鸢尾叶以及春兰叶完成小景打底。

⑩填充木草莓叶以及铁线莲。

⑪利用花泥、苔藓以及花头等组合完成小船内饰造型。

⑫作品完成。

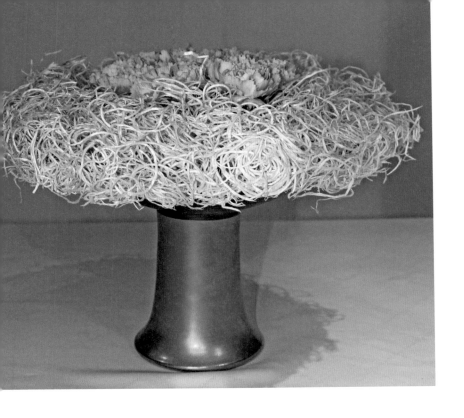

环领，顾名思义，环绕式领子。我们在花市经常看到红色的玫瑰外面加一圈白色的满天星，虽然这种做法很老套，但这就是很典型的环领式。这一节给大家演示一下如何用纸板和木屑丝做环领设计。

材料
纸板、木屑丝、康乃馨

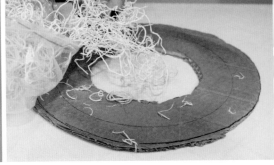

①利用箱板纸，剪裁一个圆环。在圆环表面做喷胶处理，距离不宜过近，操作环境提前做好相关保护措施。

②抽取木屑丝，整理干净。

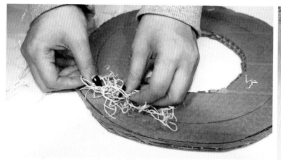

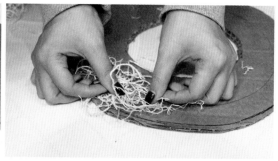

③逐一将整理完毕的木屑丝成簇粘贴至圆环表面。 ④一边整理，一边粘贴，逐步填充。

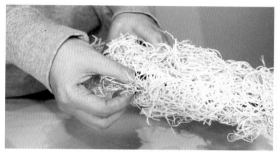

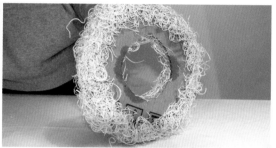

⑤完成正面填充后，进行侧面遮挡，确保每个角度 没有明显空隙。 ⑥木屑丝完整包裹侧面效果。

⑦环领结构完成效果。 ⑧准备花器，放置浸泡后的花泥，边缘可进一步裁切。

⑨在环领中部填充花材，平行插入康乃馨。 ⑩环领式插花作品效果。

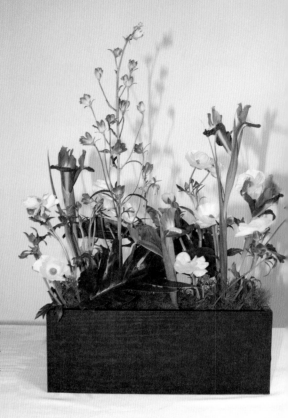

朝向式技法 1

　　朝向式不只是一个技法，实际上包含的内容会比较多。像人一样，不同的植物会有不同的形态，不同形态之间的组合会形成不同的感受。

　　朝向，是多种花材之间的一种组合关系。两支花，一个花头向着这边，一个花头向着那边，我们称之为背向，背向代表着一种离散的关系，它所表达出来的是一种朝着不同方向延伸的视觉；一支比较强，一枝比较弱，可以形成一种压迫感，即强力式；直立性花材垂直插入时，就会变成一种平行的关系，也是朝向式的一种。

　　绝对的垂直在自然界中是不存在的，植物生长都会追逐太阳。在自然界中，像路边的一些小花、野草，它们生长比较自由，适合创作野趣的花艺作品，在插制的时候，就不能使用非常人工的比如背向式、强力式、直立平行式的方法。应该高低错落，花头的朝向也应该是自由的。

 材料
蓬莱松、小天使叶、小飞燕、鸢尾、蝴蝶花毛茛

①用蓬莱松打底，遮盖花泥。

②观察小天使叶形态，进行剪裁，形成特定朝向。

③向内插小天使，形成保护形态，运用小天使叶边缘打破条缸直线线条。

④加入飞燕草，增加作品自然生长的感觉，按照黄金分割点的位置插入，确定作品高度。

⑥填充花材，花的朝向尽量规避向外撇，产生高低不同的层次。

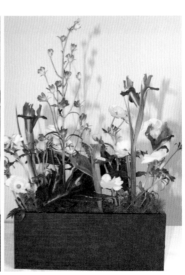

⑦在不同位置丰富花材，形成高中低不同的层次感。

⑧在不影响整体作品直立性的情形下，下部丰富花材，增强色彩对比，补充层次衔接。

⑨增加高低错落层次，完成作品。

朝向式技法 2

这节介绍直立生长的朝向，我们用到了一些线条形花材和异形花材，看看整个作品带来的感觉。

材料

蓬莱松、红瑞木、嘉兰、菊花

① 用蓬莱松打底，遮盖花泥。插制红瑞木，增加直立性线条。

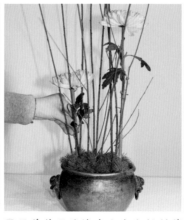

① 高低错落增加红瑞木，加强纵向线条设计，注意上半部分不要过于分散，以免重心上移。

③ 沿着作品边缘直立向上插制菊花，形成层次感。

④ 提前处理嘉兰花材的花药部分，避免沾染作品。插嘉兰，注意花头朝向，并且插制过程中与其他种类花材错落开。

加框式技法 1

加框式是通过植物性材料或者是非植物性材料在作品的外边缘制造一个视觉的框线，进行区域强调。这个案例作品演示一个非常直白的框，便于大家理解。在框线里面，创造平面的花艺作品。

材料

红瑞木、虞美人

Tips

用纸皮铁丝将红瑞木搭点进行连接，加固。

纸皮铁丝进行试管加固，加两个绑点，安装至框架上。

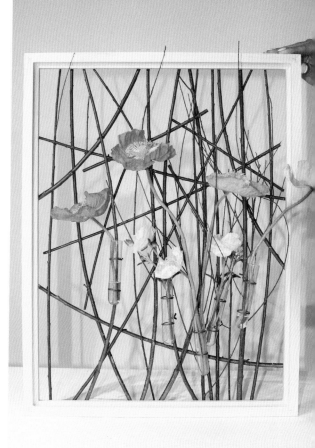

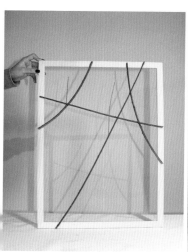

① 提前处理好红瑞木，用胶枪粘合框架类枝材。

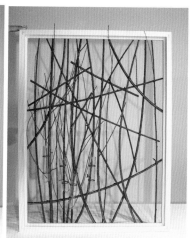

② 框架结构制作完成，添加试管，绑点尽量在画框背后隐藏起来。

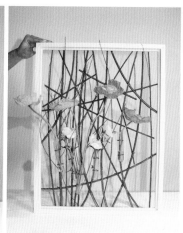

③ 试管内注水，错落插入花材，作品完成。

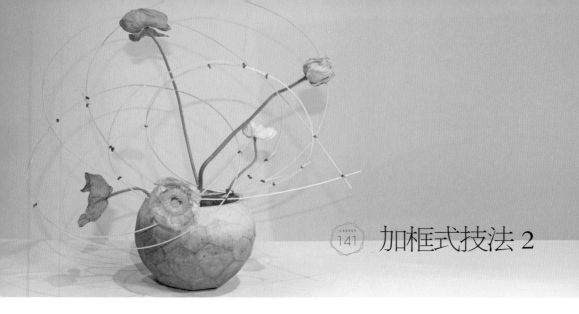

加框式技法 2

在日常设计当中，如果花材体量比较小，但是摆放的空间又比较大，加框是一个非常好的手段。加框除了起到控制视觉焦点的作用，还能创造更大的体量感。这个案例我们用非常轻薄的虞美人作为花材，外面加框处理，营造出大体量的感觉。

材料
竹丝、虞美人

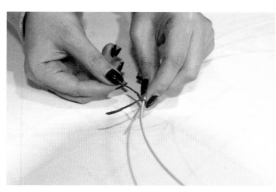

①将竹丝弯折成环形。根据用量提前剪取纸皮铁丝，利用纸皮铁丝多个绑点固定，封闭为环形。

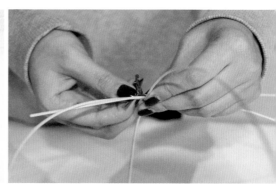

②每两个圆环用纸皮铁丝进行连接。

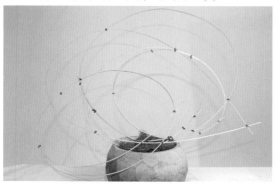

③通过一系列的固定连接，形成整体框架结构，找到合适角度，安置在花器中。

④逐步穿插添加花材，填充作品。

绿化式技法 1

绿化式简单来说就是使用一些叶材，对花泥进行遮蔽的一个手法，不同的叶材遮蔽可以形成不同的质感。

材料

龟背叶、春兰叶、小橘叶、喷泉草、蓬莱松、洋桔梗

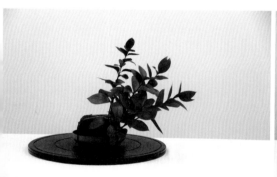

①以单放射点，进行叶材插制。

②进一步填充花材，来遮蔽花泥。

③加入喷泉草填充空间。利用龟背叶进行铺底设计。

④组群形式加入蓬莱松。

143 绿化式技法 2

这节继续绿化式作品的演示。

材料

射干花、跳舞兰、小菊、龟背叶、小橘叶、蓬莱松、木草莓叶

①以组群形式插入龟背竹叶片，用于遮挡花泥。

②以组群的形式加入木草莓叶，丰富层次。利用小橘叶进行层次之间的衔接。运用蓬莱松、喷泉草进行空间的填补。

③在空间中加入跳舞兰，零星加入射干映衬。

④进一步添加块状花材，增加底部的丰富度，以组群的形式加入小菊。中心位置加入块状花材，增加整体作品重量感。利用叶材填补空间位置。

组群式技法

什么叫做组群？三个为组四个为群，虽然不够精准，但是也充分表达了相应的含义。组群是花材排列组织的一种形式。使用组群是为了强调单种花材之美。组群花材一般用块状花，而有些异形花材紧密接触并不是特别好看，比如嘉兰。

在实际商业应用中，思路可以更发散。比如花器和花器可不可以组群？当然可以。在一些酒店，我们就可以经常看到大量容器花组群的应用。因为酒店用花都是大体量的，绝大部分的酒店选择的都是单种花材大量重复，就会大量使用到组群技巧。

园林当中也会经常运用组群，把单种花材铺设或者是种植在一个特定的区域里面，形成花境，有的区域是红色的，有的区域是白色的，也称为组群设计。

Tips

错误的做法

1.花材之间几乎都是相同方向，没有一个共同的放射点，会有高有低，但花朵的姿态几乎是一样的，不能充分体现花朵各个角度的美感。

2.平齐。做组群的时候花材一定要有细微的差别。

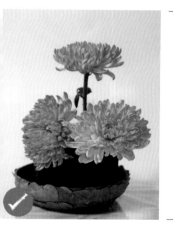

正确的方法：
相同的三支形成组合，花头形成放射状。

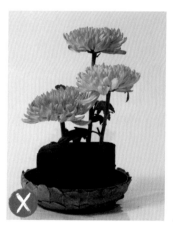

错误的方法：
相同的三支花形成组合，但是全部直立平行，没有形成放射状

正确的方法：
每组形成放射状结构，互相间隔，不形成混合交叉。

错误的方法：
在相同的三支花之间穿插了不同元素，破坏基础结构。

⬡145 群聚技法

　　群聚是花材排列的一种形式，即相同花材密集排列。它通常作为一种打底的方式，当然作为单独的一种技法也是完全可以的，比如这个案例作品戒枕。

Tips

用钳子弯折铁丝成钩状，穿插打蝴蝶结需要的丝带。

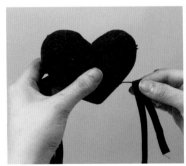

①切割花泥，并揉搓成心形，充分浸泡花泥，并完成基底制作。将处理好的弯钩铁丝插入心形花泥两侧，固定锁死。

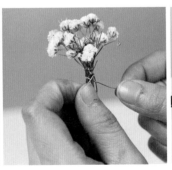

②处理满天星，剪成小单枝，用较细的铁丝将根部进行缠绕，成簇组群。

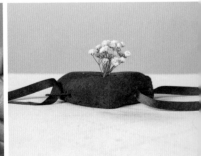

③以组群的形式逐一插制满天星，有序排列，填满表面，遮蔽花泥，并用蝴蝶结打结做表面装饰。

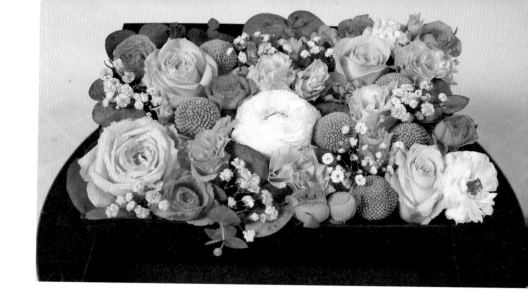

铺陈技法

铺陈技法最早源于建筑上的应用。珠宝行业中的镶嵌工艺也经常用到铺陈。花艺中的铺陈特点：第一，花材插入比较浅，花泥和花材之间的落差比较小。第二，花材之间的关系是平行关系，没有放射点，不会使用组群的设计。所以铺陈一般可以用于基底的处理。花材的类型没有限制，可以是单种花材，也可以是多种花材。下面以花盒为例，来介绍铺陈。

材料

玫瑰、花毛茛、洋桔梗、黄金球、满天星、尤加利叶

①选择礼品花盒，底部铺玻璃纸用于保护，以免被花泥浸湿。根据花盒大小，放置浸泡后的花泥。

②花材、叶材剪取，长度尽可能保持一致，落差不宜过大。

③花材插制深度不宜过深，尽量避免相同花材放在一起，可呈现如三角形的分布关系，互相错落。

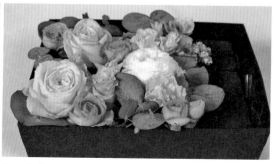

④逐步填充花材。

层叠式技法 1

层叠就是指把片状材料很紧密地排列在一起，形成特定的纹理。选择片状材料要考虑不宜过软，大小、体量要比较规则，不能忽大忽小。下面这个案例选择红叶石楠为材料进行演示。

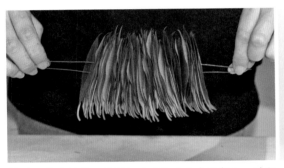

①利用花艺铁丝，穿刺红叶石楠叶片中间部分，进行叶材串联。重复串联，形成叶材串，确保串联点一致，并且缝隙均匀，形成层叠效果。

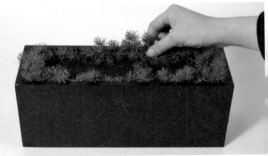

②选择花器，准备好花泥，利用蓬莱松打底。

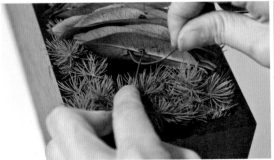

③层叠结构放置于花泥上，铁丝打结收尾，并整理层叠结构。

④利用层叠结构缝隙插制花材，起到固定以及装饰性效果。

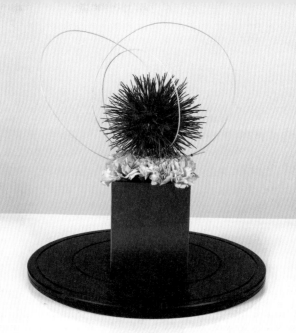

Lesson 148 层叠式技法 2

这节给大家展示的作品属于层叠的另外一种形态。如果我们遇到像线状花材，甚至于针状花材，当密布排列的时候，也可以把它视同为层叠的效果。这里以松针为例演示。

① 揉搓花泥表面，形成花泥球，并在下面加个"十"字支架，便于持握。

② 松针三根一组，这样硬度较大容易插入。也可以用镊子插。进行整体造型、定宽、定高。

③ 逐步完成松针球。为了减少松针用量，可以用蓬莱松填补缝隙，遮蔽花泥以及空隙。

④ 将竹丝弯成环状，用纸皮铁丝绑点固定，并进行组合，形成装饰框架。

反射法 1

反射严格意义上来说不能属于技法，应该说是排列方法。分平面反射、镜像反射等。垂直的镜像反射，就像照镜子一样，这样可以使视觉产生一个中心轴线，具有平衡稳定视觉感官的作用。

在婚礼花艺设计中，很多会采用镜面地毯，或不锈钢地，这样增加了实体和投影之间的互动，会呈现虚实强烈对比的效果。

在做镜像反射时，需要重点考虑周围的环境。比如镜子在很多艺术展室内使用，对于环境的洁净程度都会有非常高的要求。再比如悬挂类作品，屋顶上面有很多通风管道，感觉非常混乱。这时吊顶可以用大面积的花卉来处理，会产生很好的效果。

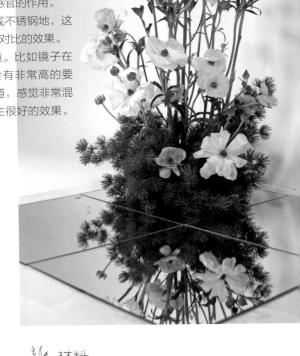

①花泥塑型，用花泥刀削切至半圆造型。插制基础花材，进行铺底。

材料
蝴蝶花毛茛、虞美人、小飞燕、蓬莱松

②逐步填充花材，丰盈作品。

③底部填充蓬莱松，遮蔽花泥。陈列镜面，并且清理表面，确保反射面洁净。

④利用镜面进行作品反射式效果，注意周边环境洁净与规整，以免影响整体作品呈现效果。

Lesson 150

反射法 2

这一节我们用两个花器做一个镜像反射。

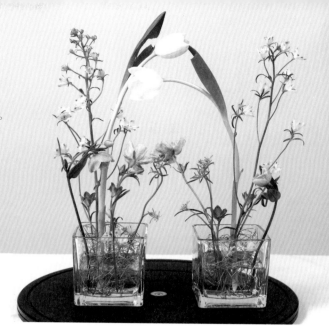

材料
郁金香、小飞燕、蔻葵

① 根据花器大小以及花量丰富度截取适量面积鸡笼网，弯折成球形。

② 用铝丝固定结构，放置于花器中。

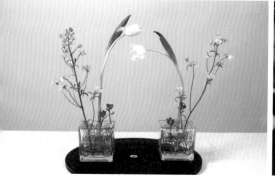

③ 根据镜像反射式技法表达，进行花材插制，左右对称，注意作品整体视觉平衡性。

④ 利用铝丝、鸡笼网的空隙进行花材固定。

平行插入法 1

平行有很多种方式，直立平行、水平平行、交叉平行、自然平行等，这节演示的是直立平行。直立平行作品比较适合放在一些高的空间中，加强纵向线条的设计。

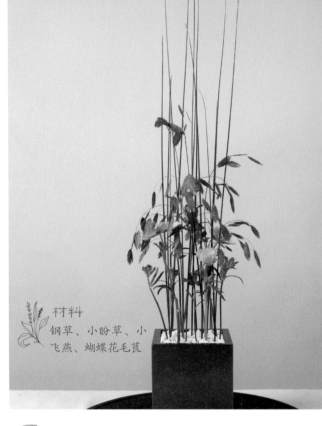

材料

钢草、小盼草、小飞燕、蝴蝶花毛茛

①准备好花器，置入浸泡好的花泥，插制钢草，确保钢草直立，保持主体向上的态势。

Tips

做直立花艺作品时，尽量不要选择狭长型的花器，否则整个作品会显得不协调。还有要考虑花材的趋光性，比如像金鱼草、郁金香，都有趋光性，插完时是直立的形态，后期可能会变得发散。

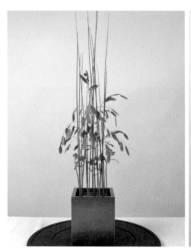

②插制小盼草、小飞燕，利用小盼草的灵动打破完全直立的态势，花茎依然要保持直立平行状态。

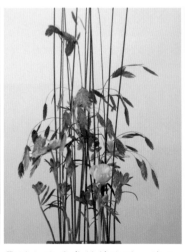

③增加体量感材料蝴蝶、花毛茛，保持直立平行结构，花头部分尽量向上，丰富作品层次。

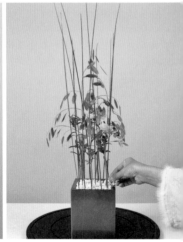

④放置白色小米粒石头，用于遮蔽花泥表面。

152 平行插入法 2

材料

剑麻叶、蓬莱松、跳舞兰

这节介绍平行插入法中的交叉平行。交叉平行会用种类比较少的花材加强动势，适宜用线状花材或者块状花材作为主体，强调副空间的设计，不同花材之间在空间中交错，形成副空间和正空间的对比关系。

1 准备好花器，放置浸泡好的花泥。用蓬莱松进行花泥遮挡。利用剑麻叶插制交叉平行起手材料。

2 添加剑麻叶，增强交叉平行体量感，确保材料同一个方向顷斜。

3 选用另一种花材与前一种花材进行交叉插制，用于打破视觉的单一感。

4 不断加入花枝，增加作品视觉体量感。

穿刺是指用硬质材料，比如常用的竹签、珠针等穿透材料，起到连接和装饰的作用。

材料
山茶叶、蓝星花、大花飞燕草

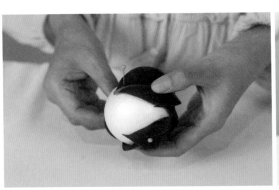

①山茶叶包裹泡沫球，用珠针固定。叶片叠加，形成半包围结构。

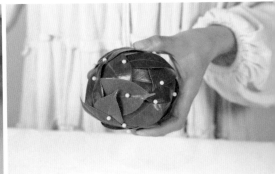

②珠针穿刺叶材全包围结构效果。

③利用不同色彩珠针穿刺完成成组结构。

④插制花材进行装饰，铺装石粒遮盖花泥表面，作品完成。

放射状插入法 1

　　放射状插入法是西方传统花艺中用到的技巧。可以想象一下烟花在空中由一点向四周绽放的样子，以及太阳像四周散发的光芒。

　　在花艺中，放射点可以是一个假想的点，我们插花时，并不是把花枝直接插到我们假想点的位置上，而是我们插入的花材顺着线延伸最终会汇集到那个点。它的位置通常有三种情况：一种是在花泥内部，这是最常见的；第二种是在花器的下方；第三种是在花器的外侧，比如上方。放射点在上方的话，在传统插花中是没有办法对这个点来进行固定的，但是在架构类的设计中，是可以的。

◆放射点在花器内部，所有花枝放射点汇于一处。

◆放射点在花器下方，上方花枝倾斜角度较小，但是一定不可平行。

◆放射点在底部示意图。

◆花器外侧放射点，花枝汇聚于外部一点。

◆放射点在外部示意图。

放射状插入法 2

这一节同时用两种插法，演示放射状插花的正确和错误方式。

◆插入第二支花时，右边上端花头等距，但是底部插制点形成一定位移偏差。

◆插入第三支，顶部花头间隔呈均等，但右侧底部放射点间距越来越大，越来越不均匀。

◆为了保证花头间距一致，右侧第四支花枝末端已经开始产生交叉点。

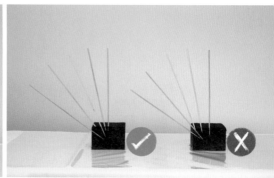

◆切割花泥侧面，查看两种放射状态对比图。左侧放射点均匀地交汇于一点，右侧有很多交叉。

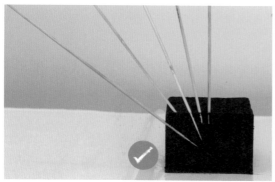

◆左侧特写：所有花枝沿线汇聚为一点，形成放射状插入。

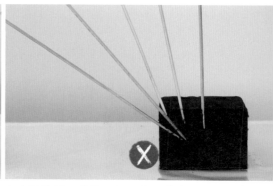

◆右侧特写：花枝之间形成很多交叉点，没有汇聚于一点。

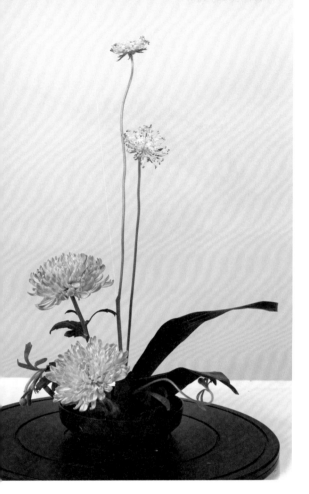

阴影式技法

阴影就是影子，它和我们之间是一种相伴相生的关系。在花材排列的形式上，我们也可以借鉴。所以，阴影技法中，花材都是成对的出现。

材料
菊花、松虫草

1 利用剑山固定花材，翠珠花茎秆太软，如果不好固定可在旁边加一段枝材加固支撑。

2 插制定高花材，成对添加，形成阴影呼应。

3 添加底部花材，也是成对添加，丰富造型。

4 添加成对装饰性材料，充盈底部。添加成对阴影叶材。

LESSON
157

遮蔽式技法 1

遮蔽和遮盖是两个概念，遮盖是为了遮挡花泥，遮蔽是为去创造一个空间，并且保持视线的穿透力，而且还要有视觉焦点。下面用案例来介绍遮蔽技巧。

材料

洋桔梗、蒴藋、龙爪藤、小天使叶、芒叶、景天

① 准备好花器，利用防水胶带进行花泥固定。

② 利用洋桔梗组群形式起手。填充花材进行空间的衔接，并遮挡瓶口。

③ 加入蒴藋，完成一侧的视觉焦点，进一步填充，完成空间衔接。

④ 加入龙爪藤线条，并用小天使叶和铁丝，帮助弯折为造型，创造遮蔽效果。

LESSON
158

遮蔽式技法 2

这一节继续带来遮蔽式技巧的案例作品。

材料
芒叶、木莓叶、绣球、玫瑰、康乃馨、长叶春兰、土伏藤

① 利用芒叶打底。

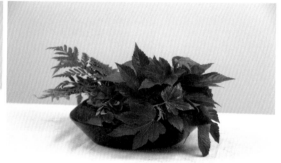

② 加入木莓叶，在对角线的位置上进行打底。采用小朵绣球进行空间填充。

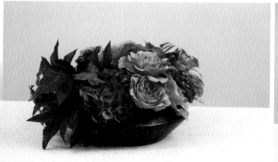

③ 加入块状玫瑰进行空间衔接；加入康乃馨，提亮整体作品，丰富作品层次；并加入叶材，对中心花泥进行遮蔽。

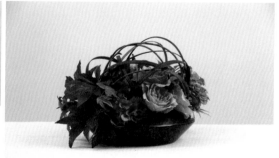

④ 利用长叶春兰，完成通透的空间；添加土伏藤，增强对比关系。作品完成。

花艺技法　203

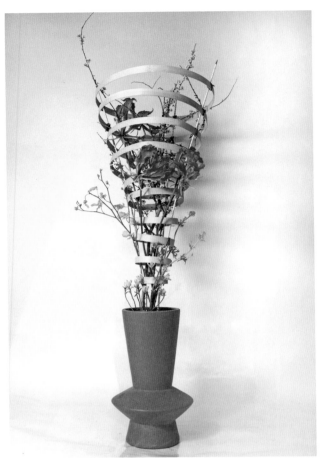

螺旋式技法 1

螺旋结构在日常生活中经常见到，比如旋转楼梯等。一些藤蔓植物也是螺旋缠绕生长。螺旋给人一个渐序的感受。花艺设计中，螺旋是一种花材或者结构的排列形式，由小至大或者是由大至小循环往复的过程。比如下面这个作品，就是用竹片通过环形的结构变成一个从下到上的渐变螺旋型的结构。

材料

跳舞兰、嘉兰、雪柳

①将竹片弯折为大小不同的圆环，订书器封口固定。

②选择花器，剪取鸡笼网。注水，插制纸皮铁丝包裹好的铁杆，顶部呈三角形，用鸡笼网固定。

③将制作好的竹片圆环按照直径大小依次套入铁杆，保持一定间距。

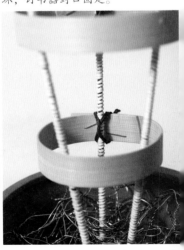

④利用纸皮铁丝逐一固定圆环于铁丝上。最后沿螺旋结构插制跳舞兰、嘉兰、雪柳。

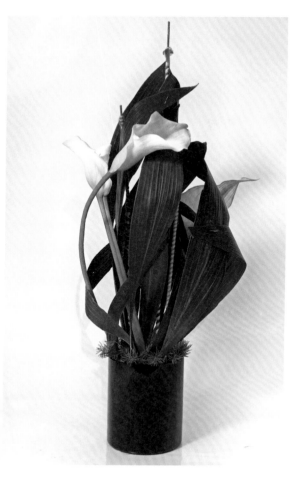

螺旋式技法 2

这节继续介绍螺旋技法。在实际应用中，螺旋并非一定是规则型的，我们的目的是通过螺旋，在有序的规则下创造变化的效果，比如下面这个作品。

材料

蓬莱松、一叶兰、马蹄莲

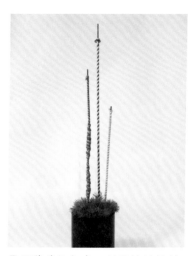

① 用蓬莱松打底，利用铁丝插制整体作品支撑结构。

② 将一叶兰叶片对比作品比例进行剪裁。

③ 将叶片进行螺旋交叉插制，利用双面胶对叶片粘合固定。

④ 叶材围绕铁丝逐一粘合，形成螺旋结构。最后插制马蹄莲。

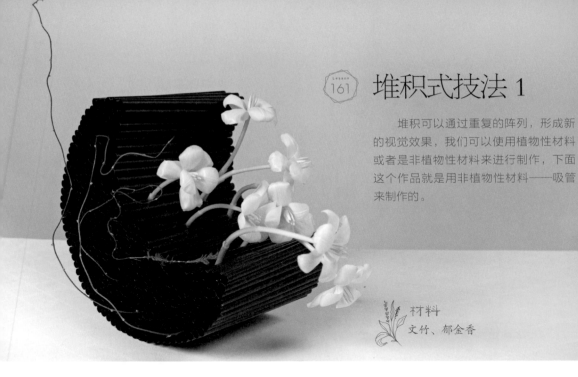

堆积式技法 1

堆积可以通过重复的阵列，形成新的视觉效果，我们可以使用植物性材料或者是非植物性材料来进行制作，下面这个作品就是用非植物性材料——吸管来制作的。

材料
文竹、郁金香

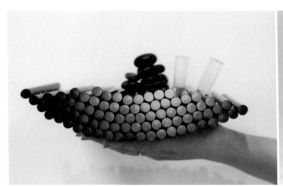

①利用热熔胶枪，将吸管逐一排列粘贴形成一定造型。

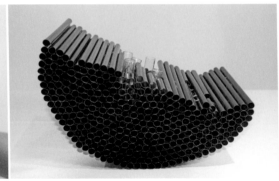

②粘合更多的吸管遮挡试管及配重。

③截取合适长度的文竹，剪除叶子，插入试管中，试管内注水。

④加入主要展示花材，逐步填充，完成作品。

堆积式技法 2

堆积是相同的材料有序地堆放在一起。下面这个作品用肉桂皮来演示这个技法。

材料
肉桂皮、喷泉草、嘉兰、跳舞兰

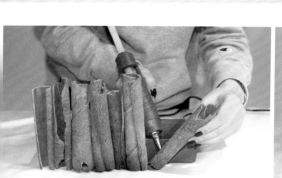

① 利用热熔胶枪，将肉桂皮逐一排列粘贴至针盘盒外壁，遮挡外部。

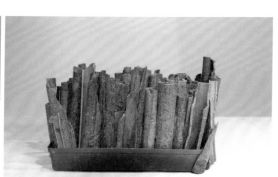

② 内部逐一堆积粘合，填充整个针盘盒。

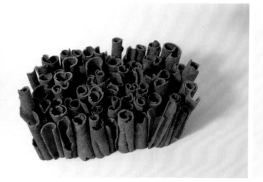

③ 粘合完毕效果，针盘盒外壁不外露，内部空隙适中，逐一粘合堆积外部材料。

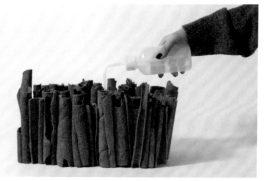

④ 在空隙处安置试管，试管高度低于肉桂皮的长度，试管内注水，加入主要展示花材，逐步填充。

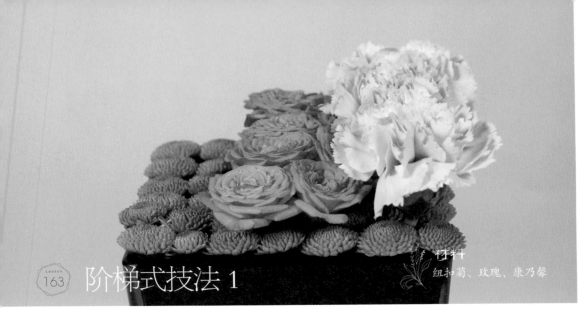

材料
组扣菊、玫瑰、康乃馨

163 阶梯式技法 1

阶梯式，顾名思义，就像爬楼梯一样，它是一种秩序感非常强的花艺手法。在设计阶梯时，材料不能是松散自由的花型，应该选择直立性、大小都相对标准的花材。下面这个作品用组扣菊、玫瑰和康乃馨来呈现。

① 准备好花器，置入浸泡好的花泥，并且明确出三层区域。

② 用组扣菊进行第一层基础阵列式铺底设计。

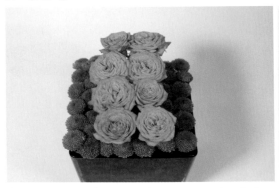

③ 插第二层多头蔷薇，形成色彩变化，高度一定要高于底层组扣菊，并且保证整层直立向上，高度一致，形成强烈的秩序感。

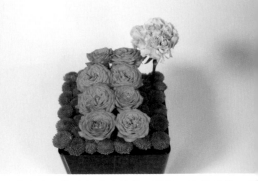

④ 通过比对，找到合适的长度，插第三层康乃馨，高度要高于第二层。

阶梯式技法2

阶梯式设计可以通过花材高低错落的层次来实现，在商业应用中，我们往往采用另外的一种形式，就是用花器来呈现，可以用于酒店大堂等大型商业空间的设计。

材料
蓬莱松、康乃馨、纽扣菊

①选择不同高度花器，将浸泡后花泥切割放置于花器中。

②其中一个容器用纽扣菊平行插制平铺花泥。

③第二个容器用蓬莱松平行插制平铺花泥。

④第三个容器将康乃馨平行插制平铺花泥。

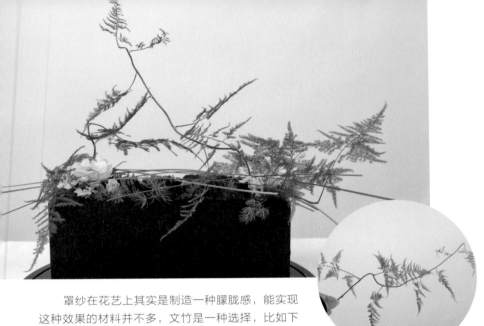

　　罩纱在花艺上其实是制造一种朦胧感，能实现这种效果的材料并不多，文竹是一种选择，比如下面这个作品。

材料

文竹、蓬莱松、跳舞兰、蝴蝶花毛茛、红叶石楠叶片

选择脉络清晰的文竹素材，根据生长方向进行修剪，确保造型轮廓清晰。

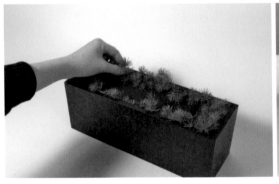

①用蓬莱松铺底。

②利用铁丝穿插叶片，形成层叠效果。

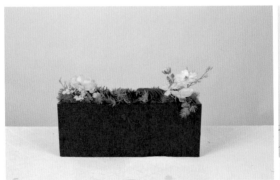

③逐步插制花材，完成被遮罩作品。

④利用文竹做罩纱遮蔽处理，形成一个通透的空间，产生东方禅意朦胧美，形成虚实对比关系。

罩纱式技法 2

下面这个作品用松针创造罩纱的朦胧感。

材料

松针、嘉兰

①拆解松针成独立单元。

②细竹签尖端粘合冷胶，用于尖细松针粘合。

③2～3根松针一组，逐一粘贴，从平面到立体过渡，形成空间结构。多个松针结构进行粘合拼贴。

④多组松针结构重复制作，形成松针罩纱结构。

材料
大飞燕草、郁金香、
蝴蝶花毛茛、矢车菊

缠绕式技法 1

缠绕是花艺设计中常用到的技巧。有时候我们需要快速完成作品，而手工缠绕太慢，可以借助手钻。

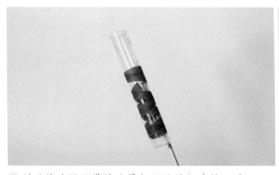

①利用花艺绿胶带将试管与竹签缠绕连接，进行固定。

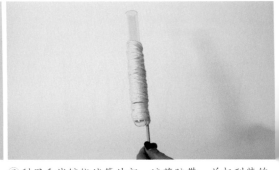

②利用毛线缠绕试管外部，遮蔽胶带，并起到装饰作用。

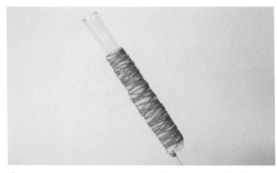

③用另一种毛线进行外部缠绕，增加试管装饰性。收尾处打结，剪除多余部分，可适当留出一部分试管空间。

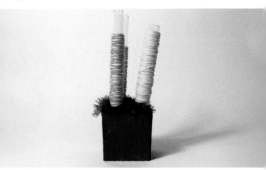

④将缠绕后的试管安置在花器上，进行列阵式陈列。在试管中注水，插制花材，完成作品。

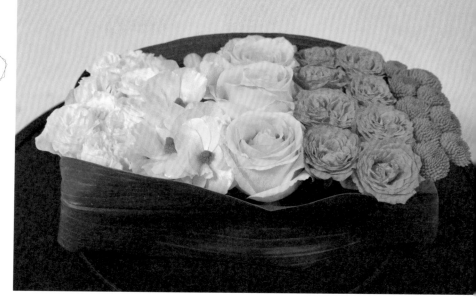

渐序式技法 2

171

材料

洋桔梗、蝴蝶花毛茛、玫瑰、纽扣菊、一叶兰

①准备花泥盒以及浸泡后的花泥，从左至右添加色彩渐序第一层花材。

②按照色块分布，增加第二层花材。

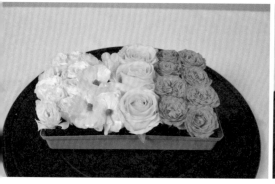

③逐步增加第四层花材，有序排列插制，确保每层整齐排布。

④填补花泥盒最后一层缝隙。运用一叶兰以及冷胶包裹整体外部，遮蔽花泥盒。

花 艺 设 计 风 格

比德麦尔风格

比德麦尔是一种赫赫有名的花艺设计风格，也称为比德麦亚。这个词是由中世纪的一本虚构小说当中衍生出来的，由德国的设计师传播到了北美洲，再慢慢在全球的范围内扩展开来。

比德麦尔呈现同心圆的形态，水果是它非常典型的标志性材料。最早的比德麦尔应用于新娘花束中。该设计风格重点表现的是花头，没有高低错落之感，表面有一定的弧度。古典的比德麦尔风格都采用放射状的插作方式，非常容易形成图案。在现代会有一定的变化，不一定保留所有的元素。

材料
康乃馨

Tips

利用花艺铁丝，穿插代表性水果元素——金橘，用于固定。

①利用针盘盒以及花艺防水胶带对浸泡后的花泥进行固定。

②运用块状花材——康乃馨，进行整体作品定高，也可以从顶部柠檬起手，进行整体作品定高。运用多枝康乃馨形成组群，图形对称，保证整体是同心圆。

③金桔围绕基底康乃馨外围，放射状插入，形成同心圆。

④再次运用白色康乃馨围绕同心圆插制，保证花型对称，关注作品平整度。

⑤围绕同心圆插制葡萄，不断观察顶视图，以免作品出现偏轴。

⑥将白绣球花瓣充分展开，增大开放面积，遮蔽底部花泥。

⑦将处理后的白绣球围绕同心圆逐层插制。

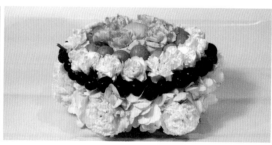

⑧运用白色波浪龙胆进行底部填充，遮蔽花泥。顶端插制柠檬封顶。

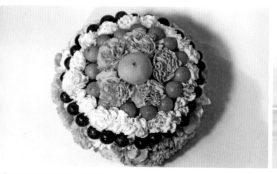

⑨顶视图形成封闭圆形。

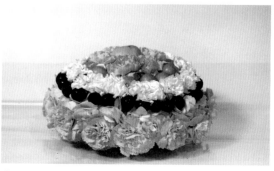

⑩底部增加体量感绿色康乃馨，同心圆方向插制，完成整体作品。

可乐尼亚风格

　　可乐尼亚风格是设计中经常用到但却很陌生的名字,花店中插的大部分花篮、花盒,都是用的这种风格。它的历史可以追溯到1607年,1920——1930年广泛地应用在一些新娘手捧花上,到了1960年左右,又更多地应用到了一些圆形的设计当中。可乐尼亚依然是一个封闭的图案,没有太多的负空间,也用放射状手法来插制,但相较比德麦尔,花材之间会参差一些,律动感更强,

　　除了花材,可乐尼亚风格中也可以用叶材,但团块状花材还是会多一些。一些细碎花材也用组群的方式处理。下面演示这种风格作品。

材料
芍药、花毛茛、郁金香、玫瑰、熊猫竹

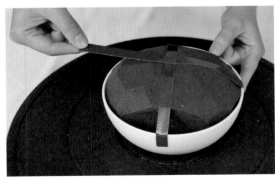

①选择敞口碗状花器。切割花泥,利用防水胶带将浸泡后的花泥固定。

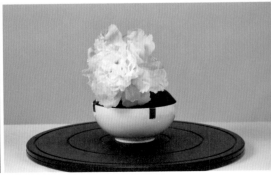

②将主焦点芍药插入花泥,花头有一定倾斜。

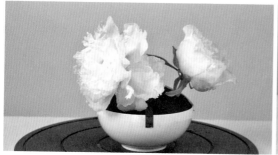

③插入副枝芍药，与主枝形成一定角度，花头倾斜，保证作品一个插点。

④添加插入芍药，形成三面观放射状，整个作品一个插点。

⑤继续增加玫瑰，注意花头倾向性，保证整体作品放射状。

⑥插入红色郁金香，整体呈放射状，松散形态，高度稍有错落，增加作品曲线以及画面律动感。

⑦增加黄色郁金香，增强色彩律动。

⑧填充花毛茛，形成聚集、块状形态，整体形态平整度较低，控制为圆形形态。

⑨增加鲑鱼色花毛茛，丰富作品色彩，形成色彩组群，依旧保证整体造型放射状。

⑩增加熊猫竹，遮蔽花泥，完成整体作品造型。

闻香小花束风格

　　闻香小花束最早起源于英国，人们会把一些带有香味的草药植物混合在一起，制作成小花束，希望能够祛除疾病。其实探究整个花艺历史，就会发现我们现在用的各种风格、技法，都有很强的时代背景和历史原因。闻香小花束刚开始以手绑花束为主，在婚礼以及祝福的场合比较多。味道其实也是能够唤醒人的记忆的一种手段，但往往在商业花艺中被忽略。

材料

蝴蝶花毛茛、加拿大一枝黄花（黄莺）、松虫草、小飞燕、康乃馨、洋甘菊、喷泉草、澳蜡花、矢车菊、尤加利叶、麻叶绣线菊

①运用手捧架将花泥托固定，利于操作。

Tips

对于过短花枝或者花头，用铁丝穿插处理，形成插杆

②运用黄莺、高山羊齿叶材等在手捧底部打底，花头向下呈一定角度，形成放射状，花茎预留不宜过长。

③插制蝴蝶花毛茛，形成放射状，确定整体花束基础体量。

④插入矢车菊和白色多头康乃馨填充造型。

⑤依次添加洋甘菊、浅粉色小飞燕草、尤加利叶、喷泉草，让整体造型更加灵动。

⑥插入小花头，整体球形逐步丰满，形成放射状。用麻叶绣线菊填充，遮蔽花泥、装饰花束。

⑦手柄顶部结构粘贴美纹纸以及双面胶。

⑧将丝带搭叠，双面胶粘贴固定，形成丝带装饰。

⑨丝带连续叠搭，收尾处包裹手柄，并粘贴固定。

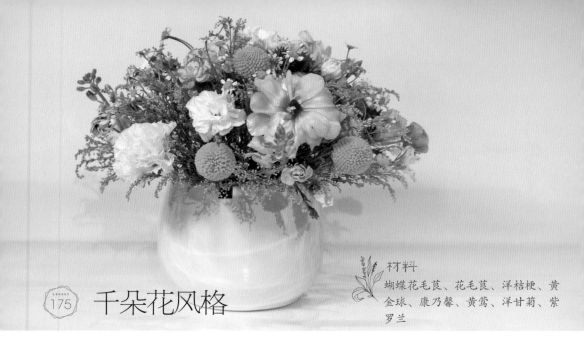

材料
蝴蝶花毛茛、花毛茛、洋桔梗、黄
金球、康乃馨、黄莺、洋甘菊、紫
罗兰

千朵花风格

千朵花风格起源于大概15—16世纪，手法可能是组群，或者是分散式的，但是相对来说都比较自然，不应该有一个很明确的色彩的倾向，比如一看上去就是红色系、紫色系等，花材种类比较多，不能使用很大的块状花，一般用散状花材，就像原生态的花园随机分布开放的样子。下面这个作品是一个非常简单的千朵花设计风格。

①根据花器口径放置浸泡后的花泥。利用防水胶带固定花泥。

②运用黄莺对整体作品定高、定宽、注意花头朝向。充分填充黄莺，注意疏密度，完成作品半球形基底结构。

③多点放射状随机增加白色多头康乃馨。

④进一步填充波浪龙胆以及花毛茛，丰富作品色彩，把控色彩比例，避免倾向性。逐步加入紫罗兰、洋甘菊、蝴蝶花毛茛填充，把控密度。

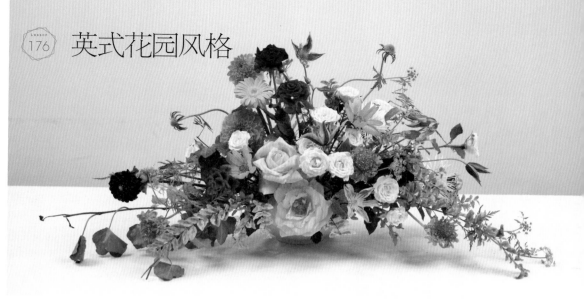

英式花园风格

Lesson 176

英式花园风格起源于英国格鲁吉亚时期（1714—1830年）。这种风格从外轮廓上可以看到非常明确的三个顶点，呈三角形的结构；有一条非常明显的中轴线，所以图形是对称的状态；花材是放射状的插制方式。材料的排列形式是古典渐序的方式，比如说上大下小、上轻下重，尽量选择当季的、花园里能采到的花材。

材料

玫瑰、多头蔷薇、非洲菊、铁线莲、松虫草、黄杨、文竹、大丽花、蕾丝等

① 利用防水胶带，将浸泡后的花泥进行处理。

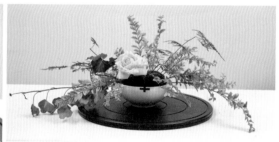

② 用藤本类植物起手，形成自然下垂状态。利用叶材完成基本造型轮廓后，加入焦点花材——香槟玫瑰。

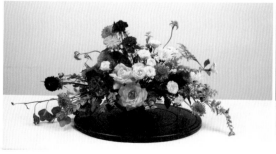

③ 进一步填充玫瑰，按照颜色、大小、质感、开放度等有规则的形式，逐步增加花材。一侧呈放射状插入大丽花。另一侧利用粉色松虫草进行空间填充。

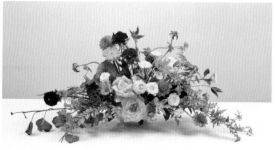

④ 适当加入散状、细碎的花材，点缀即可。加入2～3枝黄色花材，提亮整体色彩。增加叶材，遮蔽花泥。

美国威廉斯堡风格

美国威廉斯堡风格从名字上来看起源于美国，实际上它受英国的影响会比较大一些。特点是具有比较强烈的绘画感或者是油画感。外观呈四角形，通常采用比较正式的花器，比如银器、铜器等，陶瓷、竹篮等田园风的花器则不太合适。案例中采用的是青花瓷，大家不用奇怪，因为在那个时代，东方的很多文化元素已经融入到西方人们的生活当中。

材料

大飞燕草、玫瑰、洋甘菊、菊芋、醉鱼草、水仙百合、蓬莱松、喷泉草、红花檵木、文竹、茴香

Tips
瓶口处十字固定。

① 将预处理的花泥插入瓶口。利用花艺防水胶带进行花泥固定。花泥一侧利用蓬莱松起手。

② 另一侧加入文竹，底部对称下垂。顶部一侧插入大飞燕，与红花檵木形成轴对称，从一个点发散插制。

③ 以组群手法，放射状填充花材。依次加入玫瑰、茴香、洋甘菊、醉鱼草、水仙百合等花材。

法国普罗旺斯风格

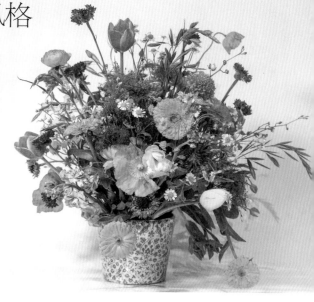

Lesson 178

说到普罗旺斯，联想到的就是薰衣草花海、明媚的阳光，视觉最直观的印象是非常明艳的色彩，所以这种花艺风格会有大量的明亮黄色、橙色和紫色的对比关系，表达热情奔放的情感。花器最好用原生态的红土陶盆、手工捏制的容器等；花材也以本地的应季花材为主，草本花卉较多，组织形式多为非组群的多点放射，感觉是随机分布的，塑造烂漫、野趣的感觉。

材料

郁金香、松虫草、金盏菊、跳舞兰、虞美人、洋甘菊、小盼草、花毛茛、紫罗兰

① 选择带有一定异国纹样的陶瓷质地花器，预处理好花泥，花泥位置略高于花器。

② 利用花材定出整体作品造型体量结构。

③ 花材分布随意，注意不要形成组群，而要形成一定自然生长的效果。在各个角度增加同色系花材，丰富整体造型，多放射点插制。

④ 丰富色彩，色彩上选择暖色系，如黄色、橘黄色或与蓝色系对比的色彩搭配。

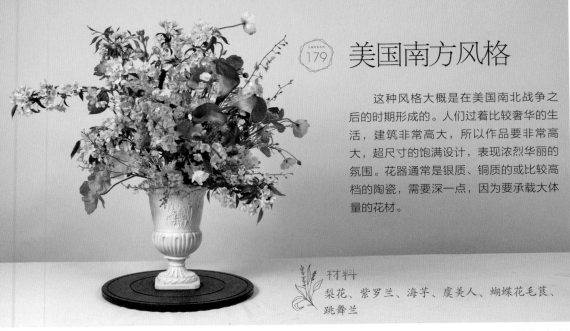

美国南方风格

这种风格大概是在美国南北战争之后的时期形成的。人们过着比较奢华的生活，建筑非常高大，所以作品要非常高大，超尺寸的饱满设计，表现浓烈华丽的氛围。花器通常是银质、铜质的或比较高档的陶瓷，需要深一点，因为要承载大体量的花材。

材料

梨花、紫罗兰、海芋、虞美人、蝴蝶花毛莨、跳舞兰

花材的分布也是组群，但是呈现多个放射点，甚至需要故意表现出一些不太受控的交叉点，就像刚刚开始学插花时的拙劣又自然的感觉。这种把控其实比较难，一不小心就会出现花茎打架的情况，鸡笼网的固定会避免很多这种问题。该风格是比较早期的花艺风格，没有那么精致，因此不太适合放在商务场合中。

①利用枝材定高，注意位置尽可能后倾，以免作品整体比例失衡。利用枝干形成整体大框架。

②利用枝条充分完成背部框架，形成设计尺寸大、体量大的作品结构。

③多组放射点插入花材，允许产生花茎的交叉。

④填充花材，加入明亮色系，增加作品的体量感，同时体现繁盛状态。

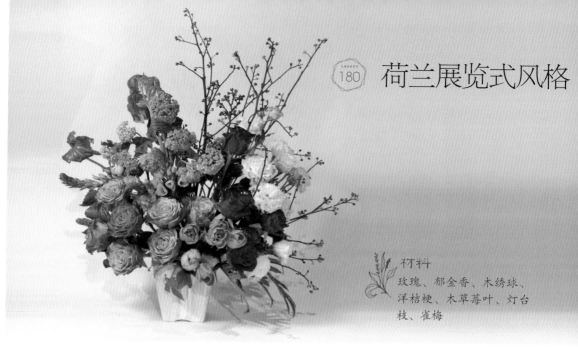

荷兰展览式风格

材料
玫瑰、郁金香、木绣球、
洋桔梗、木草莓叶、灯台
枝、崔梅

荷兰展览风格确实起源于荷兰。这种风格最早出现在荷兰的园艺种植商们去参加大型展会的时候，希望更好地展现其产品。

这种风格的特点：第一，大多数呈现放射状，平行插也可以；第二，呈现方式经常是扇形，因为后高前低这样的状态，可以非常好地分层，来对每一种花材进行展示；第三，一定要采用组群的手法，这是荷兰展览式约定俗成的固定做法。因为我们知道，组群最大的作用是突显花材之美；另外，因为源于种植商，所以材料尽量选用人工培育的植物，对于色彩没有太多要求，通常也可以加入叶材。

①起手定高。利用组群的形式插制枝材，形成视觉聚集感，充分展示材料。

②放射状插入另一种花材，形成一种非常繁茂的状态。加入木本绣球，利用花刀进行根部处理，让根部充分吸水，调整每枝花材位置，让它们充分展示。

③以组群的方式加入各种花材，体现出整体华丽的状态。整体大的色块分布体现华丽感觉。继续填充带叶子的玫瑰，同时利用玫瑰的叶子进行一定程度上的遮挡。

热带风格

讲到热带性时，首先我们要了解一下地域性。热带性只不过是地域性的一部分。最早的热带性花艺作品来自热带地区的一些运输业海报上，上面有很多热带花材的呈现。可以根据它的名字，就知道产自哪里。热带植物相对来说比较高大、茂密，花材的组织形式上尽量采用组群方式。

在做设计时，我们需要考虑到地域性。有时候我们做完一个作品，颜色、质感、形态等都符合设计逻辑，但是就是觉得非常奇怪，那也许是因为花材不是来自同一个温区。比如一个作品中用的都是热带花材，突然加入一个寒带的植物，比如松柏，就会感觉很奇怪。

材料

天堂鸟叶、小天使叶、天堂鸟、红掌、芒叶、龟背叶、跳舞兰、橘叶

① 插制天堂鸟叶，对整体作品定高。组群插制高中低不同层次的天堂鸟叶，完成作品基础铺底。

② 以组群放射状增加伞叶，增强作品体量感，以及丰富整体形态感。增加一组小天使，表现热带植物的繁盛感，完成基本轮廓。

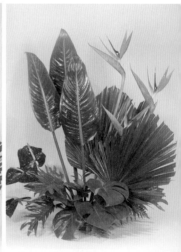

③ 以组群形式插制天堂鸟、芒叶、龟背竹，丰富植物的同时，遮蔽部花泥，并形成一定负空间。丰富整体作品层次。最后组群放射状插入红掌、跳舞兰以及橘叶。

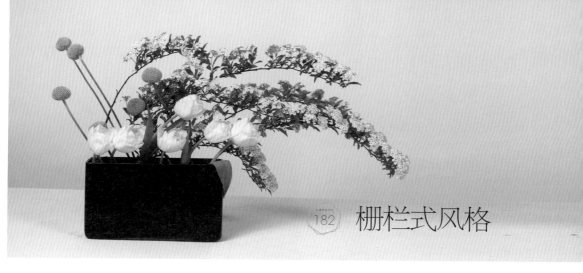

栅栏式风格

栅栏式起源于英国的篱笆、围栏。外轮廓绝大部分要么是竖长的长方形，要么是扁长的长方形，插制手法基本为平行方式。第一，平行插制的过程中，要注意层和层之间的衔接关系；第二，花型在古典意义上来说是一个封闭花型，所以我们就算有线状花材，也很少去突显线条，突显的是线状花材的块。

材料
绣线菊、郁金香、黄金球

① 栅栏式风格，花材选择具清晰线条的，可以用干燥花材，需要提前进行花枝预处理。

② 底部插入铁丝，将铁丝穿刺到头。利用铁丝将花杆捋直。

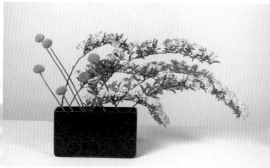

③ 选择长条形花器，利用绣线菊进行起手。相同花材排列整齐，采用弧形平行，并加入预处理的黄金球。

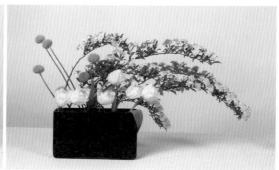

① 错落插入郁金香，要与绣线菊方向一致，但位置要低，体现层次感。

修剪式风格

修剪式也叫修饰式，它起源于欧洲的一些园林，在欧洲，大量的植物被修剪成各种各样的几何形状，后来被运用到花艺设计中，逐渐形成这种风格。一般修剪式都是放射状插入。

材料

蓬莱松、红瑞木、黄金球

① 准备大中小三个花泥球，利用蓬莱松打底，遮蔽花泥。

② 利用花剪进行表面修剪，形成圆润造型。三个尺寸的花泥球准备好了。

③提前准备好花器，放置花泥，利用蓬莱松遮蔽。

④利用枝材起手定高。

⑤放射状插入枝材，逐步增加线条，注意营造向下延伸的线条。

⑥线条结构完成。于底部丰富圆形结构，与后期装饰形成呼应。

⑦利用枝条结构，作为花泥球固定基座。

⑧加入圆球，形成奇特造型。

造景式风格

Lesson 184

造景式风格源于大自然和园林中的植物景观。所以，造景式风格第一个要求是去认真地观察大自然，从中找到灵感。

①选取水盘，注水，剑山左右平均分布。放置枯木，用于水盘装饰，以及作品画面衔接形成小桥。

在插制过程中，要划分一下我们取的景所属地域，是热带雨林，还是江南水乡，或是雪山下的松树林，等等。插作方式也是多样的，大自然中有放射状生长的植物，也有平行生长的，还有无序交叉的，总之自然就好。下面这个作品是模拟水景的。

材料

水葱、春兰叶、香豌豆、小飞燕、梨花

②利用一侧剑山，放射状插入水葱，形成一侧结构轮廓。另一侧同样方式放射状插入水葱，形成非对称状态。

③底部加入叶材，丰富层次，搭建底部造景结构。多角度添加叶材，遮蔽剑山。利用春兰叶进行轮廓延伸，增加作品灵动感。

④加入花材，营造自然生长的状态。增加蓝色系花材，丰富整体色彩层次。

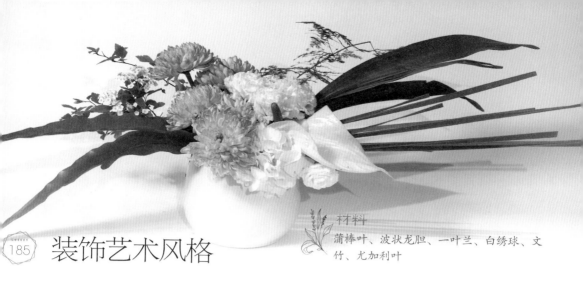

材料
蒲棒叶、波状龙胆、一叶兰、白绣球、文
竹、尤加利叶

⑱ 装饰艺术风格

装饰艺术风格听名字就好像特别近现代的感觉。追溯起源的话，这种风格应该是在1960年左右法国举办的一场展会，根据其名字缩写变化来的。1960年左右，很多近现代艺术设计慢慢涌现出来，一些现代的设计语言影响到了如家居、建筑等很多行业，也体现到花艺设计中。

其特点是：第一，它是基于花泥插作的，当然也会用到一些近现代的架构技巧；第二，花器比较简约；会大量使用到一些直线线条的花材，花材排列方式既有放射状，也有平行的，经常用组群的手法；第三，作品一般是对称的。

1 利用防水胶带十字固定花泥。单侧平行插入蒲棒叶。将预处理的鸟巢蕨平行插入，形成卷曲线条，以组群或者阴影的方式呈现均可。

2 以组群形式插入块状花材，加强力量感的表达。增加作品曲线图形花材；背部填充白色波浪龙胆。

3 另一侧添加一叶兰，形成阴影效果。

4 插入白绣球，填充空隙，遮蔽花泥。插入文竹，增加整体作品曲线线条。加入尤加利叶，遮蔽花泥。

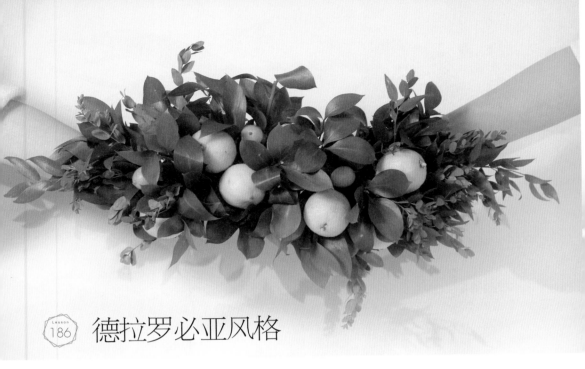

德拉罗必亚风格

Lesson 186

德拉罗必亚实际上两个名字的结合，德拉原为意大利一个陶匠的名字，罗必亚是意大利中部城市佛罗伦萨的原名。德拉不是花艺师，他以雕刻陶罐为生，主要是以圣母玛利亚作为陶罐雕刻的素材，除了雕刻人物之外，还会经常加入一些浮雕效果的植物花草的装饰纹样，慢慢就演变成了今天的花艺风格。德拉罗地亚风格的特点是：从中心点向外像半月形发散，这可能是因为陶器的面是弧形的。花材以花草为主，可以有一些水果，比如葡萄、柠檬等，还有一些带香味的药草。

①铁丝两端利用尖嘴钳弯折成钩状。

②铁丝缠绕花艺胶带。

③利用绿色花艺胶带，将叶材与铁丝连接反复缠绕花艺纸胶带，进行固定。

④增加另一种叶材，继续缠绕固定。

⑤三种叶材捆绑固定效果，注意保持同一个放射点。　⑥继续利用胶带缠绕方式增加叶材，丰富体量。

⑦将多种预处理的叶材，利用花艺胶带捆绑粘合，形成叶串，确保整体为同一个放射点。　⑧用同色系花艺纸胶带将多个叶串进行连接，形成完成结构。

⑨叶材基座结构完成。　⑩选择代表性水果柠檬，穿插铁丝，两根铁丝形成十字。

⑪旋拧固定。　⑫将柠檬缠绕固定在叶材基座上。进一步丰富水果，作品完成，可作为桌花用于圣诞节，也可作为捧花。

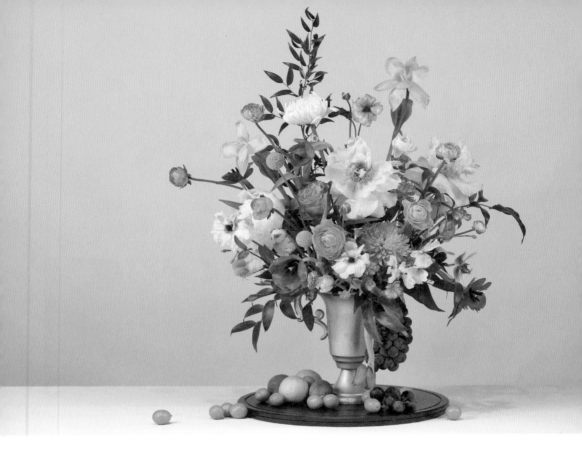

佛兰德斯风格

　　有一种油画风格叫佛兰德斯风格，其中有很多瓶花类的绘画作品，佛兰德斯花艺就源于此。其特点，一是允许有多个放射点；二是大块的团状花插得比较高一些；三是花器尽量选择一些相对来说比较古典、优雅的，比如银器；四是一定要有"S"状的线条。

　　花材可以是应季的，也可以跨季节，因为油画比较随性。16—17世纪，大部分的油画比例都是4：3，在插花时需要注意。

S型处理：花茎叶穿入一根铁丝，弯曲处理。

Tips

将铁丝完成"U"型，穿过葡萄梗固定。

材料

芍药、蝴蝶花毛茛、花毛茛、郁金香、橘叶、康乃馨、菊花、莵葵、黄金球、蝴蝶兰

①固定花泥。

②用叶材定高定宽。

③增加芍药，注意高度错落。

④多角度插入其他花材。

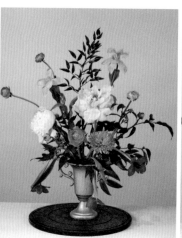

⑤填充牡丹、菊花。

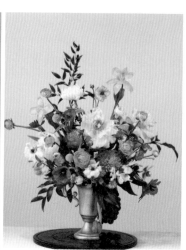

⑥插制葡萄。

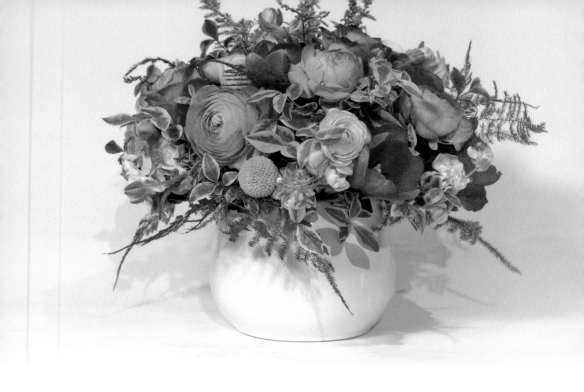

英国维多利亚风格

Lesson 188

英国维多利亚时代是很繁盛的时代，当时很多艺术比如建筑、绘画等都带有非常明显的时代特征。这个时代的花艺对西方古典花艺的发展有非常重要的影响，我们看到的一些密集的造型，很多是从维多利亚时期发展而来。

其特点是设计比较浮夸，不会有太多负空间，整体花量大，奢侈、没有节制是其非常典型的特征；为了达到奢华浮夸的效果，色彩应用非常强烈；形态来说比较简单，半球形、圆形、扇形都有。花材玫瑰最多，叶材有高山羊齿等蕨类。花器是特别精美的铜器，以及带有繁复纹样的瓷器。

材料
女贞叶、紫罗兰、玫瑰、蝴蝶兰、郁金香、花毛茛、蝴蝶花毛茛、文竹

①用防水胶带固定浸泡后的花泥。

②利用女贞叶进行作品定高定宽，花的高度是花器的1～1.5倍。

3 女贞叶打底，放射状插入，完成基础结构。

4 放射状加入紫罗兰、玫瑰。玫瑰是必备花材。

5 依次放射状加入花毛茛、蝴蝶兰、郁金香，加强
色彩表现。

6 根据花艺作品体量，筛选并剪取文竹叶材。

7 加入文竹，表现繁花、饱满状态。

8 顶视图，整体造型形成饱满圆形，花型封闭。

正确的使用方法：
不同色彩组合插制。

错误的使用方法：
相同色彩相邻插制。

圣诞风格
美国威廉斯堡

Lesson
189

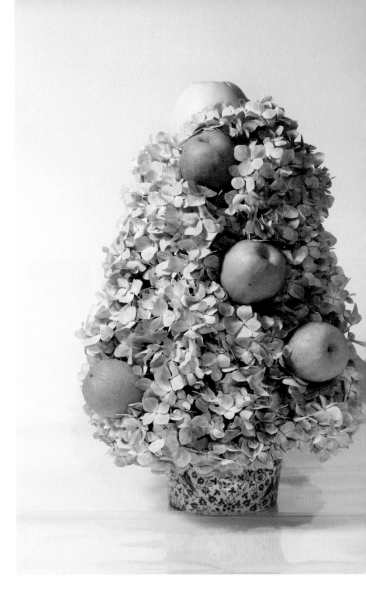

绣球花插杆处理：铁丝一端弯折成"U"形。

苹果处理。

柠檬处理。

材料

绣球花、苹果、柠檬

　　美国很多建筑会有石头质地的门头，上面会有一些浮雕图案，威廉斯堡圣诞风格其实就是从门头的浮雕演变而来的。圣诞节作为西方最重要的节日，会在门头上做很多装饰来庆祝。美国威廉斯堡圣诞风格花艺设计就源于此。

　　其花材用到大量水果，比如菠萝、柠檬、苹果，花器则偏雅致。色彩相对来说比较纯粹，体量也比较大，形态有半圆形、三角形、塔形等，花材插作还是会呈现放射状，水果尽量不要出现渐序。

　　案例作品带来的是一个清新版圣诞风格的设计，带有海洋和童趣特征。

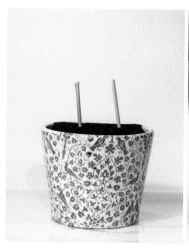

① 将花泥放入花器中，并插上两根竹签。

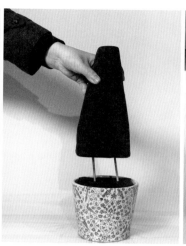

② 切割花泥成锥形。将切割好的花泥插入竹签固定。

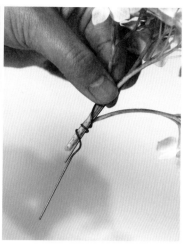

③ "U" 形铁丝连接绣球，固定，缠绕，包裹。

④ 从下至上插制绣球花。

⑤ 绣球花插满花泥，顶端插制水果。

⑥ 螺旋插制水果。美国威廉斯堡圣诞风格作品完成。

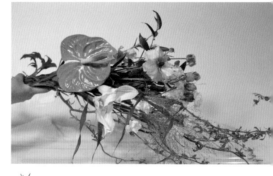

新艺术风格

新艺术花艺设计风格，听起来是"新艺术"，但其实已经非常久远了。新艺术设计风格是指建筑，最鼎盛时期是1895—1905年，所以建议大家了解一下当时的建筑史，就会很容易对这个时期的艺术特征有所认识。

新艺术风格与佛兰德斯风格很容易混淆，区别是：新艺术作品中会出现很多的弧线、波浪线，材料最好是带有自然线条的时令花材，这与佛兰德斯风格中的"S"状曲线不同。佛兰德斯风格可能会更多地去关注正空间，新艺术设计风格要求有更多的负空间感，所以作品会比佛兰德斯风格要更加通透。

材料

熊猫竹、喷泉草、龙柳、海芋、蝴蝶洋牡丹、白色多头康乃馨、橘叶、小天使叶等

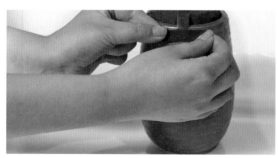

①选择适当花器，根据花器口径将浸泡后的花泥进行切割，放置花泥。利用防水胶带，十字粘贴，进行花泥固定。

②利用熊猫竹等线条叶材、枝材，进行结构打底，整体为非对称结构，打造一定负空间。

③选择带有曲线的花材龙柳，形成整体轮廓。

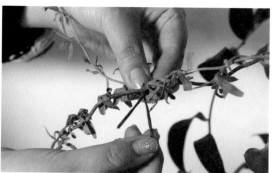

④利用纸皮铁丝将龙柳固定。

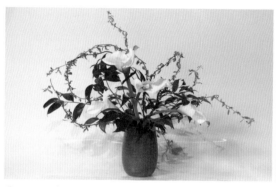

⑤加入海芋，放射性插入，让线条与形状形成一定配合。

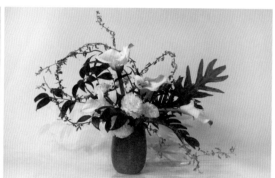

⑥加入波浪龙胆，放射性插入。加入小天使叶，丰富形态对比，增加形状以及波浪线条感，丰富艺术性。增加花材，如蝴蝶洋牡丹、白色多头康乃馨、橘叶等，增强作品质感表现。加入绿蒄葵，新艺术风格作品完成。

Tips

黄色郁金香预处理，将郁金香花瓣瓣开，形成开放状。

将海芋以及郁金香的花茎进行弯折，形成曲线。

针对比较短枝的郁金香花杆，穿刺铁丝，进行加杆以及加固。

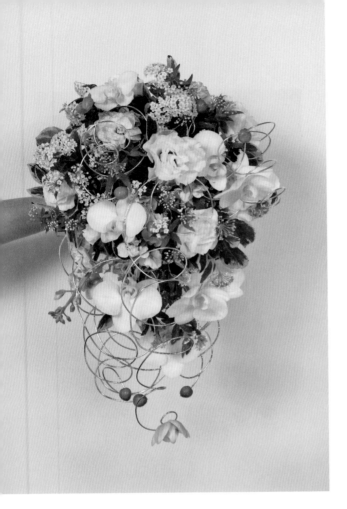

Lesson 191 下垂式风格

下垂式，顾名思义，就是整体视觉感是下垂的，是比较古典的图形，经常用于新娘手捧花中。当然也可以用花器来插，但不能用低矮型的花器。

特点：花材呈放射状，而且是单点放射。有一个跟它非常相似的图形，就是瀑布式。瀑布式和它最大的区别是：第一，下垂式背后放射状插入的花材不会翻折到前面，遮挡前面的花材；第二，下垂式用层叠、遮蔽的比较少，我们能够清晰地看到每一种花材的特征。

材料

女贞叶、紫罗兰、火龙珠、洋桔梗、蝴蝶兰、绣线菊

Tips

新娘手捧花比例

新娘手捧花的宽：高=3：5，比较高的新娘也可以做到3：8。
手捧花的中心点（放射点）一般在整个花束长度从上到下1/4的位置。

基础轮廓制作

①利用花叶黄杨定出整体作品高度。

②各个角度、同一个放射点增加叶材，形成基础基底轮廓，注意下垂空间的衔接。

③均匀丰富基底花材，丰富作品色彩以及下垂结构。以各个角度，放射状插入块状花材，丰富整体作品。

装饰物制作

① 利用铝制铁丝弯曲成想要形成的装饰曲线。

② 取少量花艺冷胶涂到火龙珠果实表面。

③ 将涂有冷胶的果实插入装饰铝丝上，粘合固定。完整装饰效果展示，以此类推，完成不同造型装饰物粘合。

组合作品

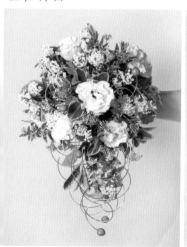 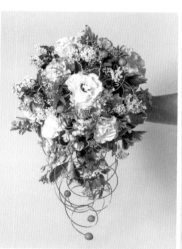 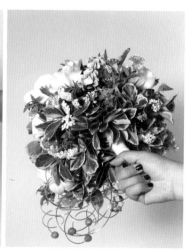

① 丰富下垂部分流动线条，平衡整体作品视觉重心。将完成的装饰线条插入手捧花泥中固定。

② 增加紫罗兰，丰富色彩，平衡视觉。

③ 进一步添加装饰铝丝，丰富整体造型，形成下垂装饰效果。背部补充叶材，遮蔽花泥、托手柄。

瀑布式风格

利用适当型号花艺铁丝，缠绕叶材枝干部分，并用绿色纸皮铁丝缠绕包裹，进行固定以及装饰。用同样方式，进行成组的叶材铁丝固定。

利用花艺铁丝，缠绕短枝材料，进行加长以及固定，并用绿色纸皮胶带缠绕固定。

将花艺铁丝十字穿插玫瑰花底部，进行预处理。

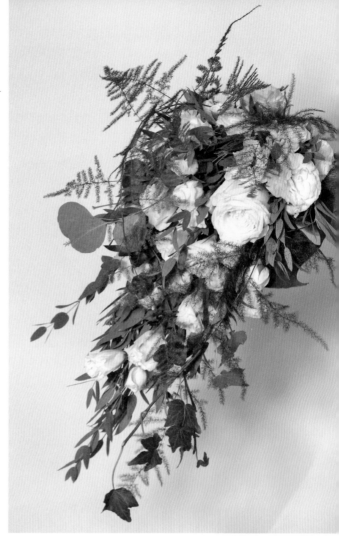

材料
尤加利叶、玫瑰、洋桔梗、龟背叶、文竹

　　瀑布式风格与下垂式风格非常容易混淆。追根溯源，瀑布式风格可以回溯到新艺术时期，到了1920年左右，美国开始慢慢流行在婚礼当中。到了1980年左右，德国的花艺师也开始大量使用瀑布风格的设计，表现浪漫、唯美的意境。

　　瀑布式的特点：第一，有一个共同的放射点；第二，会大量使用天然下垂的材料，比如铁线莲、藤本丁香、常春藤、阔叶武竹等，自然飘逸。

　　瀑布式和下垂式的区别：在花艺技法上，瀑布式会用到层叠，即一层一层地重叠和遮蔽；花材的排列上会用到渐序的手法，由大到小，由深入浅等。

　　案例作品是非常典型的铁丝杆工艺的瀑布式手捧。

作品制作

① 将多组预处理的叶材进行整体固定，形成瀑布状基础结构。

② 基础结构正面展示，叶材铺底完成，形成瀑布初始形态。增加花材，自上而下分布。

③ 逐步填充花材，形成瀑布状结构，大头花材集中在中上部。丰富周边叶材，加强外部瀑布线条。

④ 背面手柄部分，利用防水胶带进行缠绕加固，周边通过叶材进行装饰。花束背面增加体量感叶材，进行装饰。

⑤ 利用文竹进行整体手捧装饰，增加活泼的画面质感。

⑥ 手柄处利用丝带缠绕装饰。

193 植生式风格

植生式花艺设计是很多花艺师喜欢的一种风格，也是现在很多场景布置中经常会使用到的。它其实就是模仿大自然中植物生存的一种状态，也就是中国的设计术语"师法自然"。模仿并不是还原，很多花艺师误认为是要把大自然的场景完全1:1还原到花艺作品中。

植生式设计有两种手法：第一是放射状插作，第二是平行式插作。平行不是绝对的垂直平行，比如马路两侧的行道树，树干部分是笔直的，远远望去它都是平行的，但是树枝部分是交错的，这就是植生式的直立平行。植物分布会用到组群的手法，铺底可以用苔藓、松鳞、石子等自然材料。

材料

木草莓叶、喷泉草、黄莺、橘叶、文竹、小飞燕、蝴蝶花毛茛、康乃馨

①选择相对低矮的花器，根据花器大小，切割浸泡后的花泥。

②插入木草莓叶，确定整体作品高度，注意根部叶材处理干净。以组群形式直立平行地插制木草莓叶，形成高低错落之态。

③直立平行插入喷泉草，底部叶材去除，模拟植物生长状态，衔接下一个层次，让整体作品增加朦胧感。

④加入黄莺和女贞叶，平衡左右线条，底部线条清爽干净，不要过多杂叶。加入橘叶，平衡整体线条，叶材姿态尽可能舒展。

⑤底部加文竹，放射状插入。

⑥插入线条型粉色小飞燕花材，模拟自然，塑造繁盛的微型植物群落。

⑦底部进一步增加花材，丰富作品。

⑧鹅卵石铺底，大面积遮蔽花泥。

⑨作品侧面，每个角度都模拟植物自然生长状态，同时增加灵动感线条。

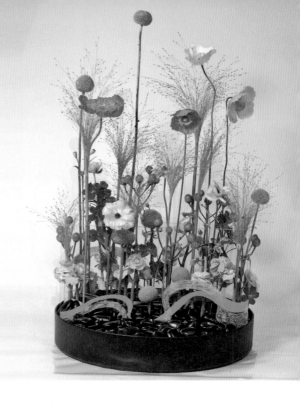

_{Lesson} 194 平行式风格

　　这节为大家带来的是平行花艺设计技法。平行在自然界当中相对来说比较少见，讲究的是一种秩序感。在纵向上的一般我们叫做直立平行，还有一种平行是交叉平行，两个结构一个向左一个向右交叉。还有自然平行，比如一个树枝的两个分叉朝向虽然是歪歪曲曲的，但是它恰好在某个部分完全吻合，间距相等，我们把它称之为自然平行。还有环状平行、弧线平行、立体平行等。

　　平行塑造的是一种秩序感，我们一旦选择了某种平行的形式，尽量不要掺杂第二种形式。接下来我们来讲一下平行的作品如何制作。

材料

紫罗兰、小飞燕、黄金球、蝴蝶花毛茛、跳舞兰、虞美人、火龙珠

基础制作

①用丙烯画笔，分别在不同亚克力板上绘制装饰纹样。

②将亚克力板平行平均放置，用热熔胶枪进行粘合。

③在亚克力板之间填充浸泡后的花泥。

④用石子遮蔽花泥。

插花

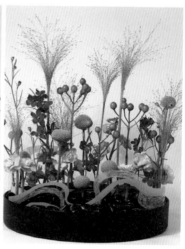

①同组花材平行垂直插入。

②逐步增加不同种类花材，丰富作品层次。

③加入喷泉草，形成中段高低差。

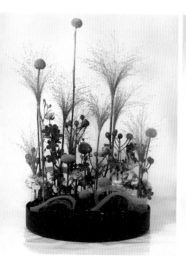

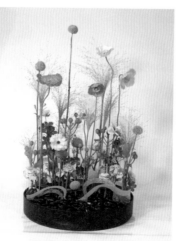

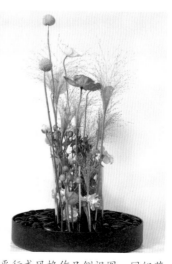

④增加高枝花材，垂直插入，形成一定负空间。

⑤按照平行层次填充花材，丰富整体造型以及层次。

⑥平行式风格作品侧视图，同组花材穿插于各层，平均分布，高低错落，形成跳跃感。

Lesson 195 新风格

　　新风格起源于古典平行结构，但是增加了一些镜像或者投影的效果，从而增加了深度和宽度。所以选材时可选择有投影效果的线条花材。花材的组织形式是组群方式。案例作品是一个长条形的直立新风格的桌花设计。

材料
鸢尾、天鹅绒、
喷泉草、茴香、
玉簪、晚香玉

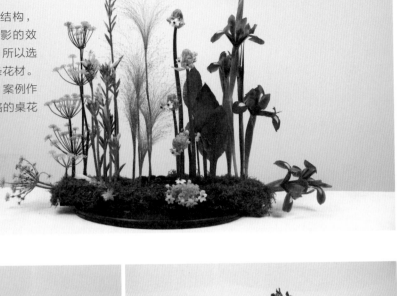

①利用针盘盒、防水胶带，将浸泡后的花泥进行处理。

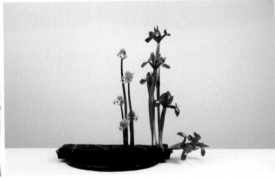

②用鸢尾起手。直立方式添加花材，并形成高低错落之态。用天鹅绒完成第二组的插制。

③运用投影的方式，处理前侧的设计。

④完成两组比较"实"的组群后，加入喷泉草此类比较"虚"的组群。加入玉簪花组群，注意疏密对比。加入茴香组群，同样以直立形态插入。

东方现代风格
作品 1

什么是现代？我们举个例子，说到青花瓷，大家都会觉得这是非常传统的器皿，但如果我说它是由不锈钢做的，那大家就会觉得非常现代。东方现代风格，就是用现代的材料和设计理念，来体现东方的意境和韵味。

Ⅰ选择适当高度花器，内部鸡笼网作为花材固定工具。充分注水。

材料
尾穗苋、小丽花

2起手，利用尾穗苋花材的线条，形成整体作品动势。

3加入线条，打造作品的空间感。

4不断填充，形成不同角度的线条结构。加入小丽花，完成作品。

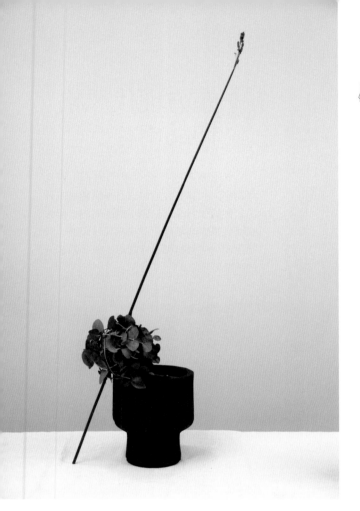

🌿 **材料**
尤加利、水葱

◆预处理尤加利，底部保持茎秆干净，弯折为环状。利用环绕以及包裹方式，逐步添加尤加利，形成团状。

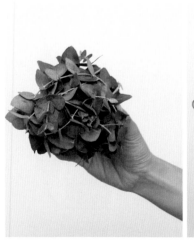

①利用尤加利茎部穿插进行固定，形成球体。

②用木本类枝材形成结构固定。

③将尤加利球体穿入固定枝。球体穿插一根水葱，完成作品。

东方现代风格作品 3

东方现代花艺设计风格比较适合一些需要快速呈现的场合，这节的案例作品非常简洁清爽，又深富韵味。

材料
须苞石竹、花葱、蔷薇枝

◆ 准备好花器，放置好剑山，充分注水，水位高于剑山针尖。

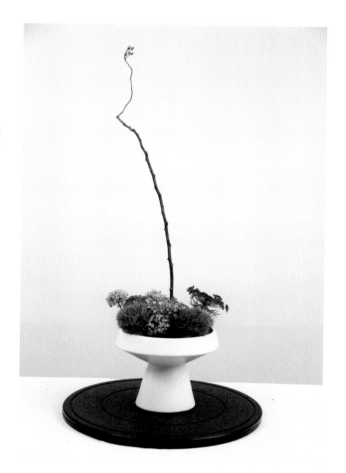

1 修剪蔷薇枝，进行作品定高，关注整体线条动势发展。

2 加入须苞石竹、花葱填充空间，形成聚集的团块状色彩对比关系。

3 进一步添加散状花材。加入黑石子，遮蔽剑山。

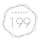

中国传统插花的定义和制作要点

中国传统插花历史悠久，先民使用鲜切花的历史可以一直追溯到三千年前，比如《诗经》里面记载了"维士与女，伊其相谑，赠之以勺药"。这就是古人以花传情的文字性记载。到了唐朝就有了相对成形的插花理论体系，比如《花九锡》这样的著作。明清时期中国的传统插花更加体系化，有了《瓶花谱》《瓶花三说》这些著作，至今都有非常重要的价值和指导意义。2008年中国传统插花入选了国家级的非物质文化遗产名录，有两位代表性的传承人，即北京林业大学的王莲英先生和 秦魁杰 先生，这两位老人也为中国传统插花的发扬光大做出了杰出贡献。

目前中国传统插花的体系分为六大类容器，即盘、碗、筒、瓶、缸、篮，固定用剑山、撒等，而不是用花泥。

在形态上中国传统插花有四种基本花型，即直立型，花枝之间开合角度相对来说比较小，一般在30°夹角范围之内；倾斜型，花材倾斜30°~60°之间；水平型，平展开来的低矮型的作品，适合案头、茶席空间等；下垂型，角度要低于花器，在做下垂型的时候，通常会使用高花器，适合中式家居当中的多宝格、书架、花几等。

相比西方花艺，中国传统插花更看重的是文化和意境，以花传情，以花喻人。

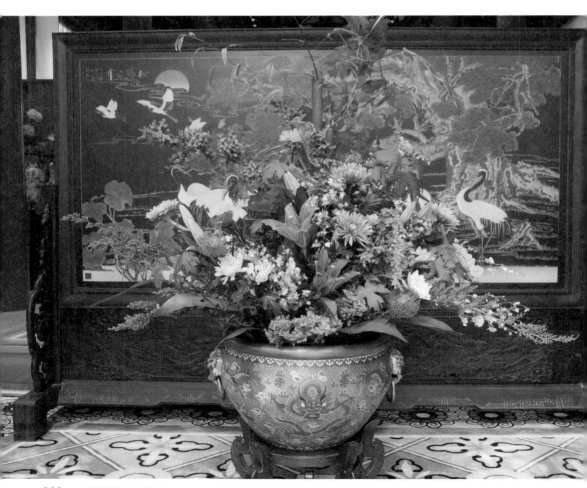

中国传统木本枝材修剪原则

　　木本类的枝材在中国传统插花中的使用量非常大，我们经常讲中国的传统插花善用木本类的枝材，是因为木本类的枝材有非常好的线条，像国画一样，线是国画的灵魂，中国传统插花也非常善用线条。

　　木本类的枝材有很多的不确定性，需要进行人工修剪。

　　首先我们拿到枝条时，要观察其朝向，就是长在树上时，是在左侧、右侧？阴面、阳面？观察它的生长角度，也就是"势"，尽量还原它在自然中的真实状态。

　　下面介绍需要修剪的枝条类型。

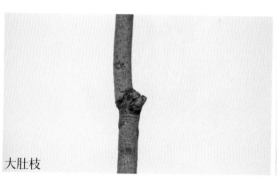

大肚枝

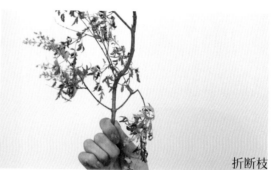

折断枝

◆大肚枝一般可以保留，可以表达苍劲的感觉。　　◆折断枝一般要去除。

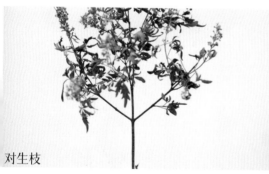

对生枝

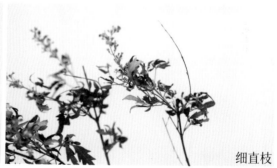

细直枝

◆容易造成视觉对称，根据设计需求进行修剪。　　◆当有多余的细直枝，一般会去除。

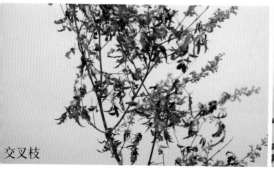

交叉枝

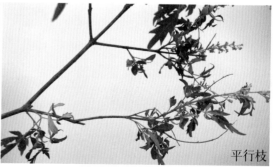

平行枝

◆有明显交叉，当设计不需要过多交叉的视觉焦点时，选择剪掉。　　◆当有多组平行枝，设计又需要一定趣味性，一般会选择性去除。

中国传统插花作品 1

这节为大家带来的是中国传统插花中直立型盘花的演示。相比其他容器，盘花相对来说制作简单一些，因为它的操作空间大，用剑山固定。

材料

钢草、菊花、木草莓叶、高山积雪、玉簪叶

① 剑山方位确认，一般放在靠边的"屋漏位"。

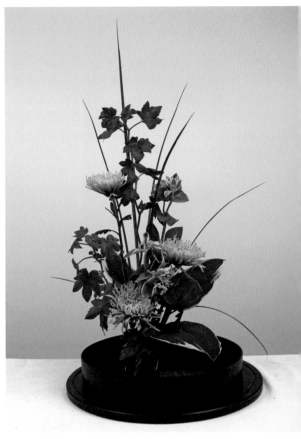

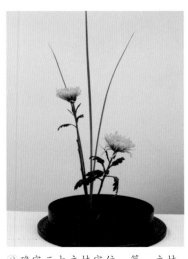

② 确定三大主枝定位，第一主枝中的主枝高度取花器的1.5～2倍。第二主枝：客枝，取主枝2/3～3/4高度。第三主枝：使枝，取客枝2/3～3/4高度。

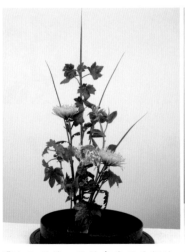

③ 加入从枝，从枝高度不要超过主枝，并且顺应主枝的朝向。继续添加从枝，衔接整体空间。填充整体造型，创造自然生长的感觉。加入心枝。

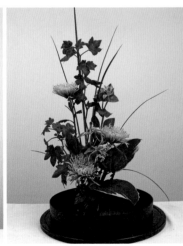

④ 加入底部叶材，起到一定衬托以及遮挡剑山的作用。丰富层次，加强线条透视感，注意插制角度和线条柔顺感。破枝，打破花器对花型的束缚。

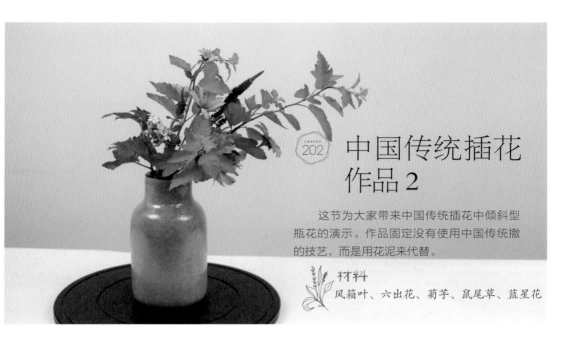

中国传统插花作品 2

这节为大家带来中国传统插花中倾斜型瓶花的演示。作品固定没有使用中国传统撒的技艺，而是用花泥来代替。

材料

风箱叶、六出花、菊芋、鼠尾草、蓝星花

①根据花器高度，倾斜插入三大主枝，第一主枝取花瓶1.5倍的长度。

②添加从枝，丰富层次，进行衔接。加入焦点花材六出花。

③加入辅助花材，丰富层次，营造春天轻盈的感觉。

④加入对比色蓝紫色系花材，完成倾斜型瓶花作品设计。

中国传统插花作品 3

这节为大家带来中国传统插花下垂型筒花的插花作品。

材料
中国桔梗、蓝星花、喷泉草

① 两支两支地插入叶材。在中心点插入心枝，并成簇地加入直立型叶材。

② 插入从枝，进一步丰富造型。

③ 加入轻盈质感花材，如中国桔梗。

④ 加入轻盈质感喷泉草以及蓝星花。加入嫩绿叶材，下垂型筒花完成。

中国现代花艺风格

中国现代花艺风格，一般是用现代的器皿和花艺手法，来表达中国插花的韵味、意境和特色。

◆纹样以及器型对比。

◆同样类型纹样，不同器型、不同材质对比，左侧更加现代。

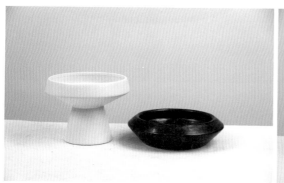

◆同类型器皿，不同高度产生现代感的对比。

◆同样高度、同类型器皿，不同色彩与表面纹样，产生现代感。

◆木质与塑料质感对比，产生现代感。

◆同质感不同线条枝材，产生现代感。

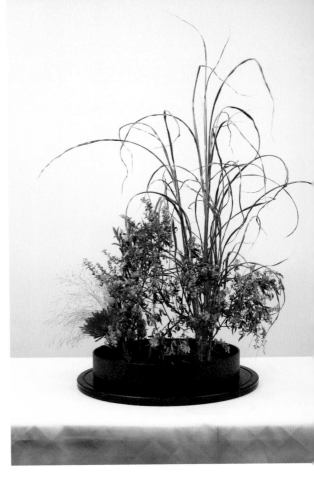

中国现代花艺作品 1

Lesson 205

这节作品我们采用了相对比较传统的低矮型的花器，带有很明显的东方风格，在配色上也采用了灰紫色，也是东方特点的颜色，木本类的枝材也使用了灰紫色系的。花材选择上，选择一些相对来说比较枯寂感觉的，因为紫色相对来说比较忧郁，作品想表达的是一种在衰败和绽放之间的思绪。可以用到一些干燥的植物，它有非常漂亮的团状的线条，这种线条在空间中形成了新的立体构成。

材料

穗花牡荆、烟花菊、喷泉草、孔雀草、斑叶芒

①运用干燥性枝材起手。

②增加线状线条，在空间上进行装饰。增加底部线条。加入修剪后的枝条，形成整体花艺造型结构，并且进行折枝操作。

③加入花材，与另一侧形成强烈对比，突出生死、枯寂与鲜活的对比。

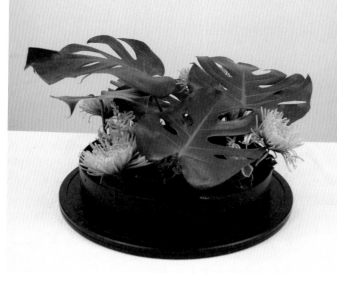

Lesson
206

中国现代花艺作品 2

这节为大家带来的是一种夏天感觉的中国现代花艺作品，设计灵感来自池塘的荷叶。

材料

龟背叶、菊花、高山积雪

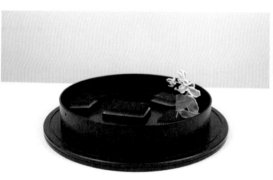

①布局好剑山，高山积雪进行起手。

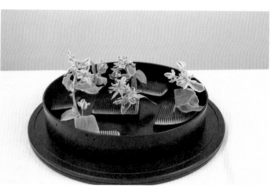

②高山积雪打底布局。

③加入龟背竹叶，注意各个角度和层次，规避重复性。

④在龟背叶中穿插加入菊花，填充造型。

花艺设计风格　　**267**

中国现代花艺作品 3

这节为大家带来的是中国现代花艺设计作品中筒花的设计，借鉴了中国传统插花中的禅意插花。禅意中的"空"，并不是无，而是介于有和无之间的状态。这个作品看上去非常简洁，但还是包含很多内容，给人想像的空间。作品选用了苔藓材质，苔藓本身就带有禅意的味道，不争不抢，安安静静。

 材料

苔藓、木草莓叶、矢车菊、山牡荆

①苔藓预处理，利用"U"形铁丝固定苔藓。

②选择有造型感的山牡荆枝材，提前修枝，选择最优造型插入苔藓，营造枯寂的感觉。

③加入有生命力的花材，如木草莓叶、矢车菊，与枝条产生强烈对比。

④利用剩余苔藓完成最后的遮蔽。

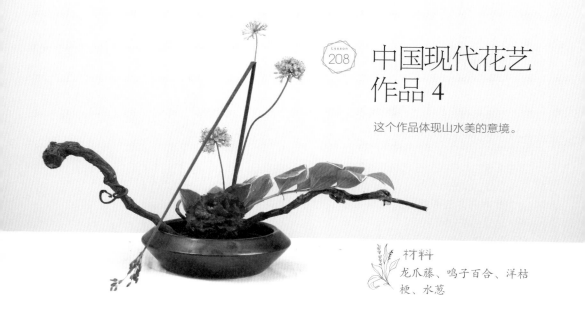

中国现代花艺
作品 4

这个作品体现山水美的意境。

材料
龙爪藤、鸣子百合、洋桔
梗、水葱

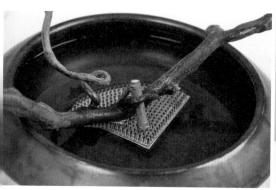

① 利用木本枝材结构进行龙爪藤的固定。

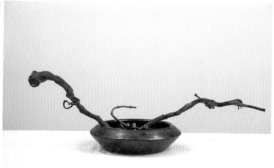

② 利用龙爪藤线条，模拟山形，固定后去除多余
部分。

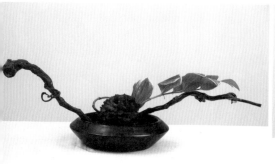

③ 利用鸣子百合线条，完成左右的平衡关系；利用
洋桔梗进行固定结构的遮挡，完成底部结构。

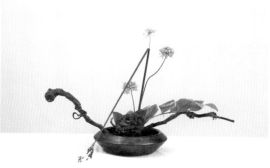

④ 将水葱弯折形成折线型，加入作品中。进一步填充
花材，增加作品线条，完成作品。

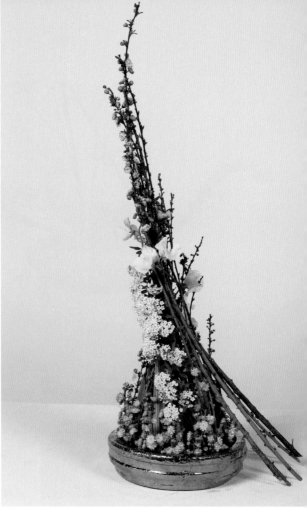

架构风格

现在架构在整个花艺体系中的归属变得非常奇妙。如果按照传统的归属，它属于实验派风格中的一个分类，但是现在来看它似乎独立于传统，甚至变成了一个对立传统的类别。

架构的方法或思路，近现代才出现，是欧美系的花艺师为了在花艺设计上取得突破而创的，受到一些建筑、结构的启发。在过去很长的一段时间内，中国花艺市场有些过度地解读了架构的意义，架构是为花艺服务的，不能为了架构而做架构。我们怎么样去判断作品有没有必要做架构？就是看我们整体做的架构的形态和最终完成作品的形态是否有非常高的关联性。

材料

新西兰麻、榆叶梅、绣线菊、香豌豆

① 选择比较有厚重感的广口花器，放置充分浸泡的花泥，花泥不宜过高。

② 剪桃枝若干，尽可能枝条长度一致，将部分枝条的花朵去除。

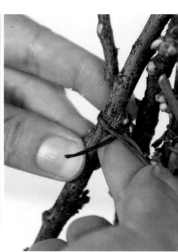

③ 利用同色系纸皮铁丝将枝条进行捆绑固定。

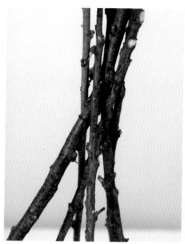

④加固后效果展示，每2～3根枝条为一个绑点，逐层丰富。

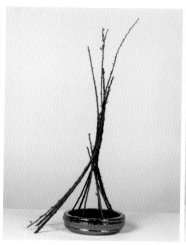

⑤逐步利用纸皮铁丝加固基座结构，确保整体造型直立。

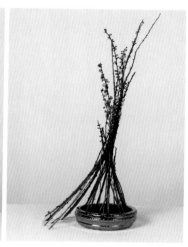

⑥增加顶部带有花朵的枝条，丰富作品层次。

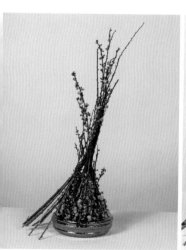

⑦底部增加带有花朵的枝条，基底完成，从顶部到底部线条过渡流畅。

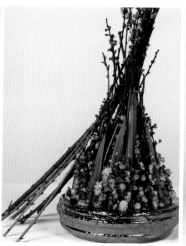

⑧底部加入新西兰麻用于遮蔽花泥以及起到装饰性作用。

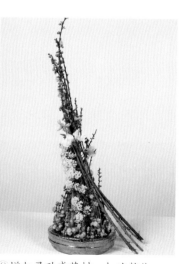

⑨增加灵动感花材，打破整体作品直线结构。

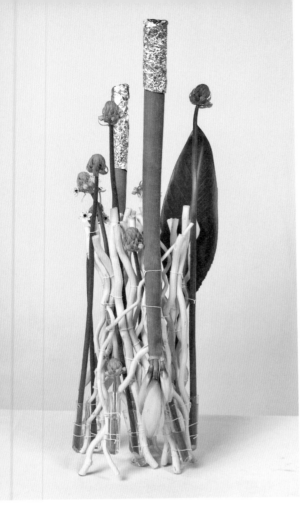

LESSON 210 雕塑风格

这节介绍花艺实验派风格中的雕塑风格。我们在外文资料中经常看到一种花艺设计风格叫做flob，它其实是两个单词floral和object拼合而成。大概是在1950年左右，有一波花艺师为了突破古典花艺技法的瓶颈，从雕塑中获得了很多的灵感，形成了这种风格。

材料
白龙桑、朱顶红、天鹅绒

Tips

利用花刀切除茎部，内部加入可吸水的棉花，确保棉花充分吸水。

外部利用锡纸进行保水处理以及形成装饰效果。

① 选取白龙桑若干，利用枝剪将尖部去除。利用纸皮铁丝将白龙桑成组串联固定。

② 逐步增加串联层次，最终形成类圆柱体结构，底部保持水平持平，可立于桌面之上。

③利用纸皮铁丝固定试管。试管分布于基座底部，注意保证双绑点固定，顺枝条走势。

④将天鹅绒利用纸皮铁丝进行多绑点固定。

⑤进一步增加花材，丰富整体基础结构。

⑥将朱顶红花材倒置固定，顶部进行保水处理。

⑦利用注水壶将底部试管进行注水。

⑧雕塑风格作品完成效果。

火凤凰风格

材料
花毛茛、康乃馨、紫罗兰、蒲棒叶、文竹

① 选择广口花器，放置浸泡好的花泥，花泥要具备一定厚度。修剪蒲棒叶，放射性居中插入，上部倒三角的放射部分不能超过花器的边缘。

② 进行铺陈，注意花头高度不宜过高，扁平化分布；插制的花材尽量规避组群形式的效果。

③ 随机性地添加花材，尽量不要同色系聚拢形成明显性大色块。花材填充最终效果，花材之间自然衔接，没有明显组群关系。

④ 用文竹营造向上蒸腾的感觉，模拟火焰燃烧后烟气升腾缭绕，表现轻盈的质感；侧面蒲棒叶放射状平均分布，不可缝隙过大。

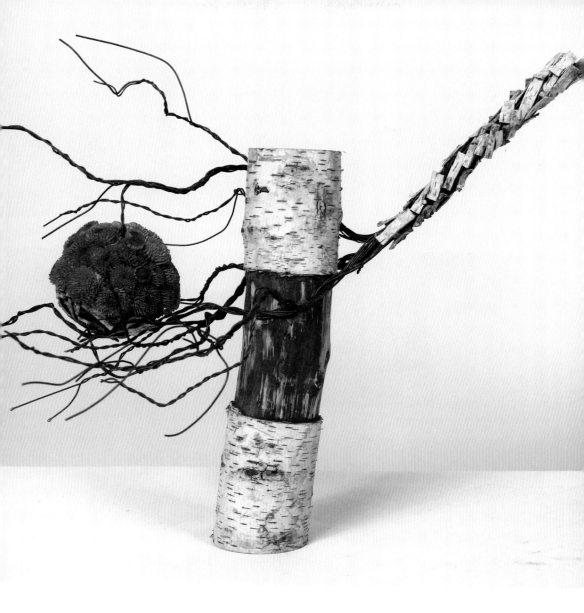

212 抽象风格

　　抽象风格隶属于实验派风格。抽象风格的作品花材使用量比较少，整体比较简约，材料并没有过多的限制，对于花器、花型也完全没有限制。它要求创作者对于某一种现象或者事件，甚至于某一个画面有一定感悟之后而创作出来的一些自我表达的作品。不一定具有装饰性，接近艺术创作，更多地是要去表达一种情感、一种情绪，或者是发出一种声音、呈现一种现象。

材料

纽扣菊、白桦木桩

①选取带皮白桦木桩作为基底原料。

②将白桦树皮中间部分用水浸泡，中间部分去皮处理。

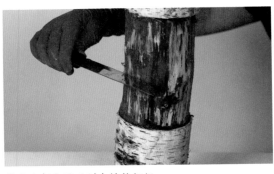

③去皮部分用刀刮去植物组织。

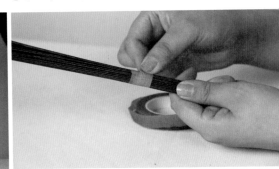

④选取花艺铁丝若干，利用花艺绿胶带进行捆绑固定

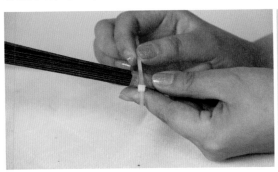

⑤进一步运用扎带捆绑加固。

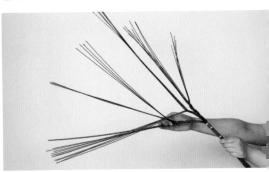

⑥将铁丝分成若干小组，分组进行螺旋处理。

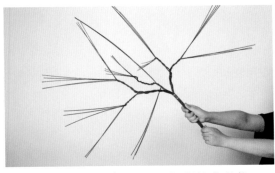

⑦每个小组铁丝进一步分组，形成"树杈"结构。

⑧用剪刀将白桦树皮剪裁为若干小方形，用于后期装饰。

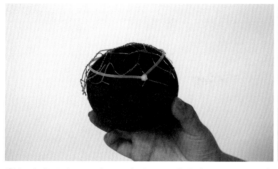

⑨提前将浸泡好的花泥削成球体，覆盖鸡笼网以及扎带。

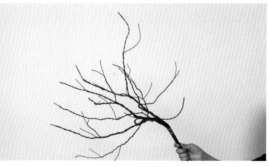

⑩将树形结构进一步细化，形成若干分支结构。

⑪花泥球底部利用胶枪粘合之前处理好的桦树木片。

⑫完成的花泥球底托装饰效果。

⑬树形结构的末端进一步旋拧，形成螺旋机构。

⑭利用花艺纸胶带进行捆绑固定。

⑮尾部利用胶枪将装饰性小木片粘合，进行遮蔽以及装饰。

⑯将完整的树形结构以及装饰后的花泥球固定在基座上，形成完整的装饰效果。

花　艺　设　计　原　理

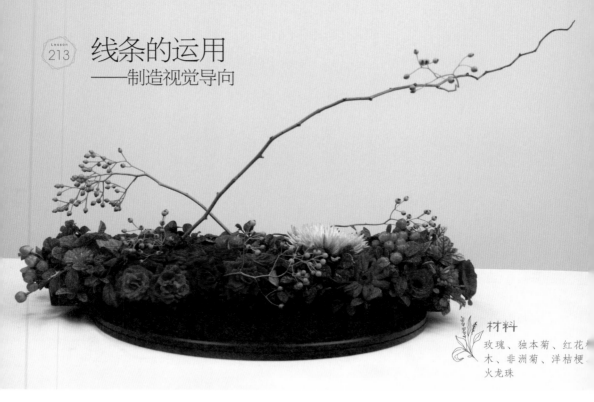

线条的运用
——制造视觉导向

材料
玫瑰、独本菊、红花檵
木、非洲菊、洋桔梗、
火龙珠

　　线条很重要的一个作用就是制造视觉导向。这是一个长条形的桌花作品，基础使用铺陈的手法，色彩上、体量上感觉比较重，也就是没有负空间，因为焦点花材在右侧，所以希望观者的视线是从左侧流动到右侧。有两种方法可以进行视觉引导，第一种是线条的引导，一根线条从左侧延伸到右侧；另一种是焦点引导，即用两个枝条交错，交错点下面是焦点花材。还可以通过枝条营造视觉焦点，向左右两侧分别移动的感觉。

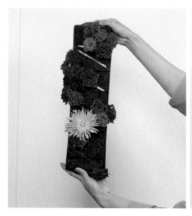

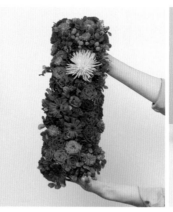

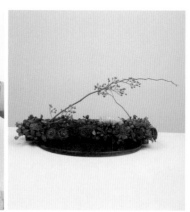

1 针盘盒中放置充分浸泡的花泥，花艺胶带进行固定，插制玫瑰起手打底，加入焦点花材——独本菊。

2 运用铺陈的方式逐步完成作品，红花檵木铺底，用于花泥遮蔽。进一步丰富花材，加入非洲菊、洋桔梗、火龙珠，进行色彩丰富以及空间填充，增加花材间的色彩呼应。

3 增加交错的线条，与焦点花材形成焦点呼应，将视线导向焦点。稍微改变枝条位置，形成视觉流动性，感觉向左右两侧移动的感觉。

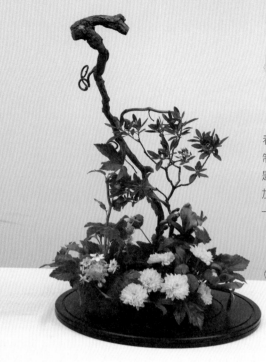

线条的运用
——增强艺术感

线条的另一个作用，就是增强艺术感。继续看下面这个作品，这个偏绿化式小桌花，如果将制作到的步骤③的作品运用到商业中，完全没问题，但是价格不会高；而如果进行到步骤④，增加漂亮的木本类线条性的枝材，效果立刻变得不一样。

材料
木草莓叶、鸢尾、天鹅绒、杜鹃、龙爪枣藤

① 选择花泥环，充分浸泡。利用木草莓叶进行起手打底。

② 加入鸢尾，形成色彩以及形态对比。加入天鹅绒以及小菊，丰富线条层次。

③ 增加叶材层次，遮蔽花泥，并丰富整体花艺作品造型层次感。

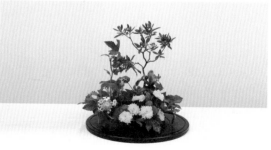

④ 通过修剪杜鹃，形成设计需要的线条，插入作品中。最后加入龙爪枣藤到作品中，增强作品的艺术感表达。

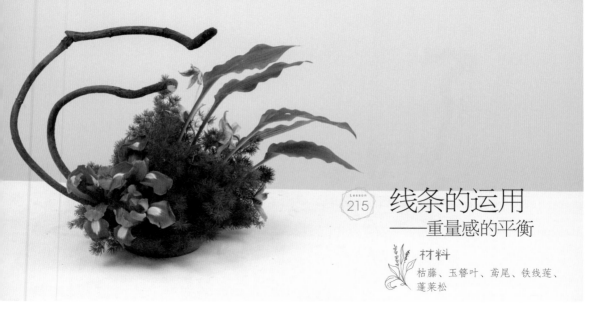

线条的运用
——重量感的平衡

🌿 **材料**
枯藤、玉簪叶、鸢尾、铁线莲、
蓬莱松

　　这一节继续讲解线条的平衡应用。在一些设计中，我们要不断地去创造非对称和平衡之间的互动关系，如果是完全平衡的状态，设计看上去比较枯燥，这时可以考虑使用线状花材制造负空间，与正空间之间形成对比关系。

①充分浸泡花泥，用花艺防水胶带以及针盘盒进行花泥固定。用蓬莱松起手。

②进一步填充蓬莱松，进行花泥遮蔽。加入铁线莲，增加线条，丰富造型层次。

③在另一侧空间中加入鸢尾，平衡设计。

④进一步填充玉簪叶，制造线条感。最后利用枯藤，增加作品的线条，以投影的形式，最后形成作品正负空间的对比平衡。

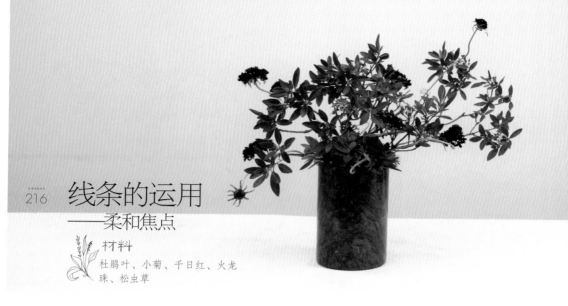

线条的运用
——柔和焦点

材料

杜鹃叶、小菊、千日红、火龙
珠、松虫草

　　线条的另一个作用——柔和焦点。线条的交错，可以产生很多的视觉焦点，同时也会造成视觉辨识的障碍，通过线条可以柔化视觉焦点，比如下面这个作品中最后加入的松虫草，它柔美的线条，可以打破杜鹃枝材所带来的凌乱感。

1 准备好花器，内置浸泡好的花泥，插制杜鹃叶进行打底。

2 加入小菊，形成整体红色基调。加入千日红，进一步填充空间。

3 加入火龙珠，丰富作品色彩层次。

4 利用杜鹃枝去创造更多的视觉焦点。加入松虫草，利用柔和线条去打破原有枝条的凌乱感。

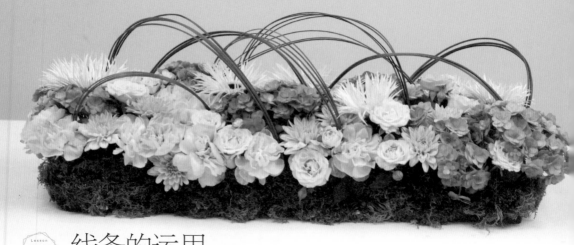

线条的运用
——韵律感表达

线条可以制造韵律感。线条有直线、弧线、折线等，不同的线条带给人不同的感受。下面这个作品演示人为制造的弧线来增强作品的韵律感。

材料

苔藓、绣球、小菊、非洲菊、钢草

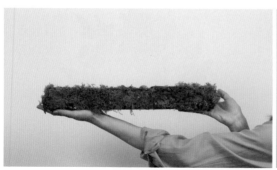

①准备好针盘盒以及花泥，利用苔藓以及"U"形针进行整体花泥遮蔽。

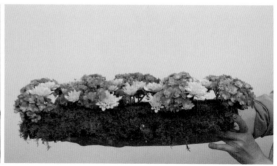

②加入绣球，完成整体空间填充。增加小菊，进一步填充空间，并且进行色彩调和过渡。

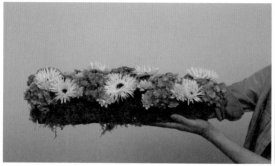

③加入非洲菊，填充空间。

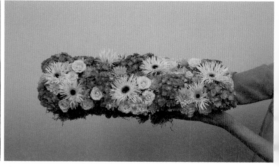

④填充花材，增加蔷薇，小菊等进行花泥遮蔽。最后利用透明胶带对钢草成组处理，多组弯曲插入作品中，通过高低起伏的变化，使作品形成韵律感。

284 全能花艺技法与设计百科

线条的运用
——填充空间

Lesson 218

这节演示如何利用线条去填充空间。这个作品其实做到步骤③，已经是一个很完整的作品，但是，如果需要放在稍高一些的空间，就可以通过增加线条的手法来实现。

材料
小菊、绣球、非洲菊、龙爪枣藤、文竹

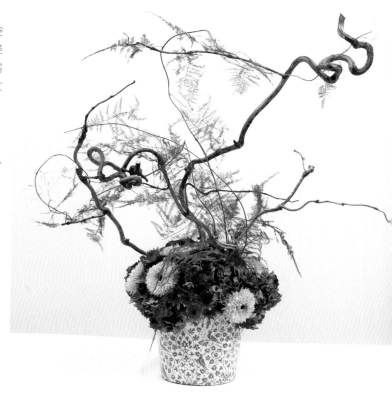

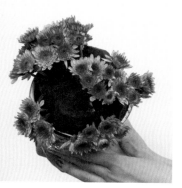

①准备好花器以及固定好花泥，利用小菊进行起手。

②加入绣球，进行花泥遮蔽以及空间填充。

③多角度分布非洲菊，进行整体色彩调和。

④加入龙爪枣藤线条，形成上部空间结构。利用文竹填充更多的线条，丰富空间。

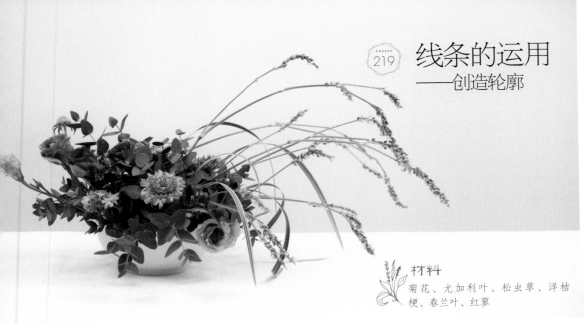

线条的运用
——创造轮廓

材料
菊花、尤加利叶、松虫草、洋桔梗、春兰叶、红蓼

线条型的花材除了勾勒负空间，还有非常重要的作用，就是创造全新的轮廓。比如下面这个作品，如果在步骤③的基础上，继续添加块状花材，不会很明显地改变它的轮廓，但是加入一些线条型的花材，大家可以看看发生了什么变化。

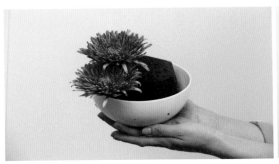

① 准备好花器置入充分浸泡好的花泥。利用独本菊起手，形成焦点。

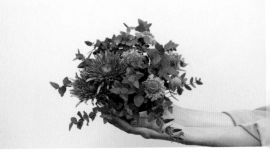

② 添加尤加利叶，进行空间填充以及花泥遮蔽。填充松虫草，作为色彩过渡以及空间衔接，形成饱满空间造型。

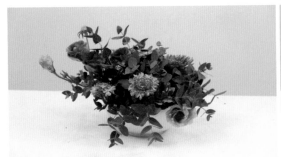

③ 加入洋桔梗，进一步遮蔽花泥。

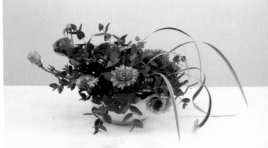

④ 加入春兰叶精细化线条，创造作品外观整体轮廓。最后加入红蓼，为作品创造具有指向性的轮廓空间。

线条花型设计作品 1

　　线是我们提炼出来的一种视觉元素，它其实是细的柱体。在设计中，我们讲究点、线、面、体，线是花艺设计中一个非常重要的元素，无论是西方还是东方，都会有大量的应用。

　　常见的线有：直线，比如水葱、竹子，它们的线条非常直；折线，比如袋鼠爪，互相带角度的连接；弧线，弧线的花材非常多，比如绣线菊、春兰叶等。在运用线条的花材时，我们要想好整体设计中主要以哪种线条为主，它们以什么样的方式来进行排列组合。这里给大家一个获取灵感的好办法，那就是多去看一些近现代的抽象画，这些画里有非常出色的线条的运用。

材料
袋鼠爪、硫华菊

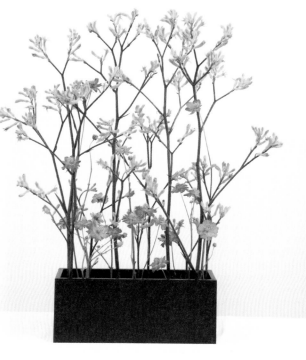

① 准备好花器，放置好预处理的花泥，用苔藓铺底。

② 加入袋鼠爪，利用袋鼠爪错综的线条，形成交叠的层次。

③ 硫华菊去除叶片。

④ 加入硫华菊线条，丰富层次。最后加强底部层次，线条花型作品完成。

线条花型设计
作品 2

一般我们把花材分为线状、块状、散状、异形，但实际运用中是灵活多变的，比如玫瑰，我们把它归为块状花材，但假如在一个大型的设计场景中，要使用1m高的超高玫瑰，它笔直的秆就会变成一种很显著的线，从而弱化了花头的体量感。就像下面这个作品用到的肾蕨，一般我们当做线状花材，但这个作品当做面状花材来使用。

材料

排草、地榆

①对肾蕨进行预处理，将叶尖剪掉。去除底部叶片。

Tips

肾蕨有着像梳子一样的纹理，非常规则整齐，在设计中既可以当做线状花材，也可以作为面状花材处理。

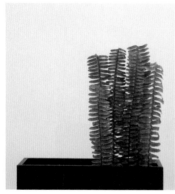

②肾蕨正面朝外，带有孢子的背面朝内。

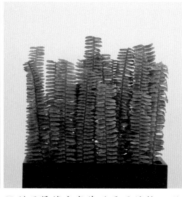

③利用肾蕨完成基础平面结构，形成线条肌理，像茂密森林。

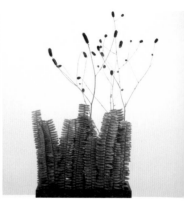

④在肾蕨的空隙间插入地榆，形成折线线条对比，作品完成。

花艺设计原理
——形态设计绪论

这部分带来的是花艺设计中的造型。我们分为古典型和变化型。什么叫古典？什么叫变化？像三角形最早起源于古代埃及，所以把这种花艺造型称为古典三角型，其他古典图形同理。变化图形是相对于古典图形而言的。古典基础的形态，古典图形有很多要求，比如说对称性、放射状等。

放射状就是当花材插入花泥的时候，花材的延长线汇集于一点，这个点也许在花泥内部，也有可能在花泥外面。所有的古典图形中，插花材的角度都要求是放射状；而变化形态我们可能会采用非对称，非放射状。作品可采用多插点，或用平行的手法来进行变化，甚至去改变一些比例结构。

除此以外，还需要了解封闭花型和开放花型的概念。封闭花型是指花材之间相对来说挨得比较紧，块状花材使用得相对较多，几乎没有负空间的设计；开放花型是相对封闭花型而言的，多使用一些线条状的花材，花材和花材之间的间距会比较大，并不是实体占据了真正的三维空间，它会产生更加开放、广阔的想象空间。

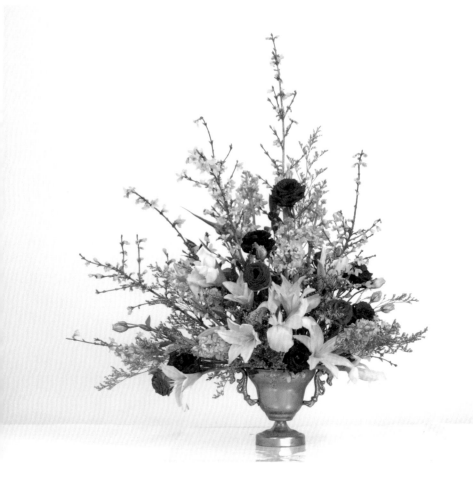

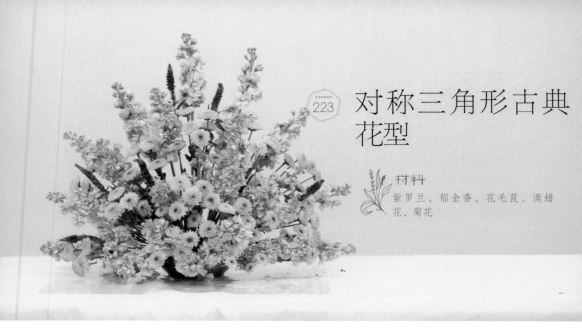

对称三角形古典花型

材料
紫罗兰、郁金香、花毛茛、澳蜡花、菊花

这一节用邻近色系的配色做一个古典对称三角型的花型演示。所有的花艺作品都是一个三维空间的存在，首先要确认整个作品的三维比例，在古典花型设计中，首先需要确定的是整个作品的高度，一般是花器高度+口径之和的2~2.5倍。古典三角型是一个单面观的花型，要注意花材的表情，即花头朝向等。

①用紫罗兰定高、定宽、定厚度。宽度取高度的2/3~3/4，不宜过短。

②注意整个作品的重心相对靠后，避免产生前倾。对三角形进行均分，形成各个连接花枝。

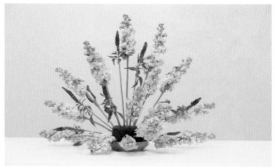

③整体轮廓完成，各个角度形成对称三角形。在三个面的维度上进一步填充花材，加入更多的分割线。

④侧面同样保持三角形形态。注意整体花枝形成放射状，一个放射点。

对称三角形变化花型

对称三角形的变化花型是相对于古典对称三角而言的。两者基本的插花原理几乎一样，那么变在什么地方？首先从长宽高的比例可以发生变化，但同样也不可过于陡峭，那样会接近直立型，也不可过于扁平，有可能接近水平型。花材的组织形式也可以变化，案例作品就采用了组群的形式，可能左右两侧的花材种类就变成非对称的形式。

材料
郁金香、小天使叶、木草莓叶、花毛茛、澳蜡花

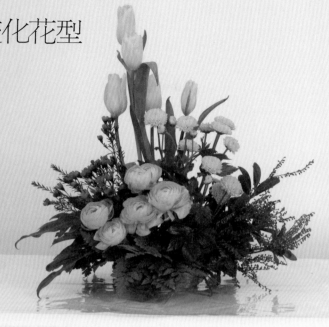

1 用郁金香和小天使叶片定宽、定高、定厚度，不宜过于陡峭或过于平行。

2 连接高、宽、厚度。

3 以组群的形式插制花材。利用木草莓叶进行衔接，把厚度做出来。

4 所有花材保证聚焦于一个放射点，而不是多个放射点。利用散状花材进行填充，柔和作品造型，加强体量感。

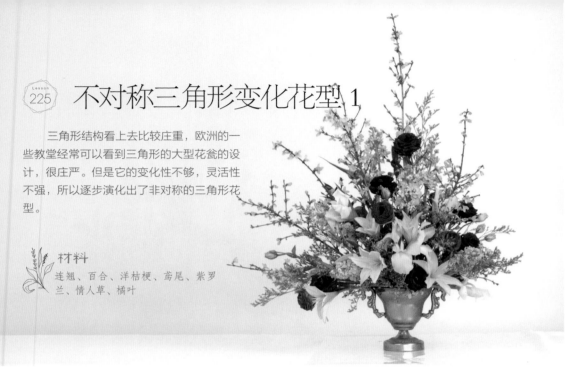

不对称三角形变化花型 1

三角形结构看上去比较庄重，欧洲的一些教堂经常可以看到三角形的大型花瓮的设计，很庄严。但是它的变化性不够，灵活性不强，所以逐步演化出了非对称的三角形花型。

材料

连翘、百合、洋桔梗、鸢尾、紫罗兰、情人草、橘叶

① 起手，完成基本造型。

② 根据花器的高度以及口径大小，确定连翘的主枝高度，完成定高。

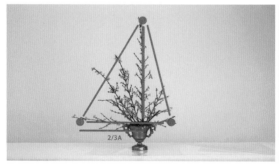

③ 注意中轴线向短侧偏移，而不是正中间位置，并且顶点尽可能贴合花器口径，避免整体形态上移。定宽主枝为高度的2/3，短枝为1/3。

④ 利用鸢尾以及部分散状花材进行整体空间的填充，充盈整个作品。

不对称三角形
变化花型 2

材料
康乃馨、黄金球、金合欢、雄黄
兰、红瑞木

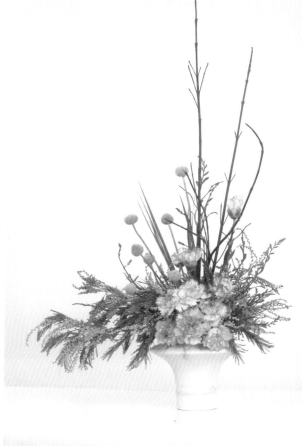

1 用红瑞木定高，尽可能保持垂直状态，插入金合欢，进行两侧不对称宽度确认。

2 弱化整体造型中顶点间分割线的部分。

非对称三角形的变化型，它是相对于非对称三角形的古典型而言的。案例作品的变化主要体现在比例关系上。其插作要点在于平衡点的掌握。

3 非对称三角形的重点在于平衡感的掌握。

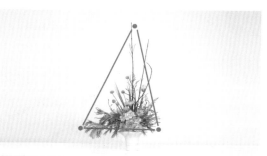

4 顶点间增加线条，加入更多负空间设计，并增加线条感，体现向上延伸之势。

水平型古典花型

　　水平型古典花型适合放在一个平面上，是非常古老的花型，最早可能用于摆放在祭坛上，所以水平型一般不会采用特别高的花器。在现在的商业场合中，多应用于一些桌花。水平型是典型的放射状图案，而且是四面观的，是一个封闭程度相对比较高的图形。比例根据实际情况来定，一般宽度取桌子宽度的1/4左右，长度取桌子长度的1/3~1/2，高度一般都控制在30cm以下。高度和它的总长度之比大概为1：4。

　　水平型有两条轴线，第一条轴线沿着水平方向，另一条沿着垂直的方向，可以前后对称、左右对称。可以大量用块状花材和散状花材。

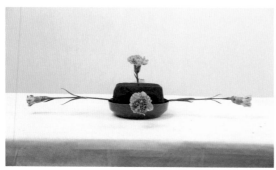

①选用针盘盒进行插制，根据桌面的尺寸定高、定宽、定厚度，确定整体轮廓。

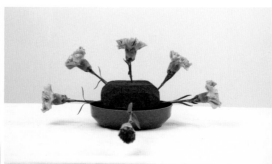

②进行高度与厚度的过渡连接，侧面形成均匀的弧度。

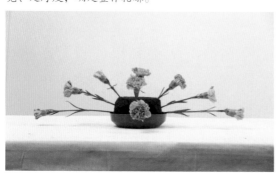

③进行宽度与高度的连接，正面同样形成均匀的弧度。

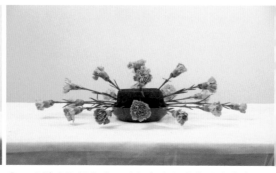

④以同样的插制方式，进行宽度与厚度的过渡连接，随时注意顶视图，保持平均弧度。

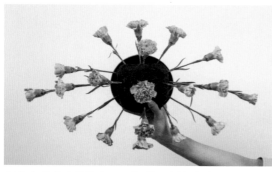

⑤各个角度连接状态，顶视图形成椭圆型。

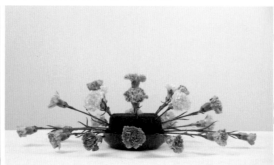

⑥填充各个角度空间，完成基础水平型古典花型轮廓。

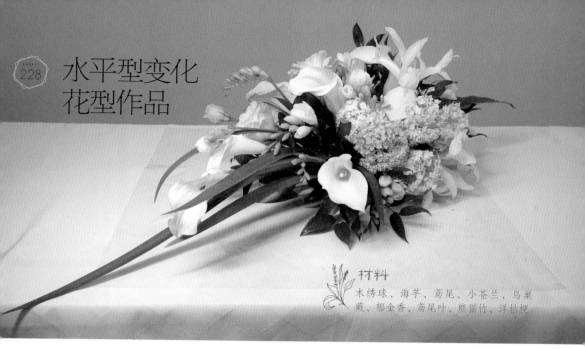

水平型变化
花型作品

材料
木绣球、海芋、鸢尾、小苍兰、鸟巢蕨、郁金香、鸢尾叶、熊猫竹、洋桔梗

　　这个水平型变化案例从比例的角度来进行改变，做一个非对称结构，但有平衡感的作品。配色是比较春天的感觉，以白绿色系为主，加一点明黄对整个作品进行提亮。

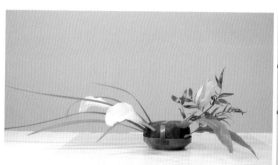

1 利用针盘盒进行非对称结构设计，左右比例有明显的变化，叶片有一定曲度变化。

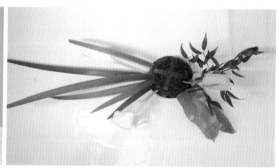

2 通过组群方式进行插制，左右形成比例差，完成作品定厚度以及定高。

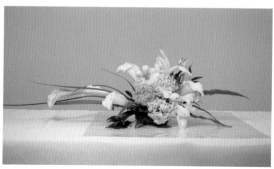

3 各个角度进行花材填充。

4 加入熊猫竹、洋桔梗等花材，进一步丰满造型，注意色彩过渡。

材料
康乃馨、洋桔梗、情人草、澳蜡花

Lesson 229　水平型古典花型

1 水平型一般不采用非常高的花器，此设计选用针　2 定高：水平型高度一般控制在30cm以下。
盘盒进行插制。

3 宽度一般取桌子宽度的1/4。长度一般取桌子的1/3～1/2。

4 填充龙胆，连接各个角度衔接空间。

5 高度值与总长度的比例为1：4之间，可以小于1：4，比如1：5、1：6。

6 水平型设计可以采用中间开放度比较高的花材，两侧花材慢慢可以闭合一些，有一个自然的感觉，两端微微向下扣。

7 顶视图形成橄榄型。水平型花朵分布，越往中间花朵越直立，越往两侧越水平。

8 作品完成。

直立型古典花型

直立古典型相对于其他图形来说，会变得更高，但依然是一个放射状的图形，这是非常容易忽略的。

材料

排草、小橘叶、郁金香、莺尾、天鹅绒、熊猫竹

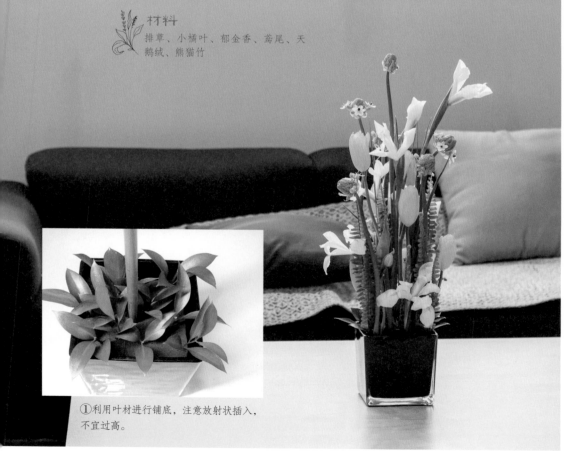

①利用叶材进行铺底，注意放射状插入，不宜过高。

2 利用小橘叶进行铺底，整体造型依然是放射状插制。

3 最高枝主枝高度需要满足花器正视图宽度的4倍以上，最少也得是3倍。

$H \geqslant 3a$

4 整体作品需要在框内范围进行填充。

5 不断加入花材，微微放射状插入。直立型主体部分不可超过花器边缘。

6 背部整体。

7 适当增加开放度较大花材，增强整体作品的表现力。

231 直立型变化花型

这个直立型的变化型作品我们选择了一个低矮型的花器，但作品相对来说比较长。高与宽的比例差不多为1：3。传统比例一般为1：2.5到1：2之间，超过这个比例一般就为现代比例。不同的比例关系所呈现效果也明显不一样。

材料

须苞石竹、郁金香、六出花、翠扇、银芽柳、雪柳

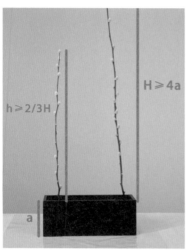

1 选择长度与宽度比例为3：1的花器进行设计。花器的高度设为a，最高枝的高度h≥4a，最矮枝高度h≥2/3H。

2 每一层花材高度取上一个高度的2/3高度，不宜超过1/2。整体造型可以越往下越密集，不可头重脚轻。

3 六出百合层次完成，整体高度低于银芽柳，形成明显层次分割。逐渐增加层次，底部利用郁金香和翠扇进行层次插制。

4 利用郁金香和翠扇交叉层次进行底部插制。

5 须苞石竹作为基底，进行花泥遮盖。

6 加入雪柳，打破规整结构，增加作品灵动感。

圆形古典花型

圆形的古典图形，其顶视图或者侧视图呈圆形，严格意义上来说应该是球形或者是半球形。与绝大多数的古典花型一样，是一个放射状的花型，但是圆形有多个对称轴。

材料

玫瑰、康乃馨、黄金球、纽扣菊、橘叶

①定高、定宽、定厚度。

②各个顶点，形成半球形状，操作过程中，不断观察侧视图来进行图形矫正。

③确认各个方位顶点位置，左右绝对对称，注意顶视图，也要呈圆形。

④十字轴完成后，进一步完成连接线花材填充。加叶材，叶尖部分不宜超过整体形态过多。

⑤填充黄金球、洋甘菊、花毛茛等花材。插入每种花材的时候，不断地从各种视图去校正。

⑥圆形古典花型造型完成，形成半球体。顶视图呈圆形。

⓶³³ 圆形变化花型

圆形的变化型相对于其他图形来说简单一些。可以从封闭和开放的角度上变化，古典的圆形封闭程度比较高，花面参差落差比较小，变化型则都可以加大。花材可以组群。另外，形状也可以变化，比如用于靠墙装饰，就可以用半球形。

材料

排草、康乃馨、六出花、洋桔梗、须苞石竹

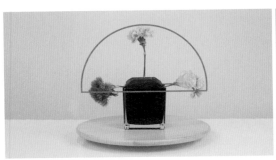

①先定高定宽，三个顶点形成圆弧状。

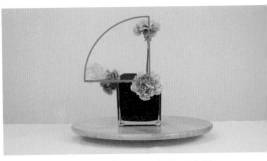

②定厚度。注意重心靠后，以免作品前倾。

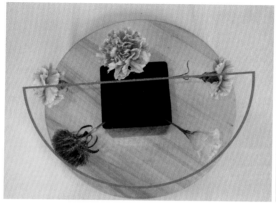

③ 顶视图观看整体造型顶点位置。

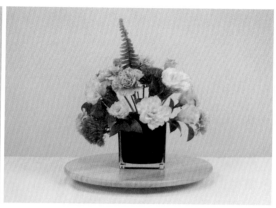

④ 各个方位加入花材填充。

⑤ 背部造型呈圆弧状半球形。

⑥ 增加线状放射点，营造负空间的设计，打破整体造型的沉闷感。

⑦ 在中轴线靠后位置，进一步填充花材，形成圆弧向后延伸过渡。

⑧ 作品顶视图。

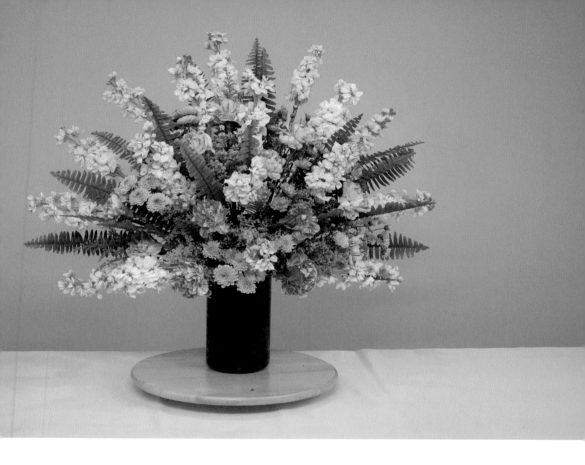

Lesson 234 扇形古典花型

　　扇形相对来说是一个比较近现代的花型，它起源于欧洲维多利亚时期，和三角形有共同之处，只是外轮廓为扇形。扇形是单轴对称的花型。

材料
紫罗兰、翠菊、康乃馨、黄莺

① 用紫罗兰定高、定宽、定厚度，形成中心轴对称图形，花枝卡在花器壁上。

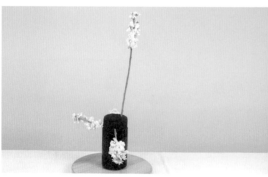

② 侧视图观看，第一主枝会稍微后倾，5°～15° 倾斜角度，使重心向后拉。

③形成半扇形，不可是三角形。

④主枝与侧枝有一定水平错位，不在一条线，形成一定弧度。

⑤紫罗兰骨架完成。

⑥侧面进行平缓角度过渡。

⑦加入肾蕨，均分填充空间，增强放射状效果。

⑧侧面展示效果。

⑨增加块状以及散状花材填充空间，进行衔接。

⑩加入小菊，丰富空间层次，打破绝对对称的秩序，完成扇形作品。

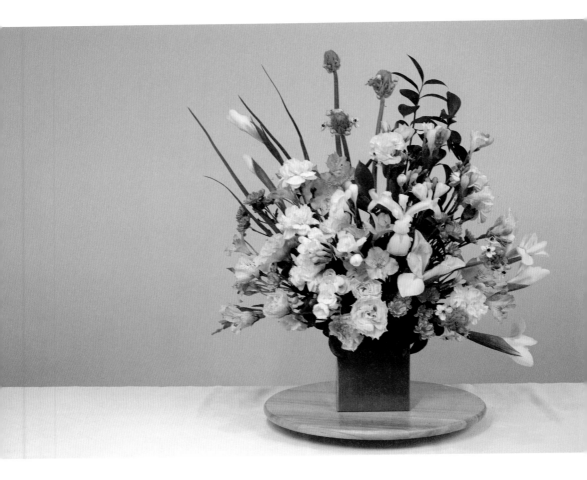

扇形变化花型

了解了扇形古典型之后，我们可以从高度比例、花材的组织形式来进行相应的变化。

材料
莺尾、洋桔梗、小菊、天鹅绒、小苍兰、橘叶、六出花

①定宽、定高、定厚度，保证一个放射点，形成扇形，可以有一些小的参差。

②组群形式插入花材，注意两侧贴合花器。

增加线状花材形成负空间。

各角度增强了形态的变化性，形成不对称三角形的图形结构。

背部结构完整，两侧贴合花器。

整体形成扇形，同时内部填充形成非对称图形，增加视线流动性。

内部填充六出花和小菊，后部需要利用小橘叶进一步遮挡花泥。

整体造型填充，形成一定厚度，有一定负空间体量。

新月形古典花型

新月形现在在中国主流花艺培训市场上已经很难见到了。它是一个流传非常久的西方古典花艺图形，可以一直追溯到古希腊，甚至到巴洛克时期，都会有设计师追求这种弧线的设计。新月形是中国的叫法，西方称其为"C"字形。它是一个非垂直对称的结构，这在西方古典图形中比较少。另外，它在设计的时候，还是会遵照古典传统比例，即3：5：8的关系。是四面观的花型。

因为要做出弧形的结构，所以对花材要求比较高，需要可以塑形的，花材的组织形式可以用渐序；花器一般选稍高一些的，特别是下弦月造型，花器就必须要高。

材料

鸟巢蕨叶、尤加利、玫瑰、
花毛茛、黄金球、雀梅

1. 鸟巢蕨叶片塑形

1 提前选取好流线形的鸟巢蕨叶片，修剪留一段叶柄做插秆。

2 将花艺铁丝穿插于叶片中，便于后期弯折造型。

③ 剪取同样体积的鸟巢蕨叶片，背部涂花艺冷胶。

2. 作品制作

④ 进行粘合，用于铁丝遮蔽以及造型加固，注意要背面粘合，分清叶片纹路正反。

⑤ 用处理好的鸟巢蕨叶片起手，注意起手位置可以稍微水平位移，紧贴花泥插入，这样整体作品展示面会更加充分。

⑥ 利用内部铁丝塑形。

⑦ 增加花材，完成外部轮廓，利用尤加利叶进行新月造型的衔接。

⑧ 插另一侧，同样稍微偏转，角度一般控制在10°~15°，紧贴花泥，左右构图比例约5：3。

⑨ 定厚、定高，利用叶材框定出整体作品的视觉焦点。

⑩ 组群注意花材的衔接，外形一定要流畅，避免断层，同时关注色彩的流动性。各个角度填充花材，注意花头朝向，并且花型相对封闭。

新月形变化花型

新月形是基于花泥原理的传统图形，我们在做变化的时候，形态上变化的可能比较小，更多的是从比例、上下弦以及材质构成方面进行变化。案例作品是一个架构原理的新月形。

材料

蝴蝶花毛茛、花毛茛、洋™
梗、木草莓叶、梨花、文心™

①提前准备好铁丝材料，取单数7或者9进行基础支撑结构制作。

②浸泡桦树皮，然后剪成若干小片，用于后期表面装饰。

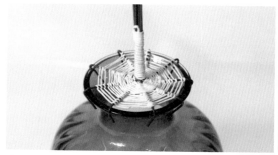

3 利用铁丝支撑结构以及纸皮铁丝，进行穿插编织，做成蜘蛛网结构。剪除多余铁丝，完成抓手固定。

4 上部铁丝分离，制作托举结构。进一步利用纸皮铁丝完成花泥托制作。

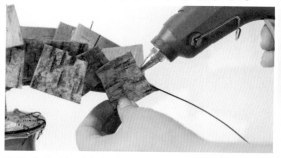

5 沿着花泥托外部轮廓，利用预处理的白桦树皮木片进行外部粘贴，形成半包围结构以及装饰。

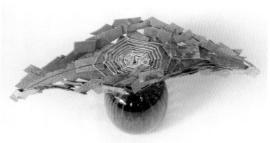

6 底部同样进行粘贴，形成稳固结构。

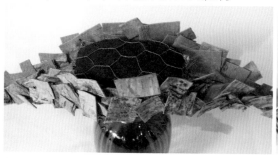

7 放置玻璃纸用于防水。切割花泥，充分浸泡，利用鸡笼网和纸皮铁丝固定。

8 利用块状花材填充。

9 不断地增加花材，进行填充，以及色彩和形态的衔接。加入叶材，进行花泥遮蔽，以及中间造型完善。

10 增加轻盈质感的花材，在整体空间中进行穿插。两侧加入小花头，细小的花材，以及东方感的木莓叶，丰富整体作品层次。最后加入文竹，形成非对称设计造型。

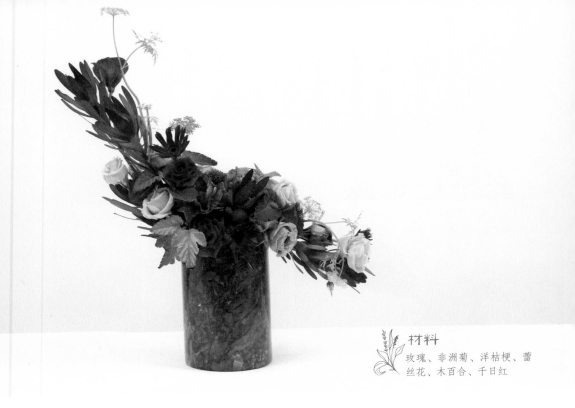

材料

玫瑰、非洲菊、洋桔梗、蕾
丝花、木百合、千日红

238 霍加斯形古典花型

　　霍加斯这个名字源于十八世纪英国一位园艺师的名字——威廉姆·霍加斯，也称为"S"型，可以理解为两段圆弧互相交叠，从正面和背面都是一样，是两面观赏的花型。古典图形中很少见到带有弧线的图形，新月形和霍加斯形是为数不多的这种类型，霍加斯花型也要求比较高的花器。

① 准备好花器以及提前削好的花泥，花器相对高一些，花泥高于花器。

② 确认好放射点后，插入花枝，定高。

③ 图形比例关系，高：宽：厚=8：5：3。

④加入深色叶材，增加空间衔接。

⑤利用木百合花枝，加强"S"形轮廓线条。

⑥填充复古色系块状花材。

⑦逐步增加花材，整体注意层次的衔接以及线条流畅度。

⑧加入千日红，增加整体作品色彩跳跃度。

⑨增加灵动轻盈质感线条，营造"S"形曲线。

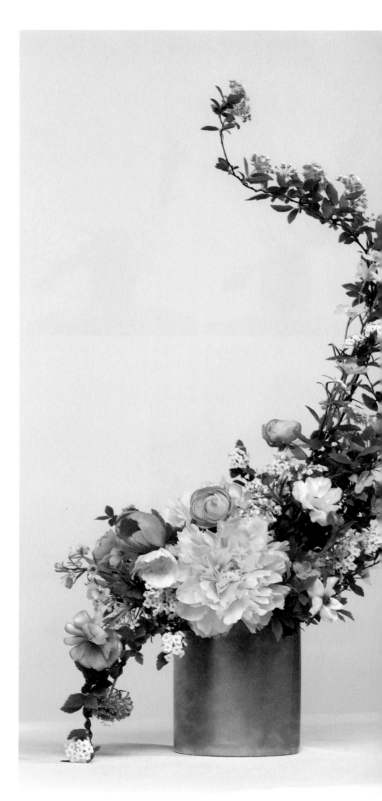

霍加斯形变化花型

LESSON 239

古典花型往往会有一些规则，比如比例、花材组织方式、色彩、花材类型等。古典花型的变化，也就是在这些方面来进行变化。

材料

牡丹、花毛茛、郁金香、绣线菊、蝴蝶花毛茛、虞美人、松虫草

Tips

利用铁丝进行花茎加固处理。

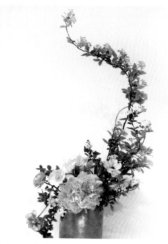
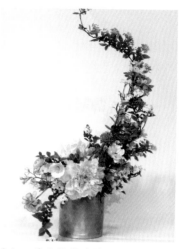

1 定主焦点花材，确定重心，注重多面观观赏性，及相应的背面焦点。

2 加入衔接性叶材，以及弯曲度比较大的花材来进行层次衔接。加入不同形态的花材，放射状插入，丰富色彩过渡。

3 加入蓝盆花等花材以及叶材，进一步色彩衔接，空间填充。

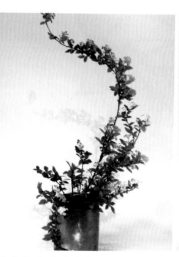
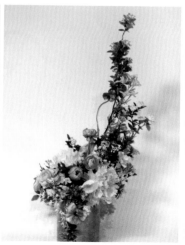

4 "S"状线条为作品必不可少要素，利用绣线菊定曲线。插一些向下的线条，完成尾部线条塑造。对线条进行延展，各个角度进行衔接。

5 注意作品的厚度，不宜过大。

6 四面观花型，注意各个角度的花材衔接。

正、负空间定义及作品呈现

Lesson 240

正、负空间是花艺设计中常听到的词汇。正空间通常是指实体空间，也叫封闭空间。举个例子，比如我们在花泥上插很多的小菊，当小菊达到一定密度，它虽然有空隙，但是已经形成了很清晰的外轮廓，那它就叫做一个正空间。正空间会有不同的封闭度，比如说小菊花头挨着花头密密麻麻的，这是一个全封闭空间；花头和花头之间会有一定间隙，但是看不到花泥，上下参差，这属于半开放空间。当然，要排除一种极端的情况，就是小菊插得特别密，只是剪取花头覆盖花泥，这构不成一个正空间，而是叫做铺底。

负空间绝大多数情况下，需要线状花材，它会拉动整个作品的形态，比如插两支花，它们在物理上没有相交，但是在正视图上形成了一个即将闭合的的空间。什么叫即将闭合，我们假设这个空间是一个圆，最少要有二分之一的区域能够互相连接，这样就形成负空间，如果小于这个就不叫负空间了。

① 准备好花器，提前放置好预处理的花泥。

② 增加线条，各个角度进行空间塑造。

③ 增加盘旋线条，增加空间通透性。

④ 各个角度利用线条打造负空间。

⑤ 填充龟背叶，形成正空间。

⑥ 苔藓打底，进行花泥遮蔽。加入块状花，形成正空间。营造视觉焦点，正负空间相互呼应。

色相的基本概念

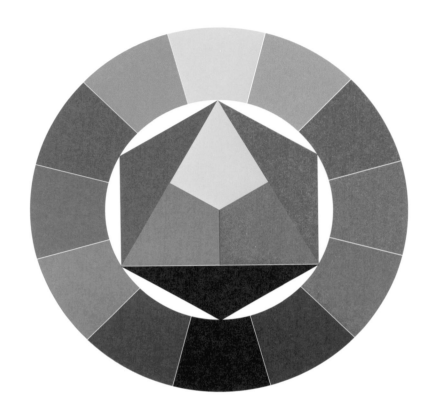

色相是花艺色彩的三要素之一，它指的是我们能够看到的花材的颜色，可以通过色环来认识。其中有三个最基础的颜色，也叫三原色，即红、黄、蓝，其他色环上的颜色都是可以通过这三种颜色调和获得的。红色系的花在日常生活中见的最多；黄色系的花也很常见，是容易吸引昆虫的一种颜色；蓝色系的花相对比较少。

除了彩色之外，还有无彩色，就是黑色和白色。白色的花材在自然界也非常多，黑色则很少，我们一般说的黑色花材，比如黑色郁金香、牡丹等其实是一种深紫红色，纯黑的植物是不存在的。

白色到黑色之间，就是灰色，灰色系的花也很少，能够呈现很标准的灰色的花材有银叶菊、绒毛刻球花（珊瑚果），以及一部分的尤加利叶和花朵等。

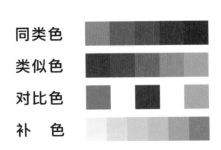

同类色

类似色

对比色

补　色

◆三原色之红色。

◆间色——红色+黄色。

◆三原色之黄色。

◆三原色之蓝色，自然界相对较少，人工处理的较多。

◆间色——红色+蓝色。

◆间色——蓝色+黄色。

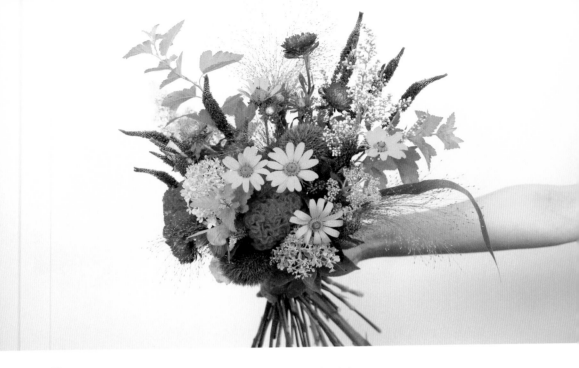

色相的运用及作品呈现

LESSON 246

　　这节介绍花艺色彩中色相要素的作品呈现。色彩是一门很基础又很深奥的学问，需要深入地学习。我们可以从大自然中寻找灵感。下面来做一个小的花束进行演示。一般来说，多个色彩搭配在一起，会给人带来缤纷感，绿色是一种调和色，它可中和很多对比色相所带来的不适感。

　　这个小花束选用了两组邻近色，在24色相环中间隔为60°的色相都属于邻近色。邻近色可以保持色调的亲近性，又可以保持差异性，使画面效果更丰富。

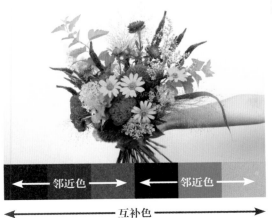

　　同时这两组邻近色又互为互补色，互补色相配色是指在24色相环上直径两端互成180°的色相间的配色。互补色具有更好的感官刺激，是产生视觉平衡的最好组合。

材料

鸡冠花、鼠尾草、木绣球、木草莓叶、喷泉草、须苞石竹、中国桔梗、翠菊

① 选择不同色相的花材。

② 以绿色系为核心进行起手，中和后续添加颜色，使整体平衡。

③ 增加红色系花材。

④ 增加不同色相花材，注意不同颜色的质感以及层次。

⑤ 增加线条、散状花材，丰富整体造型。

⑥ 色相组合花束作品完成，剪根，运用麻绳进行捆绑。

明度的基本概念

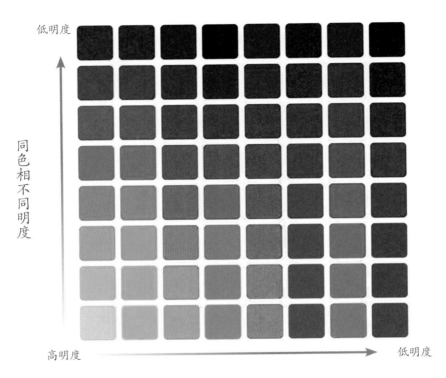

不同色相不同明度

　　明度作为花艺色彩的三要素之一，决定了作品在视觉感官上的素描关系。如何理解这种关系，我们从白色到黑色以及一系列的灰色，把它分为十个等级，最亮的是一级，最暗的是十级。在花艺色彩中的，最亮的颜色即亮色调是从一到四级，称为高明度，四至七级称为中明度，低明度就是六至十级，可以通过色环看出来。

　　高明度带给人的感受是轻盈的、干净的、通透的，低明度是凝重的、饱和的、灰暗的，中明度带给人的感受是平静的。市面上经常看到马卡龙色，是非常典型的中明度色彩。花艺设计时，尽量避免明度落差太大，比如红玫瑰旁边配一些白色的花。这两个明度值如果我们拿手机调成黑白模式，会发现红色的玫瑰部分几乎全是黑色，白色则异常明亮，这就是明度相差太大，会引起不适。其实白色和红色的搭配没有不妥，只是中间缺少一个调和的色彩，导致对比过于强烈。

1 高明度组合，可以利用手机黑白模式测试色彩明度。

2 高明度给人的视觉感受一般倾向于明快的、轻盈的。

3 低明度给人的视觉感受是凝重的、饱和的、灰暗的。

4 利用高低明度进行整体感观调和。

5 低明度组合参考。

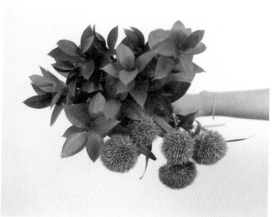

6 中明度组合参考。

明度的运用及作品呈现

LESSON 248

下面这两个案例是低明度和高明度的设计。低明度不是一定要设计成黑色。明度值比较低的有绿色，其明度值大概在四到五之间，往后有红色、蓝色、紫色、棕色，都属于低明度的色彩。

← 低调 →		← 中调 →		← 高调 →	
0 1 2 3		4 5 6		7 8 9	

| 高长调 | 高中调 | 高短调 | 中长调 | 中中调 | 中短调 | 低长调 | 低中调 | 低短调 |

材料

翠菊、须苞石竹、玫瑰、康乃馨、六出花、橘叶、菊花、风箱果

1. 低明度

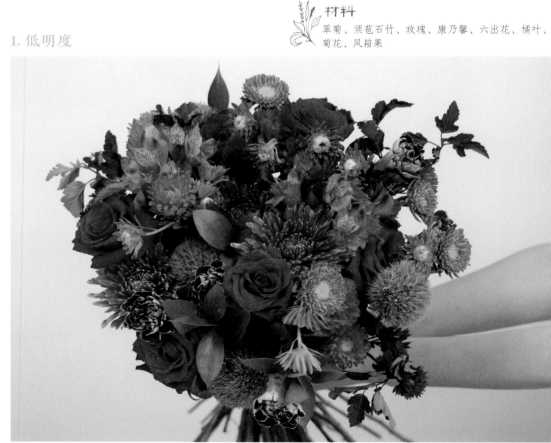

◆低明度花束适合男性以及个性内敛人群。

明度高的花艺作品，感觉偏向轻盈、少女感和通透性等。

2. 高明度

材料

木绣球、玫瑰、洋桔梗、高山积雪、蓝星花、康乃馨

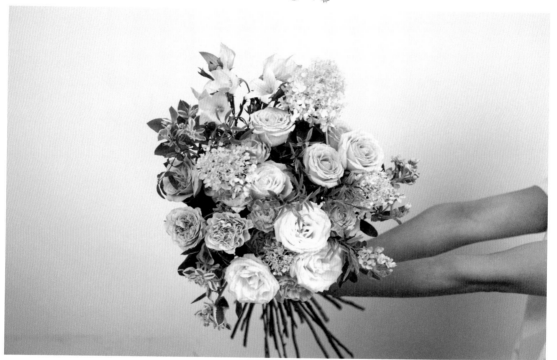

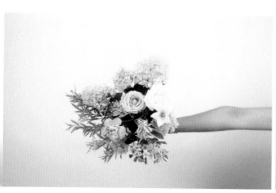

◆高明度应用花材搭配,以组群形式进行花束设计。

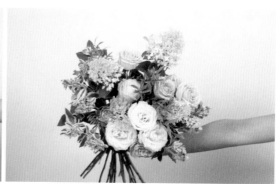

◆进一步增加花材，丰富层次。

纯度的基本概念

纯度也称为饱和度、彩度。纯度越高的颜色是指越接近于三原色的颜色，比如正红色、正黄色、正蓝色。所有色彩中，纯度最低的是灰色，其次是黑、白色。

纯度从三原色开始，向两个方向发展。降低纯度有三个方法，一是加白，它的纯度降低，但是会变亮；第二是加黑，纯度会降低，亮度也会降低；第三是加灰。只要加入了无彩色，比如在红的基础上加入白色，它的纯度就降低，就是它原来的红色的比例降低，但是亮度就看是加的哪种无彩色。

低纯度	中纯度	高纯度

1　2　3　4　5　6　7　8　9　10

◆纯度，又称饱和度、彩度。

◆低纯度参考组合（1）。

◆低纯度参考组合（2）。

◆纯度和明度取值范围为0～100%，在色彩学中，三原色纯度最高。

◆高纯度参考组合（1）。

◆高纯度参考组合（2）。

纯度的运用及作品呈现

这节演示花艺色彩中低纯度和高纯度的花艺作品。

1. 低纯度花艺作品

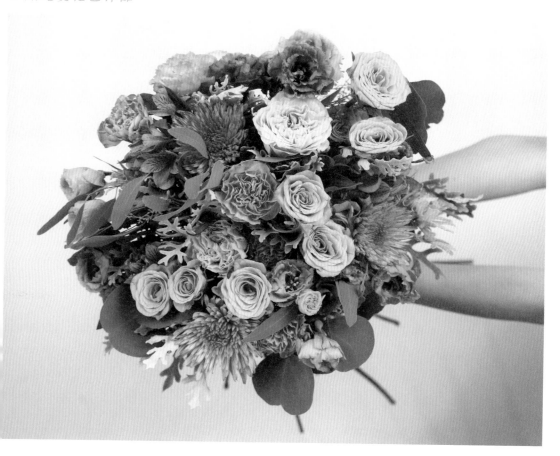

材料

玫瑰、菊花、康乃馨、六出花、尤加利叶、银叶菊

所选的花材有纯度最低的灰色的银叶菊，以及玫瑰、康乃馨、菊花，其纯度都非常低。低纯度的花艺作品要注意一个问题，就是有可能会让作品变得非常腻，就是色相上很弱，这是需要控制的。

2. 高纯度作品

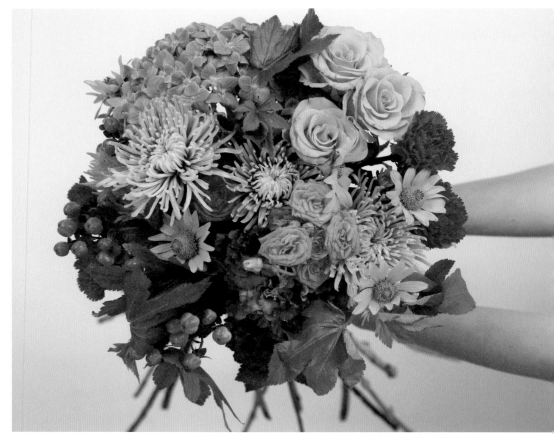

材料

绣球、玫瑰、多头蔷薇、洋桔梗、火龙珠、菊芋、独本菊

　　高纯度相对来说不太好驾驭，因为色彩鲜明，包含了色相环上一些主要的颜色，所以我们需要通过形态、比例来进行控制和调和。高纯度的花艺作品给人一种振奋人心的效果，所以在一些比较安静的场合不太合适，而适合用在品牌发布会、展会上。它的色彩感非常强，具有很强烈的油画感，可以加入一些绿色叶材，起到调和的作用。质感上也可以进行粗糙的、光滑的等多种搭配，以调和色彩。

251 同色相运用原理

这节为大家带来的是花艺色彩的同色相运用。选择的色相是紫色。紫色的色相比较丰富，明度比较低，因此选择花材时浅色和深色都要有。同色相非常容易在视觉上形成统一感、整体感，缺点是会显得单调。

如何克服单调感，可以从几个方面来考虑：第一，可以选择不同明度、不同纯度的花，比如紫色有很多不同的紫，深紫、浅紫等；第二，也可以选择不同纯度的花材；第三，可以选择多种不同种类、形态的花材，块状、线状、散状等，这样作品会变得更加丰盈。还有一点是花器的选择，建议不要选择同色相的花器，稍微拉开一点间隔，比如紫色系配一个墨绿色的花器，这样形成一定的对比关系，从而更加凸显花材本身的色相。

同色相不同纯度不同明度花材

◆标准紫色色相花材。

同色相运用及作品呈现

LESSON 252

这节继续介绍同色相的作品，一个紫色系的花束。以中间的洋桔梗作为标准紫，然后逐步加黑、加白、加灰的效果。

材料

松虫草、洋桔梗、康乃馨、穗花牡荆、鼠尾草、中国桔梗、康乃馨、孔雀草

同色相就是沿着放射线相邻的两个颜色，只要找到相应颜色的花材即可。

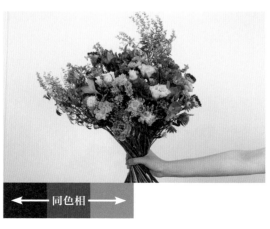

同色相

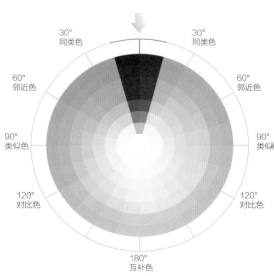

①同色相不同明度与纯度花材搭配。

②利用同色相不同形态花材进行起手。

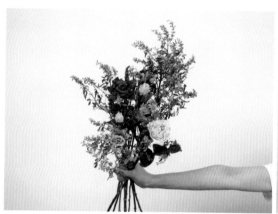

③丰富同色相不同纯度花材。

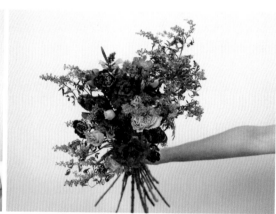

④进一步填充。

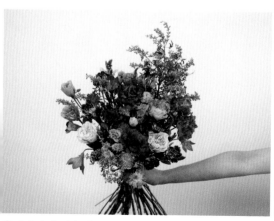

⑤注重浓淡深浅的搭配，强调层次变化。

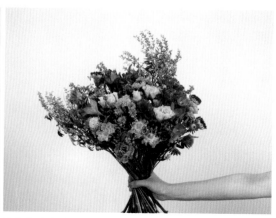

⑥完成花束造型，进行捆扎处理。

邻近色系调和原理

邻近色作为花艺设计当中经常会用到的一种配色手段，可以很好地调和同类色所带来的近似感。邻近色就是在色环上60°夹角范围之内的一系列的颜色。

◆花材自身生长为邻近色配色。

◆花材自身生长为邻近色配色。

◆邻近色组合——橙色与红色对比。

◆邻近色组合——橙色与黄色对比。

◆邻近色组合——黄色与绿色对比。

◆邻近色组合——紫色与红色对比。

邻近色系调和的运用

这节介绍花艺色彩设计中邻近色的运用，以红、橙、黄这几个邻近色为主要基调，主要控制在红色基调上，辅以橙色和黄色。

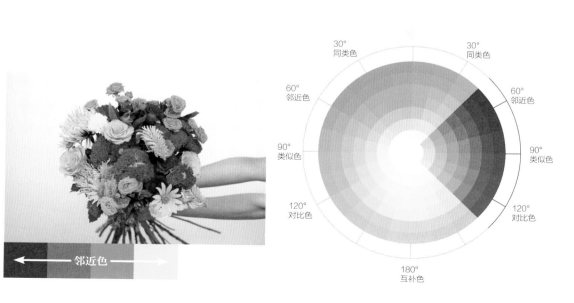

邻近色

材料

鸡冠花、茵芋、多头蔷薇、烟花菊、火炬花、六出
花、玫瑰、翠菊

① 以红色为主色调进行邻近色搭配设计。

② 以橙红色系花材进行起手。

③ 红色系比例超过50%。

④ 丰富邻近色系花材。

⑤ 适当增加黄色系花材，调和整体色彩比例。

⑥ 邻近色搭配花束完成，剪根捆绑处理。

互补色系调和原理

互补色是指在色相环上呈现180°角的两种颜色，在色相上呈现非常大的差异性。比如我们经常吐槽的红配绿，就是典型的互补色。它们在一起会产生很强烈的冲突，是一种强对比的设计手法。其实在花艺中，红花配绿叶其实是一种比较安全的设计，这是因为我们会默认为绿色叶材是一种底色。但是红花配绿花，比如红玫瑰配绿色绣球，就很难调和了。所以，一般在设计中尽量少使用强对比色。

调和的方法：降低纯度，比如黄色和紫色，可以选择明度比较高的花材，它们的纯度也适当低了，看上去对比就不那么强烈；通过分散设计，或者调节两者之间的比例，以一种颜色为主，另一种比例占到10%~15%，也可以适当调和。

另外一种调和的手法就是使用不同颜色的同类花材。

◆ 互补色：高饱和红绿对比。

◆ 同种花材：红绿互补对比。

◆ 互补色：高饱和黄紫对比。

◆ 互补色：高饱和橙蓝对比。

◆ 花材自身生长为互补色。

◆ 不同明度黄紫互补色。

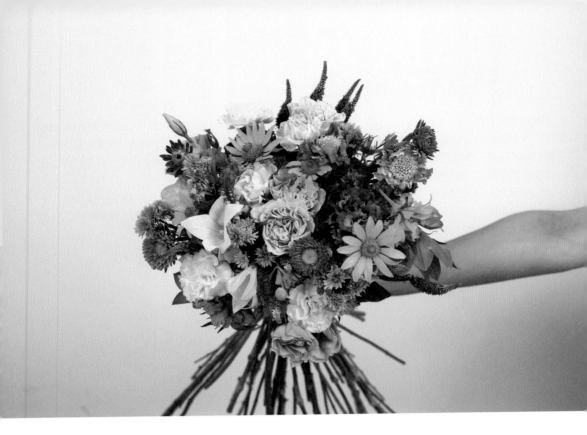

互补色系调和的运用及作品呈现

Lesson
256

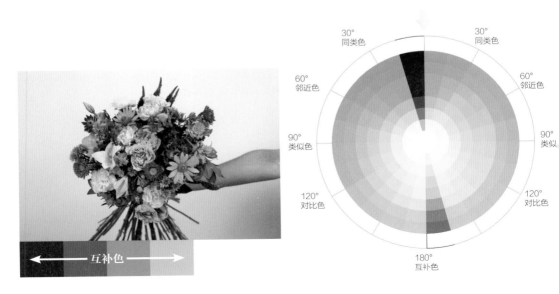

互补色

30°
同类色

30°
同类色

60°
邻近色

60°
邻近色

90°
类似色

90°
类似

120°
对比色

120°
对比色

180°
互补色

① 以紫色和黄色为主色调进行对比色搭配设计。

② 以紫色色系花材进行起手。

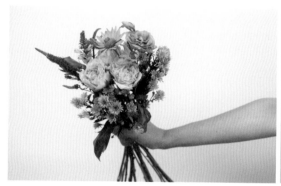

③ 增加不同形态的紫色花材丰富层次。

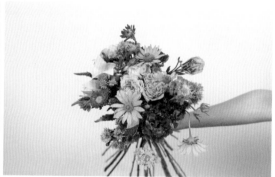

④ 增加小面积黄色花材形成对比关系。

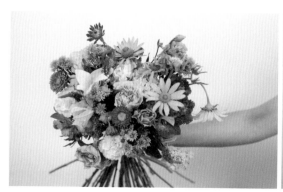

⑤ 继续添加紫色花材，控制两种颜色的比例。

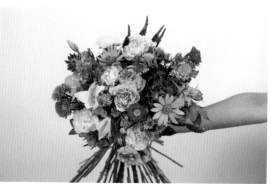

⑥ 调整细节，捆扎完成作品。

分裂互补色调和原理

上节讲了互补色的概念，它会带来一种强对比的关系。但因为对比过强，很容易造成色彩的分裂，它们之间有一种调和的手段，叫做分裂调和。

什么是分裂调和？比如绿色的互补色是红色，以红色作为基准线左右两侧的邻近色，一个是紫红，另一个是橙红，取这两个颜色和绿色再次进行对比，那么这种对比的关系就会减弱。再如蓝色和黄色是互补色，黄色两侧的颜色一个是黄橙色，一个是黄绿色，取这两个颜色再去和蓝色相配，作品冲突感就降低了。用色环来说，它们的形状在色环上会呈现一个"Y"字形。

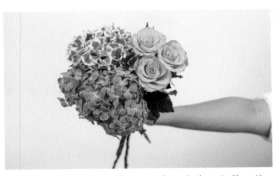

◆降低互补色对比的强烈反差感，多采用分裂互补色形式。

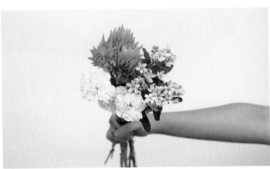

◆分裂互补色组合：橙+黄+蓝。

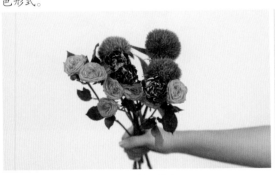

◆分裂互补色组合：绿+红橙+紫红。

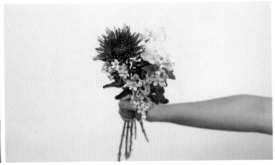

◆分裂互补色组合：黄+蓝+紫红。

◆分裂互补色组合：红+绿+蓝。

◆分裂互补色组合：橙+黄+蓝。

分裂互补色调和的运用及作品呈现

这部分我们带来分裂互补的设计。我们选择红、绿这两个互补色，选择红色的两个邻近色来进行搭配。

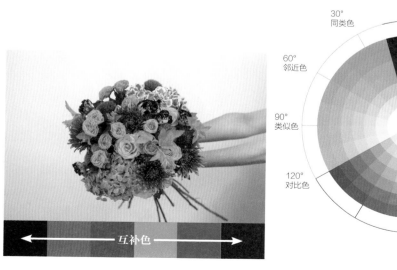

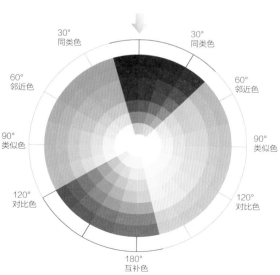

材料

木草莓叶、菊花、多头蔷薇、绣球、须苞石竹、康乃馨

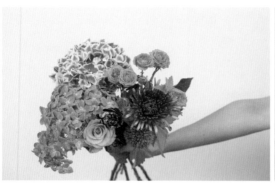

①分裂互补色系花材搭配。

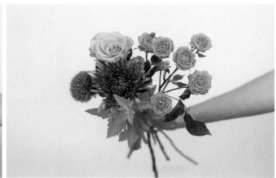

②以红色为主轴，分裂为玫红、红橙与绿色进行对比。

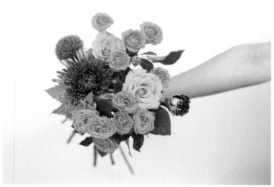

③增加分裂色系色调。

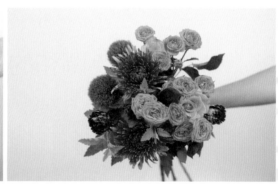

④增加绿色，形成分裂互补。

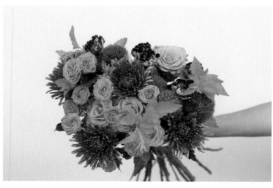

⑤增加对比层次。

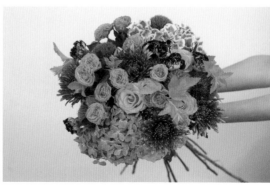

⑥设计完成。

三角配色调和原理

　　除了在色环上呈现180°角的互补色配色之外，还有一种比较强的对比关系，就是我们常说的对比色，对比色是指色相环上相距120°～180°之间的两种颜色，比如三原色，它们在色环上两两之间呈120°，所以它们任意两者都是一组对比色。对比色是仅次于互补色的一种强对比关系，调和难度也会比较大。

　　跟互补色一样，我们也可以通过调和明度和纯度的方法来减少冲突感。另外，有绿色的三角配色，相对来说容易调和，因为绿色是自然的底色，有着天然的调和作用。三个原色放在一起则不太容易，就算减弱其中一种的比例，也很难达到理想的效果。

◆三角配色组合：三原色红、黄、蓝，形成强对比。

◆三角配色组合：不同明度、纯度的红、黄、蓝。

◆三角配色组合：高饱和紫、橙、绿。

◆三角配色组合：不同明度和纯度的紫、橙、绿。

◆三角配色组合：高饱和粉、橙、蓝。

◆三角配色组合：不同明度和纯度的粉、橙、蓝。

三角配色调和的运用及作品呈现

Lesson 260

这节为大家带来的是花艺色彩设计中三角配色的作品演示。在三角配色中我们选择了二次色作为一个配色的标准。二次色就是橙、绿和紫，我们在确定花量的时候，选择了一种接近于均等的设计。这种设计并不会造成特别强烈的视觉冲击，因为绿色在花艺设计中是一种非常安全的调和色。

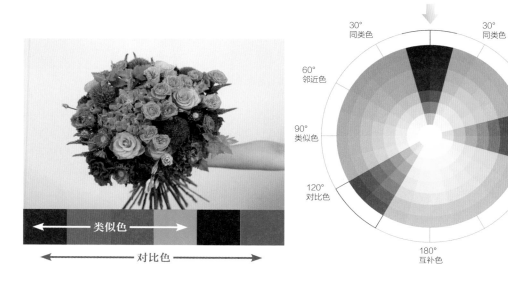

① 三角配色：橙、绿、紫花材组合搭配。

② 以紫色、橙色搭配绿色叶材为起手。

③ 增加绿色绣球，增强对比。

④ 丰富橙色系花材。

⑤ 添加紫色系、绿色系叶材，丰富层次。

⑥ 三角配色调和搭配花束完成。

四角配色调和原理

LESSON 261

　　四角配色法是互补色的一种调和手段。互补色在色环上相距180°，对比非常强烈，可以选择另外一种方式来进行调和，那就是四角配色法。四角配色法的原理就是取互补色左右的邻近色，这样就会产生四种颜色，它依然是一个对比强烈的配色方式，但是相比互补色而言，会变得柔和很多。因为四角配色有四种颜色，所以花材的选择余地更大。

◆邻近色组合：黄、绿色。

◆邻近色组合：紫、红色。

◆形成紫、红、黄、绿四角配色搭配。

◆邻近色组合：蓝、紫色。

◆邻近色组合：橙、黄。

◆形成橙、黄、蓝、紫四角配色搭配。

四角配色调和的运用及作品呈现

这部分带来四角配色的应用。选择红色、紫色、绿色和黄色来演示。以红、紫色系作为主要色系，黄色和绿色作为点缀搭配，绿色的比例稍微多一些，但实际结果绿色会被其他的颜色淹没一些。

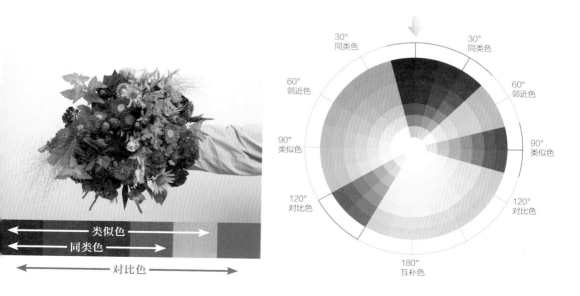

① 运用紫、红、黄、绿四角配色花材搭配。

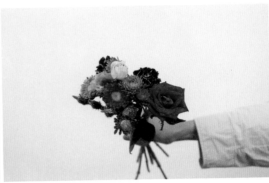

② 以红、紫邻近色为主起手。

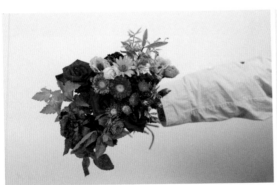

③ 增加黄、绿邻近色组合，形成四角配色。

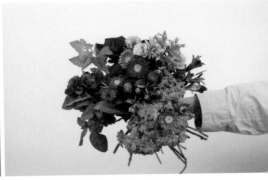

④ 丰富体量感花材。

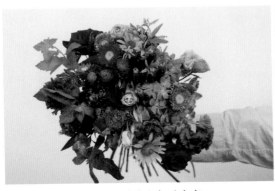

⑤ 色彩相对比较艳丽，层次也相对丰富。

⑥ 作品完成。

263 高明度与低明度对比运用

　　这节为大家带来花艺色彩设计中高明度和低明度对比的一组方案。高明度和低明度对比要控制好比例，如果做成1：1，或者是4：6，会感觉面上有很多的黑斑。可以把比例控制在2：8或1：9。

1 以高明度花材起手。

🌾 **材料**
木绣球、中国桔梗、高山积雪、玫瑰、蓝星花、翠菊、菊花

2 以高明度花材为主，低明度少量，避免过大差异。

3 低明度花材处于稍微靠后位置。

4 不断地加入花材，并且同步进行调整，低明度控制在30%以内。

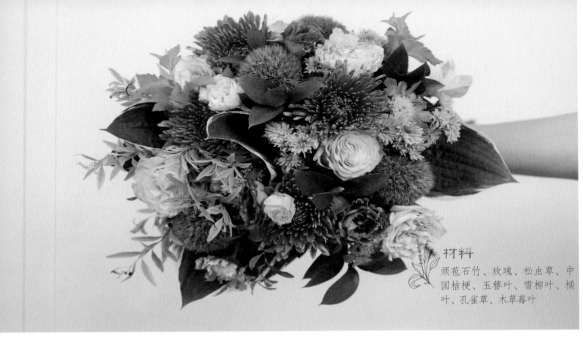

材料

须苞石竹、玫瑰、松虫草、中
国桔梗、玉簪叶、雪柳叶、橘
叶、孔雀草、木草莓叶

264 中明度与高明度对比运用及作品呈现

这节演示中明度与高明度对比的作品。前面说过，明度值如果从1~10进行分级，最亮的是白色，为1，最暗的是10。中明度大概是在4~7之间。中明度的花材给人的感觉比较平和，还会有一些收缩的作用。

①以中明度为主与高明度对比花材搭配设计。

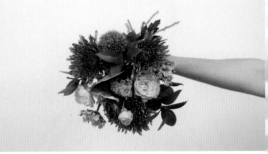

②以中明度花材为主，给人以平和的色彩感受。继续添加高明度花材，使作品更加丰富。

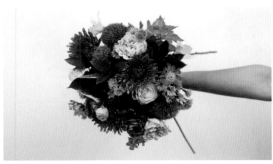

③丰富花材，增强花束对比层次。

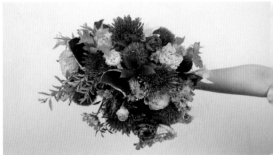

④添加中明度叶材，进行整体造型填充。完成以中明度花材为主、零星高明度花材搭配的花束设计。

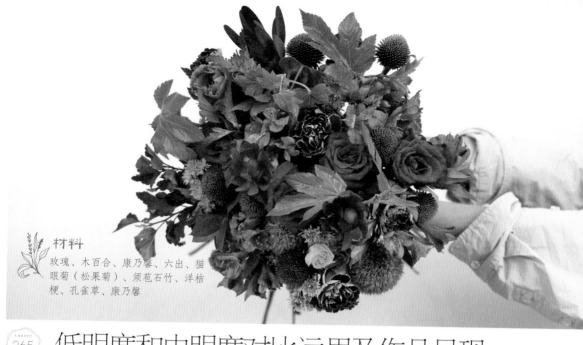

低明度和中明度对比运用及作品呈现

LESSON 265

低明度通常是指7级明度以后的色彩，主要以蓝色、红色、紫色为主，还有一些深绿色的叶子也会呈现低明度。

1 以低明度为主花材与中明度对比搭配设计。

2 低明度主要以蓝、红、紫色为主进行设计。

3 增加中明度花材，点缀花材。丰富叶材，填充造型。

4 不断增加花材，操作过程中注意花茎不要交叉。

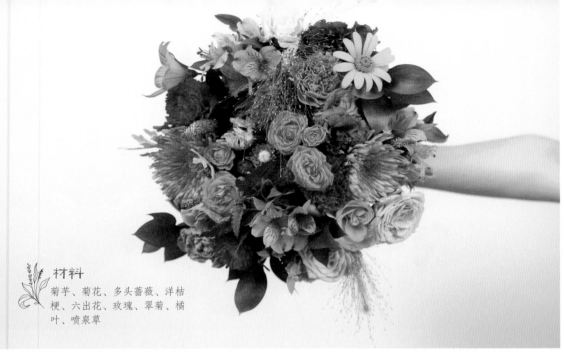

材料

菊芋、菊花、多头蔷薇、洋桔梗、六出花、玫瑰、翠菊、橘叶、喷泉草

Lesson 266　高纯度和低纯度对比运用及作品呈现

　　这节演示高纯度和低纯度对比，低纯度的花如果插在一起会产生高级感，但如果和高纯度的花混在一起时，就会显得有点脏，这时候就需要通过比例和形态来调节。

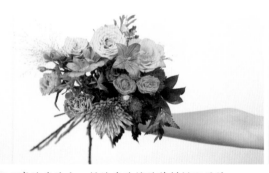

1 以高纯度为主，低纯度为辅的花材搭配设计

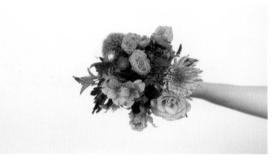

2 以红、橙、黄色系花材进行起手，增加低纯度花材。

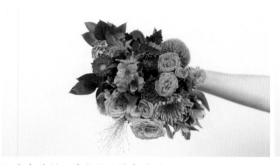

3 丰富花材，填充整体花束造型。

4 适当增加高纯度花材，调和整体色彩比例。

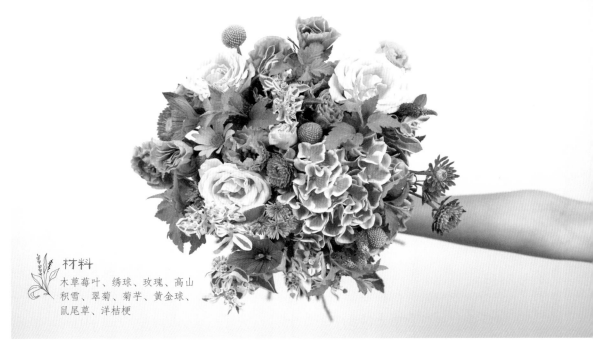

材料

木草莓叶、绣球、玫瑰、高山
积雪、翠菊、菊芋、黄金球、
鼠尾草、洋桔梗

中纯度和高纯度对比运用及作品呈现

　　这节带来的是中纯度和高纯度之间的对比关系。我们选择了一些比较有代表性的颜色，在色相上来说可能是一个邻近色和对比色之间的搭配。中纯度中加入高纯度花材，主要是为了强调和突出色彩的感觉，一般来说不会出现大的差错。

1 以中纯度为主、高纯度作为点缀选择花材。

2 以中纯度花材起手，增加高纯度花材进行调和。

3 丰富花材，填充造型。

4 适当增加高纯度花材，调和整体色彩比例。

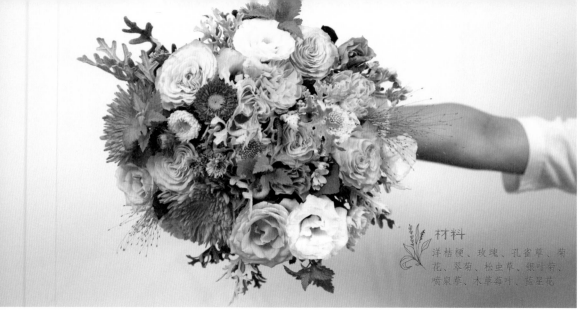

材料

洋桔梗、玫瑰、孔雀草、菊花、翠菊、松虫草、银叶菊、喷泉草、木草莓叶、蕾星花

低纯度和中纯度对比运用及作品呈现

这节讲解低纯度和中纯度之间的对比关系。这里要跟大家说明一下，很多设计师以为低纯度就是深色，但其实纯度最低的颜色是灰色，然后向两侧发展就变亮。降低纯度有三种方法，第一加白，第二加灰，第三加黑。低纯度为主、搭配中纯度的设计一般是比较安全的应用。

①以低纯度为主、中纯度为辅选择花材。

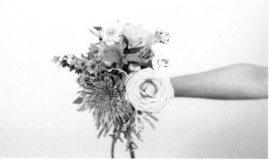

②以紫色与白色花材起手，增加低纯度花材。

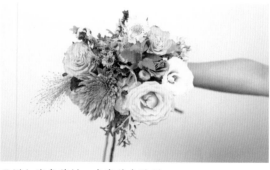

③增加线条花材，丰富花束造型。

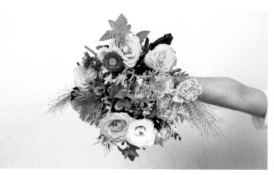

④填充花材，调和整体色彩比例。

色彩的冷暖搭配原理

　　在讲冷暖色之前，我们再回顾一下花艺色彩的三要素，即色相、明度和纯度。这是我们在描述可见的色彩体系中的三个参数。但是冷暖色和这三要素不太一样，它更多地是一种心理感受。比如白色、蓝色给人的感觉是比较凉快，粉色给人很甜美，橙色给人温暖，紫色则显得神秘。我们把色环从黄色开始分成两半，一边是暖色，一边是冷色。黑白灰在色彩冷暖的感受当中，依然规定为一个中性的色彩。按照这种划分，我们可以看到最暖的颜色是橙色，最冷的颜色是蓝色。

　　做配色时，我们也要考虑你具体想表达什么，比如我想表达收敛的、后退的感觉，用冷色会比较多；而膨胀的、前进的，就用暖色较多。

◆暖色系组合花材。

◆暖色系组合花材。

◆冷色系组合花材。

◆冷色系组合花材。

◆冷暖色调组合花材。

◆冷暖色调组合花材。

270 冷色调色彩搭配运用

材料

绣球、中国桔梗、洋桔梗、鼠尾草、蓝星花、银叶菊、橘叶、木草莓叶

这节讲解冷色搭配的示范案例，选择花材以蓝、紫、绿三个冷色作为设计的基础色，同时搭配白色和灰色作为一个中性色的调和，让作品的层次变得更加丰富。

① 以冷色调花材搭配设计。

② 以蓝、紫色系绣球起手，加入绿色绣球，形成整体花束色彩基调。

③ 以白色和银色作为整体衔接过渡。

④ 填充紫色、蓝色系花材，穿插在绿色色块中，打破过大色块聚集的形态。

暖色调色彩搭配运用

这节讲解的是暖色的应用案例。花材从黄色一直到红紫色，可以很明显地感觉到很温暖，其中我们稍微加了一点绿色。

材料

玫瑰、康乃馨、鸡冠花、洋桔梗、黄杨叶、菊花、菊芋、黄金球、六出花、翠菊

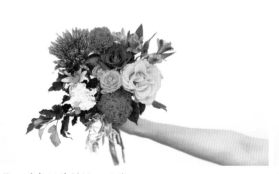

① 以暖色调花材搭配设计。

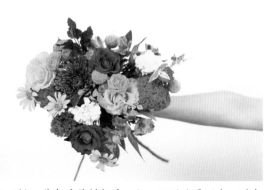

② 以橙、黄色系花材起手。加入不同体量形态、暖色系花材。

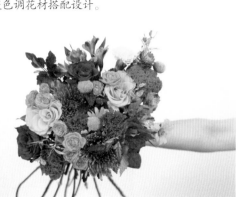

③ 丰富叶材以及花材，进行造型填充。

④ 丰富叶材，完成花束作品。

色彩寓意说明

花材寓意的背后是花文化的体现。东西方的花文化差异其实比较大。比如菊花，在中国商业应用中是一个非常敏感的花材，它代表哀思，被大量用于丧葬文化中，尤其是白色、黄色的，在日本也是这样。但在中国传统文化中，黄色的菊花其实代表着富贵、长寿，尤其是独本菊，居家养菊花的花友非常多。再比如康乃馨，在极个别国家，白色的康乃馨代表着哀思，但很多国家也把康乃馨作为母亲节的花。所以，不同的文化，赋予了花材不同的寓意，中国传统文化赋予了各种植物不同的意义，我们有非常悠久的花文化，所以也倡导大家在实际应用中，遵循咱们自己的花文化。

不同的色彩也会让人产生不同的感受与联想。

红色带来的联想——太阳、血液、火焰、红旗、苹果、心脏等；红色带来的正能量——热情、喜庆，代表爱情，多用于婚礼，七夕节以及情人节也常用，是东方设计常用色彩；同时，也有负向的——警示、危险、愤怒、振奋等。

橙色带来的联想——橙子、橘子、晚霞、落叶等；橙色系带来的感受——和谐、香甜、愉悦、活力等。

黄色带来的联想——阳光，黄金，香蕉，稻谷等；黄色带来的感受——愉悦、光明、希望、成长，适用于儿童花艺沙龙等。

绿色带来的联想——树木、草地、自然、红绿灯等；绿色带来的感受——生命、理想、清新、希望等。

蓝色带来的联想——天空、海洋、宝石、玻璃等；蓝色带来的感受——悠远、宁静、平静，同时也会有理智、冷淡的感觉。

紫色带来的联想——葡萄、茄子、紫罗兰等；紫色带来的感觉——高贵、优雅，深紫色会有一定忧郁、阴沉的感觉。

白色带来的联想——白云、白雪、纸张、牛奶、小兔子等；白色带来的心理感受——纯洁、高尚，所以常用于婚礼中，也表达了简约、纯净；负面的会有冬天的寒冷、哀伤以及虚无感。

粉色带来的联想——桃子、小爱心等；粉色带来的心理感受——甜蜜，代表少女心，负面。

黑色带来的联想——夜晚、墨等；黑色带来的心理感受——黑暗、失望、罪恶、哀悼、沉默等；同时也有一定庄严、严肃、永恒感，商务场合表达专业性。

灰色带来的联想——树干，大地等；有质朴，自然的心理感受。

架 构 经 典 设 计 技 巧

标准榻榻米

榻榻米，顾名思义，它就像在日式料理店的一些寿司卷、竹席一样，这种编织方法被借鉴到了花艺作品当中。其编织方法相对比较简单，一般使用比较坚硬线状花材或枝材比较多，下面是具体的做法。

🌿 **材料**

木草莓叶、乒乓菊、玫瑰、火龙珠、黄金球

1. 榻榻米结构制作

① 将竹丝截成相同长度的若干根，作为榻榻米基础素材。

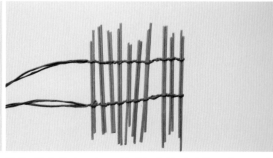

② 每2根竹丝为一组，利用纸皮铁丝旋拧固定，注意每组竹丝间距平均。铁丝务必拧紧，避免竹丝脱落，同时注意铁丝保持平行，间距平均。

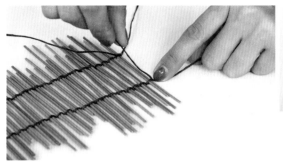

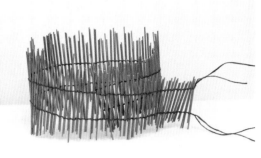

③结尾部分拧紧收尾。

④完整的榻榻米造型。

2. 架构制作

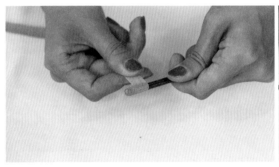

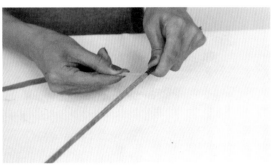

⑤取9根铁丝，戳齐，运用花艺纸胶带缠绕捆绑固定。

⑥手柄部分完成包裹效果。

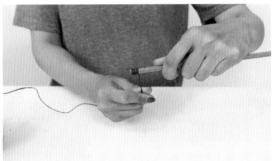

⑦掰开分支，均均分布，形成圆形。

⑧手柄部分用花艺铁丝缠绕，进行包裹装饰。

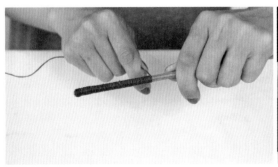

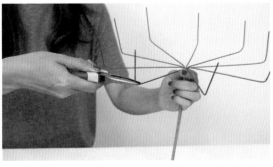

⑨连续缠绕，手柄装饰完成。

⑩弯折分支，形成骨架。

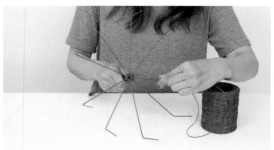

⑪手柄中心部分进行蜘蛛网编织，起到强化固定与装饰作用。

⑫架构骨架完成。

3. 结构链接

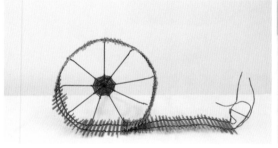

⑬将榻榻米结构包裹于骨架结构外面。

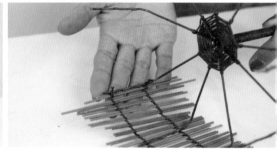

⑭比对弯折结构，对齐，利用纸皮铁丝进行连接固定。

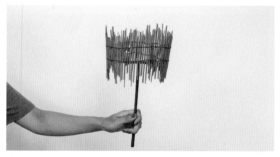

⑮侧面效果展示。充分包裹，同时确保稳定固定。

4. 作品制作

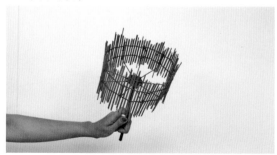

⑯榻榻米手捧结构。

⑰花材填充，调整花材角度，末端进行捆绑固定，剪根，榻榻米架构花束作品完成。

榻榻米技法的变形

这节带来榻榻米变形的水平桌花的设计。标准的榻榻米架构会追求间距平均整齐的效果，变化型则会随性很多。

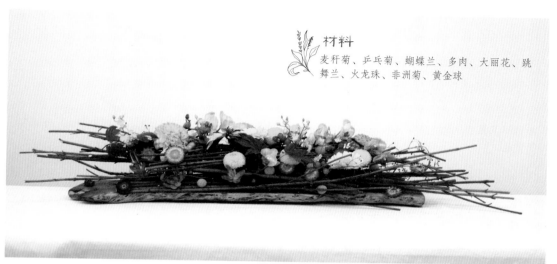

材料

麦秆菊、乒乓菊、蝴蝶兰、多肉、大丽花、跳舞兰、火龙珠、非洲菊、黄金球

1. 榻榻米结构制作

① 对红瑞木进行预处理，提前进行枝杈修剪，保留主枝结构。

② 利用纸皮铁丝进行榻榻米起手操作，做3个绑点。

③ 运用榻榻米编织技法，不断增加红瑞木，形成一定面积。

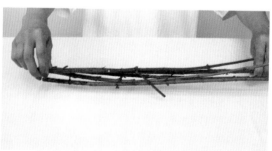

④ 利用红瑞木枝杈结构进行固定，形成榻榻米变形结构。

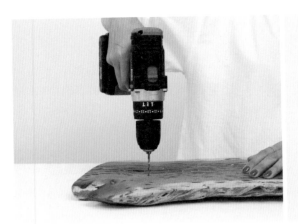

⑤确认好装置点位置，电钻打孔，孔距小于固定结构宽度。

⑥利用粗铁丝，高度适中，弯折为"U"形固定钩，末端斜剪。

2. 基座与榻榻米结构固定

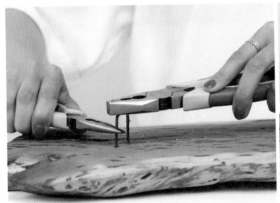

⑦运用锤击方式，将"U"形钩固定在板面上。

⑧"U"形钩固定在木板效果展示，用于连接基座。

⑨利用纸皮铁丝，将红瑞木榻榻米结构与基座固定在一起，形成新的结构。

⑩玻璃试管与塑料试管提前利用纸皮铁丝预处理。

⑪在结构缝隙内部绑扎固定试管。

⑫结构布满试管，确保红瑞木可以起到一定遮挡效果。

3. 添加花材

⑬内部嵌入试管，完整的基座结构展示。

⑭鲜花冷胶粘贴麦秆菊。

⑮利用铁丝以及棕色花艺胶带进行多肉植物预处理。

⑯利用红瑞木缝隙，穿插插入多肉、黄金球等干燥花材。在试管中插入其他鲜花。

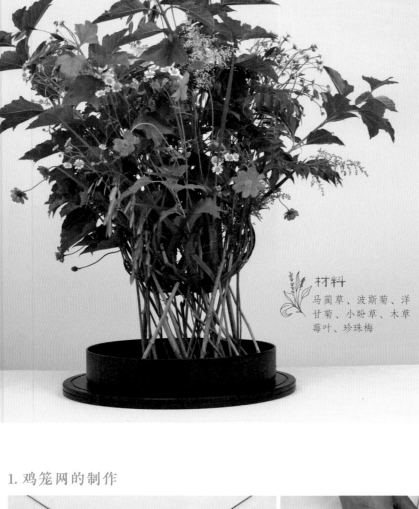

标准鸡笼网技法

鸡笼网作为架构类花艺作品最常用到的技法之一，第一次制作还是有一定难度的，需要大量的练习。最常用到的材料是花艺铁丝。

材料

马蔺草、波斯菊、洋甘菊、小盼草、木草莓叶、珍珠梅

1. 鸡笼网的制作

①取两根绿铁丝，中心点十字交叉，两端旋拧，形成四股。

②一边分支增加铁丝，比对铁丝中心，继续旋拧，保持方向一致。

③用同样方式继续旋拧。叠加铁丝，继续双向旋拧，形成网格，每两根形成平行结构。

④叠加铁丝，增加网格，注意添加的铁丝粗细一致。不断反复操作，形成网状。

⑤边缘多余铁丝截断，形成收口。

⑥收口旋拧，形成多边形。

2. 作品制作

⑦形成一定角度，完成半弧形边缘。半球形鸡笼网编织完成效果。

⑧截断边缘多余铁丝，形成半球形。穿插马蔺草于半球鸡笼网中。

⑨继续添加马蔺草，完成铺底装饰。

⑩利用枝材枝干，形成作品支撑结构。丰富叶材以及花材，完成鸡笼网架构作品。

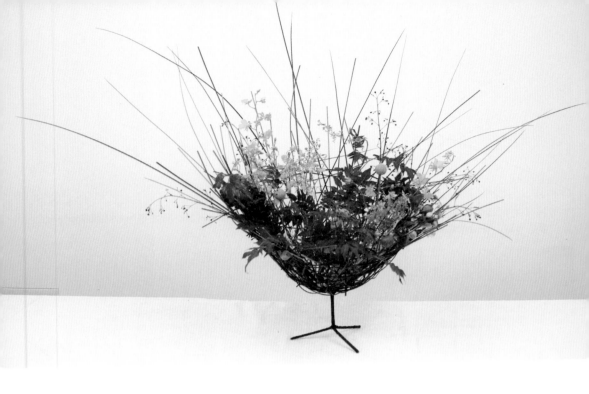

鸡笼网技法的变形

这节为大家带来的是鸡笼网技术的一个变形作品，所用的材料是染色竹丝（绿色）。下半部分做了一个铁丝的支撑结构。因为作品体量轻，所以不需要过于厚重的支撑，用6根16号铁丝就足够的。

材料

木草莓叶、跳舞兰、黄金球、珍珠梅、土人参果

1. 竹丝网结构制作

① 选取绿竹丝，用花艺剪刀截取适当长度。

② 用纸皮铁丝进行竹丝连接。

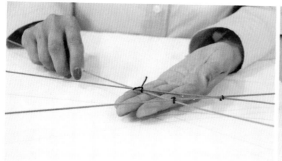

③ 三根竹丝形成稳定三角形，用铁丝固定。

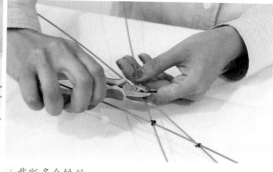

④ 截断多余铁丝。

⑤ 固定后效果展示。

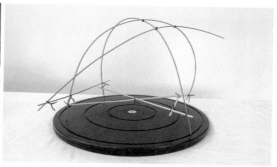

⑥ 利用竹丝韧性，弯折为类似碗状半球形，竹丝末端用铁丝固定，起到骨架支撑作用。

⑦ 逐步添加竹丝，利用纸皮铁丝固定，完成半球形。

⑧ 取3根花艺铁丝，利用纸皮胶带缠绕固定，完成基座结构。

⑨ 用花艺铁丝对基座外部缠绕，进行固定以及装饰。

⑩ 基座完成效果。

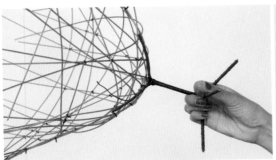

⑪用纸皮铁丝，将两部分结构连接。

⑫连接效果展示。

2. 作品制作

⑬利用网孔间隙，穿插钢草，尖端向上。

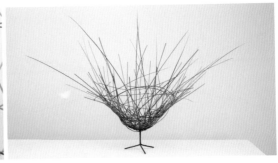

⑭逐步增加钢草，完成打底结构。

⑮利用绿色纸皮铁丝，将试管固定在打底结构上。

⑯用同样固定方式，多个角度预埋试管。

⑰用注水壶向试管内进行注水。

⑱添加花材，完成作品。

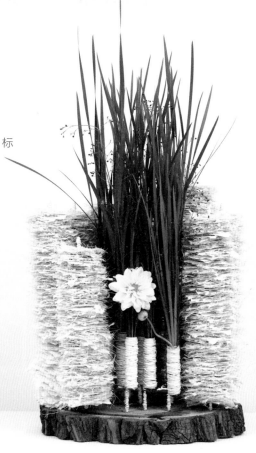

Lesson 277 标准锤击技法

这节主要使用锤击法来演示一个架构作品。标准锤击法可以使用标准钳或者其他偏口钳。

材料
马蔺草、大丽花、土人参果

1. 落水纸处理

① 剪取同规格成条的落水纸，折叠为同面积同形状，边缘以手撕的形式处理，形成自然边缘。

② 以同样的方式做若干落水纸方块。

③将铁丝以45°角斜剪，形成尖角。

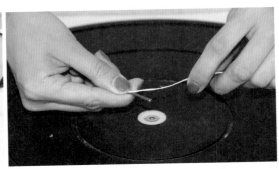

④用纸皮铁丝缠绕16号铁丝，固定起始位置。

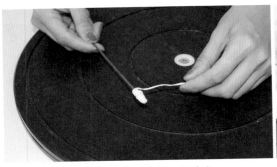

⑤将纸皮铁丝不规则缠绕，形成一定厚度。

⑥将提前处理的落水纸中心串入铁丝，间隔尽量紧密。

⑦末端尽可能贴合、固定，视觉中无缝隙。

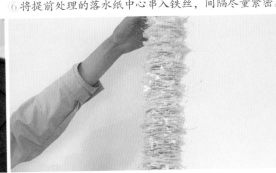

⑧将落水纸逐一穿插，形成无缝隙丰盈状态。

2. 试管装饰

⑨末端预留一定铁丝位置，利用纸皮铁丝缠绕，形成末端固定节点，用于固定与装饰。

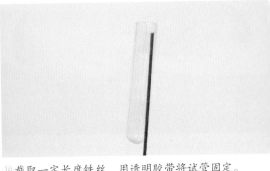

⑩截取一定长度铁丝，用透明胶带将试管固定。

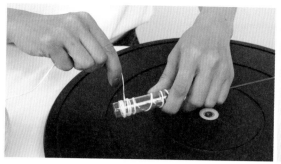

⑪用纸皮铁丝缠绕试管，进行铁丝遮蔽以及试管装饰。⑫试管完整包裹，并且底部进行缠绕装饰。

3. 作品制作

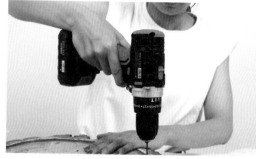

⑬提前在木桩上明确点位，利用电钻钻孔。　　⑭尖嘴钳夹紧底部，利用偏口钳进行锤击固定。

⑮将落水纸纸串沿木桩边缘平均分布，包围外延。　⑯木板中间区域利用电钻提前钻孔，将预处理的试管平均安置其中。

⑰利用注水壶，向试管内注水。　　　　　　　⑱添加花材，作品完成。

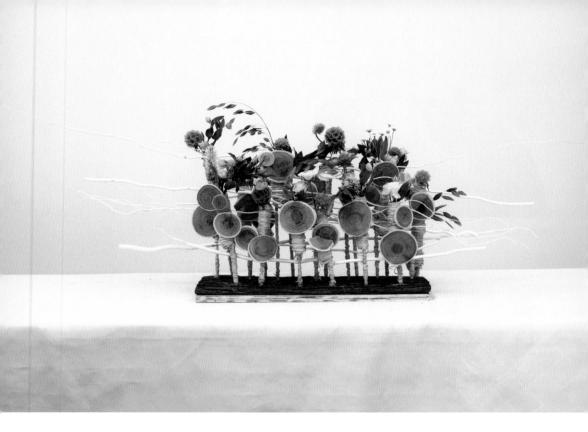

锤击法的变形

　　锤击法使用的材质一般是一些硬性的材料，铁丝类的比较多，但是在这个基础之上，可以稍微做一些小的变形，这个案例用到的竹签是一种非常好的轻质而坚硬的材料。

材料

火炬花、洋甘菊、风车果、小盼草、多头蔷薇、蔻葵

1. 结构制作

①利用五合板作为作品基底，将树皮比对五合板尺寸，用枝剪裁割。

②用泡沫胶进行树皮表面粘合。

③将附有泡沫胶的树皮与五合板进行贴合处理。

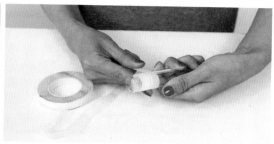

④选取试管，利用花艺纸胶带将木棍与试管缠绕固定，建议两个捆绑点。

⑤固定效果展示，注意试管底部的遮蔽。

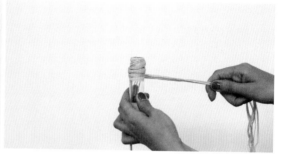

⑥试管表面利用拉菲草进行附着处理。

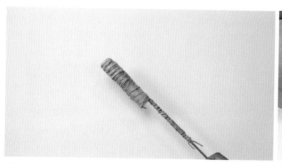

⑦处理后效果展示。

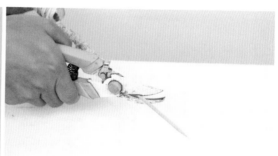

⑧运用枝剪将试管固定杆剪切，形成不同长度。

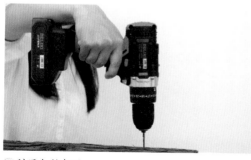

⑨利用电钻打孔。

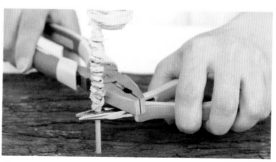

⑩将预处理的试管通过锤击方式固定。

⑪试管固定效果展示。

⑫试管全部固定效果，高低错落，形成一定层次。

2. 作品制作

⑬用胶枪粘合木片背面。

⑭将木片粘到试管外侧，高低错落粘贴，再次进行外部装饰。

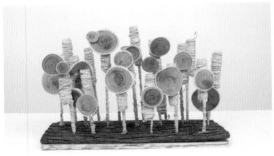

⑮装饰后效果展示，试管高低错落，装饰性木片大小不一，形成一定节奏感。

⑯穿插白龙柳，利用同色纸皮铁丝进行固定，形成新的装饰效果。

⑰试管内注水。

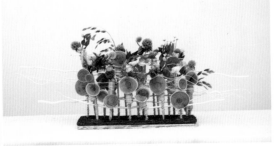

⑱完成作品。

标准蜘蛛网技法

在做架构类作品时，很多时候需要将架构固定在花器上，经常用到的手法就是蜘蛛网技法。这节演示如何用蜘蛛网技法把结构和花器进行固定。

材料

铁丝、纸胶带、蝴蝶兰

1 取9根铁丝，运用花艺纸胶带从中间部分缠绕固定。

2 一端进行分支，平均分配，形成圆形。

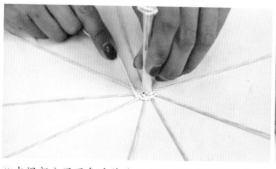

3 中间部分用同色系花艺纸皮铁丝进行穿插缠绕，形成蜘蛛网编织结构。

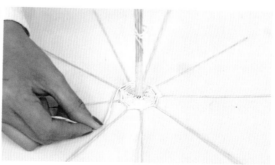

4 用不同编织规则，形成蜘蛛网编织纹样，起到固定、装饰作用。

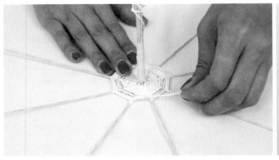

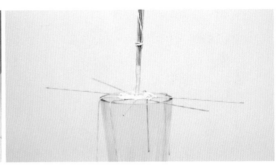

⑤收尾、打结，剪去多余铁丝，收口尽量遮蔽。

⑥花器选择，尽可能瓶口与瓶身口径宽度一致，或者是上大下小的结构，利于平衡固定，将完整结构固定在花器口径中心点。

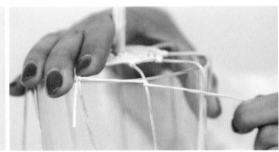

⑦架构底部结构与瓶口拟合，利用尖嘴钳将铁丝部分进行弯折，一般选择对角线位置逐组操作。

⑧截取纸皮铁丝，围绕花器口径进行缠绕固定。

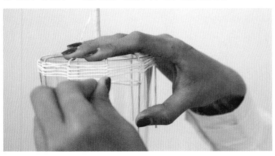

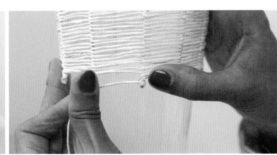

⑨封锁口进行编织，加固。

⑩收尾缠绕，并进行装饰。

⑪固定效果展示。

⑫连接杆部分运用同色系纸皮铁丝缠绕，进行装饰与加固。

⑬装饰后，弯折为一定弧形角度，铁丝对称分支，形成立体扇骨结构。

⑭用同色系纸皮铁丝从分枝底部开始，进行扇形的编织。

⑮同样用蜘蛛网编织手法，完成扇面，单圈缠绕底部分支铁丝，进行第二层过渡。

⑯用同色系纸皮铁丝，沿着扇形骨架，进行穿插编织，形成一定面积，作为加固以及扇形装饰。

⑰将完整的铝丝装饰结构安装至扇形结构上，进行加固，形成完整的蜘蛛网架构。

⑱利用冷胶将花材粘贴装饰至表面，完成作品。

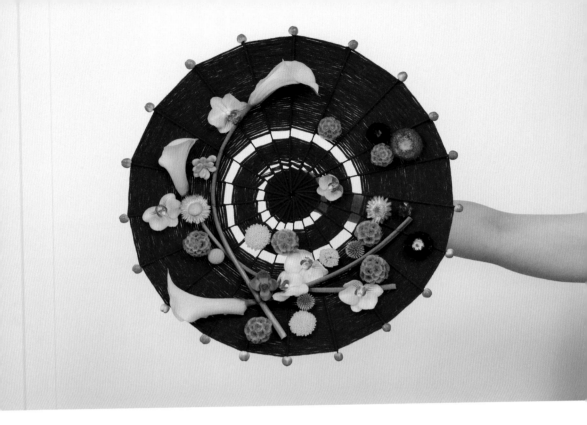

蜘蛛网技法的变形

Lesson 280

这节演示利用蜘蛛网技法制作手捧花。在材质上做了一点小小的改变，选择比较柔软的毛线来作为最基础的材质。

材料

海芋、蝴蝶兰、纽扣菊、黄金球、麦秆菊、多肉、金丝桃果

1. 结构制作

①选取20根铁丝，利用棕色纸皮胶带进行成捆缠绕，固定。

②握持手柄完成状态，底部捆绑固定，头部分散状。

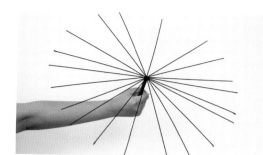

③手柄部分，利用毛线均匀缠绕，进行装饰。

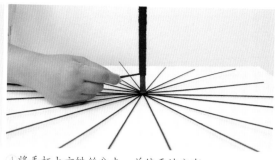

④将手柄上方铁丝分支，并使平均分布。

⑤手柄收尾处毛线不剪断。

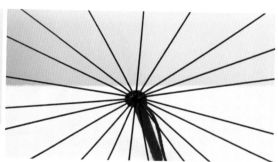

⑥毛线穿插分支，进行蜘蛛网起手操作。

⑦第一层蜘蛛网结构完成。

⑧在分支上粘贴少量双面胶，便于后续结构毛线固定。

⑨继续用蜘蛛网的方式，开始第二层的编织。

⑩利用毛线单支缠绕，完成第第一层到第二层的过渡。

⑪利用毛线单支缠绕，完成到第三层的过渡。

⑫毛线整面装饰正面完成效果。

2. 添加花材

⑬侧面效果，有一定曲面弧度。

⑭用花艺纸皮铁丝旋拧，固定花材。

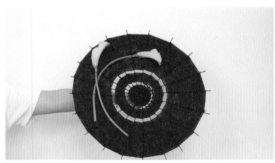

⑮背面多余铁丝剪掉，花材固定后效果。

⑯边缘铁丝剪短，涂抹鲜花冷胶，插入金丝桃果进行边缘装饰。

⑰利用花艺冷胶进行花材涂抹预处理。

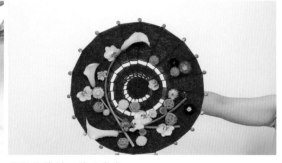

⑱粘上花材，作品完成。

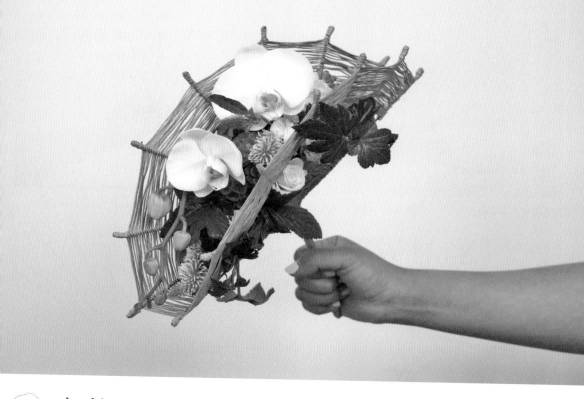

281 架构设计作品 1

　　这节演示架构类的手捧作品。结构上半部分有点像女生拿的小手包，有一些镂空的结构，里面可以布满花，下半部分是持握的手柄。在准备这个结构性铁丝时，一定需要双数，因为结构都是对称的；铁丝长度尽量一致，在制作前戳齐了确认手柄位置之后，再将末端重新剪齐。

材料

木草莓叶、蝴蝶兰、火炬花、玫瑰、风车果、多肉

1. 结构制作

1 取14根铁丝，末端用绿色纸皮胶带进行缠绕，捆绑固定形成手柄。

2 运用原色纸皮铁丝对手柄处缠绕，装饰。

③将铁丝每2根1组，平均分成7组，形成正反半圆扇形造型。

④顶视图参考，调整间距，使左右前后均匀对称。

⑤将手柄收尾处的纸皮铁丝继续均匀穿插缠绕分支。

⑥第一层编织完成效果。

⑦正反两层编织效果展示，确保两面分布均匀，中心对称。

⑧连续单根缠绕，完成到第二层的过渡。

⑨第二层编织效果展示。

⑩逐步叠加，完成第二层结构，扇形结构编织完成。

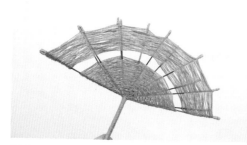

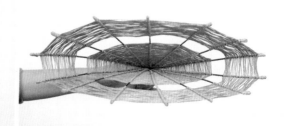

⑪收尾边缘，利用纸皮铁丝缠绕遮蔽。

⑫内部结构展示。

2. 作品制作

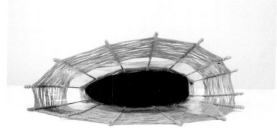

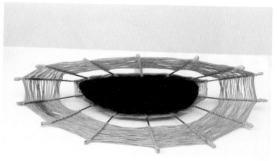

⑬放置玻璃纸，以及浸泡切割好的花泥。

⑭修剪多余的玻璃纸，修剪后完成效果展示。

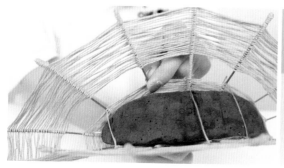

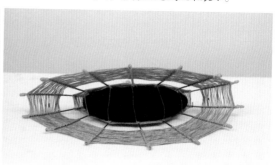

⑮利用同色纸皮铁丝，沿着扇形结构打结，进行花泥固定，收口靠内侧，避免外露。

⑯花泥固定后效果展示。

⑰填充花材。

⑱作品完成效果。

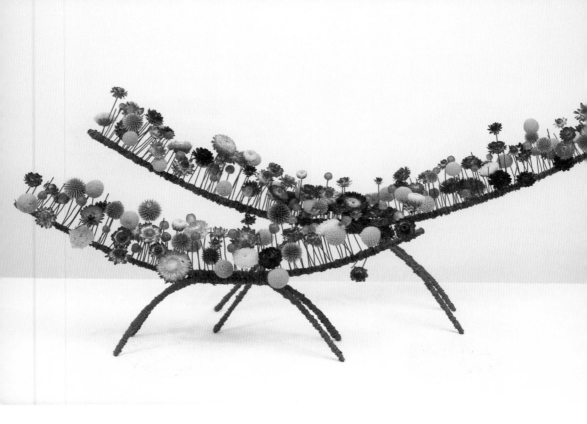

架构设计作品 2

这节演示的是一个铁丝架构的花艺作品。

材料

麦秆菊、纽扣菊、火龙珠、蓝刺头

① 选取10根同样长度铁丝，戳齐。

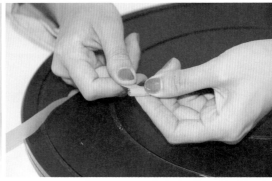

② 用花艺纸皮铁丝固定铁丝头部。

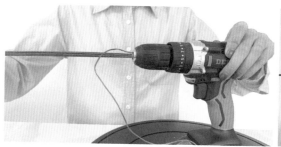

3 将固定成捆的铁丝插入钻头处，并插入纸皮铁丝。

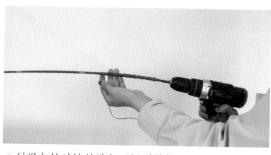

4 利用电钻对铁丝进行不规则缠绕。

5 铁丝装饰效果展示。

6 选取成捆的铁丝，找准长度参考，比对标记长度。

7 中间节点位置，用纸皮铁丝进行缠绕装饰。

8 中间部分缠绕效果展示。

9 中间部分两侧长度保持一致，平分铁丝根数，进行分支。

10 分支角度不宜过大，要有一定弯折度。

⑪运用纸皮铁丝将支脚分支部分进行固定，并用铁丝装饰缠绕。

⑫基底铁丝装饰效果展示。

⑬利用同色纸皮铁丝，将两部分进行固定连接，形成整体结构。

⑭基座完成效果展示。

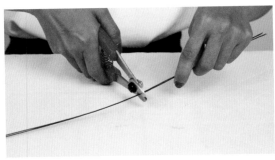

⑮利用铁丝钳，截取同样长度铁丝。

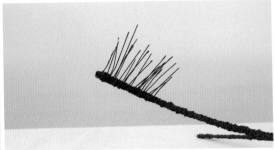

⑯将铁丝缠绕至基座结构上，间距适当，预留花材展示位置。

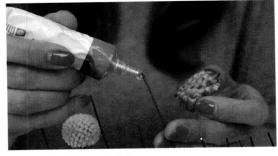

⑰利用花艺冷胶粘合花材。

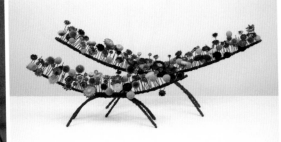

⑱作品完成。

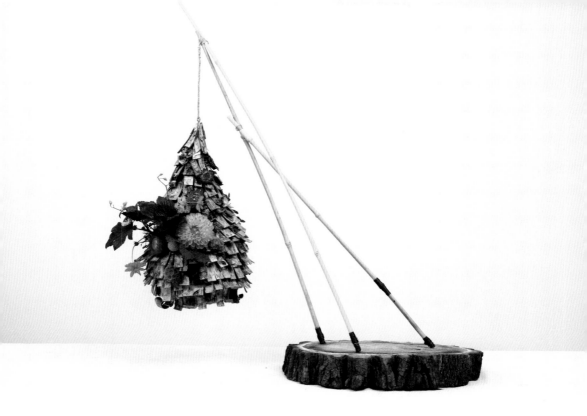

架构设计作品 3

这节继续演示架构类花艺作品，这个作品中综合运用了很多架构类的经典技法，比如最基础六角网编织方法等。

材料

木草莓叶、大丽花、麦秆菊、跳舞兰、波斯菊、风车果

1. 结构制作

① 六角网编织，网孔约为1元硬币大小。

② 编织成水滴造型鸡笼网，顶部收缩成尖状，形成水滴头部。

③ 顶部制作成钩形，形成吊点。

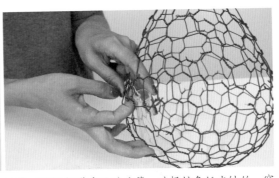

④ 尽可能选择带有孔的试管，选择棕色纸皮铁丝，穿插试管孔口，将试管缠绕至鸡笼网，旋拧固定。

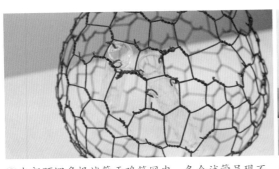

⑤ 内部预埋多根试管于鸡笼网内，各个试管呈现不同角度，充盈内部。

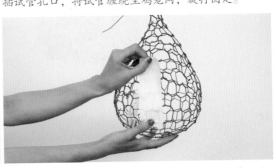

⑥ 用美纹纸覆盖整个鸡笼网水滴表面，预留出试管位置。

2. 结构装饰

⑦ 用美纹纸完整包裹结构。

⑧ 将树皮预处理，剪裁成相同大小的小木片若干。

⑨ 用热熔胶枪将白桦木木片粘贴到美纹纸表面。

⑩ 逐层粘贴树皮，层层贴合。

3. 基庄支撑制作

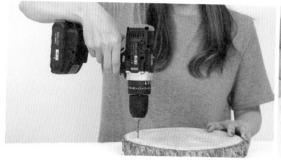

⑪利用电钻在木桩上定点打孔。

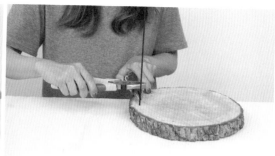

⑫利用钳子锤击，安置支撑铁丝。

⑬利用金属铁丝包裹竹棍竹节处进行装饰。

⑭将装饰后的竹棍放置在铁丝上，呈一定角度倾斜，完成底座支架。

4. 填充鲜花

⑮向试管内注水。

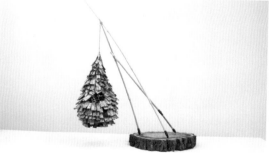

⑯水滴形结构顶部利用同色系纸皮铁丝制作挂钩，悬挂在底座支架上，操作过程中注意支架平衡性，调整位置避免失重。插上鲜花作品完成。

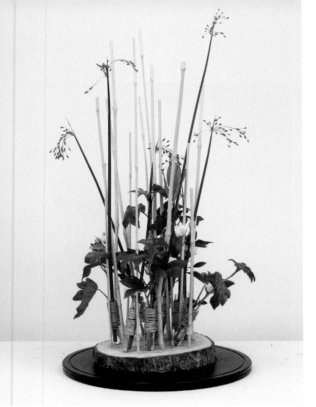

架构设计作品4

这节为大家带来的是基于锤击法的竖直的架构作品案例。

材料

木草莓叶、水葱、多头蔷薇、木百合

1. 结构制作

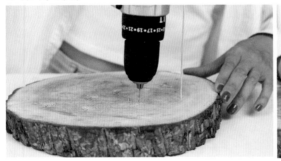

①利用电钻对底座木板钻孔，孔洞尽可能平均分布。

②提前剪取若干铁丝，锤击将铁丝固定。

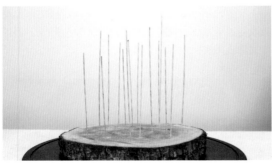

③铁丝固定后效果展示。

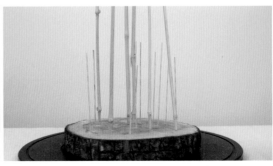

④将竹竿逐一套入铁丝上，形成加固与装饰。

2. 作品制作

⑤将所有竹竿插入铁丝，确认作品高度，剪除多余部分，完成基本支撑结构。

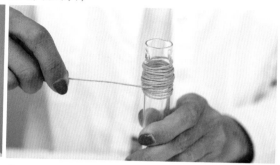

⑥利用同色系纸皮铁丝，包裹试管外壁进行装饰。

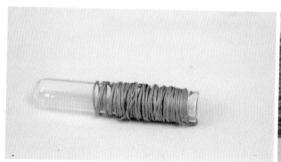

⑦试管装饰效果。

⑧将试管固定在竹竿底部，每个试管连接两个绑点。

⑨利用注水壶向试管内注水，水不宜过满。

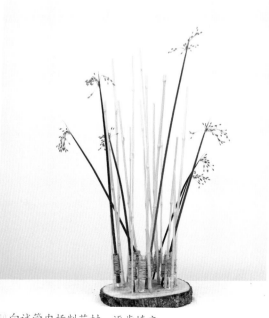

⑩向试管内插制花材，逐步填充。

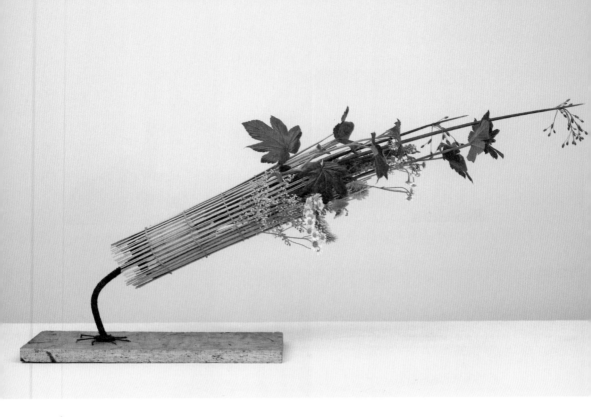

架构设计作品 5

Lesson
285

这节继续演示综合类的架构花艺作品。作品会用到很多架构技巧，其结构通过榻榻米技法来完成。

材料

木草莓叶、水葱、洋甘菊、珍珠梅叶、火炬花

1. 结构制作

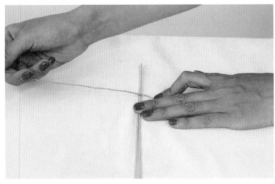

① 以2根竹丝为一组，利用同色系纸皮铁丝固定。

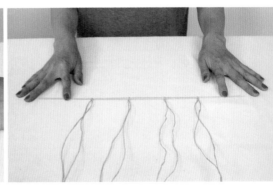

② 每组竹丝平均间隔固定4个绑点。

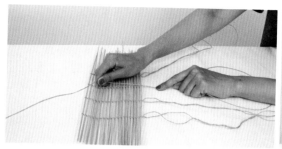

③用同样的方式，逐步增加层次。

④榻榻米结构完成。

⑤用棕色花艺纸皮胶带包裹铁丝，用于手柄结构固定。

⑥用黑色纸皮铁丝包裹铁丝，用于外部装饰。

⑦增加多根铁丝，再次利用棕色纸皮胶带一一进行缠绕捆绑。

⑧将手柄部分完全用黑色纸皮铁丝缠绕装饰。

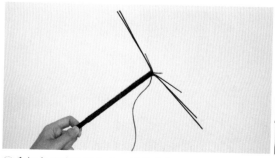

⑨手柄末端将铁丝分支，形成雪花形状。

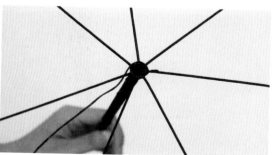

⑩平均分布后，利用纸皮铁丝继续穿插缠绕。

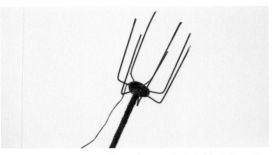

⑪逐步增加层次，形成蜘蛛网，将剩余铁丝部分弯折，形成收拢状态。支撑结构完成。

⑫底部支撑铁丝进行一定预留，周边细铁丝组成雪花状。支撑基座部分完成，底座弯折为一定倾斜角度。

2. 结构固定

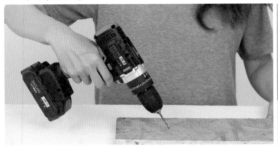

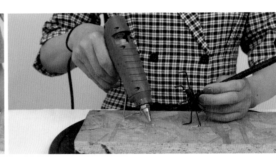

⑬选取基座木板，比对支撑基座的支撑点留出钻孔位置，中间孔位利用电钻，成45°角钻孔。再比对周边支撑点位置，垂直钻孔。

⑭中间固定点周边利用胶枪铺胶，用于辅助固定。

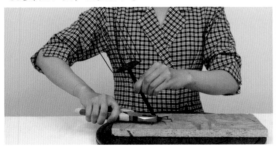

⑮锤击将支撑结构固定在木板上。

⑯将榻榻米结构用同色纸皮铁丝包围连接在基座之上，多个绑点固定。

3. 作品制作

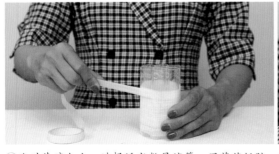

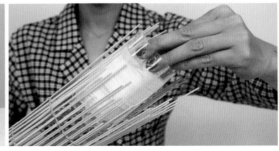

⑰比对基座大小，选择适当数量试管，用花艺纸胶带进行捆绑固定，内部45°注水。

⑱将预处理的试管结构放置于基座内，用于插花。

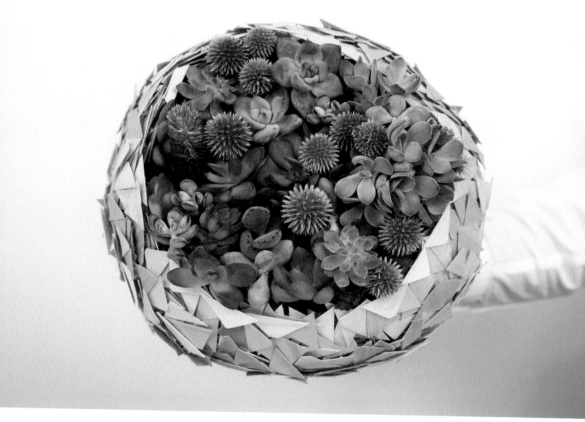

架构设计作品 6

这节为大家带来的是一个架构类的花艺手捧，基础结构部分使用蜘蛛网的技法。

材料
多肉、蓝刺头、火炬花

1. 结构制作

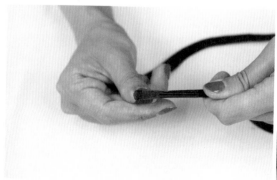

1 取9根铁丝，戳齐，利用花艺纸皮胶带进行缠绕，固定成握柄。

2 将上部铁丝分支，平均分开，形成圆形结构。

③根据手捧体量，将铁丝进行弯折。

④剪除多余铁丝，形成手捧支架结构。

⑤手捧中间部分利用纸皮铁丝起手进行蜘蛛网编织。

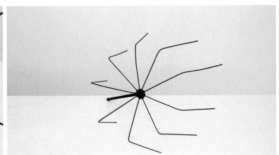

⑥中间蜘蛛网编织完成效果。

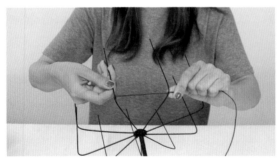

⑦边缘包围部分，从底部开始利用纸皮铁丝缠绕起手。

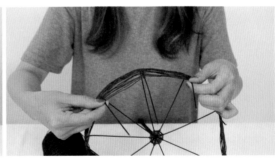

⑧边缘不断利用纸皮铁丝缠绕，形成一定面积包裹结构。

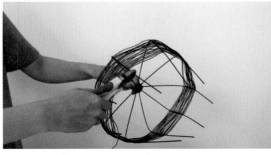

⑨多余铁丝部分，利用钳子剪除。

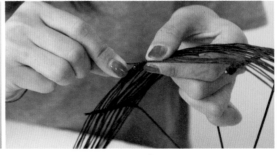

⑩边缘再次用铁丝缠绕做遮蔽处理。

2.结构装饰及花材填充

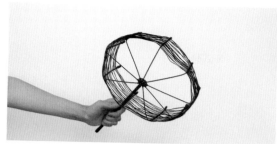

⑪架构基础部分完成。

⑫将宽竹片裁剪成若干三角形贴片。

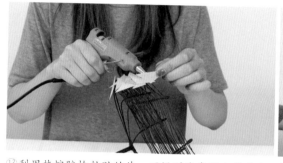

⑬利用热熔胶枪粘贴竹片，不规则地多层次多角度粘贴于结构表面。

⑭侧面拼贴装饰竹片，利用剪刀对边缘修正。

⑮运用编织技巧，底部均匀穿插长条竹片，利用胶枪对连接点固定。

⑯同样利用胶枪在底部粘贴竹片，完成外部装饰。

⑰内部填充码笼网，作为花材固定结构。

⑱填充花材，完成架构手捧作品。

花　　　束　　　制　　　作

螺旋花束

Lesson 287

螺旋花束制作是花艺师最需要掌握的基本功，因为花束销售在花店的业务中占比非常大，95%的花束中运用到了螺旋的技巧。下面演示螺旋的基本方法。

材料

多头蔷薇、翠扇、喷泉草

①螺旋花束状态，花店常见花束类型，花材分布平均，整体造型可控性强。

②四象限分布示意图。

③以自己为参照物，朝向自己为前，远离自己为后，花头冲左，花杆向右，从前往后加。

④花头向前，花杆向后，从右往左加。花头向右，花杆向左，从后往前加。

⑤花头向后，花杆向前，从左往右加。

⑥持握点确认，一般上半部分占比2/3，下半部分1/3。

⑦在一象限位置加入花材。

⑧在一象限位置加入花材。在各个象限位置填充花材，操作过程中时刻关注整体造型。

⑨剪根处理，要求底部持平。

⑩螺旋花束完成，侧视效果展示，可以自主立于桌面。

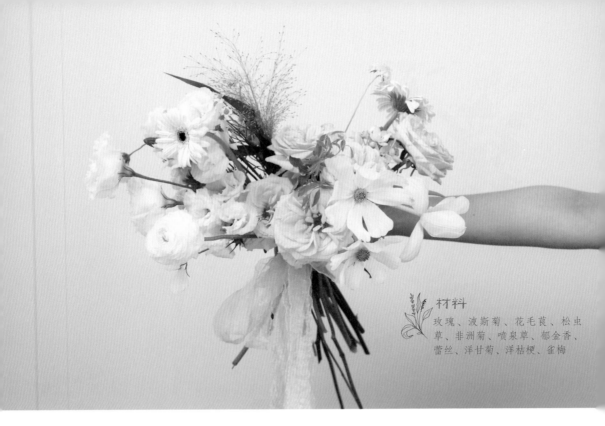

288 交叉花束

交叉花束一般适用于偏自然风格的花束，它和螺旋结构的花束还是有很大差异的，这部分演示交叉花束的做法。

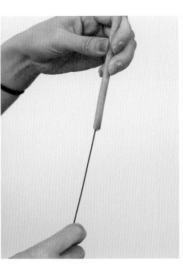

①郁金香花瓣翻开，拟合出花朵绽放的状态。

②花毛茛、非洲菊等空心花秆或者花秆比较脆弱的花材，穿入铁丝加固。

③以粉色玫瑰、喷泉草进行起手。

④利用交叉手法进行花束制作处理，注意手不宜握得过紧，花头朝向各个角度，形成自然状态。

⑤利用纸皮铁丝捆绑固定。

⑥丝带装饰手柄，花束完成。

⑦剪裁鸡笼网成长条形。根据花束大小，弯折为立体鸡笼网圆柱，一般长度与高度比例3∶1。

⑧利用鸡笼网固定花材。

⑨在鸡笼网内外侧添加花材。外部添加缎带装饰。

⑩鸡笼网收拢，进行花秆固定。

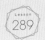

平行花束

平行花束，一般新娘手捧花用得比较多一些，因为相对来说比较容易持握，下面是制作步骤。

材料
非洲菊、天鹅绒、小飞燕、松虫草、喷泉草、须苞石竹、崔梅

①选取主花材起手操作。

②增加花材，花茎平行。

③丰富花材，花头高低错落，制造一定层次感。

④增加花材，花茎保持平行。利用透明胶带对花茎固定捆绑。双边捆绑固定后剪根处理。

⑤将花茎从底部进行缎带固定。

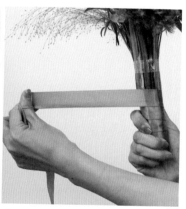

⑥用缎带从底部向上缠绕包裹。

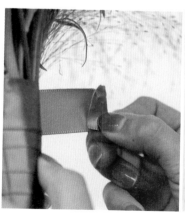

⑦收尾处缎带折回少许，隐藏修剪毛边。

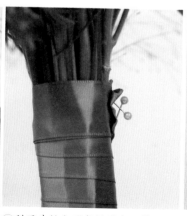

⑧利用珠针上下交错固定缎带。

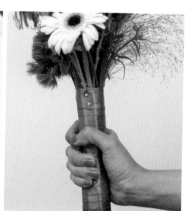

⑨手柄装饰完成。

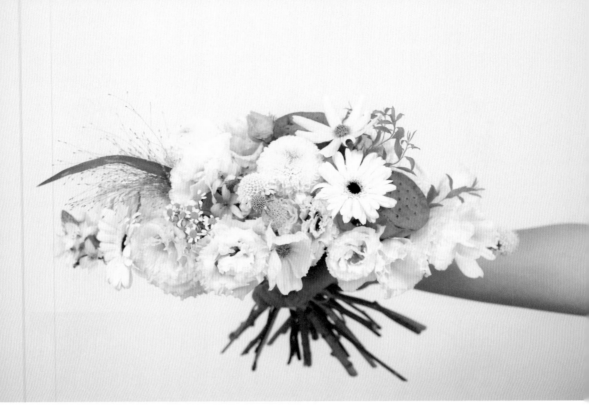

架构花束

LESSON 290

这节带来一个特殊造型的花束，比较简单的架构花束的制作方法。一般以螺旋技法或者平行技法做出来的花束，其形态都会受到限制，在顶视图上大部分都接近于圆形、椭圆形。如果我们想要一些创新，比如像月牙形、桃心形，就需要用到架构的技法。

材料

莲蓬、非洲菊、乒乓菊、洋桔梗、洋甘菊、波斯菊、松虫草、雀梅

1. 结构制作

①利用花艺纸胶带充分包裹单根铁丝，4根铁丝完成同样操作。

②将4根预处理的铁丝戳齐，从底部开始，利用花艺纸胶带包裹缠绕至一半长度处。

③将4根铁丝上部交叉成"X"形,形成手柄支座。

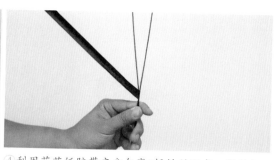

④利用花艺纸胶带充分包裹2根铁丝形成一根较粗形态,以此操作完成另外2根铁丝的处理。

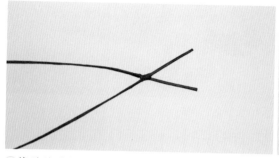

⑤将刚刚预处理的两根粗壮铁丝头部交叉,用花艺纸胶带缠绕固定,两端头部都完成此操作。

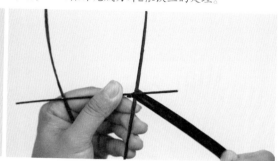

⑥剪取短铁丝,同样进行包裹预处理,用花艺纸胶带固定。

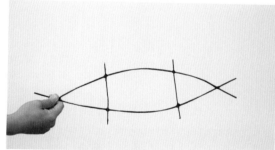

⑦用同样的操作步骤,完成基础结构。

⑧用花艺纸胶带缠绕,连接手柄以及基础结构。基座完成效果展示。

2. 花束制作

⑨比对结构,剪取鸡笼网,附着于基座表面,用于花材固定。

⑩将所需花材填充至结构中。

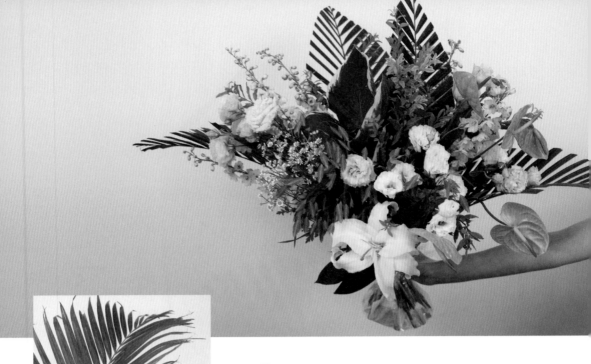

① 散尾葵预处理，将边缘叶尖剪除。

291 花束设计 1

这节演示比较大体量的，市场上称为"熊抱花束"或"腿上花"的花束。

材料

百合、洋桔梗、洋甘菊、绿掌、玉簪叶、雪柳叶、小飞燕、散尾葵

② 利用竹签以及防水胶带，附带软试管，进行绿掌花茎加长处理。

③ 大飞燕草成组捆绑预处理。

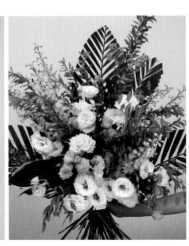

④ 利用散尾葵以及大飞燕草起手操作。剪根，然后进行保水处理。

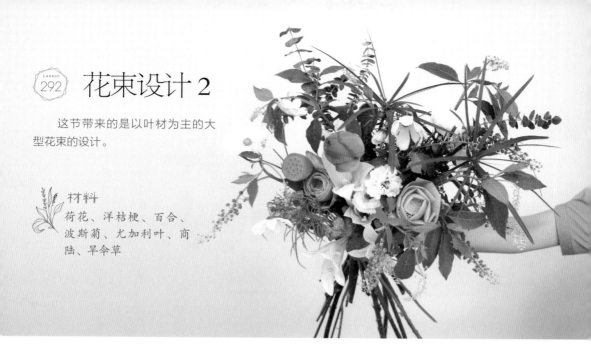

花束设计 2

Lesson 292

这节带来的是以叶材为主的大型花束的设计。

材料
荷花、洋桔梗、百合、波斯菊、尤加利叶、商陆、旱伞草

①将荷花花瓣对折收回，进行造型预处理。

②用叶材以及商陆起手设计。增加叶材，形成花束整体轮廓。

③加入预处理过的荷花及其他花材，调整花材高度，完成以叶材为主的大型花束设计。

④麻绳沾湿，进行花束固定捆绑，最后剪根保水处理。

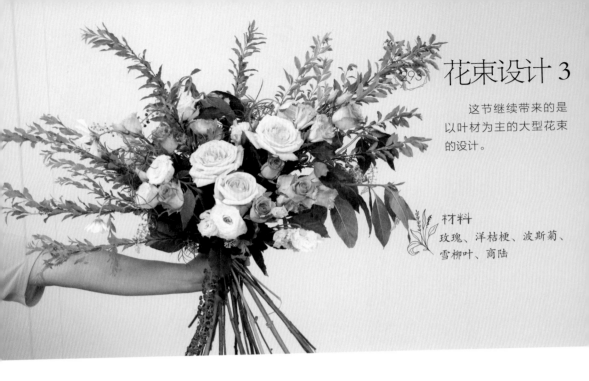

花束设计 3

这节继续带来的是以叶材为主的大型花束的设计。

材料
玫瑰、洋桔梗、波斯菊、雪柳叶、商陆

①运用玫瑰、商陆、雪柳起手设计。

②进一步丰富花材以及叶材，进行填充。

③麻绳沾湿，捆扎起手。

④剪根，进行保水处理。

Lesson 294 花束设计 4

这部分给大家主要讲述单品种花材的花束设计。

材料
玫瑰

①3支花进行起手，形成螺旋，也可以先选择同色同种花材起手。

②逐步增加花材，保证捆绑点螺旋状。形成圆形螺旋手捧。

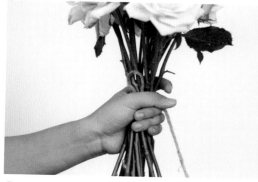

③麻绳提前沾湿或浸泡，进行单绑法固定，缠绕3～4圈。

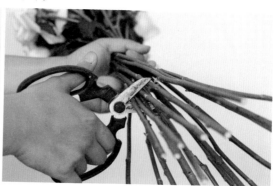

④剪根处理，上部占比2/3，下部占比1/3。

Lesson 295 花束设计 5

这个作品是一个夏日感觉的花束设计，在选择花材时，需要从颜色、质感等几个方面来进行考虑。黄色、蓝色、白色比较符合夏天的感觉。

材料

向日葵、洋桔梗、乒乓菊、非洲菊、莲蓬、小飞燕、洋甘菊、蓝星花、喷泉草

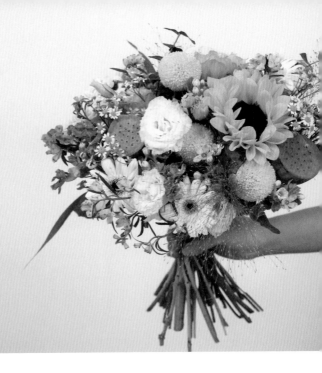

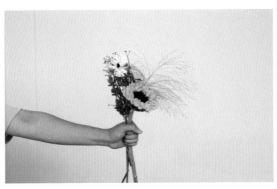

① 花束起手操作，采用螺旋式。

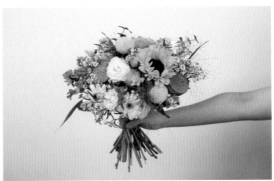

② 逐步丰富花材，喷泉草花材可以稍高一些，制造轻盈感，整体花束形成轮廓。增加小的花材，进行修饰，形成一定高低错落的层次感，四面观花束完成。

③ 将麻绳打湿，进行捆绑固定。

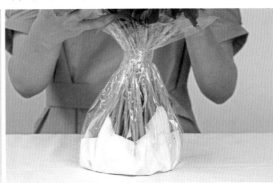

④ 利用玻璃纸进行保水处理。

花束设计 6

LESSON 296

这节演示组群花束的设计，当花材种类比较少，单种体量比较大时，比较适合用组群的设计来进行制作。

材料
蝴蝶兰、火焰兰、玉簪叶、龟背叶、紫叶风箱

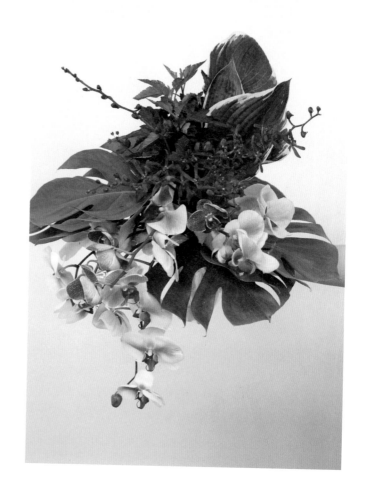

①利用组群技巧进行花束设计，用龟背叶起手。

②增加紫叶风箱组群、蝴蝶兰组群。

③利用纸皮铁丝进行花束捆绑。

④利用棉纸和玻璃纸做水袋。

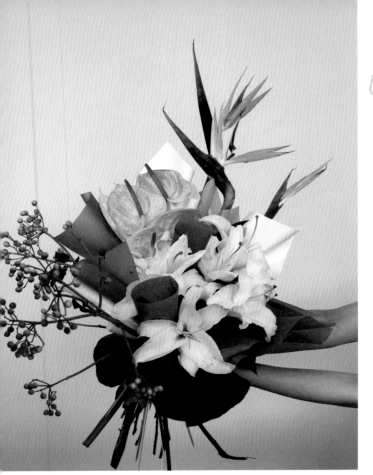

花束设计 7

这个作品演示分体式的花束包装设计。

材料

百合、红掌、荚蒾果、鹤望兰（天堂鸟）、龟背叶

① 选取包装纸等非花材材料进行预处理，利用胶带将材料与竹竿固定。

② 花材分组，利用透明胶组群固定。将非花材材料与百合组群组合，用透明胶带捆绑固定。

③ 将非花材材料与绿掌组群组合，透明胶带捆绑固定。

④ 将各组进行组合，添加鹤望兰，形成组合效果。再加入荚蒾果、龟背叶，丰富造型层次感，利用麻线进行捆绑固定，完成花束制作。

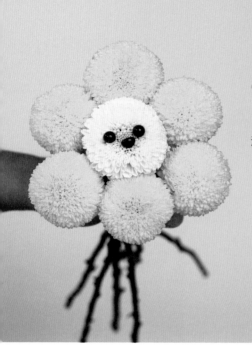

花束设计 8

这节带来一个富有童趣的花束设计，非常适合亲子沙龙活动制作。

材料
乒乓菊

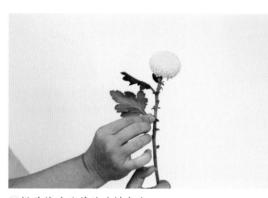

①提前将乒乓菊的叶材去除。

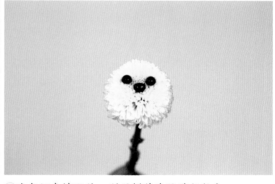

②准备好表情配件，利用鲜花冷胶进行粘合。

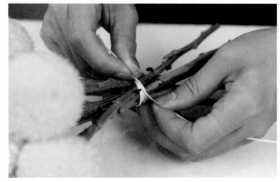

③利用四面围合的形式，将黄色乒乓菊进行围合，完成造型。利用纸皮铁丝进行花束固定。

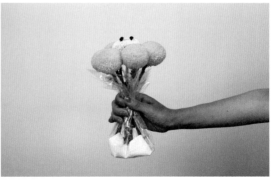

④做剪根、保水处理。

花束设计 9

这部分演示是直立型的花束，以叶材为主的绿色系。

🌿 材料

散尾葵、雪柳叶、龟背叶、天鹅绒、莲蓬、蒲棒叶、玉簪叶

① 蒲棒叶戳齐，弧度在外侧，内扣成圆，用透明胶带进捆绑。

② 用透明胶带捆绑成组效果展示。

③ 进一步丰富花材以及叶材，进行填充。以组群形式进行花材成组添加，保持整体直立上升形态。

④ 进一步填充花材以及叶材，丰富整体造型。捆绑，剪根，进行保水处理。

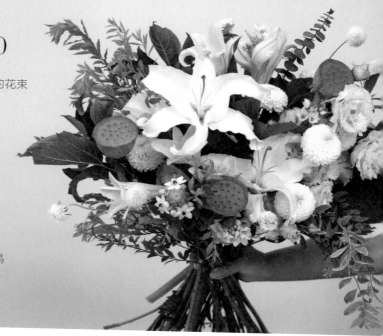

花束设计 10

Lesson 300

这节带来的是以白、绿色为主的花束设计。

材料
百合、乒乓菊、洋桔梗、天鹅绒、松虫草、雀梅、玉簪叶、英蒾、雪柳叶、尤加利叶

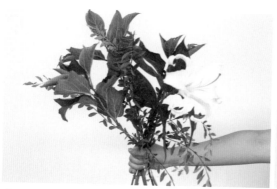

① 利用英蒾、雪柳等叶材，结合百合进行起手。

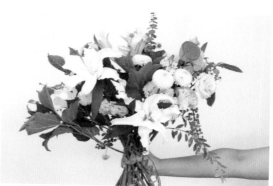

② 增加百合等白、绿色系花材。填充花材，花束逐步成型。

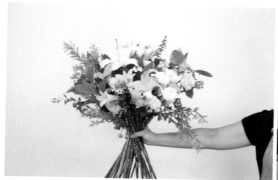

③ 进一步填充花材，加入体量感比较轻的花材进行外部衔接，丰盈整体花束造型。

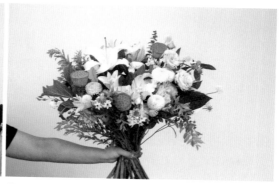

④ 调整花头朝向，完成白、绿自然主题色系花束设计。进行捆绑、剪根、保水处理。

花束设计 11
Lesson 301

这个作品是一个直立型的中式花束的设计。

材料
烟花菊、斑太蔺、高山积雪、木草莓叶、春兰

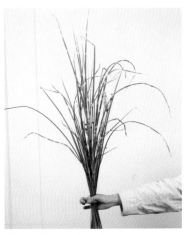

①模仿直立形态起手。

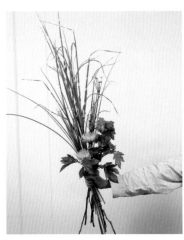

②以组群形式增加成组花材，加入木草莓组群。

③运用叶材增加整体花束层次，注意叶材层次的分布。

④运用东方的直立形态，结合西方的螺旋花束手法，完成中式花束设计。进行剪根、捆扎及保水处理。

花束设计 12

Lesson 302

这节带来目前市场上比较流行的莫兰迪色系的花束设计。

材料

绣球、玫瑰、蕾丝、康乃馨、紫叶风箱、洋桔梗

①利用绣球起手。

②丰富色彩，形成莫兰迪色调组合。加入同色系叶材，丰富整体造型。

③增加洋桔梗、康乃馨，进行整体色彩点缀提亮。

④加入散状花材，填充空间。加入叶材，进一步丰富层次。捆扎，剪根，花束完成。

花束设计 13

这节带来的是用应季花材做的花束，整体感觉富有野趣。

材料

中国桔梗、紫菀、翠扇、六道木、白廖、花葱

①以翠扇起手，完成时令性花材花束设计。

②利用穿刺的方式加入风铃花。在翠扇分叉中以穿刺方式填充花材，丰富整体作品的色彩以及丰富度。

③花材分散型的分布，整体造型松散灵动。

④不断地添加时令性花材，整体造型蓬松。

304 花束捆绑技巧 1

这节带来的是花束捆绑技巧中的双捆法。双捆法比较适用大型的花束。

Tips

麻绳使用之前用水泡一下，不需要浸泡太长时间，拿出来后把水分挤干，再捆绑会变得更牢固。

①麻绳提前浸湿，拧干。

②对折麻绳，拇指套环。

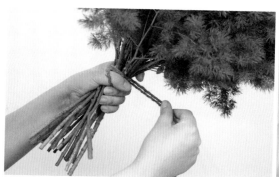

③从拇指的逆向方向，虎口上方开始绕环。

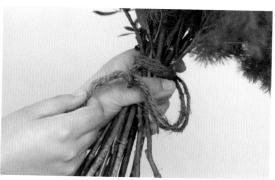

④绕2～3圈后，将剩余麻绳绕过原始圆环，拉紧。

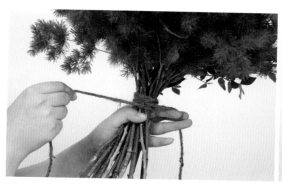

⑤拉紧后，两根绳头分开。

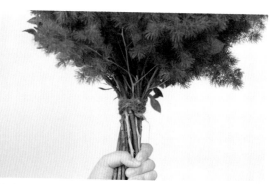

⑥背面系结，完成捆绑效果。

花束捆绑技巧2

这节演示的是花束的单线捆绑技巧。单线捆绑是零售花店中最常用的一种捆绑形式，捆绑材质最常用到的也是麻绳，稍微小体量的，也可以用纸皮铁丝。

①麻绳提前打湿，拧干。

②麻绳头部预留一定位置，捏合点压在拇指下方。

③通过大拇指虎口位置上方进行缠绕，缠绕2~3圈。

④转换位置，再次在虎口下方位置进行缠绕，环绕2~3圈。

⑤将剩余的绳穿过预留位置，拉紧短绳。

⑥系结，单线捆绑完成。

花束保水常见水袋类型

花束做好后，需要保水，常用的方法是在根部做一个小水袋。这节演示最普遍的几种方式。

①利用玻璃纸打褶充分包裹花束根部。

②利用透明胶带绑扎封口，注意封口处高于花束捆绑麻绳。

③利用注水壶注水。

◆用玻璃纸进行保水处理。

◆利用PP膜保水处理，注意后面偏高，前面包裹处偏低。

◆利用塑料袋膜进行保水处理。

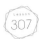
常用水袋的制作技巧

这节演示花束水袋的常用制作技巧。

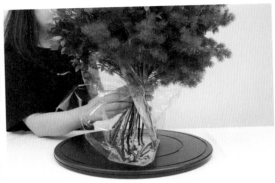

①将花束置于玻璃纸正中心，比对每个边缘，包起来　②逐一将三个面进行包裹。
边缘需要超过麻绳位置。

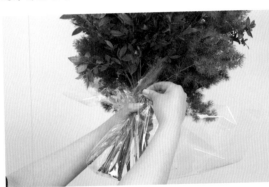

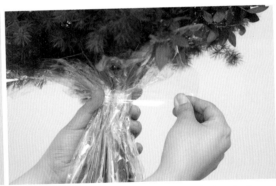

③最后一个面不断调整，形成收口。　④利用胶带粘合收口，粘合位置也需要在麻绳上面。

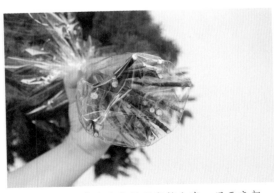

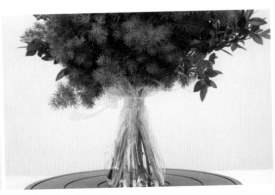

⑤底部戳齐，然后胶条粘贴完整十字，用于底部　⑥水袋完成效果展示。
加固。

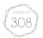
常见水袋固化材料

　　水袋是花束保鲜必不可缺的，但是在注水之后，花束只要一倾倒，可能会有水溢出来，怎么样解决这个问题呢？除了在包装时尽量扎紧之外，还可以让水固化，不容易流动。有以下几种方法：第一，吸水材质用可以吸水保水的材料，比如厨房用纸、脱脂棉等；第二，用保水凝胶，在包装花束时，提前把它倒在玻璃纸上，然后再包起来。包好后注水，水就被固化了。

棉类保水

①可用保水棉、脱脂棉等来保水。

②运用保水棉对花束根部包裹。

③放入外部保水袋，注水，利用皮筋进行封口固定。

凝胶保水

④将保水凝胶置于玻璃纸上，再用玻璃纸包裹花茎，根据说明书按照比例注水。

⑤凝固状态。

花束包装设计概论

Lesson 309

商用的花束，一般都会对其进行包装。包装相当于给花束穿衣服，首先是保护花材不受伤的，其次是可以通过各种包装材料进行装饰。

包装首先需要对花束保水，也就是做水袋。包装材料非常多，不同的材质，最后会呈现不同的效果。

◆丝带。

◆包装纸。

◆水袋用于保水。

◆附着保鲜剂。

◆用于花束运输。

◆祝福卡片等贺卡/LOGO贴/装饰物。

310 包装颜色搭配原则

花束包装时，可以从以下几个方面来考虑配色：

第一，邻近色搭配，适合有很明显色彩倾向的花束。如果花束的色彩是粉色，包装纸可以选择深粉、浅粉等会比较和谐；

第二，对比色和互补色，可以形成鲜明对比，非常突出花材，但需要谨慎使用。

第三，无彩色。无彩色是一个非常安全的颜色，各种花束都能搭配。

第四，还有一类比较特殊的包装，就是牛皮纸，它看上去是黄色，但是因为独特的质感，用起来也比较安全。

◆有彩色包装组合。

◆无彩色、中性色——黑白、金色、牛皮纸、棕色等色系组合。

◆邻近色色系包装组合。

◆互补色包装组合。

◆无彩色系缎带。

◆有彩色系缎带。

颜色搭配作品 1

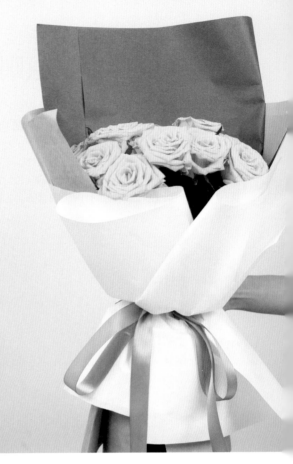

①选择灰色包装纸进行背部遮挡支撑。选择从灰色到白色过渡搭配包装。

②从两侧遮蔽与体量填充。

这节演示的是花束无彩色的搭配包装。色彩倾向比较明显的花束，为了突显花材本身的色彩，可以选择无彩色包装，比如该案例选择了从白到灰的纸张来表现，缎带的颜色也可以很好地表现花材本身的张力。

③白色包装纸用桶包方式进行前侧遮挡包装。

④起鼓处理。

颜色搭配作品2

色彩倾向比较明显的花束，我们可以采用邻近色或中性色来进行搭配，其好处是整体效果会比较和谐，不会产生特别大的色块冲突，强调了花束整体性。案例选择的颜色是一种莫兰迪的色系。

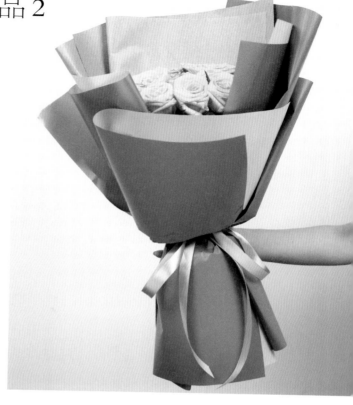

①选择莫兰迪色系包装纸进行背部遮挡支撑。

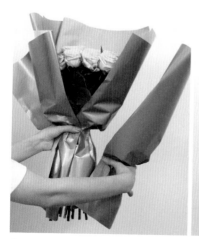

②选择同色系不同质感双面包装纸过渡搭配包包装。在两侧遮蔽与体量填充。

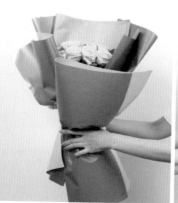

③增加同色系不同材质包装纸，进行表面包裹，丰富整体包装层次。

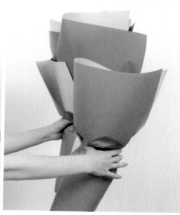

④背部运用双色包装纸进行加固，整体花束用"U"形桶包方式完成。最后进行固定，并系蝴蝶结装饰，完成花束包装。

颜色搭配作品 3

　　这节演示花艺色彩搭配中对比色的应用。花束设计有时候需要视觉的冲击，而且花束的色彩倾向比较明确的情况下，可以采用类似于对比色、互补色的手法来搭配。但是我们要注意颜色的调和，可以加入一些无彩色的包装纸，比如玻璃纸、白色的纸等。

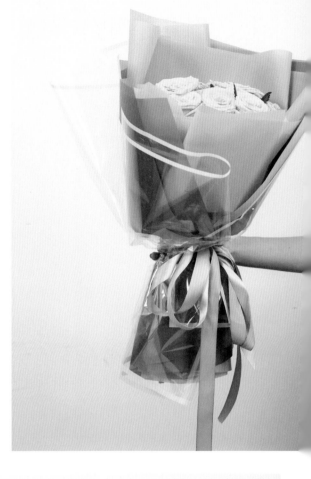

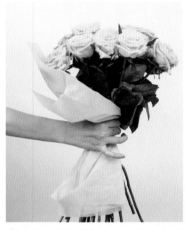

①选择与花束色彩为对比色的包装材料，运用棉纸进行前侧包裹。

②棉纸进行整体花束内侧包裹。再利用同色相不同材质包装纸做出高低层次。

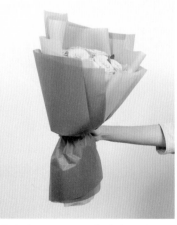

③最外侧利用深绿色韩素纸进行包装处理。

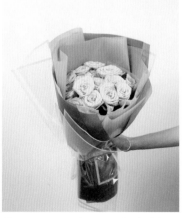

④运用玻璃纸进行整体包装外部加固，并且进行整体色彩调和处理。最后运用双色缎带进行装饰，对比色搭配包装花束完成。

材质搭配的原则

◆粗糙质感——网纱。

◆粗糙质感——落水纸。

◆双面质感包装。

◆特殊镭射膜。

◆纱质包装——卷边纱、网纱。

◆不同质感缎带。

材质搭配作品 1

这节演示的包装，我们选择了柔软质感的包装纸，整体给人感觉是柔美的田园风。

①利用棉纸进行内侧花束包裹。

②利用落水纸在棉纸外侧进行包装，增加材质的对比效果。

③落水纸半透明效果，可以充分展示花材结构。利用外部粗糙质感包装纸，同步起到整体造型支撑效果。

④选择相对粗糙质感缎带进行装饰。

材质搭配作品 2

这节演示一种比较现代、简约，又带有甜美气息设计风格的花束。

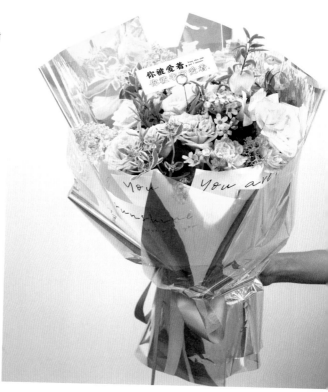

① 运用带有印刷纹样的简约风格纸张进行背部支撑包装。

② 内侧包裹高度整体控制在较低位置。

③ 外围利用镭射纸进行包装，注意包装高低层次。然后进行左右以及前侧镭射纸包装。

④ 外部充分包裹完成。利用缎带捆绑，加入装饰标语，光滑质感花束包装完成。

⬡ 317 材质搭配作品 3

这节演示的是一个比较甜美的包装设计。

①利用雾面纸进行底部遮蔽。选择与花束柔美质感相一致的包装材料，运用卷边纱进行内侧包裹。

②将网纱卷曲为筒状，用于外部包裹。

③利用网纱包裹花束，形成一定支撑以及包装效果。

④不断调整高度以及卷曲角度。最后利用缎带进行固定以及装饰。

⌬318 纹样搭配原则

◆规则图案包装纸。

◆图案纹样呼应花材。

◆勾边纹样包装纸。

◆汉字类中国风纹样。

◆规则纹样缎带。

◆镂空/图案类纹样缎带。

319 纹样搭配作品 1

这节演示的是如何用包装纸的纹样来呼应花材的性状特征。首先观察一下花材，用到了塔状的绣球、点状的珍珠梅、喷泉草等，然后寻找相匹配纹样的包装纸，比如作品中带小金点的纸张。

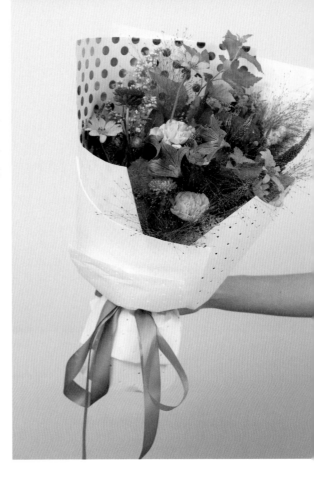

①提取花束圆形图案元素，运用圆点包装纸进行设计。

②利用镂空包装纸加固背部，同时丰富背部包装层次。再增加波点包装纸，包围花束。

③小波点镂空包装纸包裹外部，丰富包装层次结构。

④运用纯色同色系包装纸进行底部层次增加。最后进行缎带装饰。

320 纹样搭配作品 2

这个花束选择的包装纸是带有绣球纹样的包装纸，与里面的花材有很好的呼应。花束整体看上去比较杂，要取纹样相对来说会比较难取，我们取到里面体量最大的一个，绣球纹样。如果没有绣球纹样的包装纸，也可以取其他纹样，但是对比感就就不会那么强。

① 选取与花束设计花材相呼应纹样的包装纸，例如绣球，增加层次，加大支撑度。

② 利用纯色简约字母纹样包装纸进行内侧包裹。再运用纯色系包装以及纹样包装纸叠加，进行前部包装，遮蔽水袋。

③ 运用勾边包装纸，"S"折方式进行外部加固以及层次填充。

④ 勾边包装纸外围包裹，运用紫色缎带以及黄色皮绳进行捆绑装饰，完成设计。

纹样搭配作品 3

这节演示的花束包装是自然灰的颜色，它看上去比较陈旧，所以从纹样的角度考虑如何去表达复古感、陈旧感，于是选择了稍微有点褪色的旧报纸这种复古感的纹样来搭配。

①利用报纸图案作为花束背部支撑，进行起手操作。

②不同高度，逐层包裹；运用纯色以及报纸纹样质感包装纸增加花束包装层次对比。

③利用复古色系纯色包装纸进行底部遮蔽。

④增加纹样包装纸加强外部装饰，运用双拼色缎带进行装饰。

丝带的分类

丝带可以从颜色、质感、风格、尺寸等进行分类，但也可以根据花店的标志形象或标志色，定制一些缎带，可以有专属的纹样。

◆纱质缎带。

◆极细丝带。

◆圣诞主题异形缎带。

◆蕾丝材质丝带。

◆印花缎带。

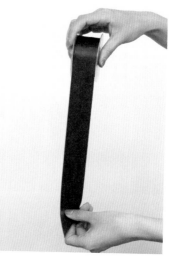

◆定制缎带，可印刷自己品牌LOGO。

蝴蝶结制作技巧

在日常生活当中，我们会经常用到蝴蝶结，比如系鞋带、裙子腰带等。花艺零售中，蝴蝶结的应用也非常多，下面演示蝴蝶结的制作技巧。

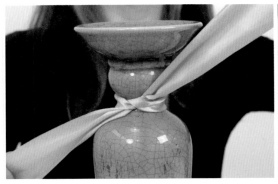
①第一步：打结,要求两端一上一下，并且同样长度。

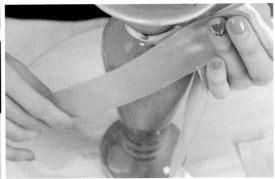
②下部缎带向上翻，注意缎带整体正面朝外。

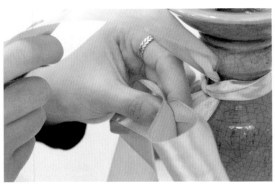
③右侧缎带围绕成型蝴蝶绕一圈。

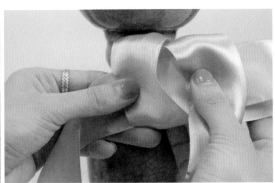
④绕一圈后，再次同样重复操作绕第二圈。

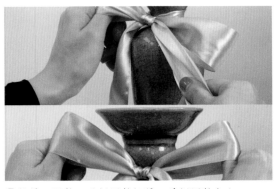
⑤拉紧，调整，后侧调整松紧，前侧调整大小。

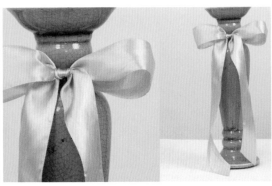
⑥蝴蝶结完成效果完整图与细节图。

法结制作技巧

法结比较复杂，但是作为一种装饰类型，职业花艺师还是有必要掌握的。

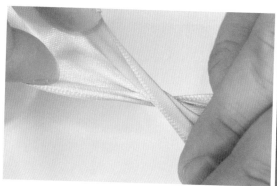

①剪取合适长度缎带，将缎带拧为"X"状态。

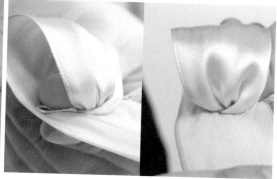

②以拧结为起点，缎带正面朝外，卷出第一个圆圈。

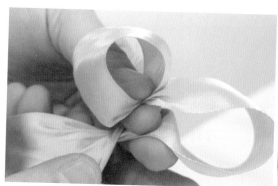

③以第一个圆圈为参考，重复操作，拧出对称的图形。

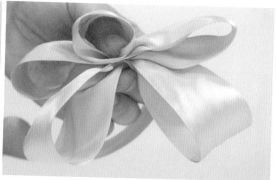

④初步增加层次，每个层次都要求为对称图形。

⑤最后用独立的丝带进行收尾打结。

⑥法结最终呈现效果以及背部细节图。

球结制作技巧

球结作为一种装饰性非常强的结，在花束或礼品包装中经常会用到，而且制作方式很简单。制作球结尽量不选择材质比较软的，比较硬的缎带才能支撑起球形的结构。

①确认球结"花瓣"数、卷圈数，其中"花瓣"数
=2×卷圈数。

②剪取缎带，其中两端留取长度不宜过长。

③捏住中间段，剪出两个三角小口，用纸皮铁丝固定
捆绑。

④从绑点位置逐一"拔"出花瓣。

⑤整理"花型"，形成立体球形花状。

⑥球结正面展示图。

常见手捧花手柄捆绑 1

这节演示的是新娘手捧花手柄的丝带捆绑技巧。在做完新娘手捧花之后，还需要再对它的手柄部分进行装饰。因为考虑到后期新娘持握的时间会比较长，花容易脱水，在装饰时也需要考虑保水因素。

①将保水棉充分浸泡，修剪玻璃纸，保水棉外覆盖玻璃纸包裹花束手柄，透明胶带固定。

②缎带包裹底部。根据花束末端直径，判断缎带用量，进行裁剪，透明胶带进行包裹固定。

③利用底部多余部分遮盖手柄缠绕起始位置，然后开始缠绕。

④持握部分，从底部开始向上，利用缎带进行缠绕。

⑤末端进行弯折，珠针斜扎进行固定。

⑥新娘手捧华缎带处理效果展示。

常见手捧花手柄捆绑 2

这一节我们利用一些杂色的丝带，对新娘花束手柄做一些小的纹样装饰。

①在原有丝带包裹的手捧基础上进行丝带二次装饰。

②从手柄底部开始进行"X"形环绕操作。

③形成"Z"形纹路。

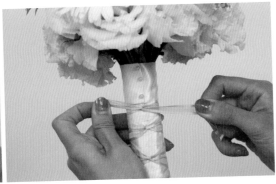

④拉紧丝带，形成装饰纹样。

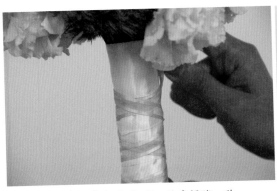

⑤背面形成有规律的"X"形，注意间隙一致。

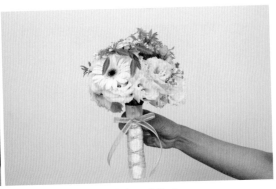

⑥丝带进行缎带表面装饰效果展示。

包装材料的分类

　　市场上的包装材料琳琅满目，我们可以从多个角度对其分类。比如按照材质，可以分为自然材料和人工材料；按照软硬程度，可以分为柔软的和硬质的，硬质的材料可以立起来。其他还可以按照规格、质感、透明度、纹理等进行分类。

◆网纱类包装材料。

◆镂空处理包装材料。

◆麻质包装材料。

◆不同色彩的包装材料。

◆纹样印刷类。

◆棉纸类。

329 宝宝包设计原理

这节演示花束包装中"宝宝包"的包装方式。宝宝包，听名字就比较可爱，它确实像包婴儿小被子、褓褓一样。

①将花束沿对角线位置放置于包装纸中间，确保尖角位置在花束之上。

②底部尖角充分包裹花束下半部分。

③左右结构对折。

④整理包装纸成宝宝包形状。

⑤上半部分整理，让包装纸尽可能饱满。

⑥通过下部空隙，运用竹棍等调整底部褶皱部分。

宝宝包常见错误分析

这节介绍宝宝包包装时常见的一些错误。

◆错误1：由于纸张大小不够，过于紧裹，挤压花束。

◆错误2：捏得过紧，产生死褶。

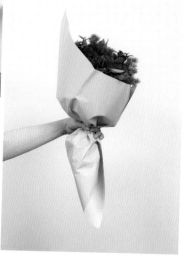

◆错误3：侧面产生弓背效果，不够饱满。

◆错误4：下部握紧。

◆错误5：正视产生偏轴。

◆错误6：下半部分过扁，起鼓不充分。

Lesson 331 宝宝包制作

这节为大家带来的是花束包装中的宝宝包设计。宝宝包按形态一般分为两种。第一种是比较狭长的，第二种是下半部分收口的。这里演示的就是狭长形的，有点像萝卜一样的形状。

①对花束进行保水包装处理。

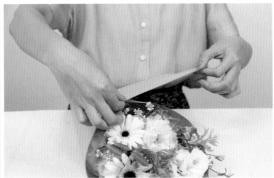

②比对花束大小，包装纸取1/2位置，进行剪裁，充分包裹花束。

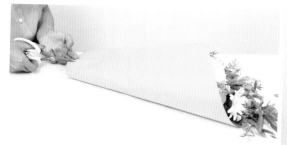

③剪除多余部分。

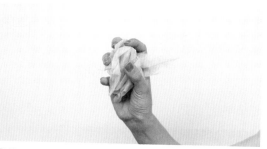

④棉纸褶皱处理，形成类似于大理石的自然纹路。

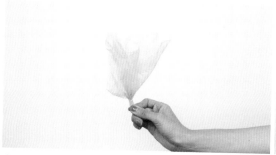

⑤透明胶固定。固定后效果展示，调整完成。

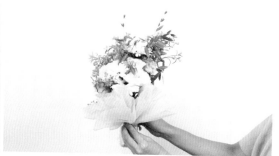

⑥将各小组棉纸充分包裹花束底部，对花茎以及玻璃纸遮蔽。

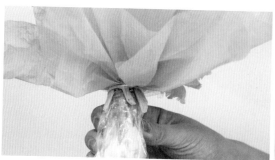

⑦用纸皮铁丝充分包裹棉纸，固定。

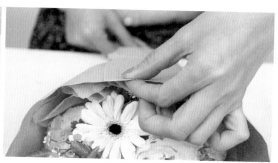

⑧外部用牛皮纸包裹。

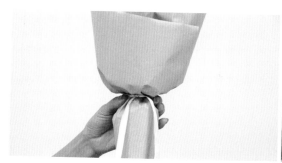

⑨捏褶，用细丝带固定。

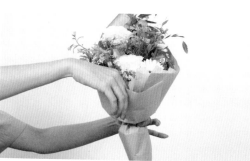

⑩起鼓调整。用丝带装饰，打蝴蝶结。

折角包设计原理

Lesson 332

这节介绍花束包装技法中的折角包形式。什么叫做折角，最简单的理解就是我们拿到一张包装纸，是摊平的状态，把它折一下，称之为折角包。不同的折叠方式，纹理不一样，呈现的包装形状也不一样。下面演示的是常规折角包的做法。

① 包装纸两次对折，避开折痕线，对折时稍微有一定错开角度，形成装饰边。

② 利用透明胶带粘合。

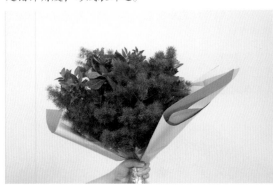

③ 制作多组包装纸后，注意叠搭，包围花束。

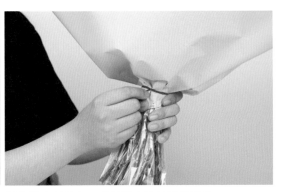

④ 包装底部重合，利用纸皮铁丝缠绕固定。

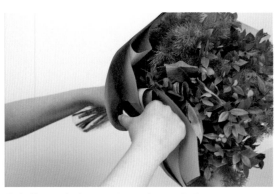

⑤ 包装纸上部内侧，利用订书器固定收拢。

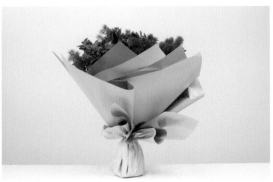

⑥ 下半部分运用水袋的制作方式，完成底部包装。

333 折角包常见错误分析

下面是折角包常见的一些错误做法。

◆错误1：不要�挆折痕。

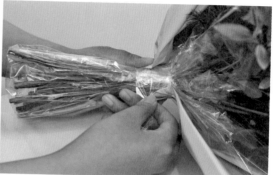

◆错误2：不要在一个位置粘胶条。

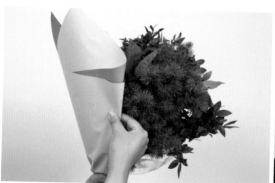

◆错误3：包装过紧，挤压花束。

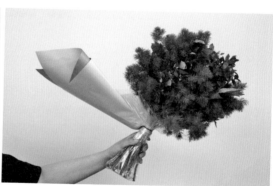

◆错误4：纸张强度不够，包装坍塌。

◆错误5：折角包下半部分绑点与上半部分绑点不一致。

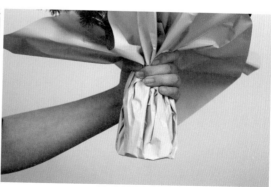

◆错误6：折角包下半部分过紧，形成棍状。

折角包制作

这节为大家带来的是折角包的花束包装形式。 折角包是四面观花束经常会用到的包装形式。案例用到的材料是棉纸和半透明塑料，如果我们为了简单快速地去完成，使用单一的纸张就已经足够了。棉纸是为了更好地衬托整个结构，在颜色、质感方面起到调和作用，包括材质上的缓冲。

①对花束保水处理。

②棉纸对折。

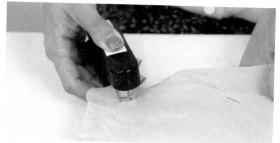

③用订书器固定棉纸。

④韩素纸面形成4个角。二次折叠。用透明胶固定韩素纸。

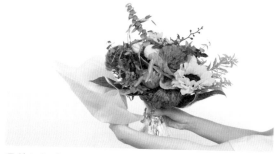
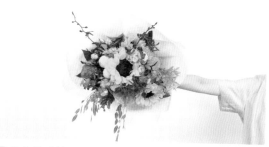

⑤棉纸起手。

⑥充分利用棉纸围绕内圈，注意折角的角度尽可能一致。

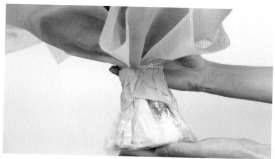
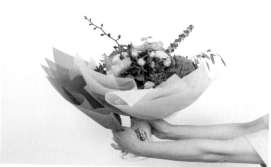

⑦用麻线、纸皮铁丝固定。

⑧用韩素纸包裹外围。

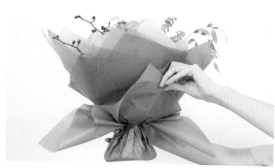
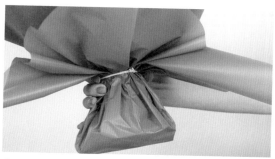

⑨底部利用韩素纸充分包裹，遮蔽花秆以及水袋。

⑩利用纸皮铁丝捆绑固定。外部加入缎带装饰。

桶包设计原理 1

335

　　桶包是目前应用最广泛的一种包装形式，它有很多种变化，也有很多技巧。它的原理类似于木桶合围一样，从四面八方把花束包围起来。其特点是对包装纸进行横向或纵向折叠，利用所形成的边缘纹样，对花束进行上下一体的装饰手法。折纸形式分为纵向和横向两种折法，纵向是和花束的垂直轴一样的方向，反之称为横向。折叠的方式不一样，呈现的效果也不一样。

◆纵向"一"字形折叠。

◆纵向"U"字形折叠。

◆纵向"S"形折叠。

◆纵向同侧对折。

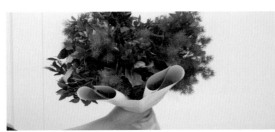

◆纵向"Ω"形折叠。

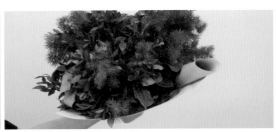

◆纵向单边卷曲。

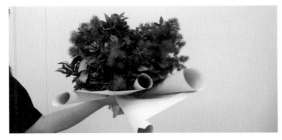

◆纵向双边异侧卷曲。

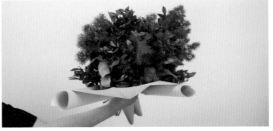

◆纵向双边同侧内卷曲。

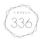

桶包设计原理 2

　　了解了纵向的折纸之后，再介绍横向折纸。实际应用过程中，横向折叠的非常少见，几乎不会存在横向和纵向同时折叠的情况。下面演示横向折叠。

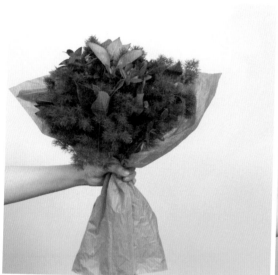

◆横向"一"字形。

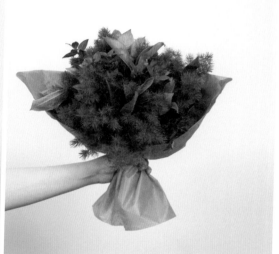

◆横向"U"字形。

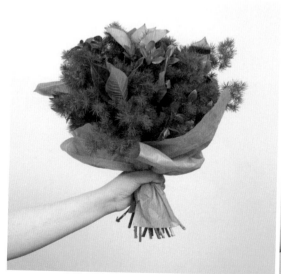

◆横向"S"字形。

◆横向单面卷曲。

桶包制作

这节演示桶包的包装方式。

①保水处理后的花束。

②比对花束尺寸，根据作品大小，剪裁包装纸。

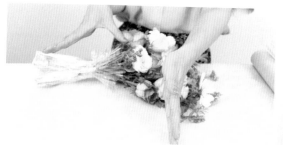

③根据花束手柄长度，比对棉纸，进行剪裁。

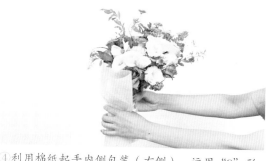

④利用棉纸起手内侧包装（右侧），运用"S"形折叠。

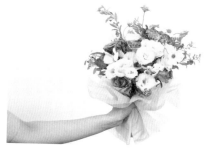

⑤棉纸遮挡花茎以及玻璃纸。

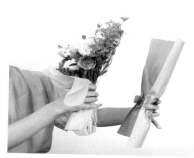

⑥进行后侧包装，注意褶皱部分细碎一些，捏合。

⑦背部细节调整。

⑧运用"S"形折叠，进行前侧面包装（左）。另一侧同样包装处理。

⑨两边起鼓，进一步调整。

⑩运用细缎带固定花束，外部装饰蝴蝶结。

桶包常见错误分析

下面是桶包常见的一些错误做法。

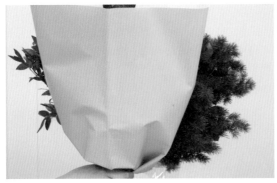

◆错误1: 纵向用纸, 折痕外露。

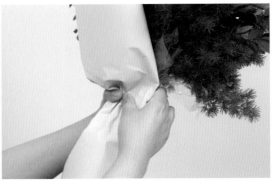

◆错误2: 持握位置产生死褶, 应该上下捏住往里推, 规避死褶。

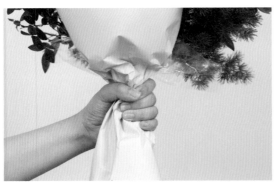

◆错误3: 绑点处过于紧捏。

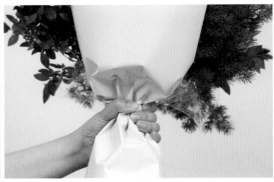

◆错误4: 包装持握部位褶皱不饱满, 不美观。

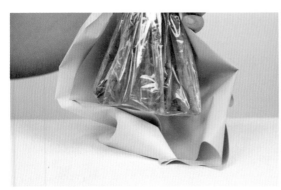

◆错误5: 下部预留过多。

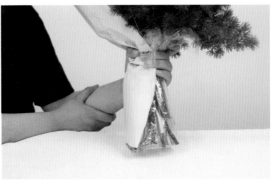

◆错误6: 下部预留过短, 导致水袋外露。需要提前预留1~2厘米。

LESSON 339 单枝花包装

这节以玫瑰为案例，演示一个单枝花的包装。

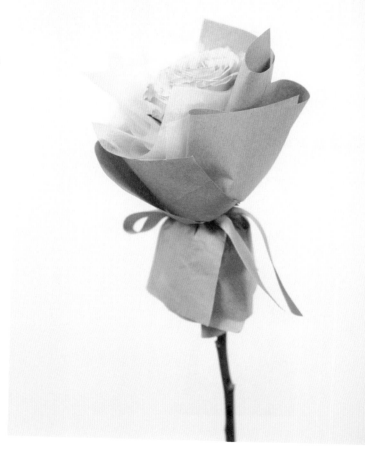

①起手，利用胶带固定棉纸。

②棉纸用做内衬围合包裹。

③内衬固定后，运用牛皮纸包装外部。

④牛皮纸运用桶包形式，完成外部包装，多张填充造型，增加体量感。最后进行缎带蝴蝶结装饰。

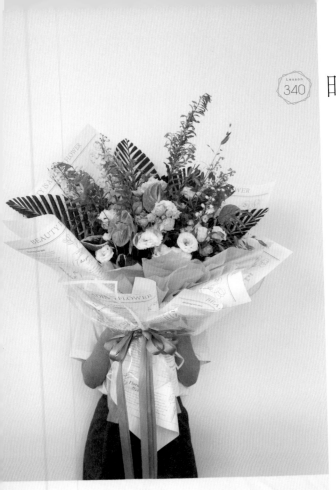

时尚花束包装设计 1

这节带来的是熊抱花束的包装设计。

① 将两种颜色棉纸，利用透明胶带组合式缠绕，形成拼合小组。

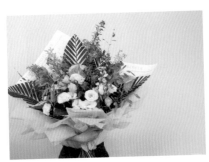

② 将预处理的组合棉纸叠加在花束底部进行包装。提前对比花束体量，比对包装纸剪裁，将完整包装纸附于花束背部，进行背部包装。

Tips

包装纸拼合有两个方法：一是纸张通过粘贴拼合；二是可以借鉴折角包的思路，上半截和下半截做分体设计的时候，可以去做一个拼合。。

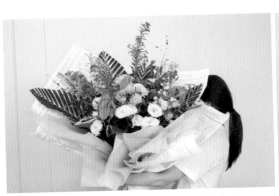

③ 逐步增加两侧层次，起到支撑以及包裹作用。

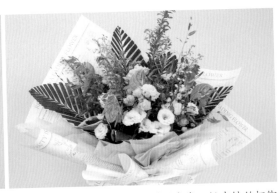

④ 各个角度增加包装效果，利用麻线、纸皮铁丝捆绑固定。用玻璃纸加固外部，绑好蝴蝶结装饰。

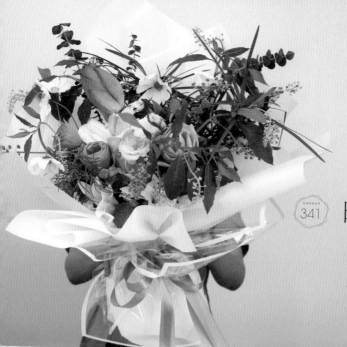

时尚花束包装设计 2

这集继续为大家带来花束的包装设计。我们主要采用的包装手法还是以桶包为主结合一点折角包的方式。

①利用韩素纸，用桶包方式进行整体包装。

②左侧包围包装纸。

③右侧包围包装纸。

④利用玻璃纸在花束包装最外围进行加固包裹，增加整体包装支撑效果。利用丝带在捆绑点进行加固以及装饰。

时尚花束包装设计 3

　　这节的花束包装设计，采用了三种不同的纸张，选用了邻近色比较柔和的配色方案，花束偏自然半开放式，在材质上选择了近于大地色的色系。运用了折角包的手法。

①用棉纸对折，做收腰处理。

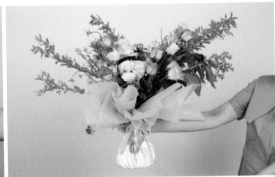

②将预处理棉纸包裹花束底部进行装饰。

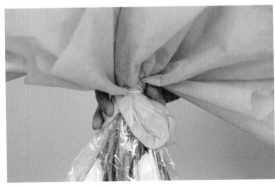

③利用纸皮铁丝固定。

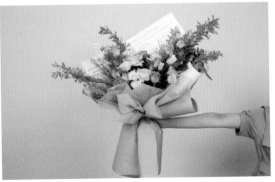

④左右两侧以及背部增加包装纸，进行包裹以及花束装饰。

时尚花束包装设计 6

这节为大家带来的是组群花束的包装设计，采用折角包的方式。

① 将雾面纸折叠后褶皱处理。

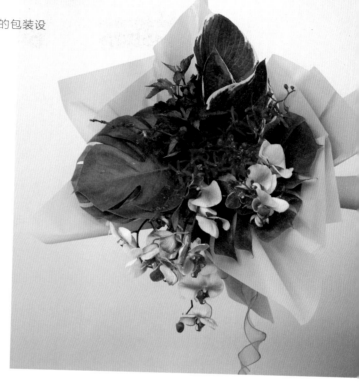

② 用处理好的雾面纸对花束进行包裹。左侧进行包装纸结构包围。

③ 内外层次添加包装纸，进行整体造型丰富处理。

④ 利用纸皮铁丝进行包装固定，并用丝带装饰。

LESSON 346 时尚花束 包装设计 7

① 包装纸和竹签进行连接固定，形成装饰性填充材料。利用透明胶带将多个素材捆绑。

② 将组合加入花束中，进行整体造型填充，底部保水处理。

③ 运用棉纸，折角包方式，将花束包裹。

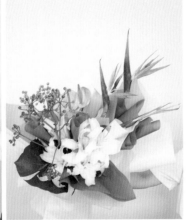

④ 逐步增加包装纸，以桶包形式增强外围层次。添加玻璃纸，加固整体包装造型，加入丝带装饰。

时尚花束包装设计 8

这节演示的是桶包的小卡通花束。

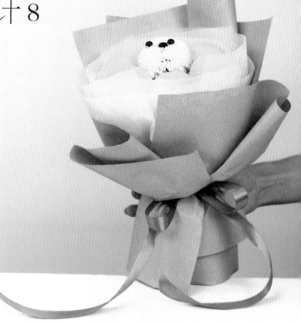

①选取白色棉花糖内衬纸，根据花束的大小进行
剪裁，去除对折痕迹。

②对比花束尺寸，剪裁牛皮纸。

③利用绵纸进行花束整圈包裹，让花束层次更加
丰富。

④外部利用牛皮纸进行"U"形、"S"形桶包形
式包装，加强造型。

⑤外部桶包包装完成，利用纸皮铁丝捆绑固定。
绑点处装饰丝带蝴蝶结。

时尚花束包装设计 9

　　这节演示直立型花束的包装。它和正常的花束包装不太一样，是在下半部分加强保护和支撑，让上半部分裸露出来。如果花束全是玫瑰做成的，也可以做成圆筒状。这里要给大家演示的是只做下半部分的，在技术层面上相对来说比较简单，跟做水袋的原理是差不多的，但有一些小变化。

① 将包装纸卷成圆锥形，底部用透明胶固定。

② 内部加入竹签加固，避免竹竿外露。

③ 将处理好的包装纸单侧包围。多个角度色彩穿插添加。

④ 底部包裹玻璃纸，遮蔽水袋。利用丝带做蝴蝶结装饰。

时尚花束包装设计 10

这节演示的是非常典型的夏日清凉花束包装。选择比较质朴的报纸，内衬加上一些棉纸，保护像紫菀、花葱这类比较娇弱的花材。

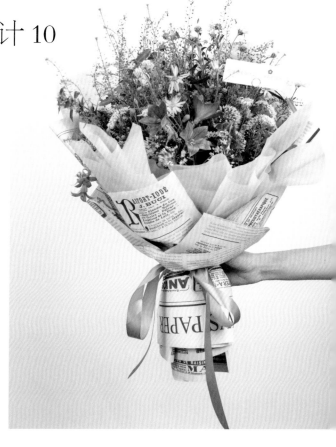

①花束进行水袋预处理。

②利用棉纸做内衬打底，对整体花束起到一定保护作用。利用纸皮铁丝固定棉纸。

③在棉纸外侧充分包裹报纸纹样包装纸，多层次添加，营造蓬松感。

④底部进一步添加包装纸，起到一定支撑且封闭造型的作用。加入缎带以及卡片进行装饰，完成包装。

时尚花束包装设计 11

这节带来的是有些中式风格的花束包装，采用了带有中国汉字纹样的包装纸。

①用桶包方式，进行花束背部遮挡。

②用不同纹样包装纸，包围花束。用带有中式纹样的包装纸装饰两侧。

③完成前侧花茎遮蔽以及层次装饰。

④利用纸皮铁丝固定。运用中国蓝色调缎带装饰，包装完成。

时尚花束
包装设计 12

351

这节演示的包装是比较复古色系
的风格。

① 花束做水袋保水处理。

② 通过文字纹样包装纸与边框
玻璃纸混合使用，进行背部支
撑包装。

③ 前侧加入白色包装纸，增加层
次，侧后方同样添加。前面加入
彩色文字纹样包装纸进行包装。

④ 前侧进一步添加玻璃纸，增加
前侧质感。加入缎带装饰，完成
作品。

襟花常见类型及特点

这节介绍襟花的常见类型和特点。襟花也叫做胸花，相传在西方国家，男生向女生示爱求婚，如果女生同意，会从求婚的花束中抽出来一枝花别到男生的衣襟孔上面，慢慢就演变成了现在所佩戴的襟花。制作襟花时尽量和新娘手捧花里面的材料有关联性。

常见的襟花以固定方式来分，可以分为磁力扣、"T"字扣，以及珠针和别针扣，可根据实际情况来选择。尤其是磁力扣要考虑一些特殊情况，比如装有心脏起搏器的人就严禁使用磁力扣襟花。

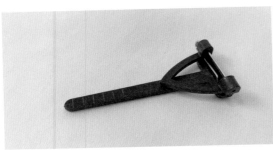

◆ "T"字扣。

◆ "T"字扣背部固定效果展示。

◆磁力扣。

◆磁力扣背部固定效果展示。

◆珠针。

◆利用珠针固定效果。

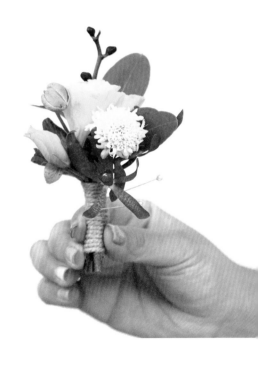

襟花设计
——自然杆

这节演示自然杆的襟花设计，很多婚礼追求一种比较质朴、原生态的风格时，适合选择自然杆的襟花设计。制作比较简单，接近于做平行花束的方式。

①选择质量相对较轻，不容易脱水的花材。

②形成高低错落层次感。

③利用麻绳进行整体缠绕，收口处利用冷胶进行固定。

④剪根处理，去除多余长度。

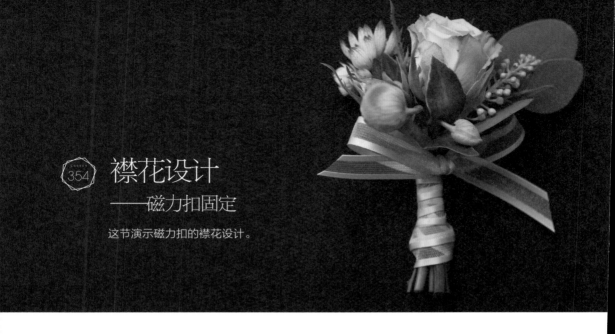

襟花设计
——磁力扣固定

这节演示磁力扣的襟花设计。

① 选择质量相对较轻且不容易脱水的花材，形成高低错落组合。

② 利用花艺纸胶带进行花材缠绕固定。

③ 将磁力扣提前剪好预处理，同样利用同色花艺纸胶带进行缠绕固定。

④ 外部利用丝带从下往上缠绕进行装饰，系好蝴蝶结。利用磁力扣磁力，将襟花固定在服装上。

355 襟花设计

—— "T" 字扣固定

这节为大家带来襟花设计中 "T" 字扣的固定技巧。

①剪取喷泉草头部，利用透明胶带分组固定。形成小组形态。

②利用花艺纸胶带将花材组合缠绕固定。

③将 "T" 字扣与花材组合缠绕固定，保证花材组合可以充分遮挡 "T" 字结构。

④ "T" 字扣襟花正面展示。底部缠绕丝带绳进行装饰。

襟花设计

——铁丝应用技巧

这部分介绍铁丝杆的襟花设计技巧，以下是具体的制作步骤。

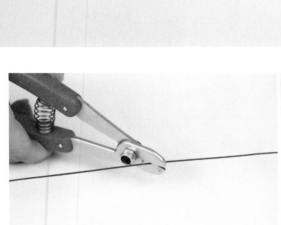

①利用铁丝钳斜剪铁丝。

②花艺冷胶涂抹花头，用于固定。去除花萼部分。

③将一段铁丝穿过花头，用于固定。选取细铁丝弯折穿过花萼，成"U"形结构。

④细铁丝形成长"U"形穿过叶材底部，缠绕。将所有材料组合缠绕，并且附着磁力扣，进行缠绕固定。利用铁丝进行花头以及叶片角度调整，设计完成。

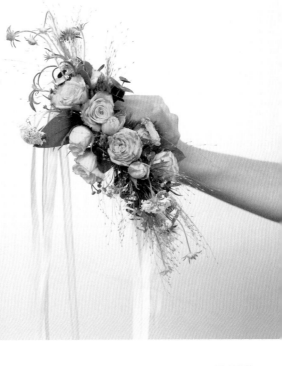

357 头环花设计与制作

这节为大家带来的是头环花的设计。在很多的户外婚礼或者时尚街拍中，我们经常看到模特或新娘带着很漂亮的头部装饰。包括在一些大型的花艺比赛中，人体花艺中的头饰是一个不可缺少的比赛环节。接下来讲一下这个铁丝杆工艺的半头环如何来进行制作。

材料
多头蔷薇、喷泉草、松虫草

①将铁丝提前用花艺纸胶带缠绕进行包裹预处理。铁丝两段弯折为圆钩，整体形成圆弧状。

②用铁丝给花头加杆以及铁丝缠绕预处理，用花艺纸胶带进行缠绕包裹。

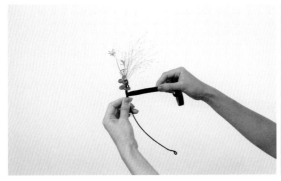

③利用同色系花艺纸胶带将预处理的花材、叶材缠绕固定在弯折的铁丝杆上。

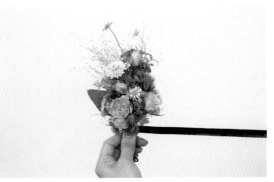

④不断填充花材，调整花材、叶材位置，形成头环装饰。

手腕花
设计与制作

　　手腕花作为新娘或者是伴娘的人体花艺装饰形式之一，有很多种制作的形式，这里为大家演示的是铁丝杆工艺的制作技巧。

①利用钳子将铁丝弯折为环状，完成2个相同结构。

②利用同色系花艺纸胶带将两个相同结构捆绑合并为手腕花结构。

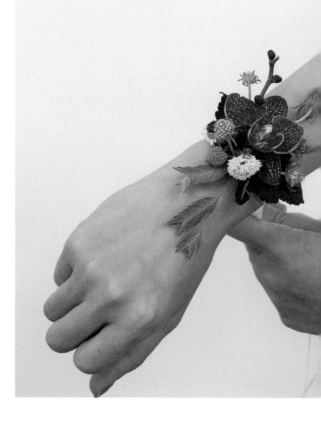

材料

蝴蝶兰、松虫草、小盼草

③根据设计需求，预留位置，剪除多余部分。手腕花主结构展示，保证两个圆环在一个水平面位置。

④花材自然杆穿插于主结构中，也可以利用铁丝杆处理方式进行花材预处理，最后运用花艺纸皮胶带固定花材。后部穿插丝带作为固定，完成。

主创团队

总策划　中国林业出版社·花园时光

执行策划　STYLAB格调研究所（北京格研文化发展有限公司）

统筹　张宇

花艺讲师　曹江

制片/导演　张宇
摄影　刘杨　蔡梓轩
摄像　刘杨　张宇
后期剪辑　张于庆　薛义豪　崔洪睿
视频及文字校审　张宇　蔡梓轩
场地支持　美后肆时景山市民文化中心Wework隆福寺社区

参编人员　蔡梓轩　金玲玲　李明姬　齐麟　刘丹丹　关九州　张意涵　郝元元
　　　　　　吴莹莹　张鑫心　周家乐　杨清喻　徐雨欣　冯雯萍　郑杭芳　许智
　　　　　　平娟　苏鑫　王海洋

图书在版编目（CIP）数据

全能花艺技法与设计百科：美好生活　花园时光系列 /
格研文化编. -- 北京：中国林业出版社，2022.7

ISBN 978-7-5219-1738-3

Ⅰ.①全… Ⅱ.①格… Ⅲ.①花卉装饰－装饰美术－设计
Ⅳ.①J525.12

中国版本图书馆CIP数据核字(2022)第110436号

策划编辑：印芳
责任编辑：印芳　赵泽宇
出版　中国林业出版社（100009　北京市西城区刘海胡同7号）
　　　　http://www.forestry.gov.cn/lycb.html
电话　（010）83143565
发行　中国林业出版社有限公司
印刷　北京雅昌艺术印刷有限公司
版次　2022年10月第1版
印次　2022年10月第1次印刷
开本　710mm×1000mm　1/16
印张　30.5
字数　580千字
定价　198元